Negatives

ATIVES

NEGATIVES

A Photographic Archive of Emo (1996–2006)

KODAK 5063 TX 29 KODAK 5063 TX 30 KODAK 506

28A 29 29A 30 30

By Amy Fleisher Madden

Foreword by
Chris Carrabba
of Dashboard Confessional

CHRONICLE BOOKS
SAN FRANCISCO

For my darling baby girl, Elle, who was only four years old
when I started this book and who will be on the cusp of eight
when it sees the light of day—you are my everything.

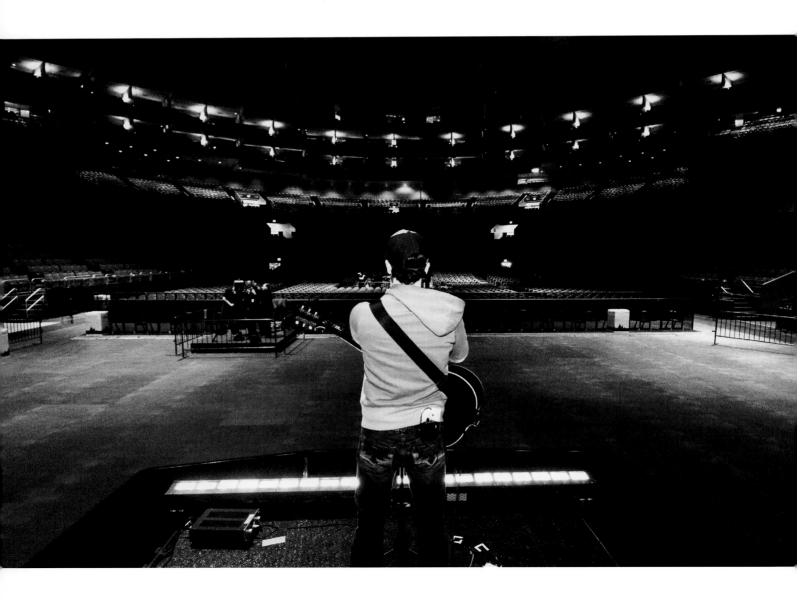

Have you ever heard a song and, instantly, the whole world changed?

**Dashboard Confessional
at Madison Square Garden
during sound check.
Photo by Michael Dubin.
New York, NY. 2006.**

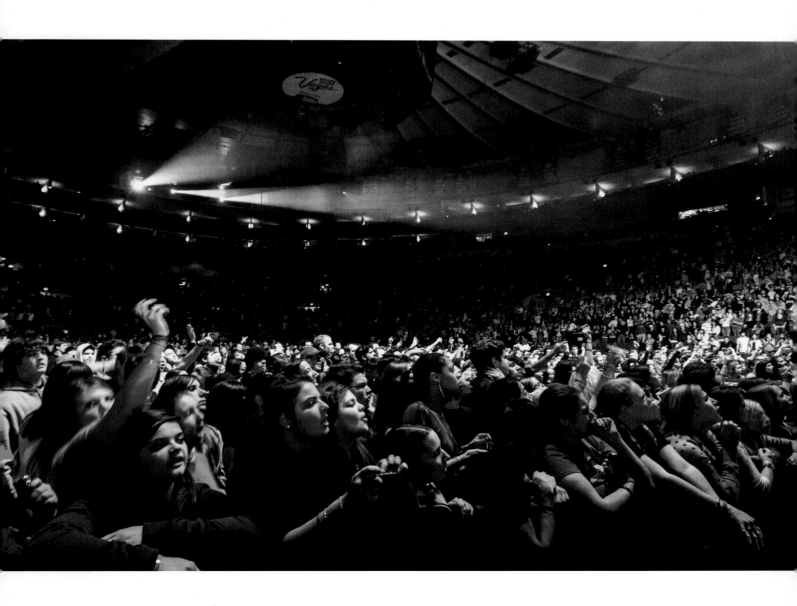

This book is for us.

Dashboard Confessional's crowd
at Madison Square Garden
later that evening.
Photo by Michael Dubin.
New York, NY. 2006.

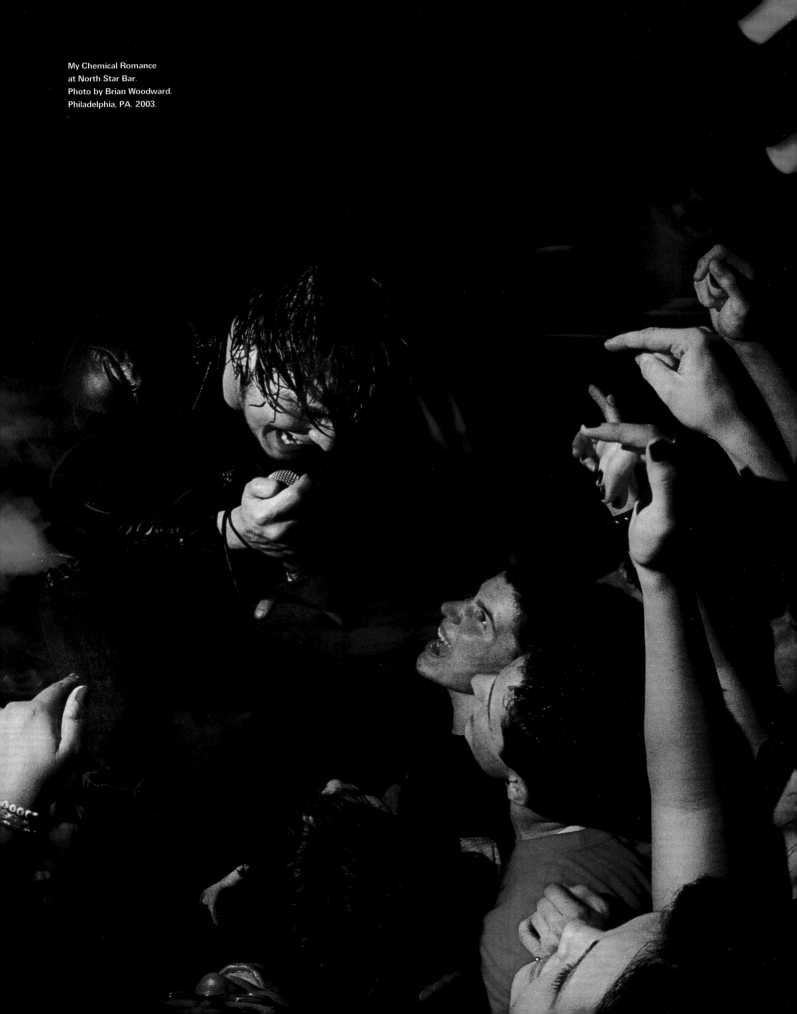

My Chemical Romance
at North Star Bar.
Photo by Brian Woodward.
Philadelphia, PA. 2003.

Contents

Foreword

Chris Carrabba
Dashboard Confessional /
Further Seems Forever

Speaking broadly, we were high school—or maybe college-aged—kids from city-adjacent suburbs. We had access to public transportation or a friend with a car. We coupled our desire to make sense of the world with a feeling that the borders of our lives were too confining. The music we discovered came to be centrally important to us in a way that is often common for people of that age, but to a comparatively uncommon degree. We found deep comfort in the songs that said, sometimes so plainly, what we felt so privately, and they helped us to better understand ourselves.

We were children of the divorce era, coming of age at the end of a century newly free of a cold war, with complicated feelings and time on our hands. We were looking for a musical experience that reflected who we were, and we were finding only hints of it, at best, in snippets on the edges of alternative radio or on borrowed VHS recordings of *120 Minutes*. Until somebody handed us the map.

Of course the map could take many forms and was only one of the essential pieces needed in order to discover underground music. There were other necessary tools and the order in which we found them may have varied, but their importance was inarguable. Among them were mixtapes, indie record stores, a scout further along in the hunt for songs who was willing to share what they had learned, and a small-but-growing circle of friends with whom to share in the adventure. But the map was essential because the map showed the way to where we wanted to be more than anywhere else. The map led to community. The map led to The Scene.

In all likelihood, if you lived in South Florida, the map that you were handed took the form of a photo-packed fanzine of write-ups and reviews called *Fiddler Jones*. In the issues of *Fiddler Jones*, its writer/

publisher/photographer, Amy Fleisher, chronicled the state of what was happening in our own regional music scene with the same sense of seriousness she granted to the national acts who would only rarely make their way to our city. In doing so, Amy helped her readers understand that this scene may have been remote, but it was no less talent rich, and in fact was more vibrant for its self-reliance. The scene wanted for more shows, so it turned inward for the answer. The members of this scene were going to have to be both the audience and the bands, and they found support in the pages of *Fiddler Jones*, where emphasis on the community of musicians and artists writing songs and starting bands was a mainstay of every issue. *Fiddler* legitimized the efforts the members of the scene were making, and it was the first piece of evidence that many of them could hold in their hands as proof they could point to when they told people that, yes, something special was happening here.

"It was never meant to be kept a secret. The mission was to tell everyone. We took our mission to heart."

As Amy would chronicle in the pages of her zine, the scene in South Florida was growing beyond its early punk and hardcore rigidity, allowing space for new and interesting fusions of other styles. Those styles were evolving and melding, and the resulting music was often challenging and sometimes revelatory. Punk begat hardcore, which evolved into post-hardcore, which dovetailed with shoe gaze and became something else entirely. People were calling it emo, but it wasn't quite. In the pages of *Fiddler Jones*, Amy treated all genres with the same respect

and, by way of this inclusion, was able to chronicle the second and third waves of emo from their earliest days.

The songs she wrote about shared a certain commonality of sound. We've come to recognize the hallmarks of these kinds of songs as pieces that are near fundamental to the genre, and their power continues to be remarkable. Those clean guitars, stripped of artifice, as bare and revealing as the truth. Lyrics that reflected who we were and who we were trying to be. The dynamic build and release of tension from the rhythm section. The rich and yearning melodies. The sense of conviction at the heart of it all.

This was still a time when the genre of emo was a subset of a subset, a sliver of a scene. The fact that the scene blew up and the bands became fixtures in the larger musical and cultural lexicon came as no surprise to those of us who were there at the outset. It was never meant to be kept a secret. The mission was to tell everyone. We took our mission to heart.

Of course, it takes work for a scene to grow and thrive, but in our scene we were no strangers to hard work. We were latchkey kids after all. We already knew how to do everything for ourselves and nobody I knew could do more themselves than Amy. Booking shows, making flyers, finding venues, taking photos, writing articles, printing zines, and eventually even putting out records. She would work the door, pay the bands out of her own near-empty pocket. She would go to band practices and help a band identify what worked in their songs and what did not work simply through her unbridled enthusiasm and her underdeveloped poker face. She would load your gear with you, or, if your work made you stay late, she would load it all for you. And when

she thought the bands were ready to put out records, she would take all the money she'd earned from every birthday and odd job and start a label fittingly called Fiddler Records.

Amy was tireless and dedicated and had a near-obsessive commitment to the grind of it all. No one I knew had ever outpaced her when it came to doing the legwork. And this effort was never for her own personal gain. It was all to show some person she might not even know what was special about some other person she might not even know. And that is why she was the person you could trust with your fragile idea. The person you could show your nearly finished song to. The person you could share your photos with. She still is.

"The music brings us together and holds us together now just as it always has."

This scene has grown wildly, yet it continues to bind us. The music brings us together and holds us together now just as it always has. The borders have broadened immeasurably, but it remains, at its heart, a community . . . and this community has seen some amazing things. If we didn't have the pictures to prove it, I'm not sure anyone would believe us.

Photo by RJ Shaughnessy. Chris Carrabba's house, watching *Reservoir Dogs*. Boca Raton, FL. 2000.

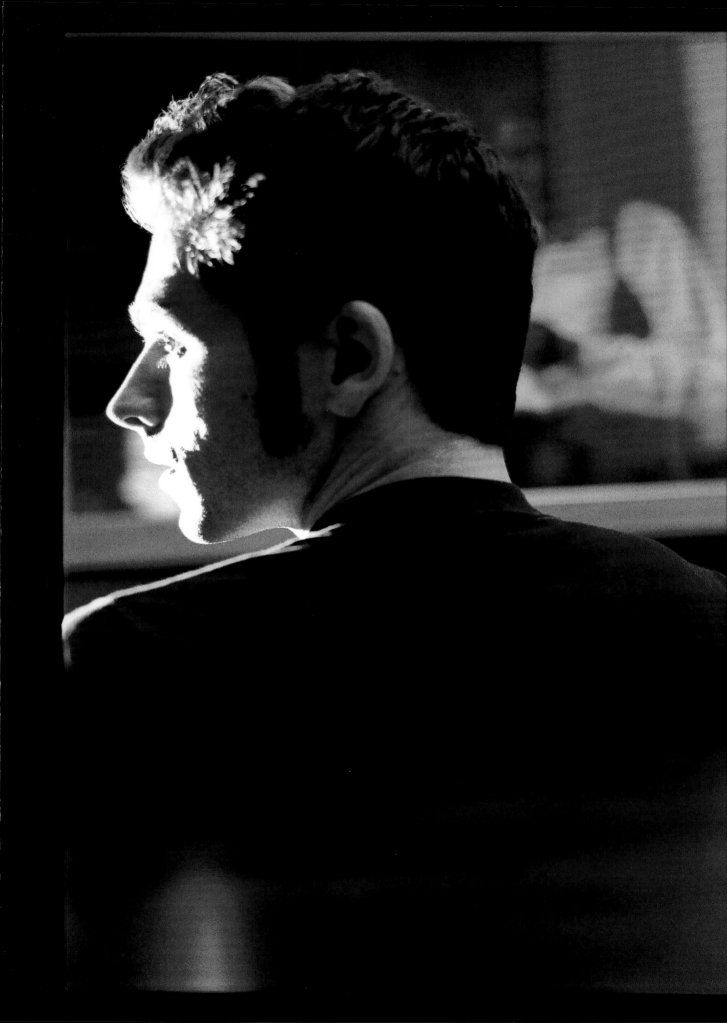

Introduction

Amy Fleisher Madden

There's really no other way to explain it than to say I just missed my friends.

Music has been part of my life since before I can remember, and in 2020, due to the pandemic, music—as a live event and a place to gather—stopped. With nothing to do all day, not even knowing why I was doing what I was doing, I started digging through old boxes, finding photos of a previous life when I had a record label, when I toured with bands, and when I decided to just be young all over the place with my friends without fear of ridicule, poverty, or death. I think I told myself I was "cleaning out the house" to make the daylight pass and maybe show my daughter some old photos of her mom when she was younger. But the deeper I dug, the more real these two-dimensional friends became. I don't mean for this to sound depressing, but I felt like I was hanging out with ghosts of living people.

I kept digging, and before I knew it, months had passed, the quarantine mandate was lifted, and I had become Frankenstein. In the spare bedroom of my apartment, I had created a monster—it was a vision of all of our old lives and it felt *so real*. So, technically, I have been working on this book for about three years—but in fact, I've been working on this for over twenty-five years.

My story begins in the mid-1990s in Miami, Florida, a place not known for its music scene or punk rock sensibility. Just logistically speaking, Miami might as well have been an island. A band would have to drive all the way through Florida for hours just to get down to Miami, so most would travel only as far south as Orlando and just play there. That meant, as a fan, if you wanted to see a larger band, you had to drive four hours north, attend the show, and then drive four hours back that night if you didn't have a place to crash or money for a hotel room

(and, let's be honest, we barely had gas money to make it to a show—so hotels weren't even a thought that entered our minds).

Nevertheless, I started going to local punk shows when I was about fifteen. Music became, for all intents and purposes, who I was, and in some shape or form, it's who I still am. I became part of Miami's underground scene, which was a strange isle of misfit toys. This was not a singular experience by any means. Watch any music documentary, and my story starts the same as almost every other personal discovery of a subculture: Outcast, disaffected youth finds community in the form of oddballs rallying together. But there's magic in that narrative because it holds true, every time.

In 1995, after discovering what to me felt like a secret counterculture, I started a zine called *Fiddler Jones*. I took the name from a poem by Edgar Lee Masters that was assigned to me in my English class. The first two lines of the poem read:

The earth keeps some vibration going
There in your heart, and that is you.
And if the people find you can fiddle,
Why, fiddle you must, for all your life.

Until then, I had never identified with something so profoundly, so I just *had* to use the poem's title, "Fiddler Jones."

Anyway, in my zine, I wrote reviews of shows and of the records my friends made. After a few issues, when I started receiving promotional copies of albums from real record labels, I reviewed those, too. I'll never forget the feeling of getting home from school each day, eager to check the mailbox, waiting for another oversized padded mailer. When most of my other friends were dying to receive college admissions brochures and acceptance letters,

I was just dying to get a package from Epitaph, Fat Wreck Chords, or even a major label like Capitol. I had known my whole life that I was different, but getting these promo CDs was one of the first times that different was starting to feel . . . cool? At least I thought it was cool—my parents definitely did not think this was cool. They would have much preferred a thick envelope from a prestigious university any day.

At local punk shows, I gave away copies of *Fiddler Jones* to anyone and everyone who would reach their hand out to meet mine, immersing myself more and more in this small, growing scene. One night, at Cheers, the only all-ages venue in Miami (it also doubled as a gay bar *and* a Latin jazz fusion bar), the owner, Gaye Levine, asked for a copy. She proceeded to grill me on all things scene related, and eventually she gleaned that I knew what I was talking about. She offered me my own night, Tuesday, at her club. Looking back, Tuesday is the absolute worst night of the week to host a show. No one goes out on Tuesdays. I didn't know that then, but even if I had, I'm sure I wouldn't have cared. I thought Tuesday was the loveliest night of the week, and I was going to make it work. I called all my friends that were in bands and I told them that Tuesdays were *ours*, and we were going to do such great things. I argued with my parents for a good week about having no curfew on Tuesdays because now I had a job, and I had to stay out past 9 p.m., damn it.

And to probably everyone's surprise—it worked. Those of us with parents who cared had the same conversations, and those of us whose parents didn't care—or who didn't have parents at all—showed up to help. I have no idea how, but I did it. I convinced people to give a shit, and it was like being given keys to the castle. My first "locals only" show on a Tuesday night featured three bands, and it was

so pure and so organic. Kids from local high schools and colleges showed up—no one fought, everyone was supportive, and there was no pretense or competition. The only drama was that the parking lot was too small and the neighbors complained about the spillover.

We did this every Tuesday for months. People even stayed late to sweep the floors and help the sound guy break things down. We had this tiny little ecosystem all to ourselves, and we cherished it. And as Tuesday nights became Thursday nights and eventually Fridays and Saturdays, we had this thriving community that could suddenly support national touring acts. At that moment, we were all collectively standing on the edge of the high dive, looking down—we hadn't quite figured out how to jump off yet, like the national acts. How do you just quit normal life and leap into the abyss?

That part came later, once I started releasing records for the same friends who played my Tuesday night shows. There were a few local record labels that I looked up to and supported endlessly, and because of this, they granted me unfettered access to a wealth of knowledge that helped me learn how to do what they did. One of the biggest bands in the scene back then was Against All Authority. They were a piss-and-vinegar punk/ska band, South Florida's answer to Operation Ivy, and they had a serious problem with cops—but they had no problem with me. Danny Lore, the band's vocalist and bassist, had his own record label, Records of Rebellion, and along with local legend Chuck Loose, drummer of the band The Crumbs (who were on Lookout! Records, Green Day's original home), these two guys—who were at least ten years my senior—took me under their wing and showed me the ropes. I learned where to press records (United Record Pressing in Nashville); I learned all about distribution (Rotz Records in Chicago, Revelation Records

in Huntington Beach, Lumberjack Distribution in Toledo, and a few others); I learned about consignment; and Chuck even gave me my first crash course in Photoshop—a skill that has propelled me creatively through every facet of my adult life. I seriously can't thank these guys enough.

So, officially speaking, in 1996, I founded my own record label, Fiddler Records, and my first release was from a hometown favorite called Vacant Andys. It was a flop. The release didn't flop because the music was bad—it wasn't—it flopped because I was sixteen and, even with my elder punk friends giving me every bit of information they could, hearing about how to climb a mountain and actually climbing it are vastly different. So things didn't go as planned the first time around, despite all of my bright-eyed hopefulness. There's even footage of this—if you want to see an emotionally ruined sixteen-year-old on the verge of tears sitting on the sidewalk in front of Cheers, get your hands on a copy of the documentary *Release*, directed by Brant Sersen. Anyway, I pressed five hundred 7" records. I hadn't taken into account that there were only about a hundred people attending shows at the time. Let's just call it a lesson learned, because after a handful of other releases that were less floppy, I released a CD EP from a new band that hadn't even played a show yet, called A New Found Glory (they dropped the A a little while later). This release was not a flop. We sold a thousand CDs before I could even figure out consignment at our two local record stores (Uncle Sam's and Blue Note Records) or ship them out for distribution. So I pressed more CDs and looked into booking a tour.

At the time, there was no internet the way it exists now. There was, however, a wonderfully helpful zine called *Book Your Own Fuckin' Life* that the top-shelf zine *Maximum Rocknroll* released yearly. This guide listed people you could call to book

a show, city by city. Some shows were in living rooms, basements, backyards, and occasionally a VFW hall or a real bar. It was an analog punk rock network—and it fucking worked. I booked a two-week East Coast tour for New Found Glory solely using this resource, and friends of friends from this resource, and finally we took that leap off the high dive, venturing out beyond our little corner of the world, ready to take on everything.

From here, life moved at warp speed. My friends and I untethered ourselves from any sense of normalcy, our families, and the early days of our youth—

"We were no longer nerds, geeks, outcasts—we finally fit into something. We moved through time unfazed by the normal world."

the days that followed were a new chapter for all of us. We were no longer nerds, geeks, outcasts—we finally fit into something. We moved through time unfazed by the normal world. None of us could function as ordinary people. Sticking us behind a desk or in a classroom was like torture—we longed to drive aimlessly to towns and cities we'd never been to, hoping that even just five people would be there to see us. Belongings were moved into storage spaces, parents' garages, friends' rooms—anything. We did anything just to get financially lean so we could afford to survive off the hundred dollars or less that we'd collectively make each week. Breakfast, lunch, and dinner were from gas stations—or Denny's if we had a really good merch night—and the kids that hosted us in each new city we visited became fast friends that some of us have kept for the rest of our lives.

We slept in vans with our shoes on, we slept under kitchen tables with kitty litter pressing into our faces, we bathed in rest stop sinks, and we brushed our teeth while driving seventy miles an hour. Home was nowhere and home was everywhere. We were free.

During this period, I transitioned from fan to participant. All the years I had spent collecting records, reviewing things, writing things, taking photographs—that was during the second wave of emo, when I was just a fan. In the late '90s and early '00s, when we were making this noise and driving these miles, my friends and I had no idea that we were pioneering the third wave of emo. But we didn't really refer to ourselves or our movement as emo. *Emo* was this weird joke of a word that didn't make a whole lot of sense to us. We just called ourselves punk, or indie, or rock 'n' roll. We never breathed the word *emo* to each other, mostly because no one would have known what we were talking about. In the span of ten years, I released twenty-seven records—some you might have heard of and some you definitely have not—but I never labeled a single one as emo. When I shuttered my company in 2005, I still stuck to my guns and called it "an independent record label" until I was blue in the face. Sometimes I even referred to it as a punk label because, by an ethos yardstick, it was punk. Just not by sound. But time does what it does, and lo and behold, we were emo, and we were the third wave.

Chris Carrabba, the singer of Vacant Andys, the first band I worked with, became my closest friend—despite his first release not working out quite like either of us had hoped. After that band broke up, and after a frustrating moment with another group, he decided to go solo, and he called his new band Dashboard Confessional. Chris and I, despite living fifty or so miles away from each other and being four years apart in age and life

experience, became inseparable. We were that nauseating boy-girl pair of best friends who wore each other's clothes, stole each other's food right off the plate, and fell asleep at each other's houses more often than not. This made things wildly simple and fun when I decided to release the first Dashboard record and go on tour with him.

You probably know the rest of this story, which is the reason this book exists. Dashboard Confessional went from playing to ten people to a hundred to a thousand. By 2006, Chris had sold out Madison Square Garden. The audience of a hundred kids we knew by name and face, all from the southernmost tip of the United States, became thousands of kids showing up from across the country—but we still tried to know everyone's name and face (and still try).

This book, for me, is proof. We existed. I grew up poring over photo books about the '70s and Woodstock and legends like Led Zeppelin and The Rolling Stones—and I never imagined what I was doing, the thing that I was part of, would hold the same sort of weight. I never thought, when I was spending every dollar I had pressing records for bands that I was working with, it would become *this*. Turns out I was wrong.

Emo has gone on to change the face of pop culture, repeatedly, through the years, but its adolescence is not as well known and how long it took to get it where it was going is a mystery to some. So back to the pandemic, when I was digging and digging through those boxes, finding hundreds of negatives from my past—images that seemed silly, unimportant, and maybe even embarrassing at the time. When it came to "professional band photography" for bands on my label, I usually outsourced the task to "professional photographers." I would always just take photos of backstage, hanging in

hotel rooms, and living in our vans. I realized that these photos tell a different but just as important story. When I was alone with my family, trapped in our house, taping these photos to my walls, I found that these memories kept me alive. I was instantly transported to a Waffle House in a no-name town in the middle of America, drinking a milkshake at 2 a.m. with the most unlikely cast of characters. At the time, I didn't think my behind-the-scenes photos had any merit whatsoever—but it turns out they do. These snapshots I took, of friends, and people, and places, are the most honest representation of what independent music felt like, on- and offstage.

"I started reaching out to old friends who followed a similar path, and they also had hundreds of negatives. Before I knew it, I had over five thousand images from around forty-five photographers to help me paint this picture of youth in all its splendor."

Once this book was starting to become something, I knew I needed more. I started reaching out to old friends who followed a similar path, and they also had hundreds of negatives. Before I knew it, I had over five thousand images from around forty-five photographers to help me paint this picture of youth in all its splendor. This is the first official photographic record of this scene.

As you turn these pages, there are a few things you should know. This book documents two eras, which I am labeling the second (1996–2000) and third (2000–2006) waves of emo. First, I believe that

1996 to 2006 was a golden era of music and, more specifically, of emo. Second, this era matches my personal involvement: I experienced the second wave as a fan and the third wave as a participant in the business, and I am adamant about retelling only what I experienced firsthand. I am not Ken Burns; this is not a comprehensive history. This is a personal account from someone who was there. Someone who physically, emotionally, and financially contributed. Someone who put themselves on the line to build and grow this scene. Be wary of folks who try to tell you about "how things used to be" when they weren't really there or they just stood in the back.

Further, while this book contains plenty of "scream your heart out until your eyes water" concert photos, I also wanted to highlight what happened during the other twenty-three hours of the day, before and after the performance. Anyone who attended these shows saw Jay Palumbo of Elliott with his guitar

"Music, and pop culture as a whole, does not exist in a vacuum. Music is experienced subjectively. A subjective experience creates an alternate version of a truth, one that's our own—and I've had to make my peace with that in making this book."

soaring through the air and the vertical leaps of Casey Prestwood of Hot Rod Circuit. What only a few people saw was how Aaron Stuart from Piebald once had to sleep in a bathtub because that was the only place left to lay down. That's what I want to show you. This is life as it really was. I can only hope my deference and celebration comes across in these pages. This is a showcase. This is an archive. This is a record of how it felt, how things sounded, how we dressed, and, most importantly, who we were.

Finally, this book isn't for musical purists, who might disagree or even be angry with some of the bands I've included. *Emo* is such a difficult word. It's been bastardized, monetized, criticized, and most lately commodified—the list goes on. That's why I'm doing this. For better or worse, I've spent most of my life being part of this thing that can't really be defined, that some people don't really want to be a part of, that bands aren't sure if they're for it or if they're embarrassed by it. The debate over what is and isn't emo has become one of the most argued points I have ever seen. If I could tell you how many arguments I was part of or overheard about the actual punk-ness of Green Day in 1997—well . . . Therein lies the truth. It's perception. What you believe is what it is, and your truth belongs to you. For some, it's blasphemy to consider Sunny Day Real Estate and Saves the Day members of the same genre, and that's okay. There is space here for a difference of opinion. Simply put, this is my account of things as I saw them, and I absolutely include the third wave bands that have gone on to become some of the biggest bands in the world.

Music, and pop culture as a whole, does not exist in a vacuum. Music is experienced subjectively. A subjective experience creates an alternate version of a truth, one that's our own—and I've had to make my peace with that in making this book.

We were all in this community. We drove in circles around each other. Which is why, sure, technically speaking, American Nightmare might not be an emo band, but I'll be damned if they didn't influence emo, and vice versa. So I have included them,

and others that I felt were wildly influential and important, because to understand the whole thing, you need to see the whole picture.

I have also treated everyone in this book with equal respect as I feel that everyone here has done immeasurable things for our scene as a whole, and I know that I haven't included every band and every person who made a difference. It's possible and entirely likely that I've forgotten or overlooked bands that you hold dear. This has kept me up at night, but as I say, I can only share my own experience. This book represents the era as I moved through it. So please take this for what it is—a celebration of a genre that was initially overlooked, that started a movement, that introduced a swell that changed the lives of millions of people worldwide.

Which brings me to the last point. I hope this book proves that whatever emo is and whatever it was, it's beautiful. I hope these photos make you smile. My eyes welled up with tears of joy more times than I can count when these images appeared on my monitor for the first time, and every time after. The origins of the music I have loved dearly and nearly more than anything else in my life is in danger of being forgotten, typed over, erased. Photos that existed only on film and old hard drives have been sitting in our garages, parents' houses,

and storage spaces for too long. Sure, you could argue the scene is stronger now than it ever was, but these early images, these memories, were in jeopardy of being lost—tossed out with boxes of old newspapers and baby clothes or, god forbid, at risk of being drowned in a flood or burned in a fire. This is my rescue mission. I will fight to keep these memories from being the depressing kind of ghosts.

For the souls who grace the pages of this book, those whom I personally know and love, I hope this feels like a yearbook of our lives and less like a place to worry about who was and wasn't something. If you are already emo-familiar, I hope this gives you a sense of joy—to see these memories and hear anecdotes that we can all smile about or commiserate over. And if you are new to this world— welcome, please come in and look around, make yourself comfortable. This world will hold you tight when nothing else will; I can personally attest to that. All I ask is that you leave things better than you found them.

For everyone who has been there from the beginning, for everyone we lost along the way, and for the people who will come long after us, this book is for you.

I hope these photos find you well.

Amy Fleisher Madden
at The Standard Hotel.
Photo by RJ Shaughnessy.
Los Angeles, CA. c. 2002.

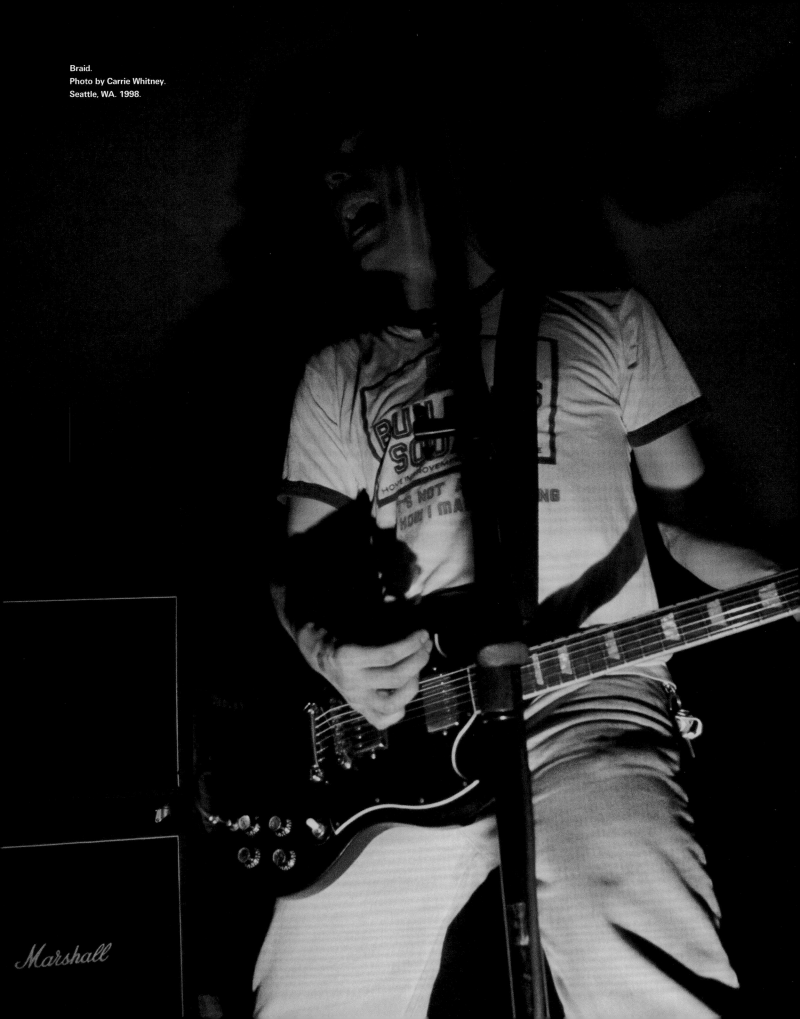

Braid.
Photo by Carrie Whitney.
Seattle, WA. 1998.

Second Wave

An Introduction to the Second Wave

Matt Pryor
The Get Up Kids

The whole thing was meant to be temporary. In 1997, I was twenty years old and had already dropped out of college. However, my bandmates Rob Pope and Jim Suptic were still in college at the University of Missouri–Kansas City and the Kansas City Art Institute, respectively. Our drummer, the youngest member of the band, Ryan Pope, was just about to graduate high school. At the time, Jim was particularly adamant about the temporary nature of our band's future—he had a scholarship, after all, and he didn't want to lose it. But at this point in our "career," we had released a couple of EPs that were well-received; we had just recorded our first full-length album, which was supposed to come out that summer; and we had a three-week tour booked with Braid—a band we had never met but knew by reputation. They were hard working and by all accounts a good hang. I had grifted my parents into letting me keep my tuition money to purchase a 1993 Ford Econoline van, and the plan was to do this summer tour, then go back to school in the fall.

"However, it should be noted that the feeling of being an outsider, whichever kind of outsider you happen to be, all comes from the same place—it's just how you choose to manifest it."

At the time, nobody really used the term *emo*, especially not the way it's used now, and our style of music was not so widely accepted outside of the underground. *Emo* as even just a word had been bubbling up around the scene, sure, but it was mostly a derogatory term that hypermasculine hardcore kids called bands like ours. *Emotional*, like *weak*—and dare I say, *feminine*—was not a term of

endearment back then. So, when I tell you that our plan was temporary, this is why. There was no plan to get famous or anything like that. Going on tour was just always something we wanted to do. We're from Kansas City, for fuck's sake. There was no delusion of grandeur.

"There was no 'us' and 'them,' there was just a collective 'we.'"

This was mostly because a band deemed "emo" was considered a lesser band to more than a handful of folks. If hardcore bands—and by extension the rising nu metal scene that was starting to get radio play—were on one end of the range of youth frustration, we were very far away on the other side of that spectrum. We were post-Cobain, Weezer-obsessed, glasses-wearing nerds. We were much more likely to read a book than start a fight.

However, it should be noted that the feeling of being an outsider, whichever kind of outsider you happen to be, all comes from the same place—it's just how you choose to manifest it. At the time (with some notable exceptions that I won't name here) we were, by some miracle, accepted by a select few members of the hardcore community. This is no doubt thanks to those who can recognize a fellow lost soul within a counterculture movement, who were also not concerned with our bespectacled nature and vintage clothing in lieu of sportswear.

All of that said, more often than not, we were playing shows with the few hardcore bands that accepted us, a slew of pop-punk bands, and ska bands, and so on, all on the same bill—the only thing we had in common beyond being bands was that we didn't fit into the mainstream. In that moment that was enough of a common thread for us.

We played many a basement, record store, living room, and, eventually, the occasional club. For a minute there, we were convinced that we always played worse on a stage than on the floor. There is some truth to that because, for us, when everyone is on the actual same level, it breaks down the barrier between band and audience. There was no "us" and "them," there was just a collective "we." There aren't many feelings like that. In the following years, we drove from sea to shining sea, playing anywhere and everywhere that would have us. I became a human atlas, knowing exactly how many miles everywhere was from point A to point B. Amy promoted shows for us back then, and she was probably one of the first people to bring us to Florida, actually. It was a wild time, and there's a whole mess of stories from that period, but I want to focus on that first tour with Braid in 1997 because two very memorable things happened:

The first thing is that we played the legendary CBGB in New York City on a Sunday matinee bill. If I'm being honest, I was too young and confident to feel scared, but looking back on it now, it terrifies me. CBGB was such hallowed ground, to put it mildly. But on that particular day, Braid, Ethel Meserve, and my band were sandwiched onto a bill with three hardcore bands—California thrash kings Spazz, New York straight-edge locals Monster X, and New Jersey's 97a. The flyer for the show featured a picture of Black Flag and described Braid as "a damned emo band on tour," our band as "another wretched emo band from somewhere," and Ethel Meserve as "hmmm . . . more emo, still?" I guess it was a fitting introduction to the mean streets of New York, but it really stung.

Even worse than the flyer was the fact that our set times and the hardcore bands' set times were alternating, so things were hardcore, nonhardcore, hardcore . . . In the end we had the last laugh, though,

because it became wildly clear that while the derogatory nature of the word *emo* mattered to some people, it did not matter to the ones that came out to our show. Because while our tour mates and my band traded off performances with the hardcore bands, the kids in attendance would walk outside when the hardcore bands took the stage. It was a clear visual shift in the nature of things that I witnessed firsthand. And it even led New York hardcore veteran Rick Ta Life to exclaim from his distro table, "I like these emo shows, there's lots of chicks here." It probably made me laugh.

The second significant moment from that tour happened while we were driving to a show in Rhode Island. We were on our way to play in a house in Providence, and most house shows are unique, but this one was particularly special because we set up in one corner of the basement and Braid was in the other. That night, we traded songs back and forth like a rap battle—it was awesome. I don't really even remember if there were many people there, but the two bands were just playing for each other. Anyway, on the drive to the "gig," I just had this gut feeling. I was driving and I turned to Rob, who was riding shotgun, and I told him, "I think we could do this more." He agreed, but he also noted that it would be a hard sell to Jim, with the scholarship and all. It turned out not to be a hard

sell at all. Jim saw that the fact of the matter was that school would always be there, but this was an opportunity, and we'd be fools not to take it.

The following years we went all over the world, played over 250 shows a year sometimes. When I look back on that period, I think I was so focused on our own trajectory that I didn't really pay too much attention to the scene around us and how it was rapidly changing. Sure, we made lifelong friends with the bands we toured with. Touring is kind of like summer camp; you form fast bonds but then you disappear from each other's lives for years at a time. When you're reunited, it's like no time has passed at all. But I think what I wasn't cognizant of as an insider looking out was the tide rising all around us. In just five years, from 1997 to 2002, I watched this basement show scene explode into actual mainstream success. It does give me a feeling of somewhat parental pride knowing that we may have had a part in facilitating that.

Matt Pryor playing acoustic
live on a radio broadcast.
Photo by Michael Dubin.
Denver, CO. 2001.

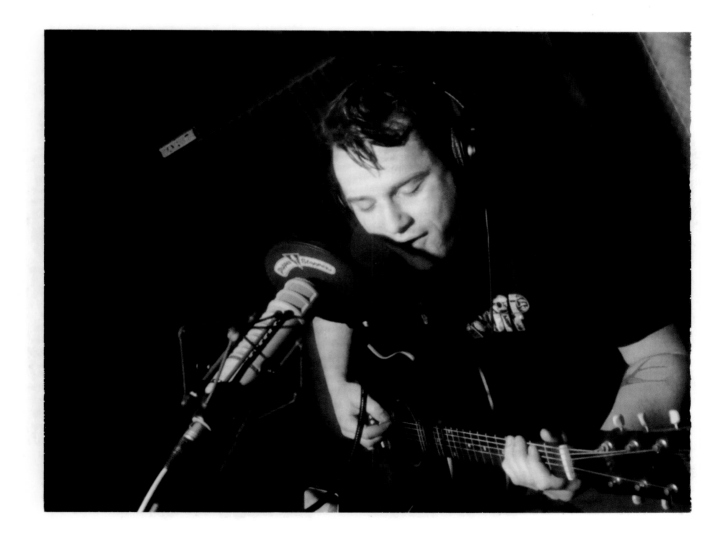

American Football

Photos by Aaron Schultz.
Milk magazine Christmas
Show at The Rave Bar.
Milwaukee, WI. 1998.

Est. 1997
Urbana, IL

—

If I had to pick one song—one single song—that embodies the sound and spirit of second wave emo, it would be "Never Meant" by American Football. Upon its release in 1999, "Never Meant" became the wonderfully obligatory opening song on countless mixtapes sent to love-drunk and long-lost friends around the world. When Mike Kinsella sings, "'Cause you can't miss what you forget," it doesn't matter who or what you need to forget or wish you could forget—you just feel the raw power of longing and loss under your skin, all the way down to your bones. The swirling and notey math-rock melodies—that, let's be real, this band essentially patented—can still send chills down each and every die-hard fan's spine.

Although initially short-lived as a band, American Football's legacy lives on and inspires thousands of kids around the world to pick up a guitar and just play. Their prominence is alive and well, and their ripple in the pool that is this genre was actually more of a tidal wave.

"It's a small miracle I shot that show. I was making $4.50 an hour fresh out of college 'paying dues' at an ad agency and was sleeping in a wool peacoat because my roommate and I were having trouble paying heat the first winter I lived in Milwaukee. My parents would send me back with boxes of cornflakes after visits and I pretty much lived off them so I'd have money for shows, film, and darkroom stuff."

—Aaron Schultz

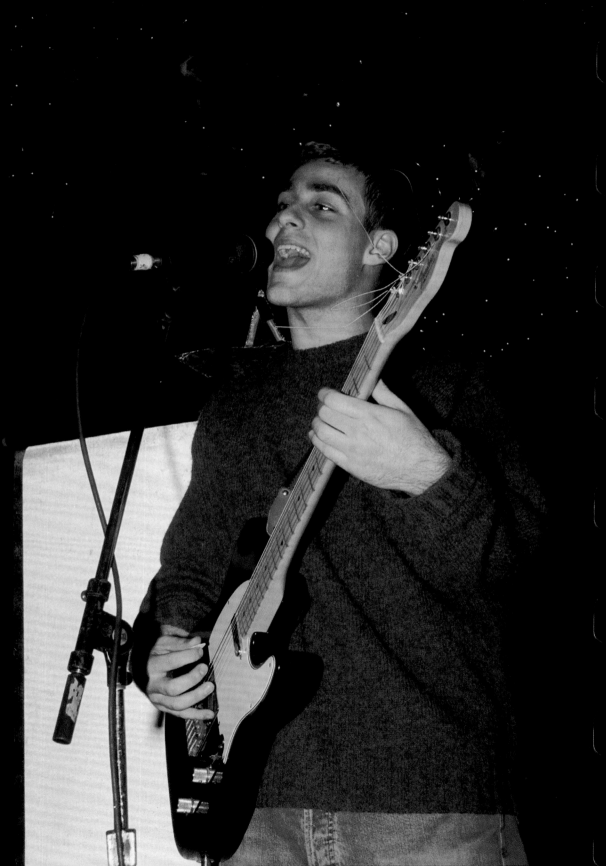

The Appleseed Cast

Est. 1997
Lawrence, KS

—

The Appleseed Cast hit the scene hard with the song "Max," which appeared on the second installment of *The Emo Diaries* compilation series. It left listeners feeling like a fifth grader writing an essay, wondering, "Who, what, when, where, why?" Superfans of bands like Sunny Day Real Estate and Mineral had found themselves a new band to obsess over. Shortly after this landmark song was released in 1998, The Appleseed Cast dropped *The End of the Ring Wars* the same year, and the opening track alone, "Marigold & Patchwork," solidified the band as serious contenders in all things driving guitars and crooning vocals.

Photo by Peter Ellenby.
San Francisco, CA. 2003.

At the Drive-In

Est. 1994
El Paso, TX

—

At the Drive-In's live shows were the stuff of legend, and to witness one was to be a part of history. The band technically belongs to the second wave of emo, but their influence spreads so far that they transcend waves, and even the genre itself. Some may argue that they were a punk band, a hardcore band, a post-hardcore band, or somewhat of a political post-core band—but none of that matters. They ran in the crowd that was this scene and some could even argue that they actually ran the crowd that was this scene. Stylistically speaking, once At the Drive-In played a city on tour, tight pants, long hair, and white belts were everywhere, and handstands on kick drums were the new high bar.

And that was the most impressive thing about At the Drive-In: They elevated everything. Every band wanted to be as good as them, as explosive as them, as loud as them. Every band wanted to matter like At the Drive-In mattered. No one on the heavier side of the emo scene had an impact quite like this band, and they blazed the trail for so many other up-and-coming experimental bands that followed.*

*

Including Cedric Bixler-Zavala and Omar Rodríguez-López's wildly popular and even more left-brain-centric follow-up endeavor, The Mars Volta. Jim Ward, Paul Hinojos, and Tony Hajjar went on to form the impressively heavy Sparta. Both are worth a deep dive for two completely different audio adventures.

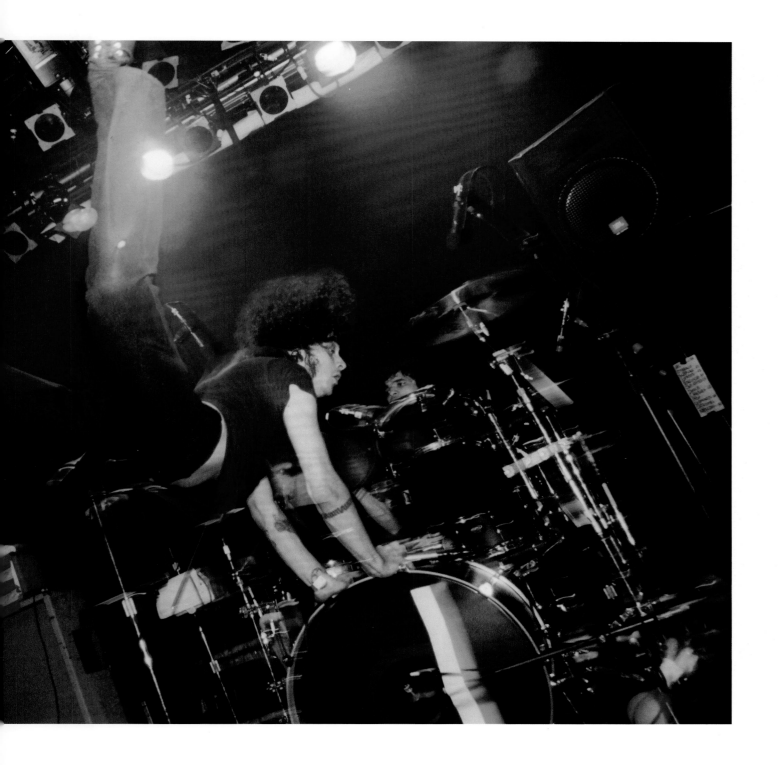

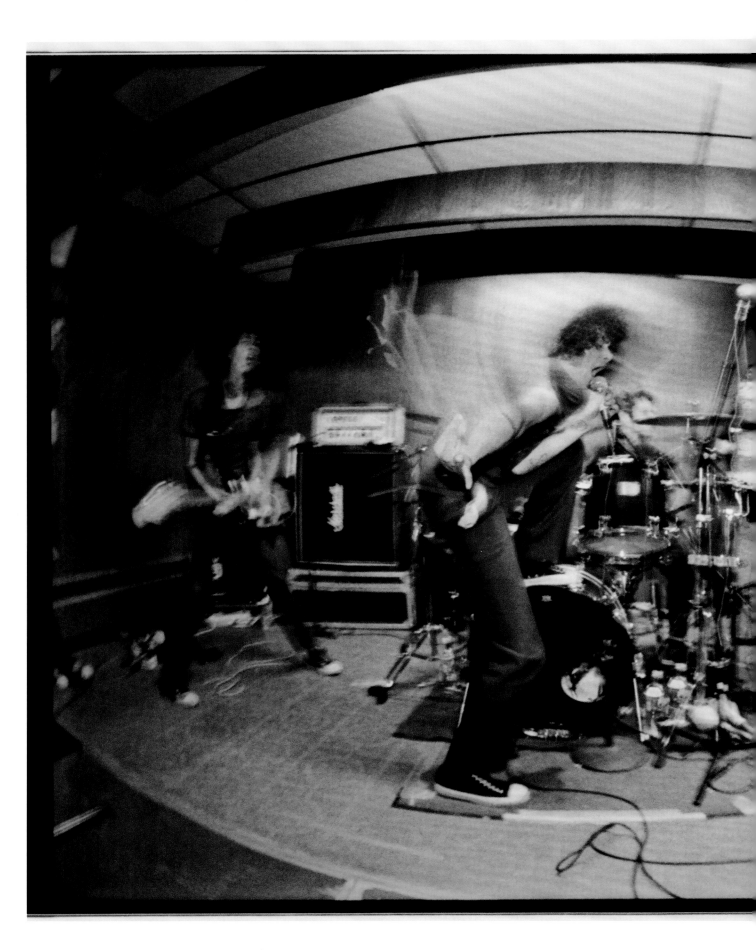

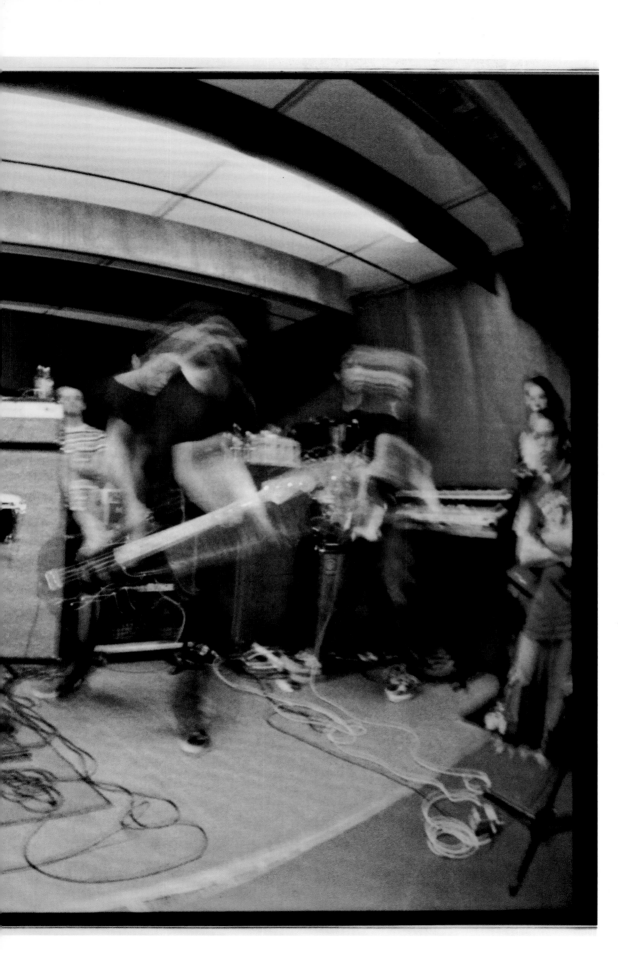

Photo by Paul D'Elia.
The Manville Elks Lodge.
Manville, NJ. c. 1998.

Photo by Paul D'Elia.
The Manville Elks Lodge.
Manville, NJ. c. 1998.

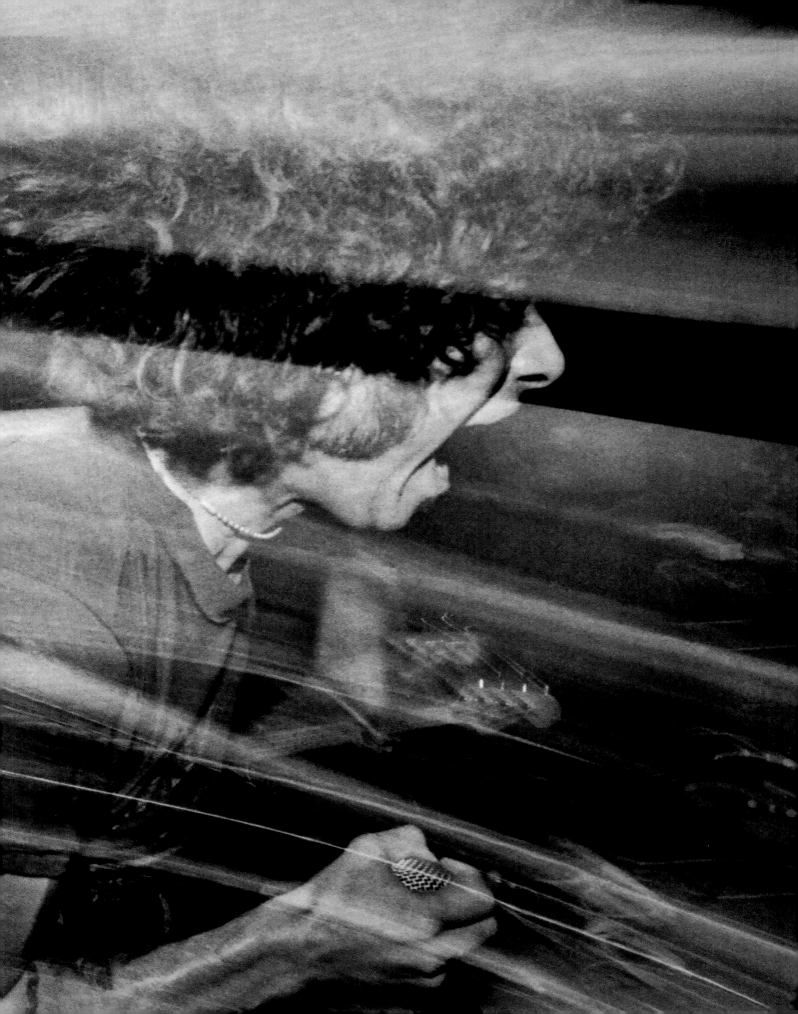

Boysetsfire

Est. 1994
Newark, DE

—

Boysetsfire was a portrait of vulnerability. Singer
Nathan Gray used the band as a vehicle to exorcise
personal demons and diffuse his anger in the most
inclusive and creative way. The band selflessly invited
fans on their journey of self-discovery, looking at
identity and even sexual preference at times, with-
out fear of judgment or hatred. Gray's vocals were
one of a kind, and the band's live shows were not
to be missed. Their fearlessness helped shape heavier
third wave bands like Thursday. Without Boysetsfire,
so many bands that followed wouldn't have had
the courage to get on stage and yell to the brink of
tears and exhaustion.

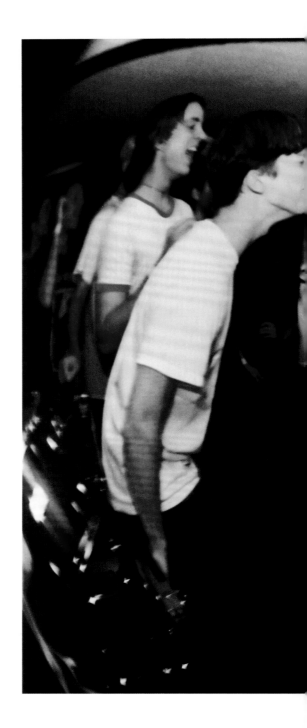

Photo by Michael Dubin.
Club Soda.
Washington, DC. 1997.

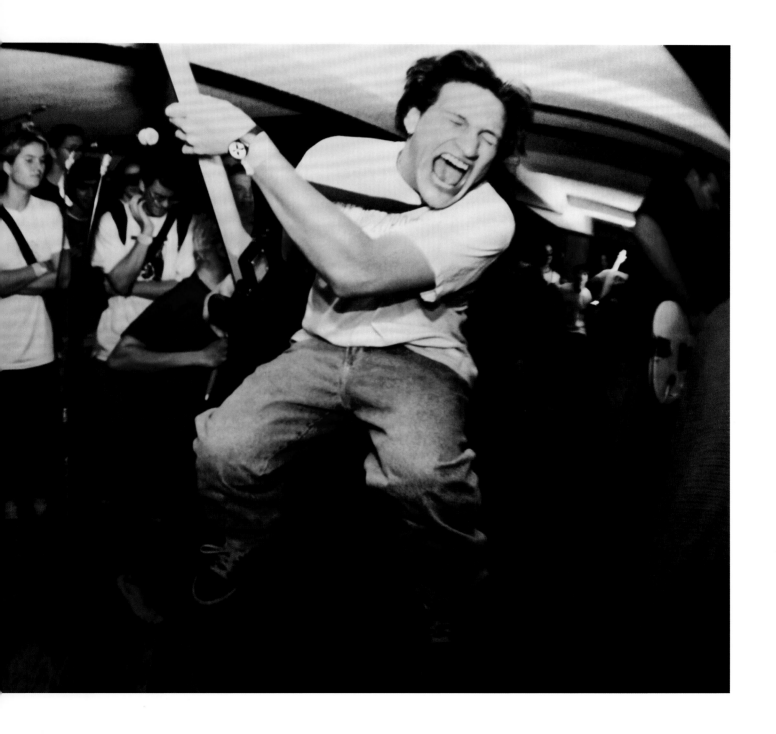

Braid

Est. 1993
Champaign, IL

—

Braid was a second wave miracle. They had an unquantifiable sonic style that felt more like emo-jazz: dissonant and chaotic but somehow still wildly personal, as if you'd happened upon someone else's diary and found it was filled with the same formative experiences as your own.

When *Frame & Canvas* was released in 1998, Braid was already such a heavy hitter that rumors of their impending breakup had me in shock—what band in their right mind would break up after releasing such a masterpiece?*

So, when Braid announced their final shows at the Fireside Bowl in Chicago, I spent every dollar I had (and mind you, I did not have a lot of dollars) on a plane ticket. I'll never forget getting to the venue and seeing a giant *Wheel of Fortune* apparatus onstage. They had written all their song names on little pennant-type pieces of paper, and in between every song, they let a fan come onstage and spin the wheel to pick which song they would play next.

Once the band called it quits, three of the members went on to form Hey Mercedes. If you were a Braid fan, this satiated the Bob Nanna vocal itches that you needed scratched, but there was no matching the electricity of the original Braid lineup. If you listen to their anthology records *Movie Music* (volumes one and two), you'll get a comprehensive sense of the delicate chaos that this band was able to control with their fingertips. "What a Wonderful Puddle" remains one of my favorite songs of all time—those octave riffs have been borrowed by almost every great emo band that followed.

When Bob Nanna sang and Chris Broach yelled, it wasn't perfect. That was key to loving Braid: They weren't polished, and you liked that. That's what made them so good. To exhibit that kind of rawness and realness for all the world to see and hear took guts. While other sects of punk rock were heading in a direction that would leave them "flawless" by using Auto-Tune to death, Braid hung themselves out there naked, and goddamn, I respect them for it.

*

By 1999, so many great bands had broken up or were about to break up. I was never able to see most of my favorites from the early '90s because they had already thrown in the towel, and I had already seen so many other "last shows" by the time this wave of breakups hit the late-'90s circuit that I was downright bitter. This somehow helped me understand my uber-jaded scene predecessors in a way I never had before.

Photo by Andy Mueller.
Mueller's living room (a.k.a. his
studio) on Evergreen Street.
Wicker Park, Chicago, IL. c. 1997.

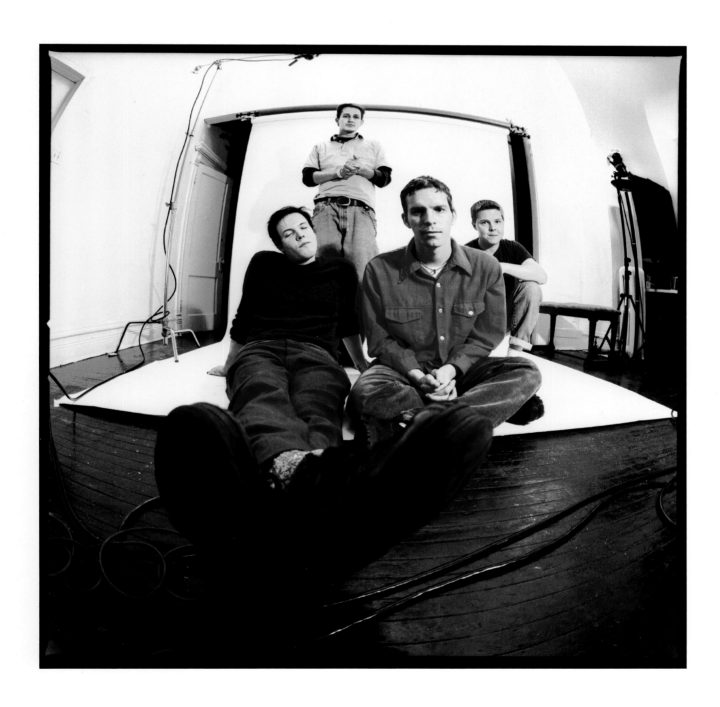

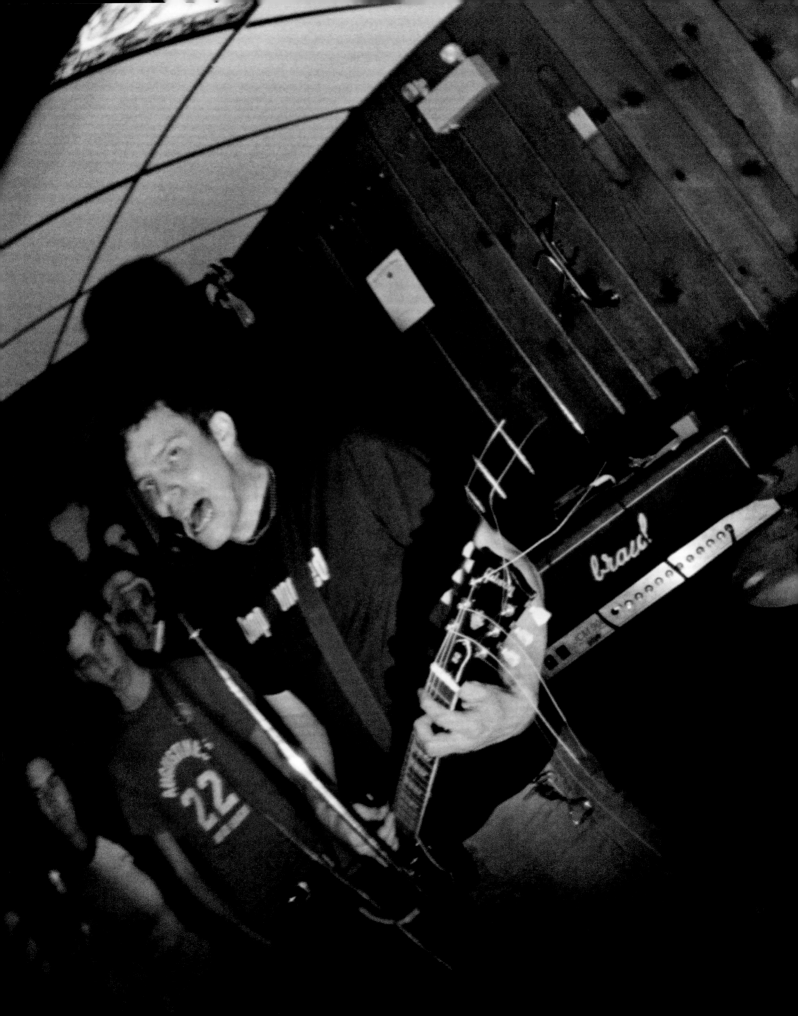

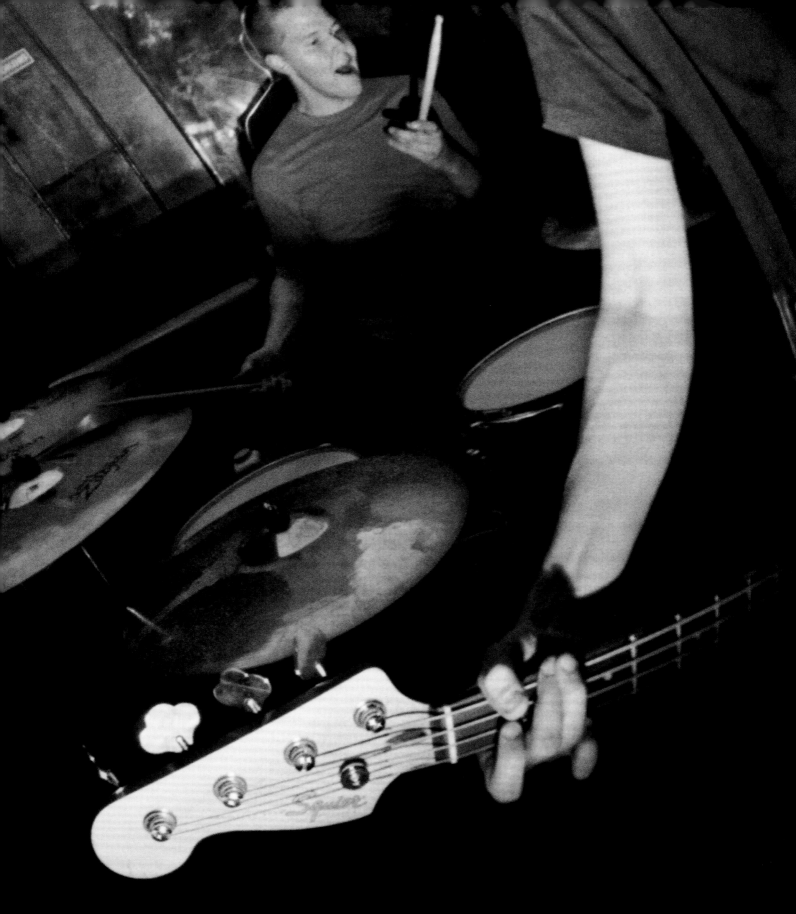

Photo by Paul D'Elia.
Somewhere in Upstate
New York. c. 1997.

Bright Eyes

Est. 1995
Omaha, NE

—

Oh, to be young and to have never heard Bright Eyes. To have never lain upon a sunbaked hardwood floor on a late-summer Sunday afternoon with the bass shaking your chest. To have never pondered, "*Is this shit real?*"

With a voice and a mind like Conor Oberst's, your reaction can only go one of two ways—you either love it or hate it. I am in the camp led by fiercely beating ventricles. My love affair with Bright Eyes is an epic one. It began the first time I heard "The Calendar Hung Itself . . ." and honestly, I have to say it's never really ended. With the lyrics, "Does he walk around all day at school with his feet inside your shoes? Looking down every few steps to pretend he walks with you," I was sold, I was done, that was it. This was something I did with my ninth-grade boyfriend—how could he have known? And that's the secret: Oberst has this way of illustrating long-hidden memories you didn't even know you had, and he's able to bring them to the forefront of your mind, letting them play out like a film.

Purists may argue that Bright Eyes is an indie band, or maybe even a folk band, with no emo crossover—but I wholeheartedly disagree. Granted, once the label Saddle Creek had made a name for themselves, seldom was there comingling with artists from other labels that would have led to more intertwining of genres. But trust me: Bright Eyes is as emo as emo gets. They also get the award for having that rare quality where they were a fan favorite but were also wildly influential with other bands of the era (and countless since then). You usually get one or the other but rarely both.

It wasn't just their indie emo cohorts who were fans—by 2005, Bright Eyes was sharing stages with none other than Bruce Springsteen and REM. That year, they released two albums simultaneously—one was folk-driven, the other skewed much more digital. I am more a fan of *Digital Ash in a Digital Urn* (I could listen to "Gold Mine Gutted" on repeat for days if you let me), but a sleeper acoustic hit on *I'm Wide Awake, It's Morning* really solidified Bright Eyes as a household name. "First Day of My Life" was the soundtrack du jour for both television shows and commercials, and it received the most commercial radio play the band had seen to date.

You could say that Bright Eyes continues to exceed everyone's expectations with their wonderfully prolific career, but everyone saw this coming. You don't release music like theirs at such a young age without feeling the positive effects down the line. The Omaha, Nebraska, scene that birthed geniuses like Oberst and Tim Kasher (Cursive) was a gift that kept on giving, and most artists from this scene are worth digging into for deep full-catalog listening sessions.

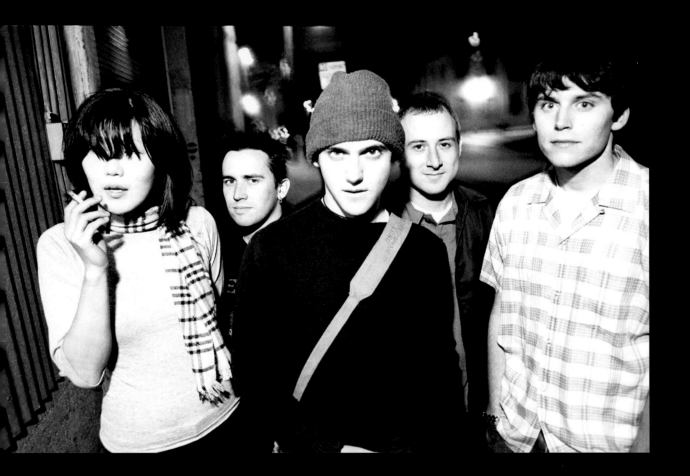

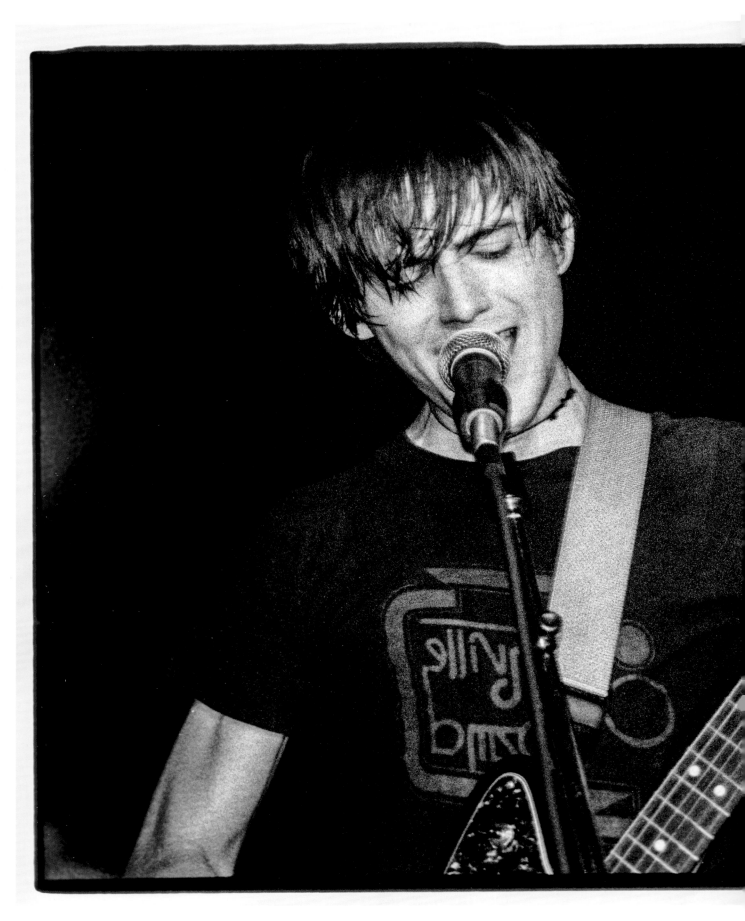

Photo by Nathaniel Shannon.
The Magic Stick.
Detroit, MI. 2001.

Cap'n Jazz

Est. 1989
Chicago, IL

—

This band often felt like an inside joke that everyone in the Midwest was in on*—and the rest of the country (and the world) had to just sort of pretend they were in on it, too. One thing is for certain, Cap'n Jazz deserves its place in second wave history, as it was the springboard for its members, who would go on to become some of the most influential people of the era. Mike Kinsella would go on to play in Joan of Arc, American Football, Owls, Owen, and more. Tim Kinsella would join him in Joan of Arc and Owls. Davey von Bohlen would go on to found The Promise Ring and Maritime.

If you don't have an affinity for chaotic and off-key vocals backed by spasmodic drumming, this band might not be for you. But if you're adventurous and are dying to have more than a myopic view of the second wave, full speed ahead toward their aptly named anthology, *Analphabetapolothology*.

Photo by Steven Wade.
Detroit, MI. 1995.

48

*

The band's only full-length album is titled *Burritos, Inspiration Point, Fork Balloon Sports, Cards in the Spokes, Automatic Biographies, Kites, Kung Fu, Trophies, Banana Peels We've Slipped On and Egg Shells We've Tippy Toed Over*, but it's also sometimes referred to as *Shmap'n Shmazz*.

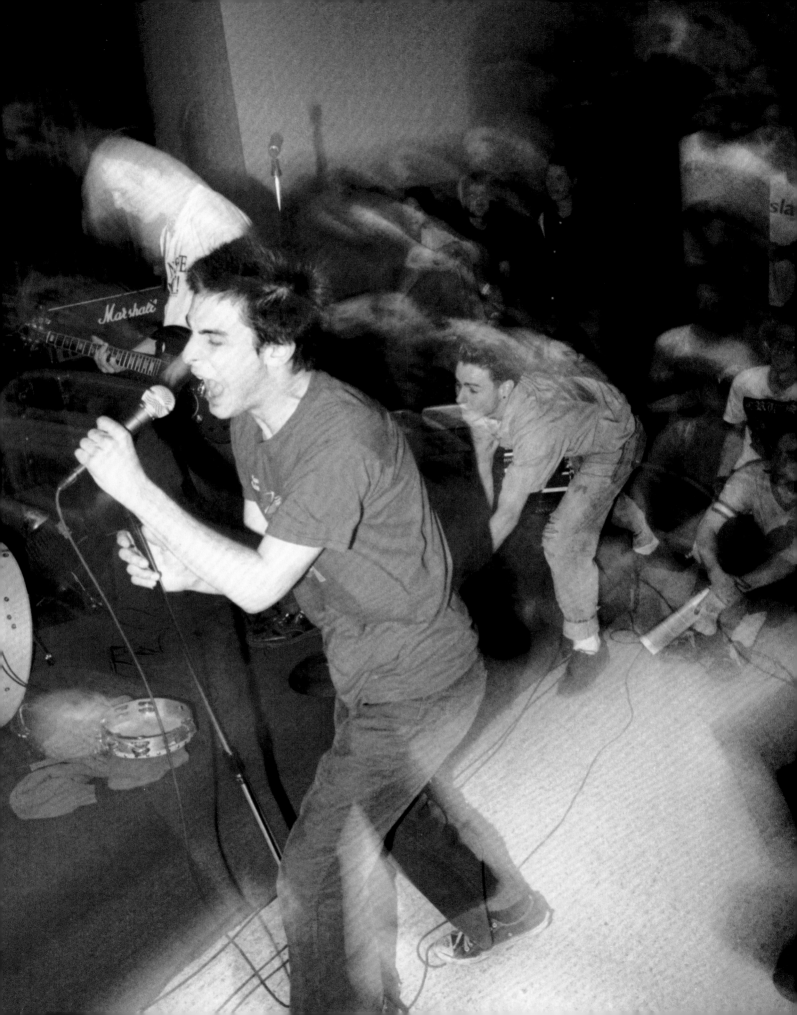

Chamberlain

Est. 1995

Indianapolis / Bloomington, IN

—

Chamberlain could have been—and should have been—huge. Unfortunately, it seemed they were repeatedly in the wrong place at the wrong time.

Once upon a time, there was a band called Split Lip. Everyone loved Split Lip. On the tail end of the first wave of emo, they were Midwest post-hardcore darlings and heavily influenced the second wave. Then Split Lip decided that they wanted to change their sound and their name, and so Chamberlain was born. This is something elder scenesters loved to drop knowledge about back in the day—a "didyaknow" moment that was pretty exhausting, to be honest. And now, in an unavoidable ouroboros fashion, I impart this information to you.

Anyway, my first encounter with the band was through their Doghouse Records release *Fate's Got a Driver*, which they first released as Split Lip, and later rereleased as Chamberlain. Despite hating (*hate* is a strong word, but I want to be real) anything that sounds like country, I loved that album. The twang made sense—you can't grow up around that many cornfields and old red barns and not have it come out in your writing at some point.

The band was courted by and tangoed with major labels here and there, but they never made it through the madness. Due to an incredibly obtuse (and potentially false) "signing freeze" at the major label they decided to partner with, their upward trajectory was thwarted.

Curtis Mead, the band's bass player, sent over an enormous number of images for me to sort through—so many that I could make an entire Chamberlain book. The interesting thing about the photos is that they're so much older than everyone else's photos. Chamberlain was really early on the emo tip; had they emerged on the scene later, I think their fate would have been vastly different. When I see their photos, I feel like I'm looking at an alternative band like The Lemonheads, more so than a Midwest emo band. The photos give me a sense that they were also muddled within the grunge movement, and with a voice like David Moore's, it checks out.

Nevertheless, the band became a favorite among their peers—their "don't rush me" country vibes resonated with the horde of artists driving around America enjoying its vast spoils. And while not all bands in this book can be easily recommended to the masses, Chamberlain is a rare instance. Listen to *Fate's Got a Driver* on vinyl and you might just find yourself a fan. I dare you to say that "Yellow Like Gold" isn't one of the hookiest songs of the era.

Photo by Matthew Reece.
Somewhere along I-70 near the
Indiana/Illinois state line. c. 1993.

Christie Front Drive

Est. 1993
Denver, CO

—

One of my favorite things to do in a museum is visit the video installations. You walk in, look at some paintings, look at some sculptures—but from across the room, you can hear some audio, and it's piquing your interest. Maybe it's voice-over or dialogue—whatever it is, it's pulling you in. Christie Front Drive is, metaphorically speaking, the video installation in this emo museum. You need to walk in, sit down, put your bag on the ground, and look, listen, and feel everything entirely, submerging yourself deeply within this band as it's meant to be heard.

Their releases, which have all been combined into anthology records for streamers and the like, are meant to be enjoyed start to finish, and definitely with headphones. Once you're deep in the trenches, you can see that their sound is an amalgamation of so many first wave emo pioneers like Moss Icon and the earlier, punk-leaning Samiam, as well as a handful of bands that could be considered alternative or even grunge. All those influences are topped off brilliantly with guitar leads that could only be written by someone with a deep love for all things metal who then somehow found love for all things emo.

If you're unfamiliar with Christie Front Drive, start with "Radio." Go, start, like now. I'll wait . . .

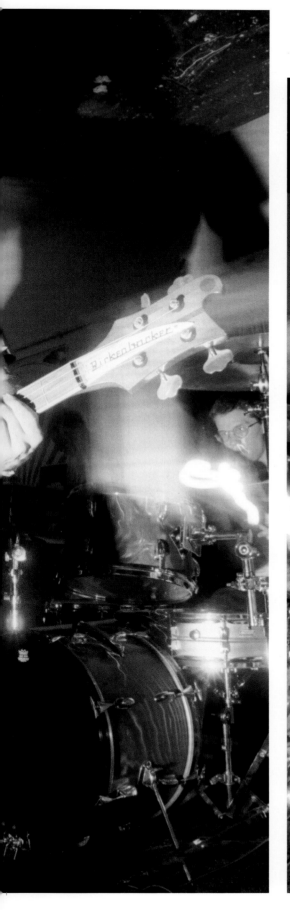

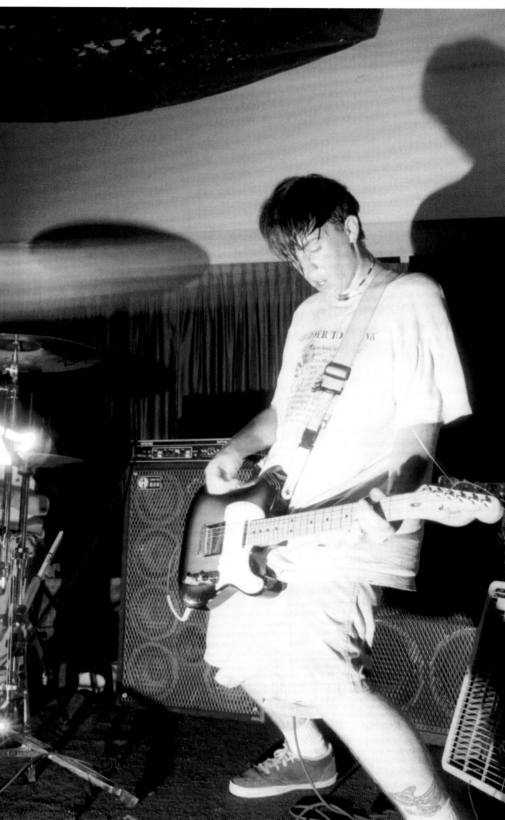

Photos by Steven Wade.
Speak in Tongues.
Cleveland, OH. 1996.

Cursive

Est. 1995
Omaha, NE

—

Cursive is one of the most powerful bands I have
ever had the pleasure of hearing and experiencing
live. Even conjuring the words to encapsulate their
existence just takes it out of me. Every time I listen
to this band, I feel like I'm going through a breakup,
but in a good way—sort of. Meaning, it's not pas-
sive or easy listening. It's purposeful, "this is going
to fuck me up for the rest of the day" kind of lis-
tening. And if that isn't the definition of art, pretty
baby, I don't know what is. I highly recommend
listening to this band as often as you can stand the
sweet, sweet, gut-wrenching, soul-destroying
torture.

Photo by Nathaniel Shannon.
The Majestic Theatre.
Detroit, MI. 2003.

54

"It was fascinating watching and photographing emo as it exploded. I first
saw Cursive play a bowling alley in Lansing, Michigan, with Small Brown
Bike, and within a few years they were selling out one thousand–cap rooms,
singing to the world about trying to find yourself amid the collapsing world
around you. They were leading the charge of bands' bands, usurping the
musicianship of their contemporaries. Punk is cool because anyone can do
it, but that gets old quickly. Cursive learned how to craft complex tunes
with incredible melodies, add strings, and take that show on the road,
blowing everyone out of the water, all while humbly staying fresh and
one step ahead."

—Nathaniel Shannon

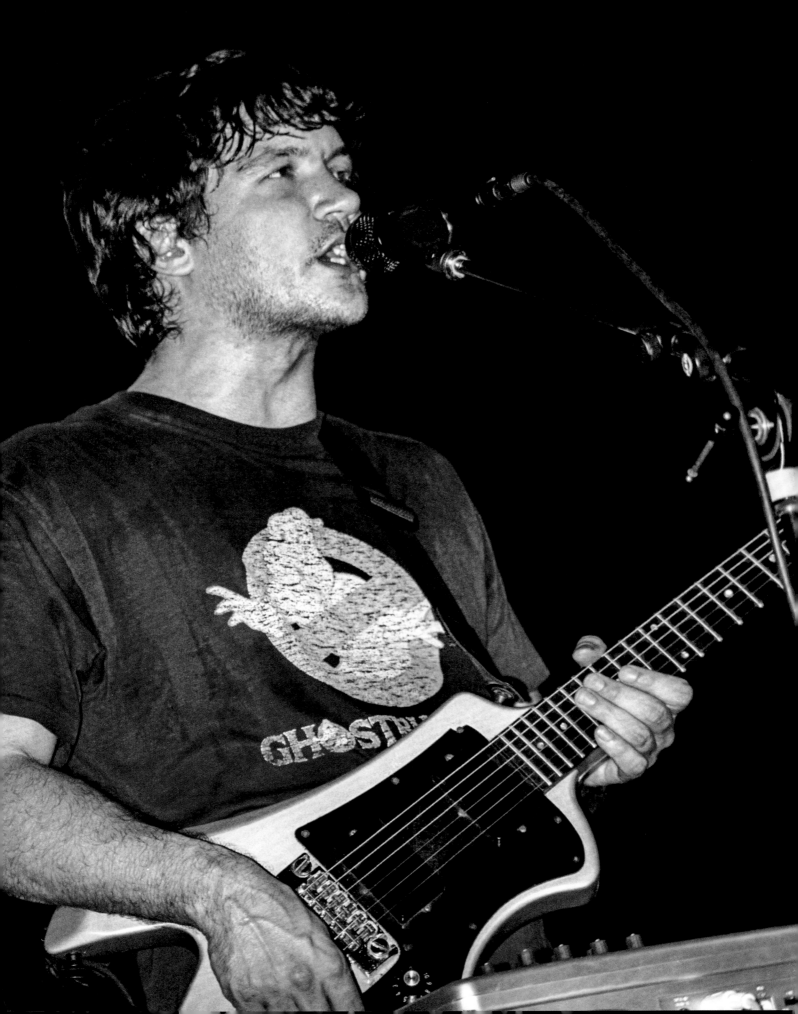

Death Cab for Cutie

Est. 1997
Bellingham, WA

—

Death Cab for Cutie is not a band. They are a ghost—a sonic ghost. They supersede their corporeal existence and manifest themselves as a phantasmic representation of every sanity-swaying emotion you've ever had. If you don't believe me, listen to their early work. If you can get through "Title Track" or "A Movie Script Ending" without somehow reliving everything in your life that has gone wrong, then you're lacking the same brain chemicals as me. Or rather, maybe you possess the brain chemicals that my brain is lacking, and if that's the case, I'm a wee bit jealous.

Hailing from the Pacific Northwest potentially isolated them from the rest of the tight-knit East Coast and Midwest scenes—and it seems like they became accidental loners, which only accentuated their ghostlike nature. And further, front man Ben Gibbard has been very vocal about being pained by the mere existence and vernacular of emo. But just as one can't pick their geographic birthplace, you can't really deny a genre that you've been placed into by hundreds of thousands of people.

Beyond their early work, *Transatlanticism* is as close to perfect as any album has gotten in my book. Since its release, I've spun "The New Year" (and the entire album) on January 1 every single year (and on several other days, too). *Plans* has been in constant rotation since its release in 2005 as well.

Photos by Peter Ellenby.
San Francisco, CA. c. 2003.

Elliott

Est. 1995
Louisville, KY

—

Elliott can be summed up in one word: *ambiance*. No one sets the mood quite like this band; and the proof is in the two opening tracks of *False Cathedrals*. Is it too much to say that the introductory track "Voices" was life-changing? Because it was. Followed by "Calm Americans," the band created two songs that possess so much style and depth, that for bands familiar, they became a gold standard. The album was scene-changing as well: *False Cathedrals* raised the bar for audio quality, and everyone took notice. It was no longer enough to just write some songs and bang them out in a studio. You had to bring the same theatric sense of ethereal brilliance that Elliott introduced with their sophomore album. And their live show was not something you wanted to miss. Flailing guitars and broken glasses accompanied their soul-shaking music, and to say it felt like a religious experience is not an overstatement.

Photo by CJ Benninger.
The Shelter.
Detroit, MI. 2000.

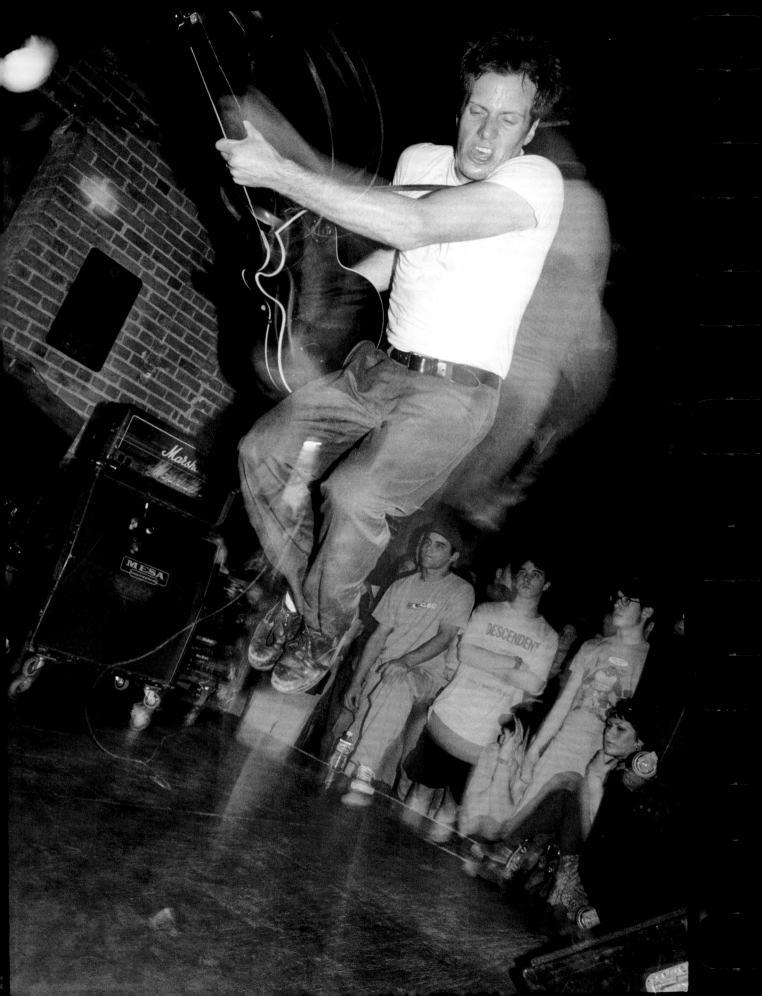

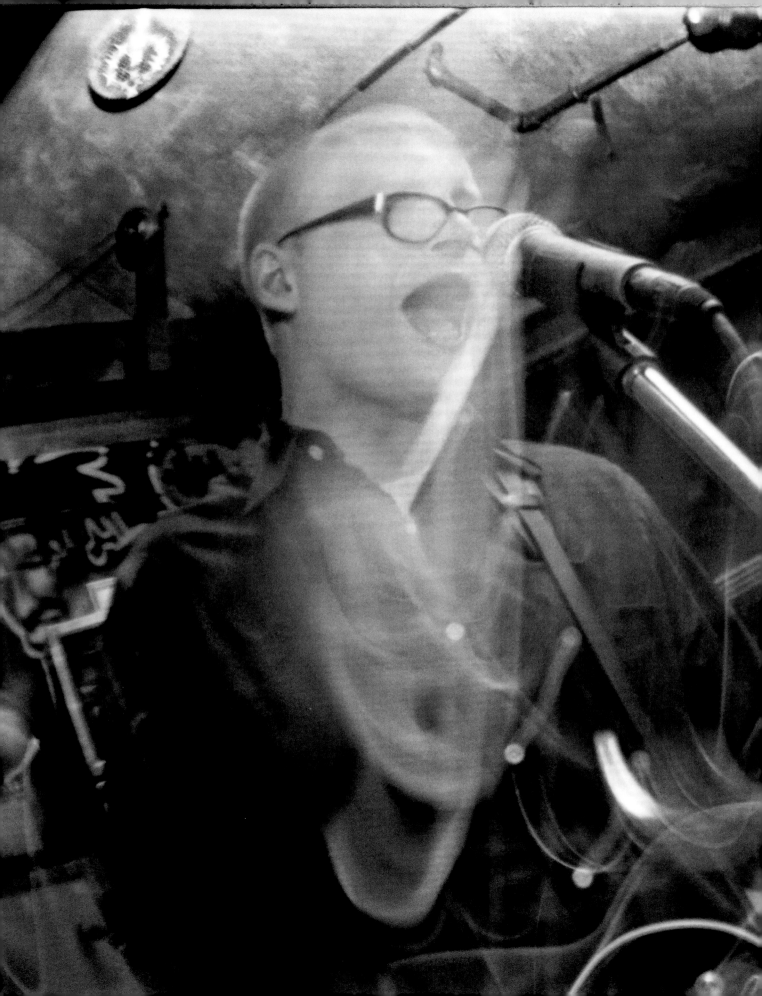

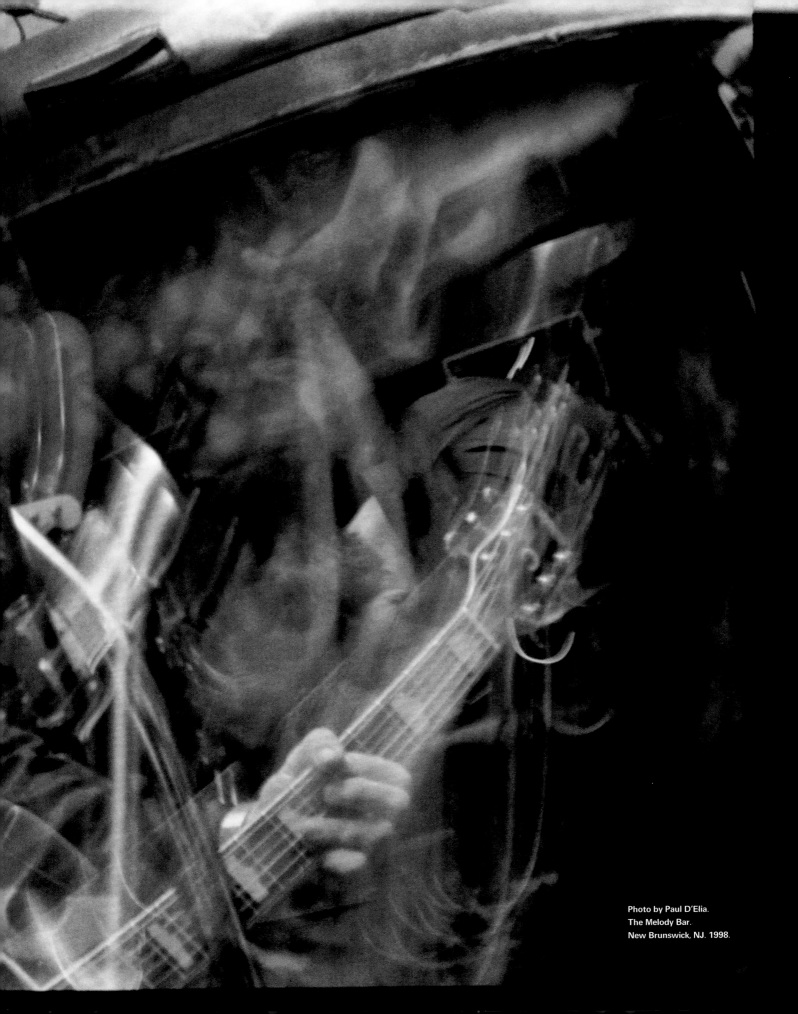

Photo by Paul D'Elia.
The Melody Bar.
New Brunswick, NJ. 1998.

Engine Down

Est. 1997
Richmond, VA

—

Seeing Engine Down live made me feel as though I was on a boat, rocking back and forth, ceding to the waves that pulled me to and fro in the best way. I met this fine quartet at MACROCK in 2000. Or maybe it was 2001 . . . No clue, but I do know I fell in love with their live show. Guitarist Jonathan Fuller and I were wearing the same charcoal-gray wool sweater, and we bonded over that and mutual Virginia-based music friends. It was instant friend-love and instant music-love.

There are bands in this book that are what I call "my darlings." Engine Down is one of them, and that's the beauty of this genre. Whoever you are, there's always that band that hits just right, that means something—or sometimes *everything*—to you. It doesn't matter whether you've met them or not, whether they're your friends or strangers you sing along with in your car, whether you own the same sweater or you wear their merch—you just get it.

I toured with the band whenever I had time off from touring with other bands that were technically my "job," and I always crashed with them when I happened to be anywhere near Richmond, Virginia. We were just on the same wavelength, and in hindsight, this connection had nothing to do with me—there was a magical force field that came into existence whenever these guys occupied a space together. And once I happened upon it, I just wanted to be around it. It was infectious, and I think I've only felt this same feeling a handful of times. I think we now call this *energy*—or a *vibe*. The vibe was just so high; it was borderline intoxicating.

If you're unfamiliar with Engine Down, start with 2002's *Demure* and work your way backward. And if you fancy an impassioned chat about the band, you should know I'm always up for one—also, I still have that sweater, and tattered though it may be, it still kind of fits.

Photo by Amy Fleisher Madden.
Europa.
Brooklyn, NY. 2003.

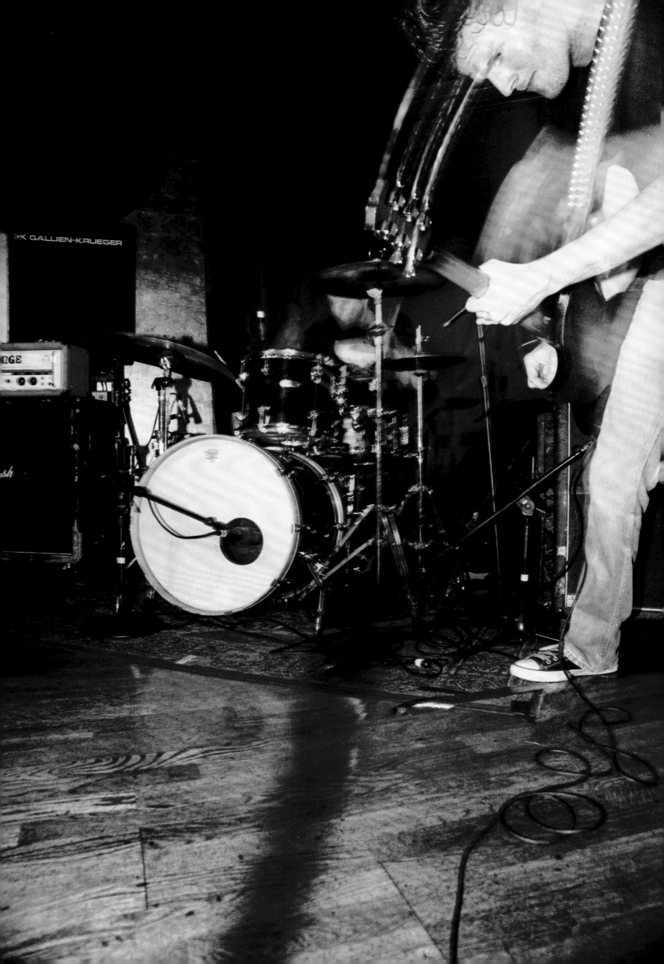

Far

Est. 1991
Sacramento, CA

—

With some bands, you can fight through the nostalgia and understand why they never broke into the mainstream. Maybe they lacked the musical chops or vocal talent, or maybe it was an inability to contribute to the zeitgeist. It pains me to say it, but some bands are just hometown heroes—and that's okay.

Far is *not* one of those bands.

When revisiting *Water & Solutions*, I'm hit with a tidal wave of sound and skill that only gets more accentuated by the album's pure and raw—dare I say—emotion. It is a wonder to me why this band didn't take off into superstardom. I actually caught them live in Los Angeles at The Roxy in 1998 before I even knew what I was doing with my life.* I was in Los Angeles looking at colleges and my friend Kevin Kusatsu** invited me to see a band he was trying to sign.

Going to The Roxy with Kevin felt like walking into a movie. I was going to *The Roxy*—this venue that I had seen a zillion times in, like, Guns N' Roses videos—on the Sunset Strip with *a label scout* to check out a band he might sign. When you're from a place like Miami, doing real-life music business things in New York and Los Angeles just felt bigger, and honestly, it still does.

Seeing Far live hit every neurotransmitter in my brain in the best way, and I remember leaning in to yell in Kevin's ear, "Holy shit! You have to sign this band!" when they tore through their first song, "Bury White." Had my label been a little bit larger, I would have tried to sign them, too. Kevin didn't end up signing Far, though. (He signed a little band from Kansas City, Missouri, called The Get Up Kids instead.) Far signed with Immortal (Epic) and broke up one year later.

Needless to say, Far didn't pan out the way the gaggle of A&R people at The Roxy that night thought they would, but that didn't stop them from being wildly influential. If you're trying to get into the nitty-gritty of why heavier third wave emo bands sound the way they do, do your homework and listen to Far. Vocalist Jonah Matranga's solo effort, Onelinedrawing, is not to be missed either.***

*

I still don't know what I'm doing with my life.

**

Kevin Kusatsu shot several photos in this book, in addition to being super important for third wave A&R.

Oh, and one more thing: In 2010, Far reunited and released a cover of Ginuwine's "Pony," and it's just sublime.

Photo by Chad Stroup.
Cup o' Joe.
Pomona, CA. 1995.

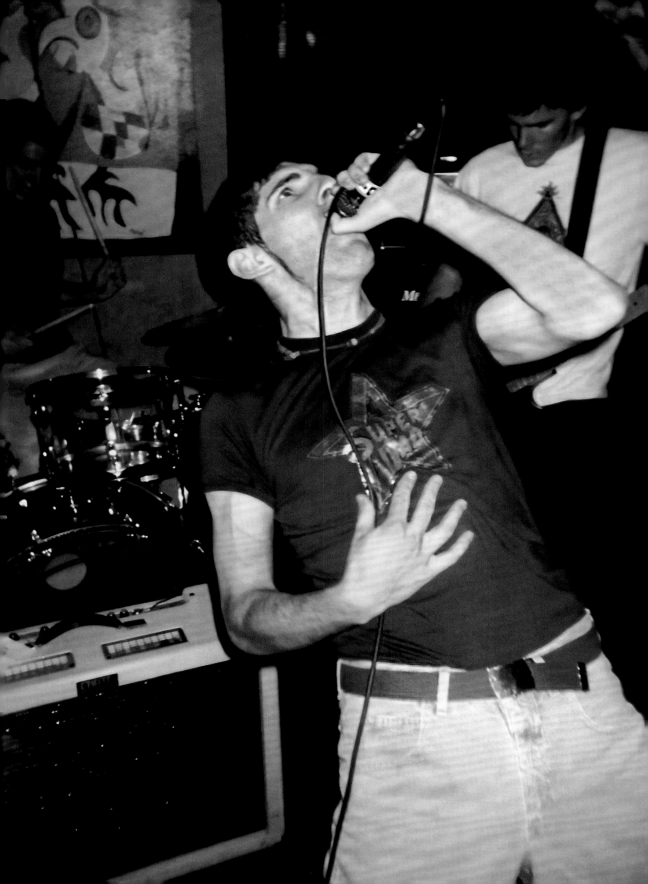

The Get Up Kids

Est. 1995
Kansas City, MO

—

The Get Up Kids were the James Dean of emo, rolling into a different city night after night with their 1950s-inspired clothes and haircuts—they had style, and everyone knew it. And beyond something as superficial as looks, to those of us who experienced their music in the present tense, this band was everything.

They were *the* band from the second wave that legitimized the whole thing. It's because of them that we saw bands who were previously relegated to VFW halls and random basement clubs start to play more substantial venues like House of Blues and Irving Plaza, and they were able to slide right into the third wave without skipping a beat. The game changed between *Four Minute Mile* and *Something to Write Home About*, and the band went from basement emo darlings to headlining beasts. Small city scenes of one hundred kids turned into one thousand. Broken-down, fifteen-passenger vans became tour buses. Merch money became a "per head" number—and suddenly there was so much industry involved in everything.

Even when the band's popularity soared, and they reached heights that would have been previously unimaginable—touring with bands like Weezer and Green Day—they remained unafraid of making decisions in the name of art, and they were never shy about making a record that *they* were proud of above everything else. This fact deserves any fan's utmost respect. And the most important thing to remember: Through all the career ups and downs, The Get Up Kids endured. They played reunion shows and toured in the years following their initial hiatus, and their influence on all things emo is still so tightly woven into the fabric of today's scene.

If I were to make a playlist for this book, you know I'd have to throw "Don't Hate Me" on there, as well as, like, ten other songs, too.

Photo by Kevin Kusatsu.
c. 2000.

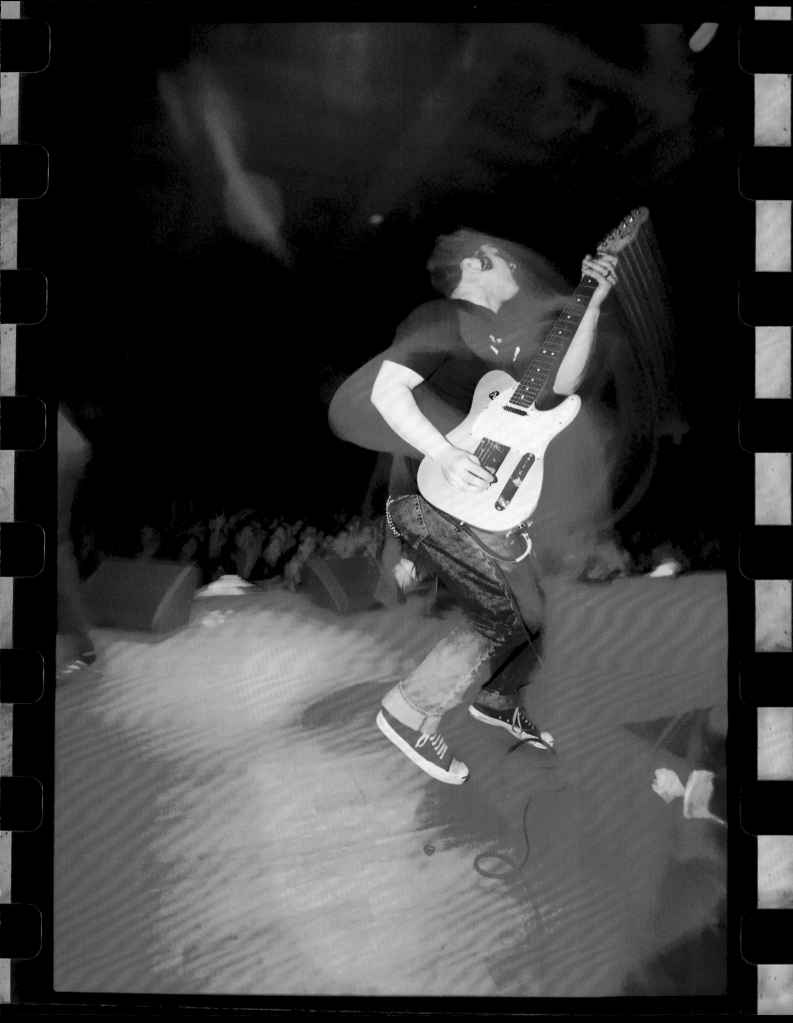

This was at a truck stop on the Weezer tour.
We had a full day of driving and none of us
got dressed—also, we all bought knives."

—Michael Dubin

THIS PAGE / RIGHT TOP:
Photos by Michael Dubin.
Somewhere in Arizona. 2001.

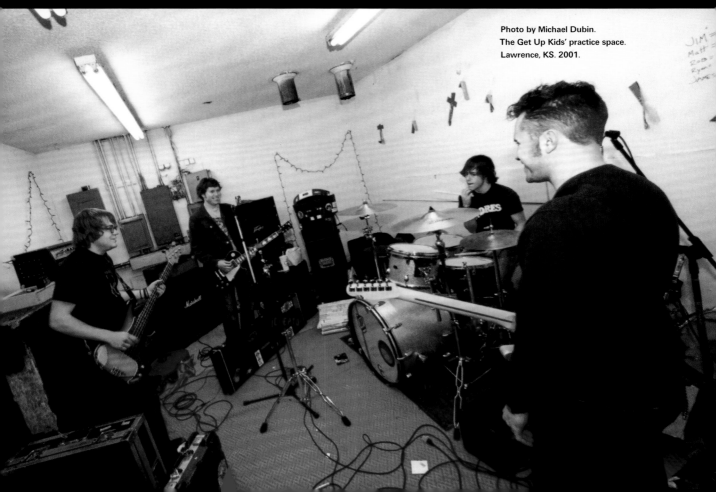

Photo by Michael Dubin.
The Get Up Kids' practice space.
Lawrence, KS. 2001.

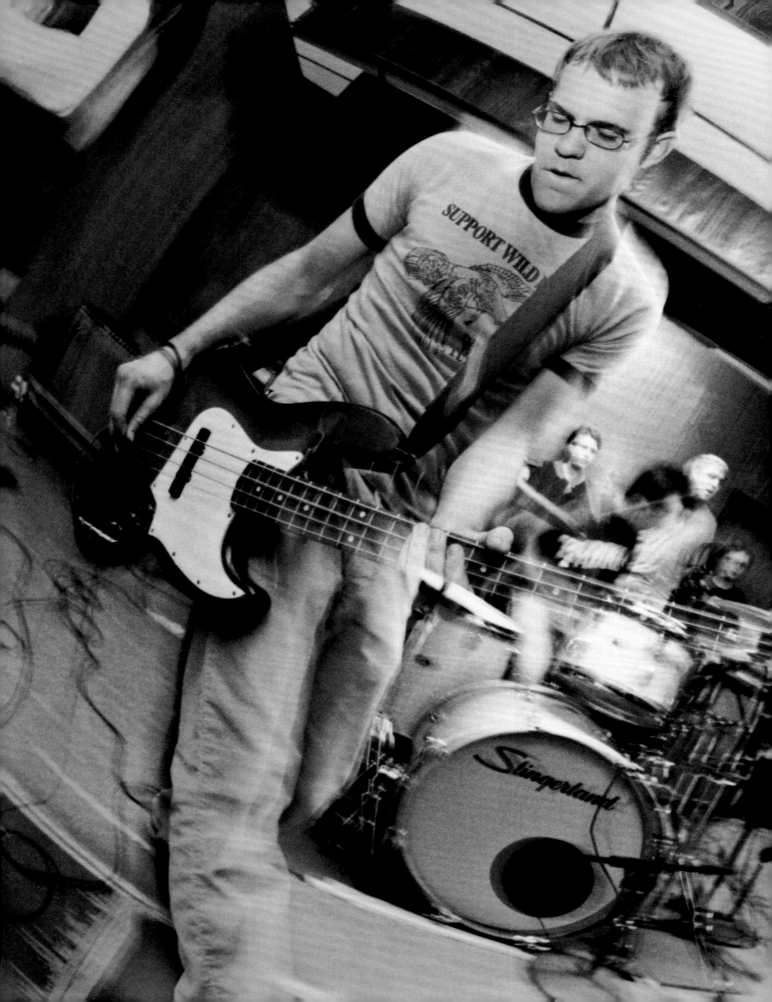

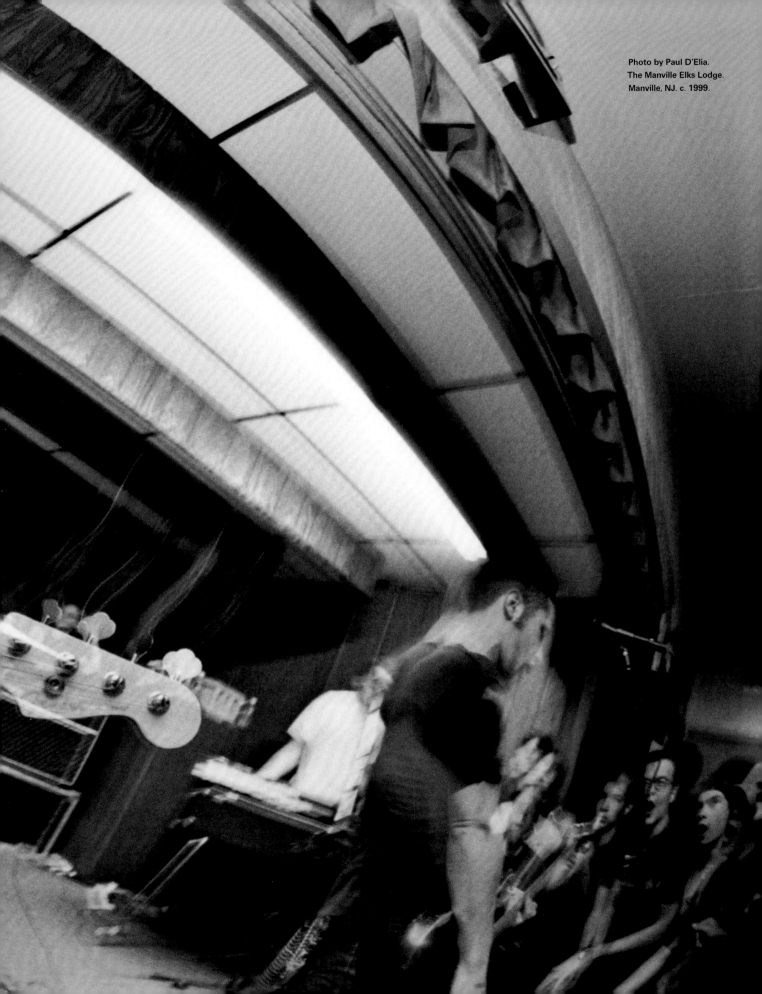

Photo by Paul D'Elia.
The Manville Elks Lodge.
Manville, NJ. c. 1999.

Hot Water Music

Est. 1994
Gainesville, FL

—

I have been waiting years for the moment when I could publicly put this band into the emo category. While the belief that they're purely a post-hardcore band is sound, if you were there and you saw them in real time, you felt it. And beyond anything that's seen or heard, I rely on feeling for these things. Because if you're reading this book, chances are that, like me, you believe feelings are real and they matter.

Hot Water Music was a gang of burly bearded dudes from northern Florida, and they were superb. To see them live was a full-body sensory experience. You left the show drenched in your own and other people's sweat (and sometimes blood), and you didn't even care. Their trademark dueling shout-screaming is a high art form that simply cannot be recreated or imitated. They were 100 percent original, and I've never felt this to be more true than I did when listening to the song "Turnstile"—it made me feel every feeling capable by a sentient human being.

I remember catching up with David Soloway from Saves the Day after their tour with Hot Water Music in 1999, and he said it was "life-changing," and that they essentially "taught us how to tour." He explained that Hot Water Music was the first band who'd taken the time to pull Saves the Day aside and explain the etiquette for very crucial things like arrival time and set times, and how to make the most of an infinitesimal rider.

This band was such an advocate for independent music and the community. They were the band that took the time to talk to every fan after a show and took every demo from every local band they encountered. A younger version of myself drove six hours from Miami, Florida, to Gainesville, Florida, to see them play live and bring them freshly minted sweatshirts from my tiny label and CDs from all two of my artists. When Chuck Ragan took the stage with my logo emblazoned on his chest, I think I cried. So many bands of this era preached things like community and family, but not all of them actually walked the walk—these guys were the real deal. Their dedication to consistently touring and doing split releases with friends and up-and-comers, working exclusively with indie labels, and just shouting that home team pride vibe from the rooftops (ROOFTOPS!) was unparalleled.

Photo by CJ Benninger.
Michigan Fest.
Wayne, MI. 1999.

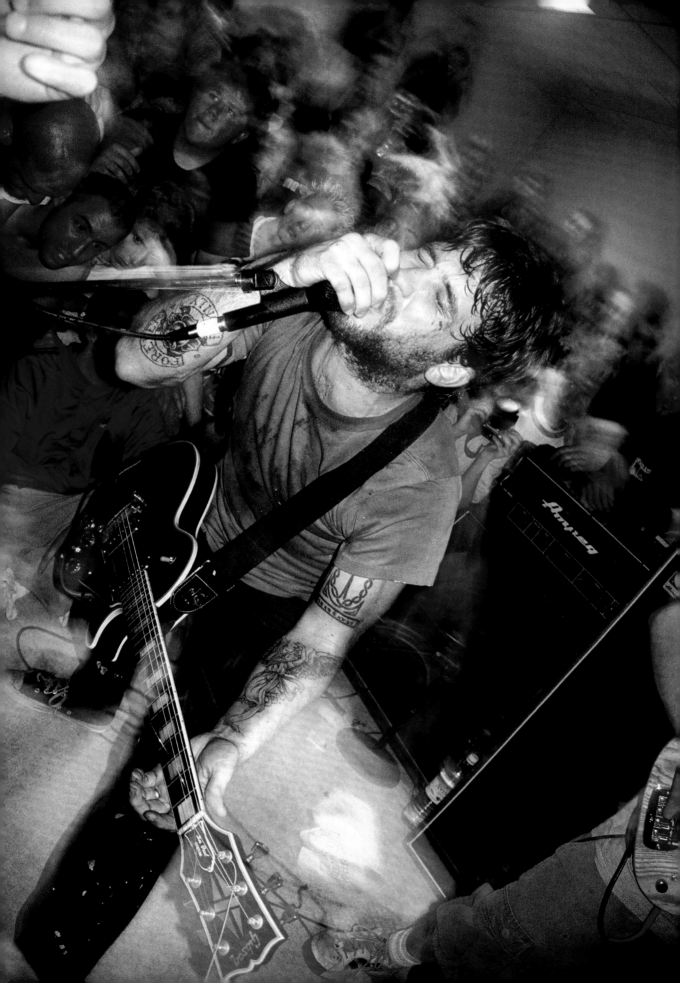

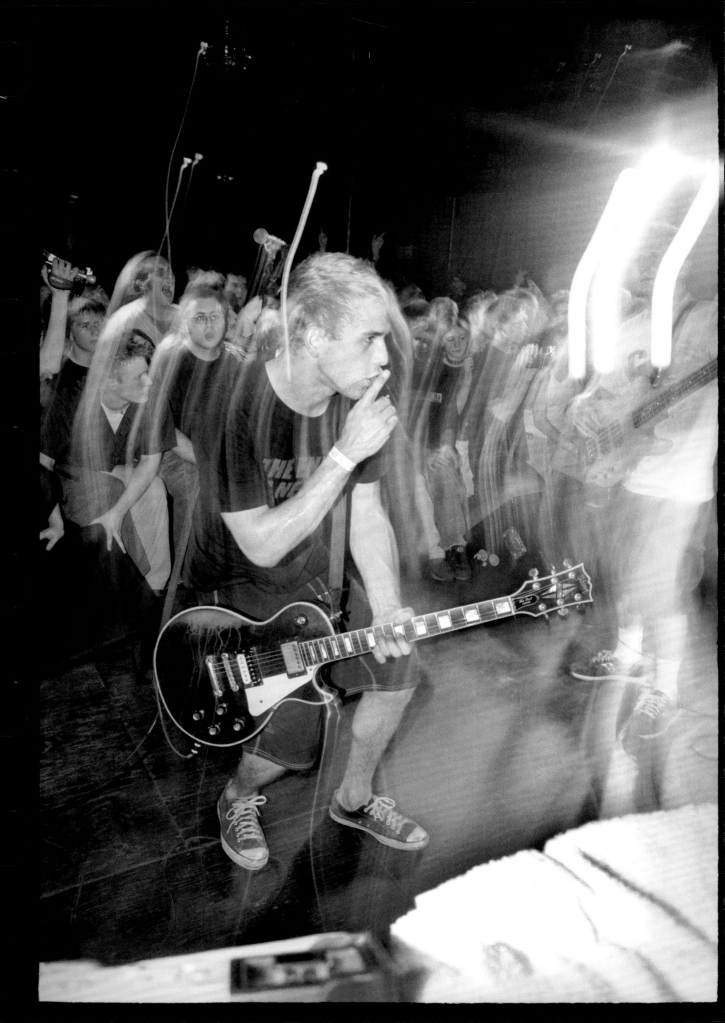

Photos by CJ Benninger.
The Shelter.
Detroit, MI. 2000.

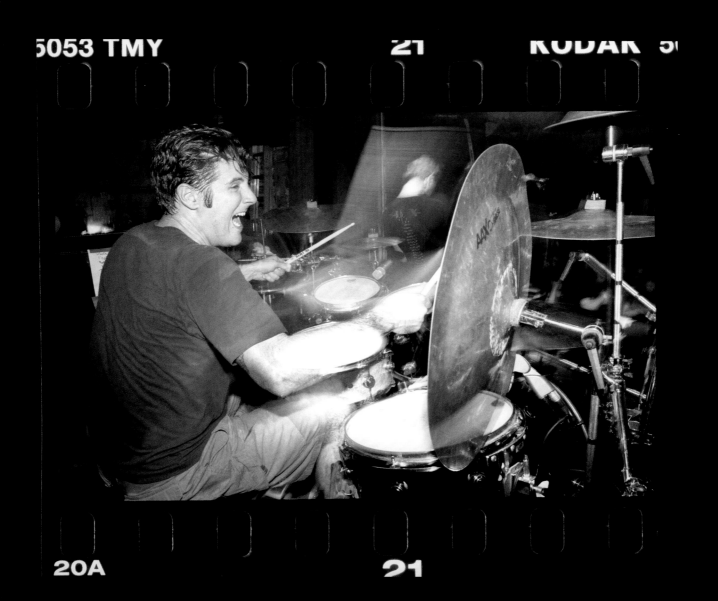

Jawbreaker

Est. 1986
New York, NY / Los Angeles, CA / San Francisco, CA

—

Jawbreaker's legacy is difficult to nail down in short form because there are so many nuances and pitfalls that aren't easily seen in the band's trajectory; but alas, I am here to try. Initially, Jawbreaker was a punk band—they really were. They toured in a shitty old van. They ate terrible gas station food. They ignored the progressively faltering vocal chords of their singer, Blake Schwarzenbach. These are very punk characteristics. Their first real breakout "hit" boasted the lyrics "One, two, three, four, who's punk, what's the score?" See? There's nothing more punk than singing about being punk.

But then everything changed. Much to the dismay of the band's core fan base (who, by the way, experienced zero financial repercussions due to the band signing to a major label), the band signed to DGC Records (a major label founded by David Geffen). At the time, this was a big deal, particularly because the band had previously said that they would never sign to a major. It's an understatement to say "things were different in the '90s." Grunge was happening, and words like *sellout* and *cred* were thrown around aggressively with what you could call fear and loathing. Nevertheless, the band went major after Blake had much-needed surgery on his vocal cords. These two developments led to a much more polished sound, musically and vocally. This also upset the same people that were still experiencing zero financial repercussions because of the band's career choices. Even sadder, though, is that DGC and the team that did have a financial investment in the band didn't seem to get *Dear You*. In the end, it just didn't pan out. The album was met with poor reception, tensions between members mounted, and the band began to splinter. They decided to break up.

But *Dear You* ended up changing the emo landscape without even knowing it or intending to do so. Jawbreaker and this record settled into the murk of strange fandom and emo urban legend while active second wave titans like The Get Up Kids and The Promise Ring toured to the brink of exhaustion. The record and the band continued to lay dormant only to see third wave bands using *Dear You* as a blueprint for how to write heartfelt hooks.

Bands like My Chemical Romance and Saves the Day took cues from *Dear You*, delivering their own bleeding-heart lyrics that felt more poetry than punk rock. Rob Cavallo, who produced *Dear You*, also produced My Chemical Romance's *The Black Parade* ten years later. Funny how that works out.

Photo by Isac Walter.
On tour with Jawbox.
El Dorado Saloon.
Carmichael, CA. 1994.

Photo by Isac Walter.
On tour with Jawbox.
El Dorado Saloon.
Carmichael, CA. 1994.

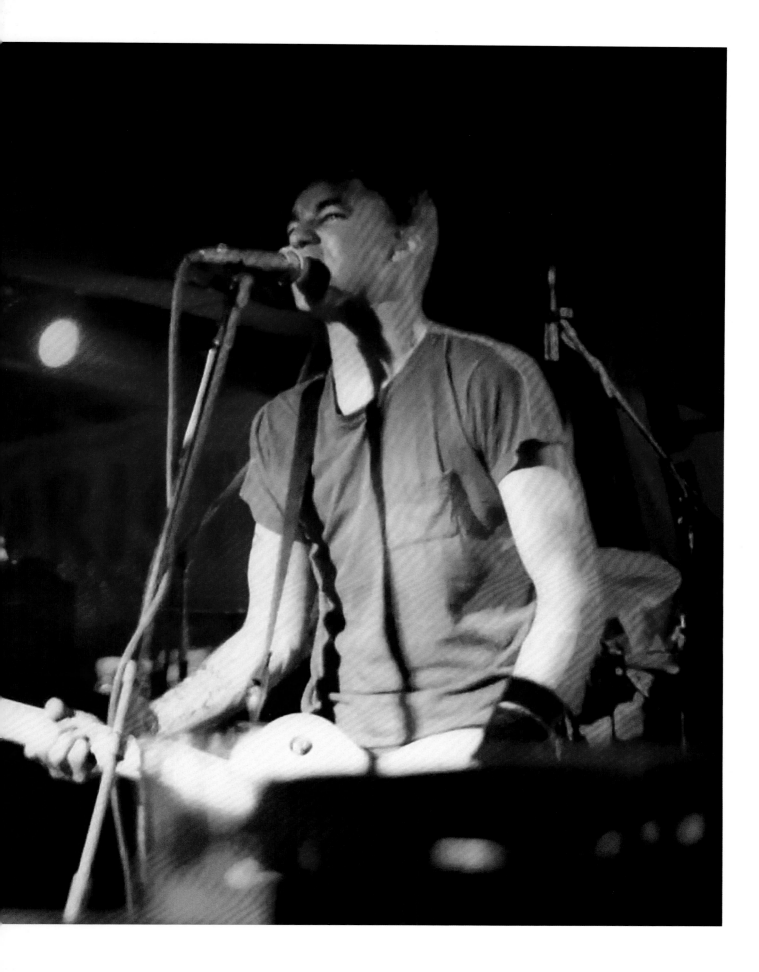

Jejune

Est. 1996
Boston, MA

—

When I was younger, I had no idea what *jejune* actually meant before looking it up in a dictionary. Once I learned its definition, I was always confused as to why the band chose this word as their moniker. "Naïve, simplistic, and superficial" are not words I would ever use to describe this band. I guess that was the joke, though. Opposite day? Or maybe they just thought it sounded cool. Whatever the root of the name, Jejune was this delicate and soft-spoken whisper of a band that would hit you with intricate melodies—and then they'd explode into a wall of noise.

The band released a track on the compilation *The Emo Diaries, Chapter One: What's Mine Is Yours* followed by an impressive string of split 7" EPs that are still worth their weight in gold to the knowledgeable collector. And despite forming in Boston, where all members were in school together at Berklee College of Music, they had this air of Southern California cool. Perhaps that's why they eventually relocated to San Diego.

Jejune had this unique way of toeing the line between old and new—when you saw them, you almost felt like you were digging through a time capsule from the '60s or '70s; but when you heard them, you knew you were hearing something totally new. Arabella Harrison's vocals intertwining with Joe Guevara's harmonies were a quintessential *moment* during the second wave—one second you're in the most delicate lullaby and the next you're surrounded by soaring arena rock guitars that hadn't sounded this good since The Smashing Pumpkins released *Siamese Dream*.

As of 2022, their catalog isn't fully available to stream, so you're going to have to get in line to find some old vinyl—or, get this, *a CD*.

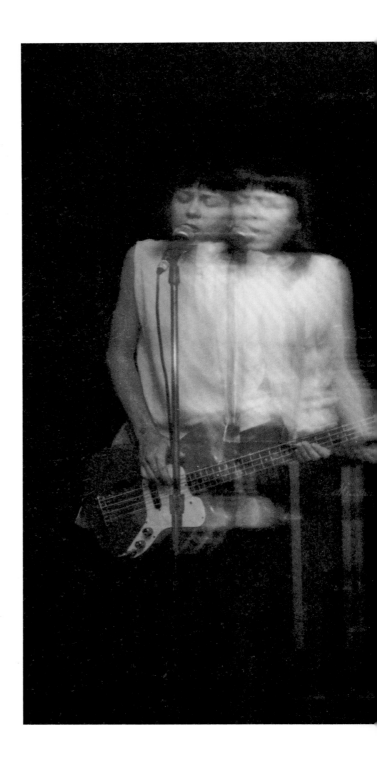

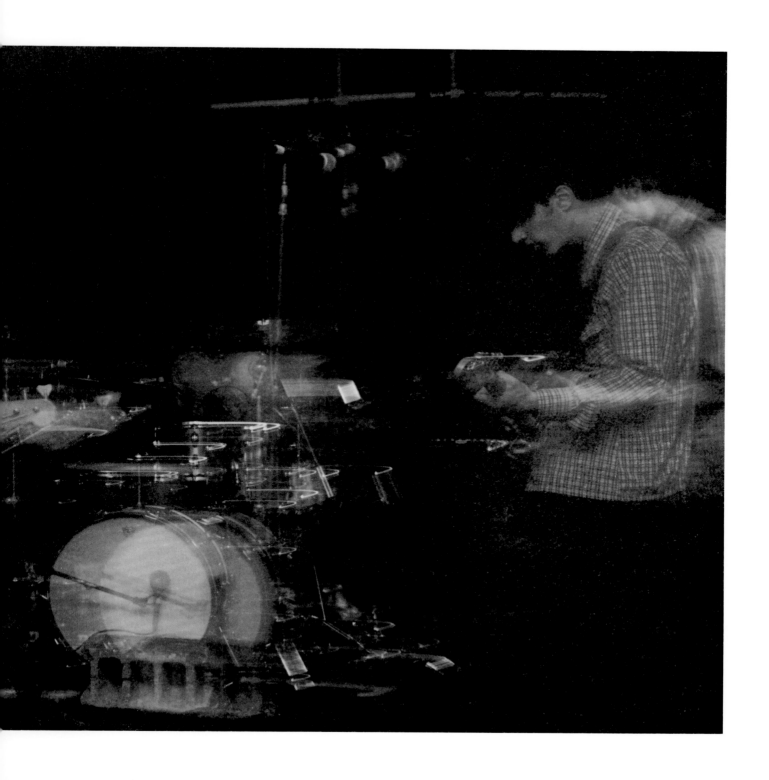

Jets to Brazil

Est. 1997
Brooklyn, NY

—

After Jawbreaker's untimely breakup, Jets to Brazil was the answer to the burning question: *What do we listen to now?* Jets to Brazil, beyond being "Blake's next thing," was a supergroup to the Nth degree. The band was rounded out with Jeremy Chatelain on bass (Insight, Iceburn, Handsome), Chris Daly on drums (Texas Is the Reason, 108, and more), and, after their initial album release, guitarist Brian Maryansky (The Van Pelt), making them one of the most solid and metronomic live bands of the era.

By the time I had discovered Jawbreaker, they had already disbanded, so seeing Jets to Brazil was the only way for me to catch Blake Schwarzenbach in the flesh. While Jawbreaker's *Dear You* was a top ten desert island record for me, Jets to Brazil's first record, *Orange Rhyming Dictionary*, hit me differently, but in a good way. It's like Blake was writing records just for me—they all seemed to perfectly match the progression of my life.

I was in college by this point, flirting with the idea of being a writer of some kind, and in my opinion, that's what Blake seemed to me—much more than a vocalist or just a guy in a band, he was a writer, capable of expressing these wonderful, effervescent, sometimes painful narratives. Despite his lyrics being utterly personal, I still felt like he was somehow in my head, taking my thoughts and expressing them better than I ever could. While I first felt this as a fan and a listener, I later realized this experience was an attribute that I looked for when working with bands.

But I digress. Jets to Brazil was a fantastic band. Their wonderful little corner of the world was delicate and poppy and sarcastic and smart, perfect for those of us who knew what to listen for.

RIGHT:
Photo by Mark Beemer.
On the corner of Riverside
and Cedar.
Minneapolis, MN. 1998.

OPPOSITE PAGE:
Photos by Paul D'Elia.
Jade Tree CMJ Showcase
at The Wetlands.
New York, NY. 1999.

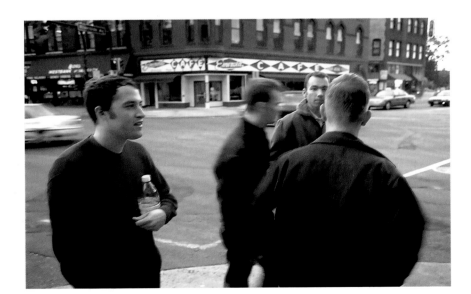

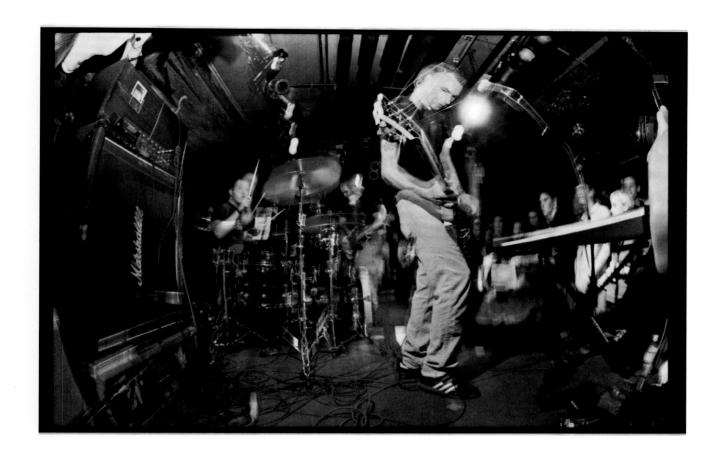

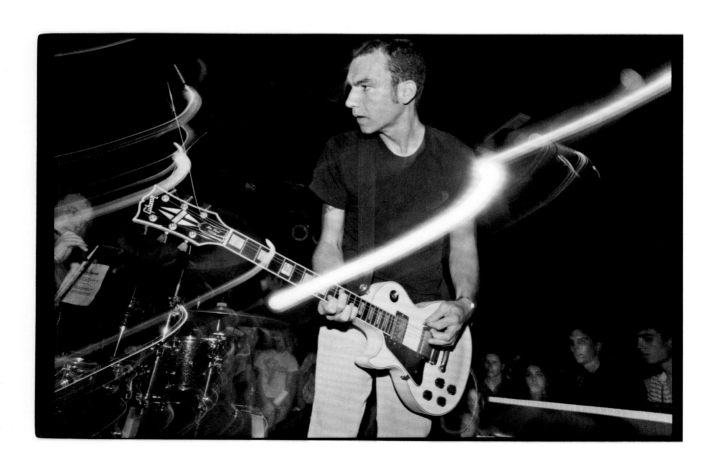

Jimmy Eat World

Est. 1993
Mesa, AZ

—

In 1996, I was in high school, and I spent all of my free time making a handmade photocopied zine. I received a promo from Capitol Records of Jimmy Eat World's *Static Prevails*, and at the time, I had never heard the word *emo*, but when I put the CD into my stereo and let it play, I somehow knew the music I was hearing would become my favorite thing for all time.

Everything about the album spoke to me. Beyond the music, the artwork was subtle. The cover photograph of snowy chimneys was oversaturated in blue so that it was indiscernible; it could have been barstools or maybe knobs on a mixing board shot with a macro lens. There was a poster enclosed in the package as well—it had a photo of the band on it, and was so stylistically different. Most glossies that I received in the mail back then were boring black-and-white photos of the members standing somewhere random, like an empty pool, and looking a certain way, usually very serious and borderline angry. When I saw this amazing snapshot of four guys laughing on a bench in front of a café, juxtaposed harshly against a tonally different photo of pampas grass, it spoke to me. I promptly used push-pins to affix this masterpiece to a space on my wall above my desk. From that point on, I wanted to work with bands that sounded like this and I wanted to make art that looked like this.

When I heard *Clarity* in 1999, the band had solidified their place as an eternal favorite. I officially pivoted from being this weird skate-rock baggy-jeans punk kid to whatever *this* was—and it's what I've been ever since. I had discovered emo, it had discovered me, and we were about to skip off into the sunset holding hands. The first twenty-five seconds of the album, devoid of vocals, sold me in an instant. At the twenty-six-second mark, when Jim Adkins began to sing, something happened inside my mind that was akin to the big-bang montage in the movie *Adaptation*. Suddenly, everything made sense—by discovering this band, I had discovered myself.

All of that said, to only speak about the early days of Jimmy Eat World's career is pretty shortsighted. If my math is correct, Jimmy Eat World has been the longest-running emo band of all time, never taking a break, never calling it quits, never disappearing from the lives of those of us who need them most. They followed *Clarity* with *Bleed American** in 2001, *Futures* in 2004, and so on, and are still releasing super solid albums twenty years later.

Jimmy Eat World is *it* for me—the most pure and simple example of *it*. I'm going to go listen to *Static Prevails* now. And then *Clarity*. And then *Bleed American*. And then *Futures*. You get it . . .

*

The album was initially titled *Bleed American*, but quickly became self-titled after the attacks on September 11, 2001, just three months after the release. It has since been retitled to its original *Bleed American*.

Photo by Paul D'Elia.
First night of an East Coast tour.
Somewhere in Maryland. c. 1999.

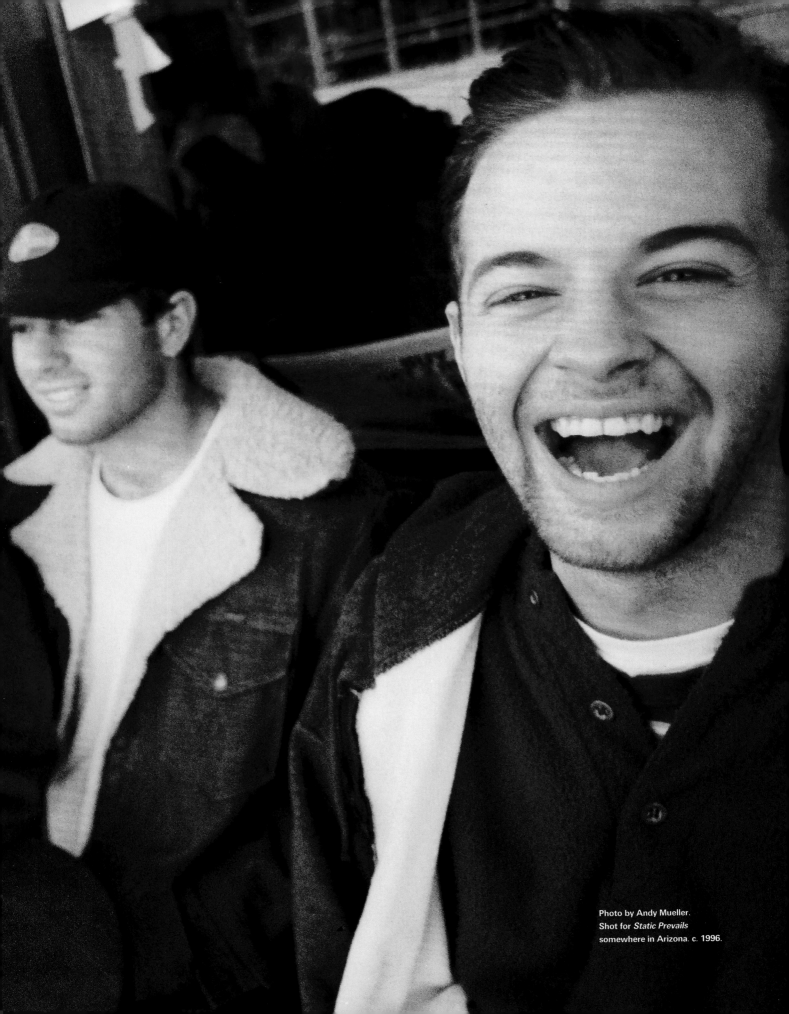

Photo by Andy Mueller.
Shot for *Static Prevails*
somewhere in Arizona. c. 1996.

Photos by Day19.
Somewhere outside
of Los Angeles, CA. 2004.

"I was pretty nervous going into this shoot. I had met Jim a couple times in Boston and when first moving to LA but really didn't think he would remember me, so I thought it was a fluke that I was called to do this shoot. As soon as I arrived solo, Jim yelled out, 'Jeremy, so glad you're here for this. We really appreciate you doing this for us.' And I was more than flattered."

—Day19

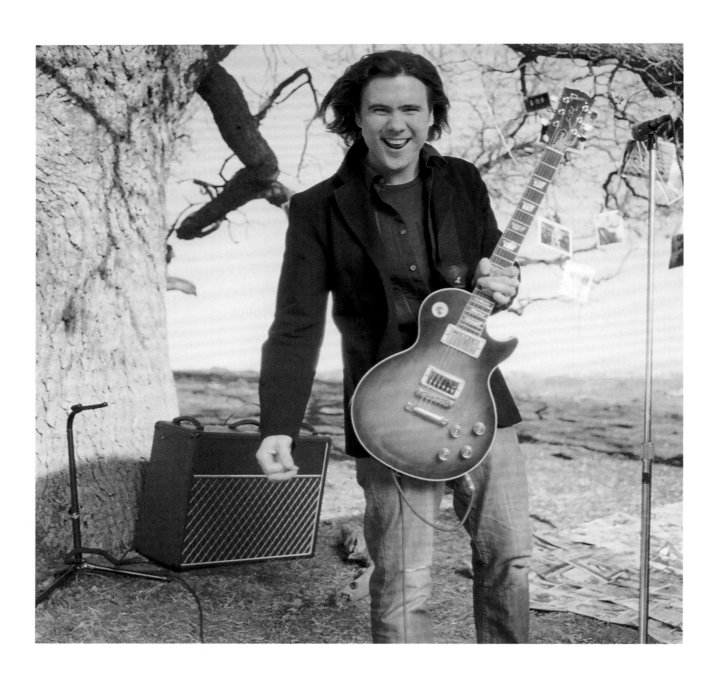

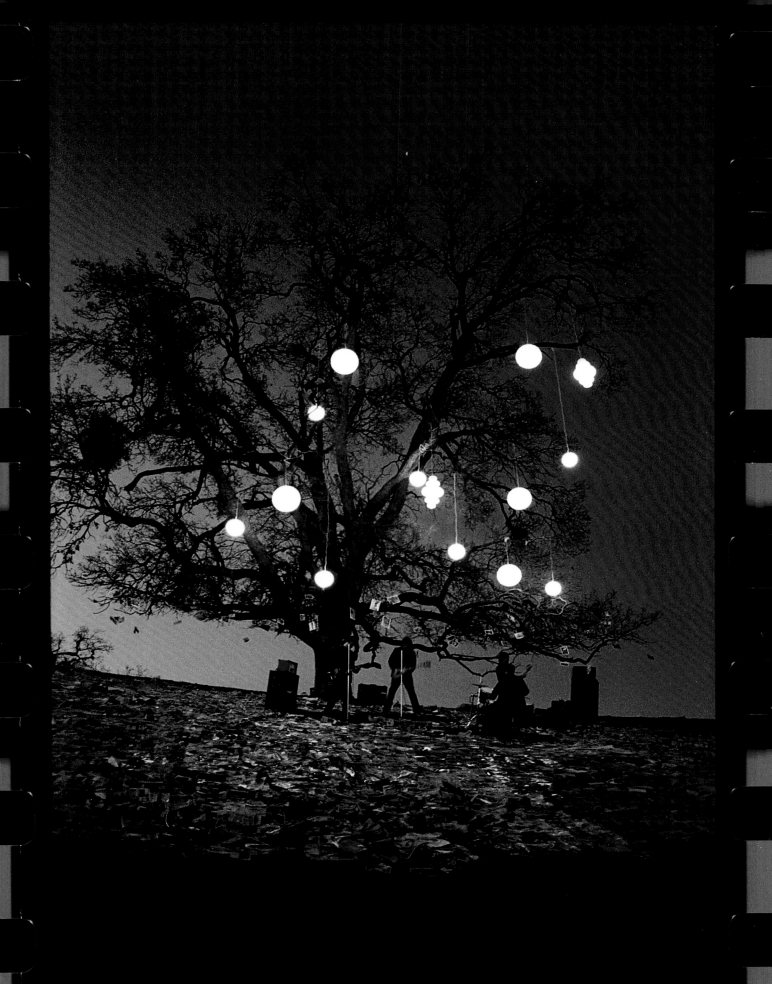

Joan of Arc

Est. 1995
Chicago, IL

—

I cannot tell you facts about why Joan of Arc sounded the way they sounded—I can only speculate that they took a look at their musical community and thought to themselves, "Okay, but how can we do something else?" And then they did that something else and called it Joan of Arc.

Delicate, cacophonous landscapes balanced by layers and layers of loops and samples really set them apart from other bands who were poised as major players but at times lacked imagination or adventurousness in the studio. They also had a sense of humor. They named their 1999 album *Live in Chicago*, and you'd think the album would be a live recording . . . It is not. Being a follow-up to Tim Kinsella's previous band, Cap'n Jazz, I feel confident in saying this tongue-in-cheek nature that ran rampant in Cap'n Jazz endured with Joan of Arc.

For me, the jam will always be "The Hands" on *A Portable Model Of*.

Photo by Paul D'Elia.
Jade Tree CMJ Showcase
at The Wetlands.
New York, NY. 1999.

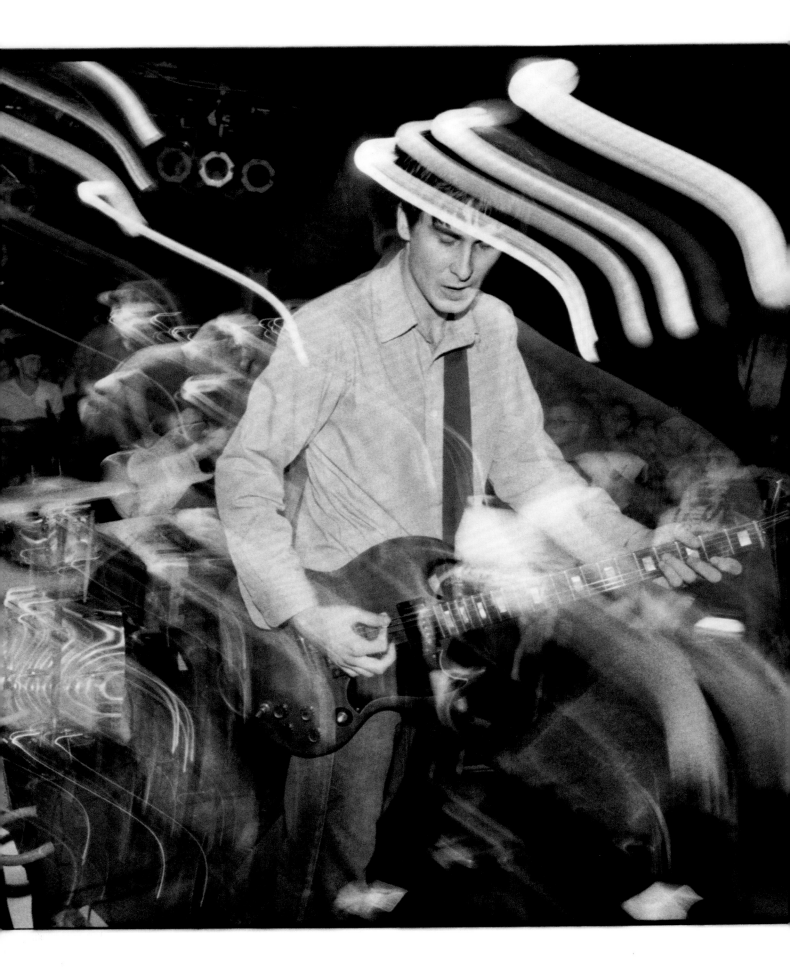

Karate

Est. 1993
Boston, MA

—

Karate had this way of making the earth sway a little bit more noticeably, side to side and up and down, like a brilliant waltz you didn't even know you were participating in. Beyond an archive, this book is a map, a bread crumb trail left for those who may have not been born when the second and third waves hit, or who may have gotten into the scene too late and lacked a cool older sibling to help guide them on their musical journey.

What you need to know is that Karate is a crucial, wonderful crumb, and I implore you to sit down and give them a listen. Jazzy, somehow alt- and post-rock at the same time, and absolutely brilliant, Karate's catalog is something that should be experienced on sleepy Sunday farmer's market afternoons—and as often as possible, whether you bought $12 organic carrots or not. They're not the kind of band that you obsess over, but once you've heard them, you can't imagine your life without them.

Photo by Paul D'Elia.
The Melody Bar.
New Brunswick, NJ. c. 1996.

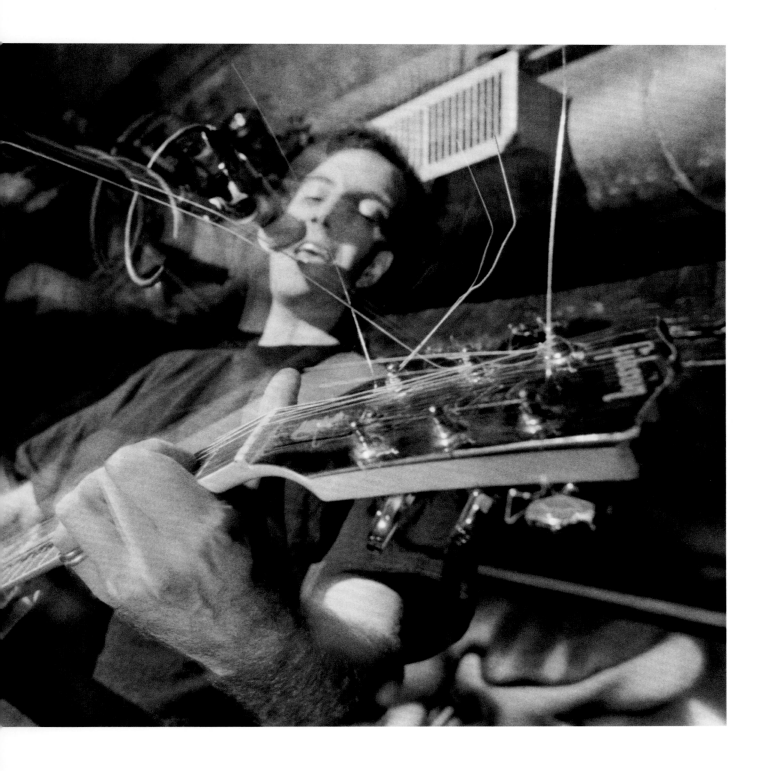

Knapsack

Est. 1993
Davis, CA

—

While Knapsack formed in 1993, their emo tenure, in my opinion, begins in 1997 with the release of *Day Three of My New Life*, when they became a pillar of the scene. Prior to this, the band had a much more post-grunge/punk feel. Having the range to alternate between the sweetest whisper and the most urgent yell is a skill very few vocalists can wield alone, and Blair Shehan nails it. And it only added to their sonic wonder when Sergie Loobkoff from Samiam joined the band in 1998, further showcasing that clean octave guitar sound he's known for.

I cannot call out singular songs to listen to—this is a *full album band*. You have to listen to the aforementioned *Day Three* and the follow-up *This Conversation Is Ending Starting Right Now* to fully appreciate their greatness.

Photo by Peter Ellenby.
South of Market,
by the now-defunct Slim's.
San Francisco, CA. 1998.

"This photo reminds me of two things: our friend Peter, the photographer, who we lost in 2022, and the sense of fun that came with Sergie joining the band. We needed some levity!"

—Colby Mancasola
(Knapsack)

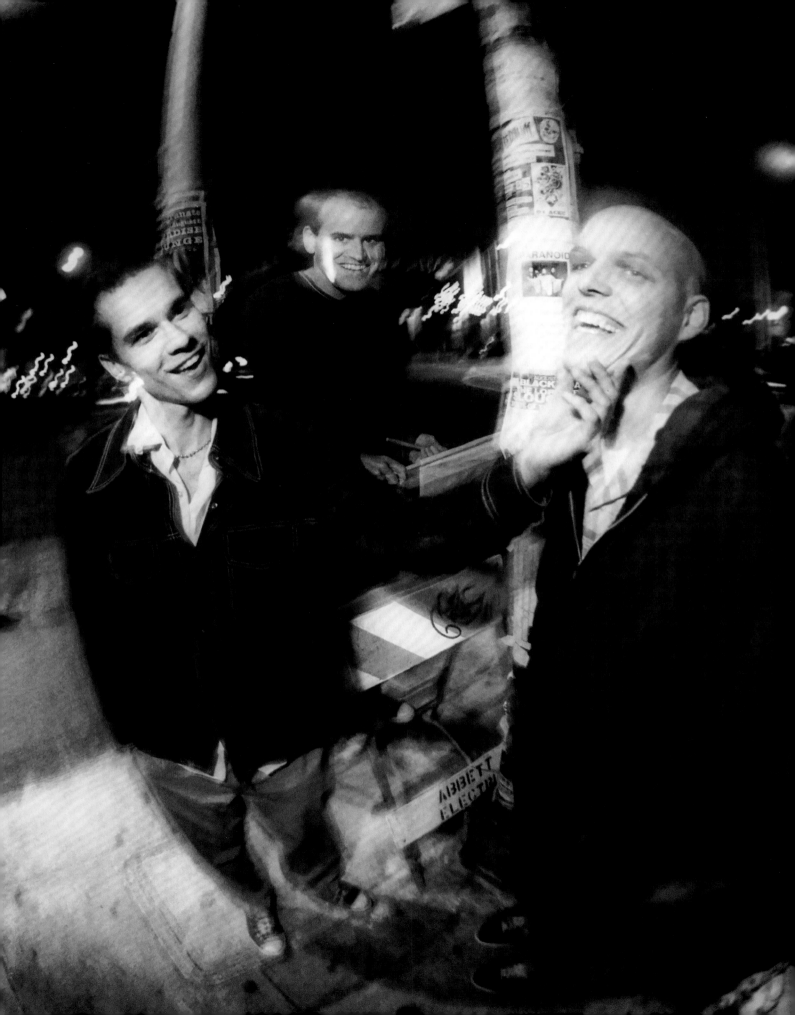

Lifetime

Est. 1990
New Brunswick, NJ

—

Helen of Troy was the face that launched a thousand ships. For me, Lifetime is Helen—they're the band that launched a thousand bands, or maybe even more. So many bands used Lifetime as part, if not all, of their foundational DNA. Fall Out Boy, Saves the Day, New Found Glory, Midtown, and The Movielife are just a few of the bands who proudly cite Lifetime as a key influence on their sound.

Some purists can argue that Lifetime is strictly a punk band, but I cannot deny the blueprint they provided for so many third wave bands who followed. *Jersey's Best Dancers* and *Hello Bastards* are required listening for those who would like a profound understanding of what "good music" is and you know, to give a listen to the band that shaped the emo landscape for generations to come.

Photo by Justin Borucki.
Brownies.
New York, NY. 1995.

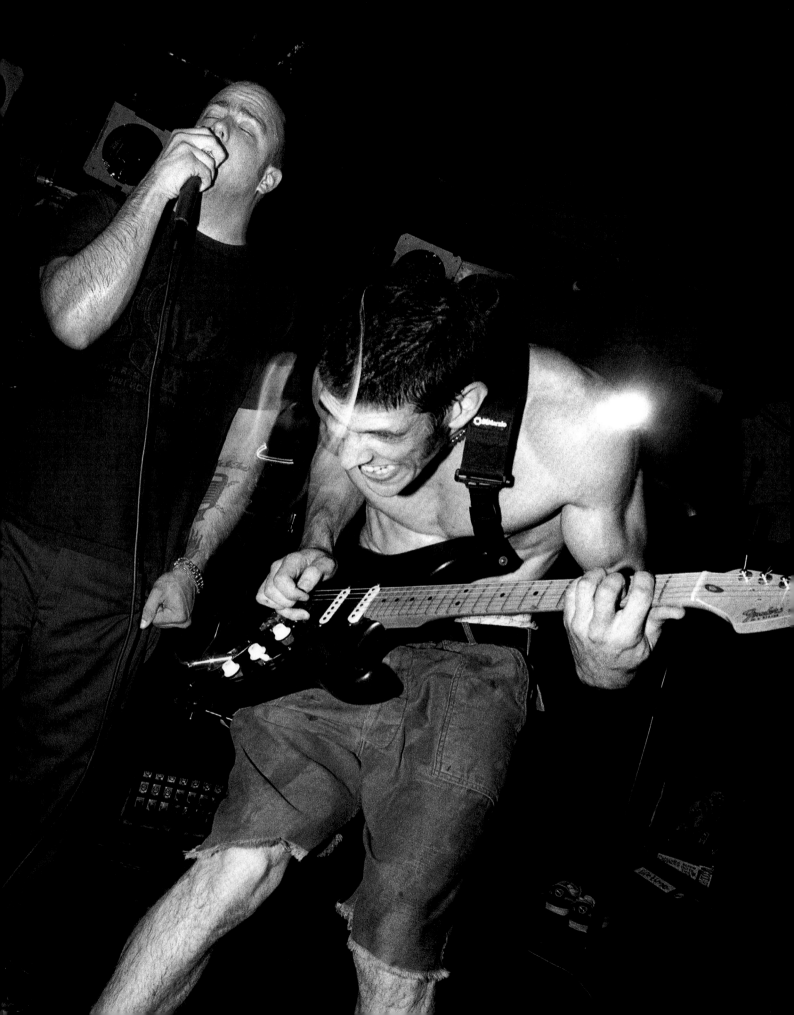

Mineral

Est. 1994
Houston, TX / Austin, TX

—

Where so many bands in this book are sure to spark a fiery debate about who is and who isn't emo, Mineral is quintessentially, undeniably, irrevocably emo. And, whereas some bands require a discerning listener who can handle an off-key symphony, for anyone that errs on the maudlin side Mineral is such wondrously gentle listening—it goes down so easily.

The band has all the landmark emo features, but their roots in alternative rock really cut through the chaff and create a thick wall of sound that teeters between slow and delicate and overwhelming and brazen. But it never comes on too quickly. Maybe that's the secret—they never spook their listeners. It's almost as if they reach out to hold your hand so they can guide you through a dark hallway at night—you never feel alone or surprised.

If I could get an entire album tattooed on my body, it would be *The Power of Failing*. No band to date has gotten me through so many disastrous breakups. They're the best friend that just sits on the edge of your bed while you soak your pillow with tears. And if that isn't emo, then I don't know what is.

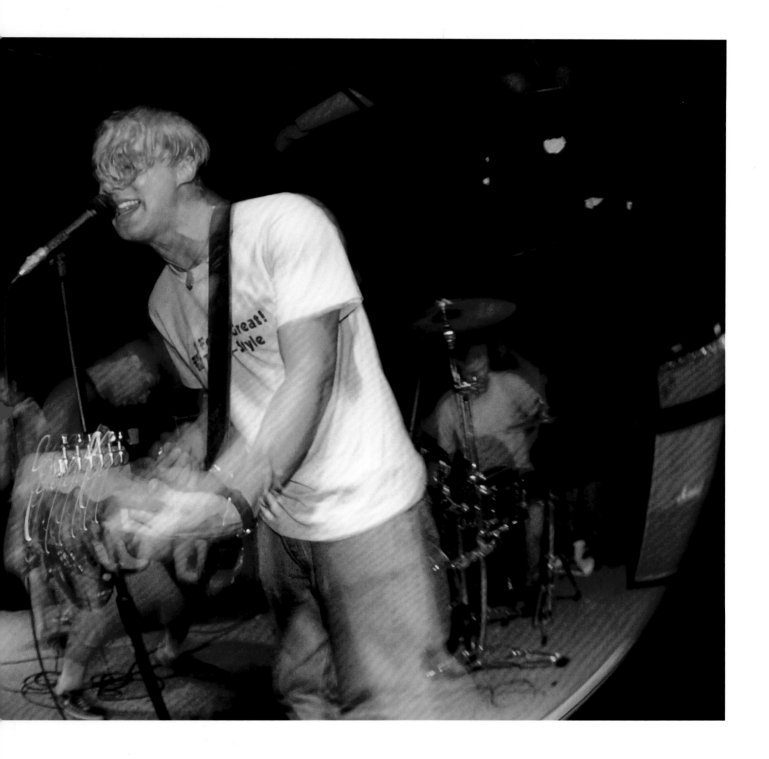

No Knife

Est. 1993
San Diego, CA

—

Unfortunately for most of the world, No Knife was
a secret. They were a password. If you whispered
their name into the ear of certain members of the
scene, they knew that you knew what was up and
knew how to dig deeper to find hidden treasure
bands. I refer to this phenomenon as being a "band's
band." And while being a band's band is special,
the downside is that most band's bands don't
blow up.

No Knife's quick, repetitive, upbeat, dissonant music
slid right into steady rotation as soon as I heard
them. Their unique style, which boasted arpeggiat-
ing guitar riffs and fretboard walking bass lines, were
one of a kind in my book, and I still listen to their
catalog on the regular.

Give "Academy Flight Song" a listen, and we'll no
longer have to keep this band a secret.

Photo by Paul Drake.
Basement show on tour
with The Get Up Kids.
Somewhere east of Arizona.
c. 1997.

Pedro the Lion

Est. 1995
Seattle, WA

—

Pedro the Lion is a little dangerous for me—I can listen only sparingly or I get in way too deep. For all who are familiar with this genre, I am guessing this is relatable, if not for this band then surely for another. We all have our Achilles' heel bands that just make us too damn sad. (And if you're new to this genre, welcome! Please grab yourself a life jacket before diving in.) The undeniable melancholic nature of the music just pulls me too far out from the shoreline, and before I know it, I am caught in a rip current and swimming parallel to the shore sounds much easier than it really is. While more than the occasional afternoon dip is too dangerous for me, maybe wait for a perfectly sunny summer day to give David Bazan's prodigious project a listen. *The Winners Never Quit* album will always be a favorite of mine. And if you see me posting lyrics from Pedro the Lion on my socials, maybe drop me a line just to check on me.

Photo by Peter Ellenby.
San Francisco, CA. c. 2002.

104

Piebald

Est. 1994
Andover, MA / Boston, MA

—

For a good amount of time, no one did it better than Piebald. They were louder, smarter, and even funnier (albeit a trait antithetical to emo) than everybody else—and they did it all with such style. From the moment the band pulled up to the venue in an old, short, yellow school bus to the moment they took the stage, they were hands down the best band to be in the company of. They were the kings of merch, the kings of sing-alongs, and they were second wave emo trailblazers. In fact, they rode their own wave straight into the third wave, where they took a number of younger bands on tour with them and acted like a crew of proverbial big brothers.

Their earliest albums (*Sometimes Friends Fight, When Life Hands You Lemons,* and *If It Weren't for Venetian Blinds, It Would Be Curtains for Us All*) are such a big part of the die-hard fan's repertoire, but later fans took a liking to the newer material that boasted tracks like "American Hearts" and "Long Nights." I'm a fan of any and all Piebald. I'm a fan of the old Piebald who shared a stage with Cave In and American Nightmare, and I'm a fan of the later-days Piebald who just wanted to see how far this ride could go.

Travis Shettel crafted lyrics that could weave between intensely autobiographical, sociopolitical, and sarcastic. That should be impossible, but for Shettel it seemed like it was just easy. Singing about a house fire as the result of a motorcycle accident while questioning the ethics of the modern public school system and professing his love to their yellow tour school bus? Easy-peasy, right?

"In the summer of 2000, we were out on tour with Saves the Day and New Found Glory. After a legendary night of partying in New Orleans, we headed back to the East Coast. Somewhere in Alabama, we spotted a sweet bridge just begging us to jump off it. Aaron and Travis skipped stones while Al and Rama walked over to the bridge and I grabbed my heavily taped-up Holga to snap a couple shots. Little did we know that by the end of the week we would be saying goodbye to our beloved bus, Melvin, the true king of the road."

—Andrew Bonner (Piebald)

Photo by Andrew Bonner.
The side of the road somewhere
in Alabama. 2000.

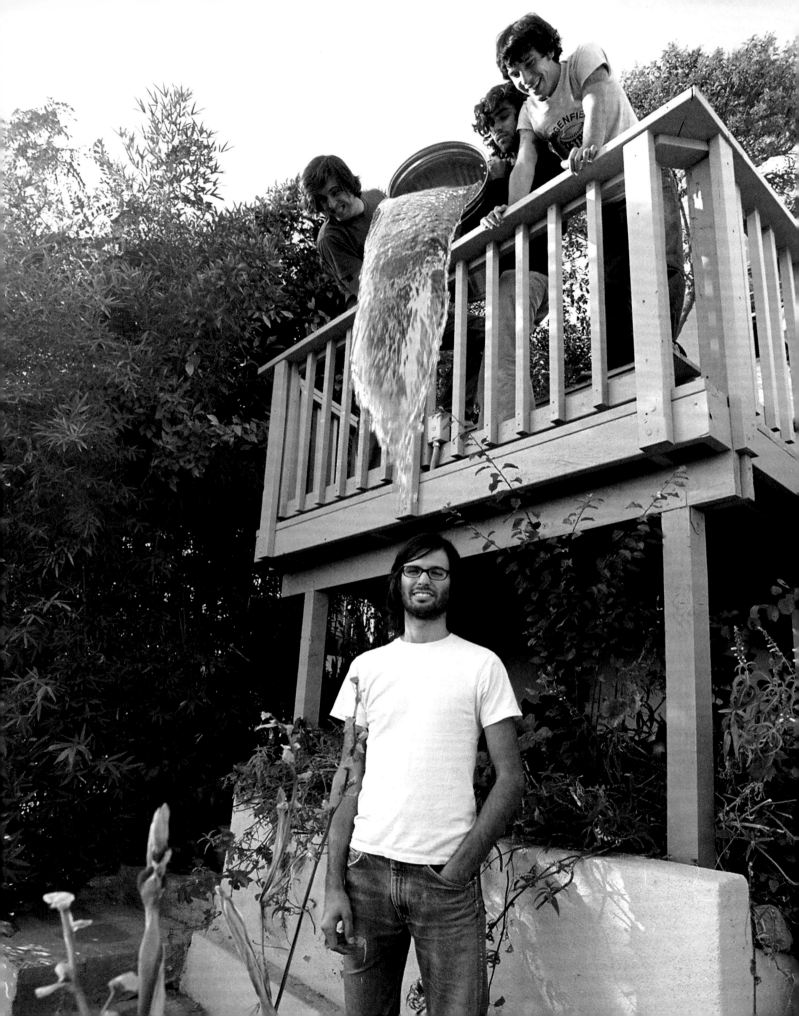

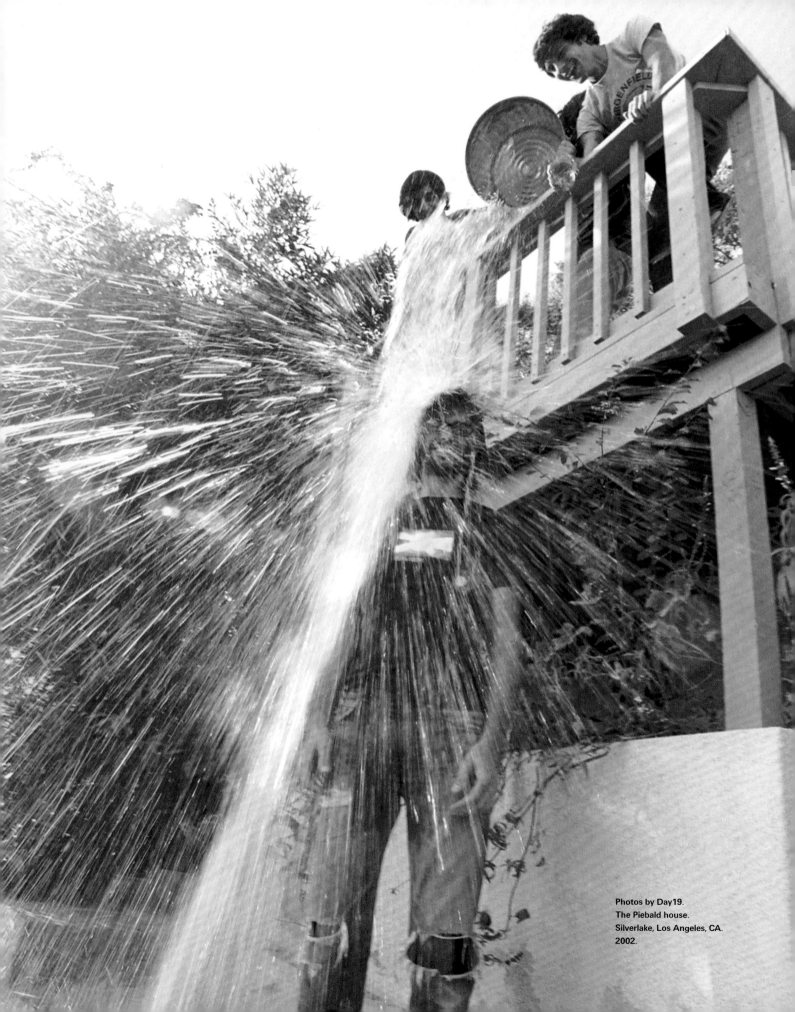

Photos by Day19.
The Piebald house.
Silverlake, Los Angeles, CA.
2002.

Planes Mistaken
for Stars

Est. 1997
Peoria, IL / Denver, CO

—

If you're looking for a band that exemplifies what it means to be sincere and authentic, all while shredding your face off, look no further than Planes Mistaken for Stars. The band's self-titled album, released in 1999, leads with the track "Copper and Stars," and the blazing guitar tone alone evokes enough emotion to land this band in the emo hall of fame. Gared O'Donnell's ripping vocals project the kind of unrelenting ferocity that simply cannot be attempted by a band just posturing for fans and fame.

Like several other second wavers, the band definitely toed the line between emo and post-hardcore, but for me, the lyrics push them forcefully into the emo basket. If there's anything that this band wants you to know, then or now, it is that time is the most precious thing we have, and how you spend it, and who you choose to spend it with, is what matters.

RIGHT TOP:
Photo by Nathaniel Shannon.
The Shelter.
Detroit, MI. 2002.

RIGHT BOTTOM:
Photo by Nathaniel Shannon.
The Magic Stick.
Detroit, MI. 2006.

"When Planes Mistaken for Stars started really touring frequently, they were the ultimate cool at the time to me. The fashion for the fans and bands that danced around Planes was always pretty square. There was a uniform that got redundant fast as 'emo' turned into a major label commodity. The swoop and celebrative hair, thick glasses and 'nerd' look that used to get you beat up in high school was now all the rage. It was like the next generation of the Seattle/Subpop lumberjack look that came during the Nirvana boom. Then came Planes. They had long hair and beards and smelled like whiskey and struggle. They wore cowboy boots, slept in dumpsters, and drank blood. They were real. There was nothing polished or marketable about them. RIP Gared. You were real as fuck."

—Nathaniel Shannon

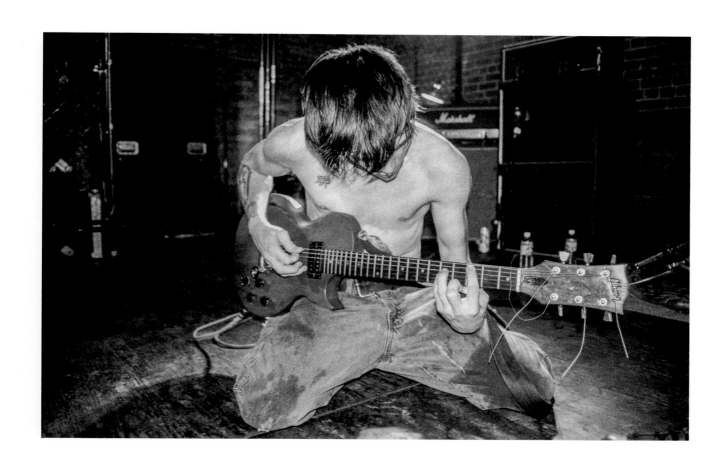

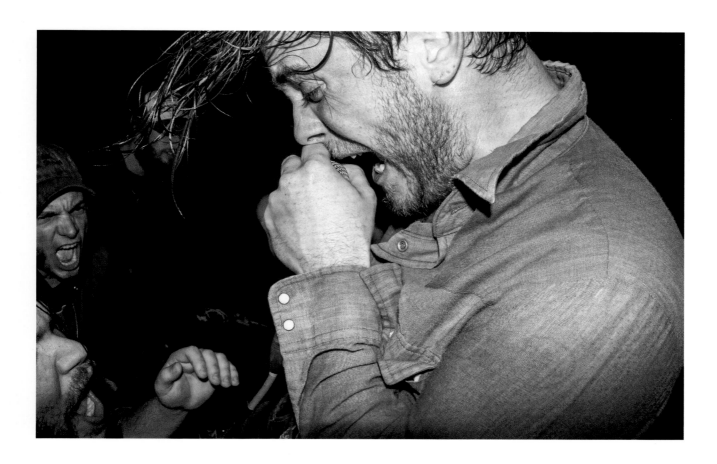

The Promise Ring

Est. 1995
Milwaukee, WI

—

There are two kinds of people in this world. People who can finish this sentence: bop bop bop do bop bop bop do ba dop . . . And people who have no taste.

But really, The Promise Ring had such an incredible dualistic quality—their songs could be so sad, but the listener could still feel so effervescent while singing and bouncing along. The repetition and perfectly off-key vocals made for some unexpected sounds, and you cannot deny their songs have become some of the most fun second wave emo anthems of all time. To the untrained ear, the formula might sound simple (play the off-key thing, play it over and over, and maybe yell a little), but there's such an art to it. The Promise Ring is often imitated but has definitely never been replicated. It's still unbelievable to me, the way they're able to make you feel like you're dancing with your high school sweetheart in a poorly decorated gymnasium. Even if just for a moment, you get to feel that sense of wonder that usually dies by the time you're eighteen. Start with 1997's *Nothing Feels Good* and move forward or backward in time however you like—either direction is golden.

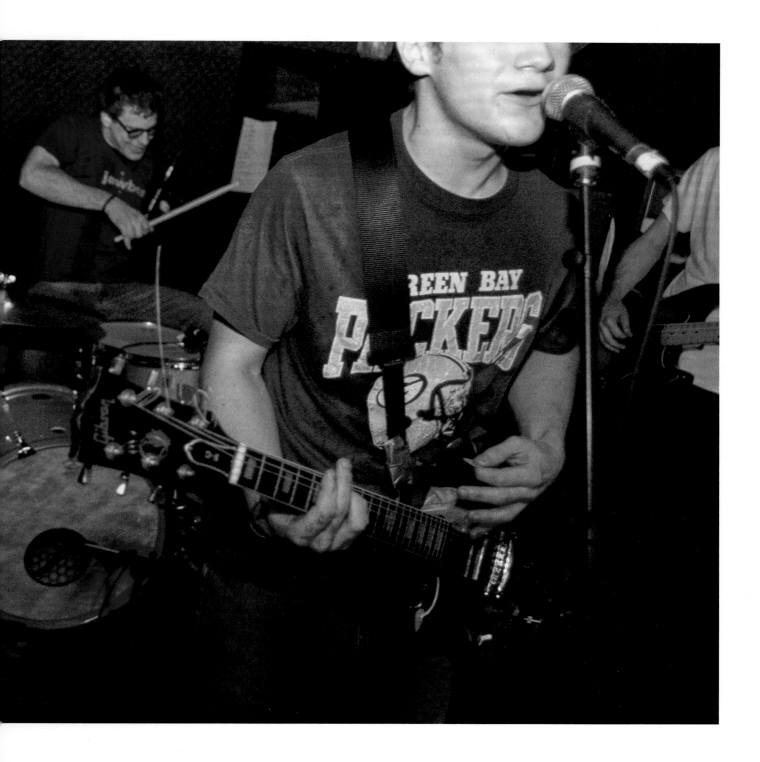

Photo by Michael Dubin.
Somewhere on tour
with Jimmy Eat World
on the East Coast. 1998.

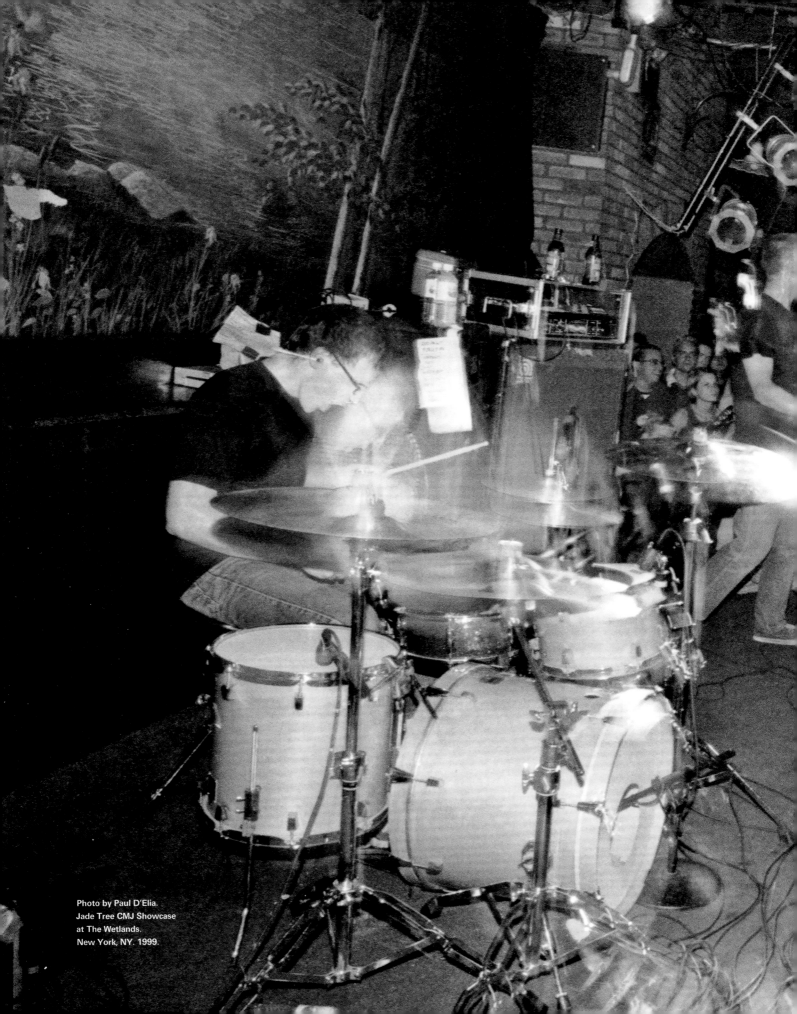

Photo by Paul D'Elia.
Jade Tree CMJ Showcase
at The Wetlands.
New York, NY. 1999.

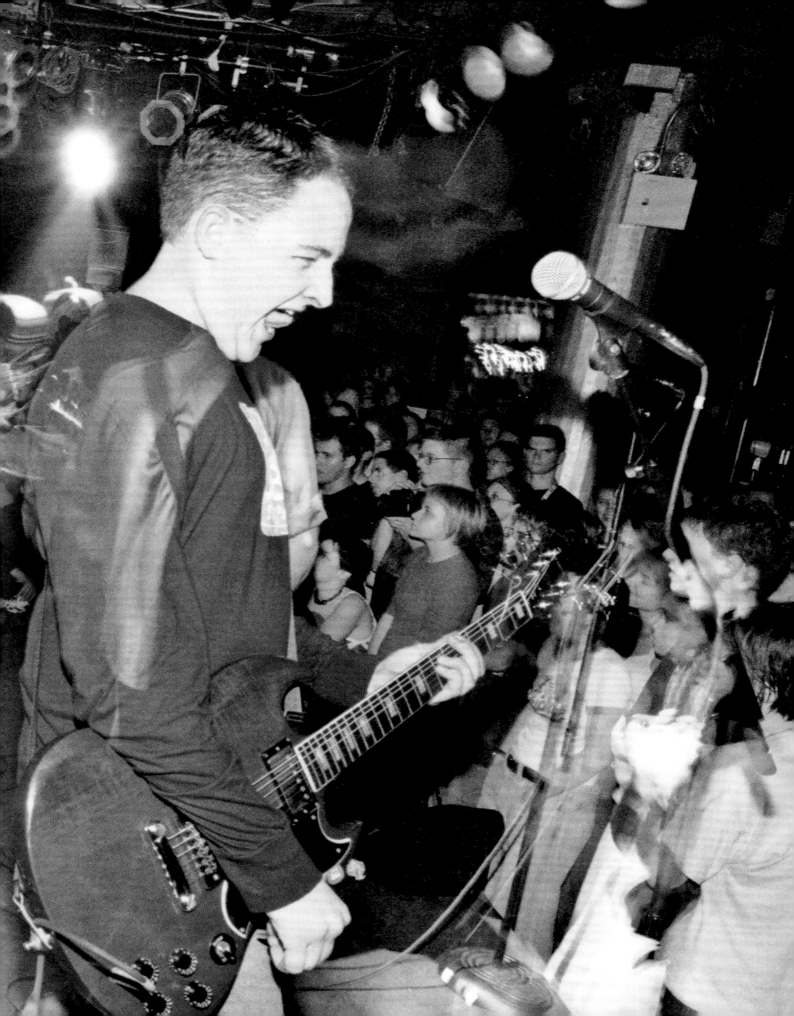

"I ended up shooting the album art for *Very Emergency*, and I think this subway photo is from a 'press' photo day that I shot to go with that record release. I remember doing a more traditional studio shoot with the band in my living room studio, but then heading out to see what else we could come up with. It's funny thinking back on those days in terms of lack of pre-planning or location scouting. We'd just wing it—I guess we all had more free time to explore and experiment back then . . . It's one of my favorite photos and nicely captures the spirit of that day and the band."

—Andy Mueller

Rainer Maria

Est. 1995
Madison, WI

—

So you must not be frightened . . . if a sadness rises up before you larger than any you have ever seen; if a restiveness, like light and cloud shadows, passes over your hands and over all you do. You must think that something is happening with you, that life has not forgotten you, that it holds you in its hand; it will not let you fall. Why do you want to shut out of your life any uneasiness, any miseries, or any depressions? For after all, you do not know what work these conditions are doing inside you.

—Rainer Maria Rilke, *Letters to a Young Poet*

Talk about a mantra for an entire movement. Rainer Maria Rilke was an Austrian poet from the turn of the last century, and there's some magnificence in the fact that a band from Madison, Wisconsin, could give sound to the sentiments Rilke wrote nearly one hundred years before the band's existence. I don't usually like for a band's entire story to be reduced to their name, something either so arbitrary or wholly polarizing that it becomes a part of pop culture vernacular. In this case, though, Rainer Maria could not have chosen a more perfect, beautiful, and fitting name for their band. And it's always commendable when your art in turn makes accessible other art worth discovering—this emo band from the Midwest was a conduit for the work of a poet to whom their listeners wouldn't normally have been exposed.

Rainer Maria, the band, endured for about a decade and won the hearts of many with their honest and real-to-life vocals before eventually deciding to take a break. However, fans still find comfort in the albums *Look Now Look Again* and *A Better Version of Me*. Here's hoping for one more reunion show . . .

Photo by Paul D'Elia.
Cafe Metropolis.
Wilkes-Barre, PA. c. 2000.

118

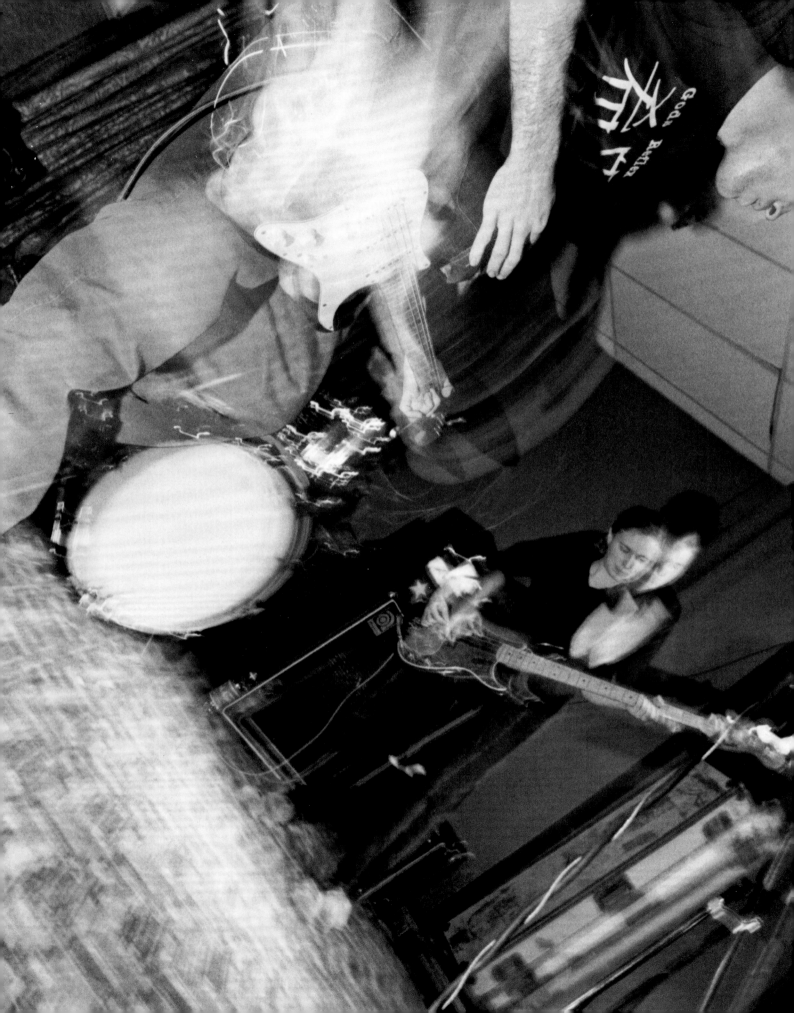

Samiam

Est. **1988**
Berkeley, CA

—

Samiam's trajectory is similar to Jawbreaker's in that they started as a punk band and maintained that sound for their first three albums. But by the time they released *Clumsy* in 1994 and *You Are Freaking Me Out* in 1997, their sound had become much more polished and streamlined, and they executed a perfect swan dive into emo.

Samiam's music makes you start singing along *even if you don't know the words*. That's a really rare trait. Let's call it sonic empathy—is that a thing?—because ten seconds into "Full On" and "She Found You" you'll be singing the WHOAAAHHHHs and YEAAAAAAHs like you're in the band, belting harmonies alongside vocalist Jason Beebout. I swear, I fell so far in love with this band the moment I heard *Clumsy*, and I still spin their music on the regular. Such a fun band, really.

Photo by Samiam.
Hunters Point in front of Jason's van. We rehearsed there when writing for our LP *Whatever's Got You Down*.
San Francisco, CA. 2006.

"We did a regular photo shoot later, but at this point we decided that digital cameras were the new 'wave of the future' [sic] and plopped one on the asphalt, set the timer, and, boom, we came up with a shot pretty much on par with any we paid for."

—Sergie Loobkoff (Samiam)

Sense Field

Est. 1990
Los Angeles, CA

—

For those who don't know, before there were "play-lists" on streaming services that are curated by a mathematical robot wizard who can predict your taste, there was something called a comp, which is short for *compilation*. They were largely made by record labels to be handed out for free at shows, or occasionally to sell. There are a few comps that are the holiest of the holy, and one of them was *In-Flight Program*, released in 1997 by Revelation Records. The first track on this legendary comp was "Building" by Sense Field, and for many of us, it went down in history as one of the best compilation openers of all time.

Immediately after hearing this song, I filled out the order form that came with the CD with a ballpoint pen, put $10 cash and the form in an envelope, licked a postage stamp, stuck it on the envelope, and mail-ordered Sense Field's album of the same name, *Building*. Three weeks later, when my CD arrived, I put it into my stereo (or "boom box") and listened to it on repeat. God, I suddenly feel like I was born in 1955, but this is how we bought music from bands that wouldn't have been in a major record store in the '90s. It was called mail order. What a time to be alive, folks.

But the golden nugget of this whole story is Sense Field, of course. There was something so unique about Jon Bunch's voice. I felt like I was listening to someone otherworldly, not some guy from Los Angeles. I brought their album with me wherever I could take it—I listened to it daily in my Discman headphones and in the cars of those friends who would let me pick the music. I know for a fact this was not a singular feeling of obsession. So many other friends cite this record as what started their own proclivity for emo, and even for music in general. I implore you to listen to "Building" as soon as humanly possible.

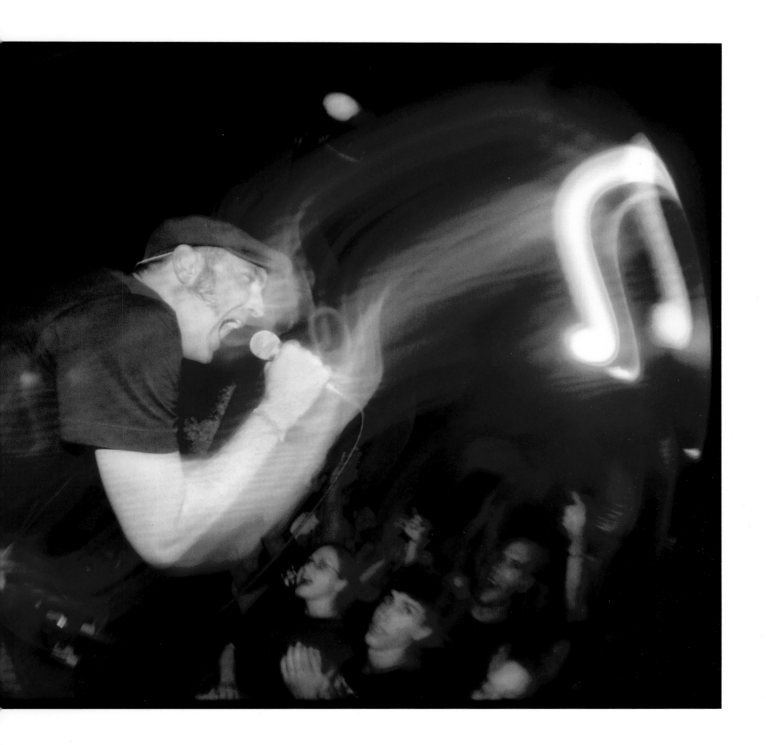

Sunny Day Real Estate

Est. 1992*
Seattle, WA

—

Diary by Sunny Day Real Estate was an absolute force—instrumental to the second wave's big bang. I admit, I was a little late in discovering SDRE. This may have been because they were from Seattle, which, growing up in Miami, Florida, might as well have been Australia or you know, Mars. Bands didn't always make it down to my neck of the woods on tour, the internet didn't exist the way it does now, and there certainly wasn't mainstream press coverage of the scene. I got my "news" from other fanzines (Iggy Scam taught me how to make free phone calls on a pay phone in her notorious *SCAM* zine) and rags like *MRR* and *Punk Planet*. What I'm trying to say is that I was slow on the uptake and didn't discover SDRE until after their first hiatus. However, when I did come across them, I fell in love. Like, love-love. Like, "let's just play that record on repeat forever" kind of love.

And to be even more transparent, I was so confused by SDRE at first. Looking back, it's possible to interpret SDRE as an answer to the question that was grunge. But instead of deep Eddie Vedder-esque crooning, they gave us the delicate meandering and swirling of Jeremy Enigk's vocals. It became clear to me that he was doing the very thing he was put on this earth to do. His vocals are just so delicate—nothing compares. The almost droning sound of his breathy melodies are matched perfectly by Dan Hoerner's clean guitar leads, and the unbreakable rhythm section backs each track in what feels like a practice in tantric meditation. There was no desire from the fans to see the band run around and put on "a show." They let you do exactly what you needed to do: listen. Just close your eyes and listen.

The second wave curse really crushed this band for a moment, though, and they didn't last much longer than their second album (although they did reunite a few years later to record two more albums that are just as flawless as their first efforts). It feels ridiculous to call out albums or tracks for you to explore because that's like saying, "Air—have you tried breathing air?" Their music is just essential to emo. If you need a hand, though, start with *Diary*.

*

For the record, I believe Sunny Day Real Estate transcends waves of emo. Technically, they've been active during all three of the first, second, and third waves—but I believe their origin story lies firmly in the second wave, even though they released albums as late as 2000. The fun part of quantifying all this data is that, at a certain point, you should feel free to shrug your shoulders as I have and just enjoy the music.

Photo by Michael Dubin.
The *How It Feels to Be Something On* Tour. Irving Plaza.
New York, NY. 1998.

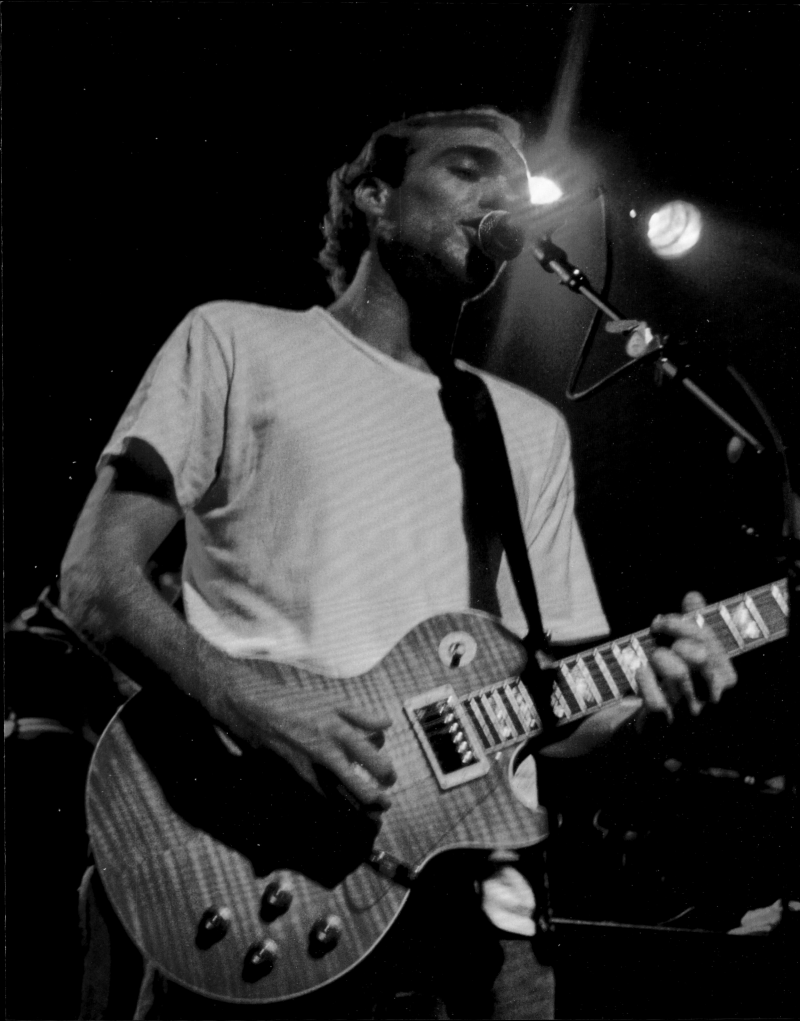

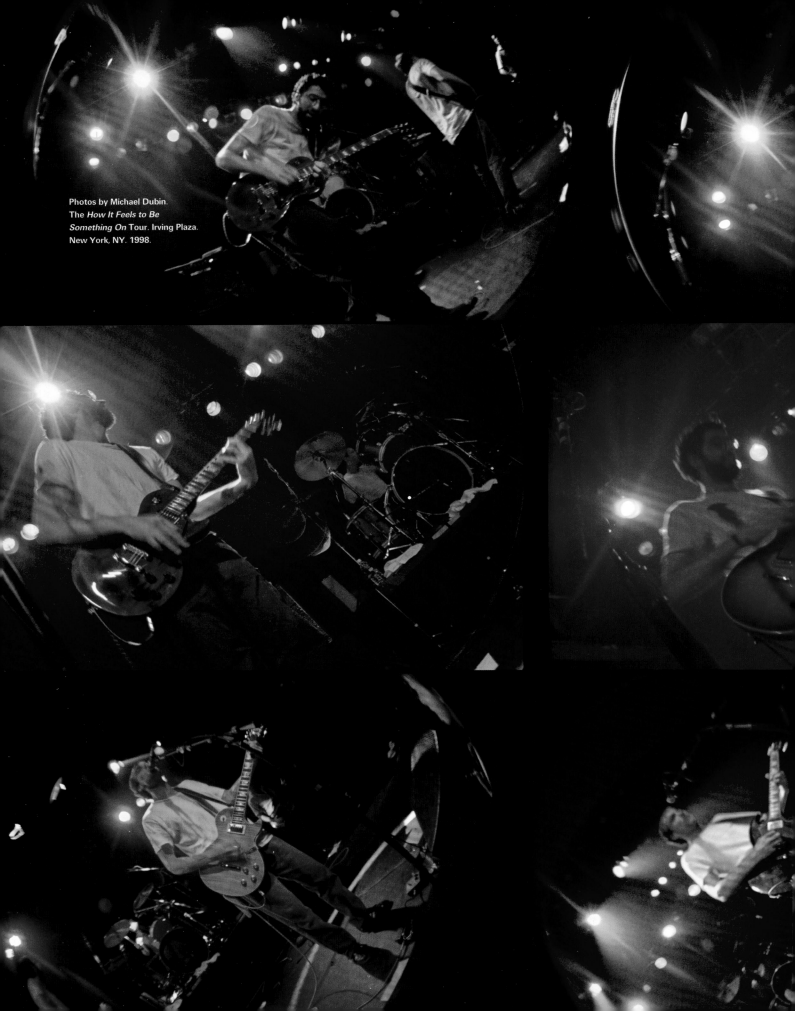

Photos by Michael Dubin.
The *How It Feels to Be
Something On* Tour. Irving Plaza.
New York, NY. 1998.

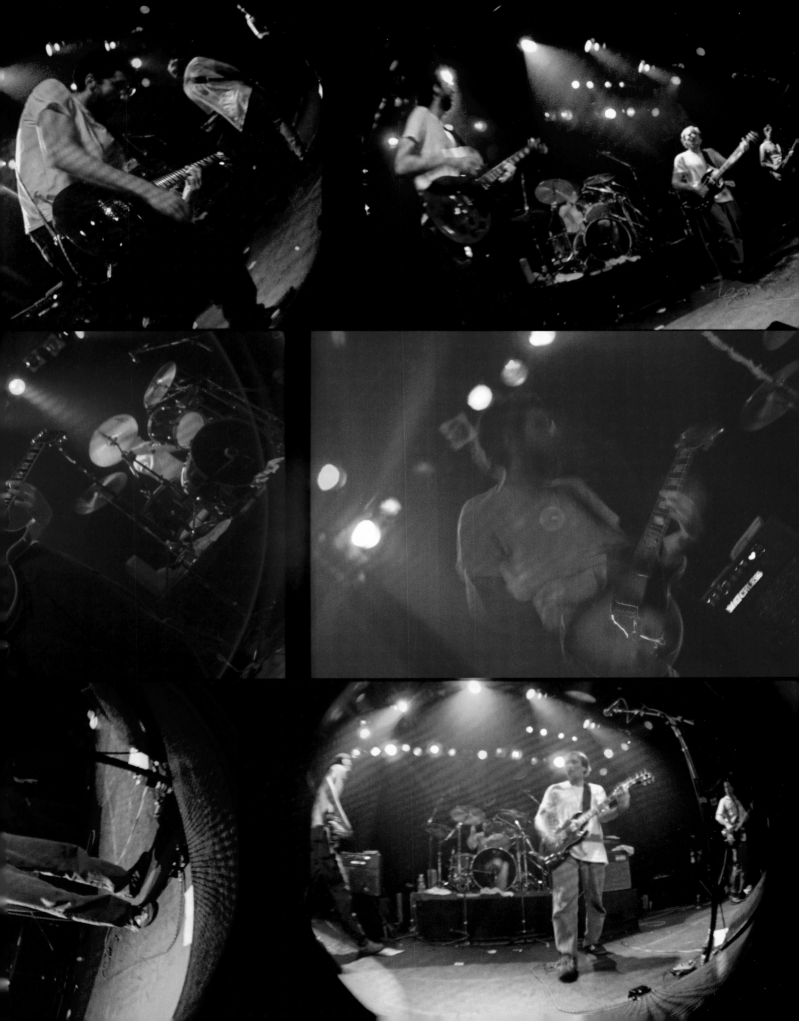

Texas Is the Reason

Est. 1994
New York, NY

—

The opening track of Texas Is the Reason's self-titled debut EP emitted such an unbridled sense of energy and urgency that it felt like someone had shaken (not stirred) ten shots of espresso with a supersized Jolt Cola, and jammed the concoction directly into the veins of the American suburbs, and it still does.

The band, formed by ex-Shelter and ex-108 members Norman Brannon and Chris Daly, respectively, continued to set the standard for members of foundational hardcore bands bringing the unmistakable sounds of the genre into a much more melodic setting (the only person who had most notably done this prior was Walter Schreifels with Gorilla Biscuits and Quicksand). Tied together with bassist Scott Winegard (Fountainhead) and ex-Copper vocalist Garrett Klahn's oft raspy and sometimes Southern-sounding vocals, the music gave you the sense that you weren't sure what you were hearing, but you knew you wanted to hear it really loud and as often as possible. Texas Is the Reason played basements, VFW halls, and eventually smaller punk clubs, and as their band's popularity spread by word of mouth, they were playing sold-out shows in the States *and* in Europe before they knew it.

Released the same year as Jawbreaker's *Dear You*, the band's debut EP put a flag in the ground with three songs that helped set off the second wave of emo, and by the time the band released a full-length album, they were scene royalty. Which, in hindsight, isn't necessarily a good thing, because at this point in the '90s, if you were rocketing toward success, you were 99 percent more likely to break up. And to the dismay of every fan around the world, in 1997, break up they did.

Regardless, there's something unique about Texas Is the Reason. Even though twenty-some-odd years have passed since their prime, their musical style has never felt dated. If heard by someone for the first time today, it would be hard to tell when the songs were actually written and recorded. I think that's the definition of a "classic."

"Brian McTernan—a friend from home [Bethesda, MD]—was setting up shop in Brighton, Massachusetts, and invited me down to watch our buds Norm, Chris, and Scoots record a demo for their new band. They had recruited a singer from Buffalo no one really knew, but were willing to give him a try. On a break during the first sessions, we went out for Dunkin' and shot a few spontaneous portraits in and around Brighton, Allston, and Boston. Listening back to the music—there were no vocals yet—in the car, I was surprised how aggressive it played. All that changed later that night when Garrett laid down his locals. It was a great demo—I still have my TDX from that night."

—Mark Beemer

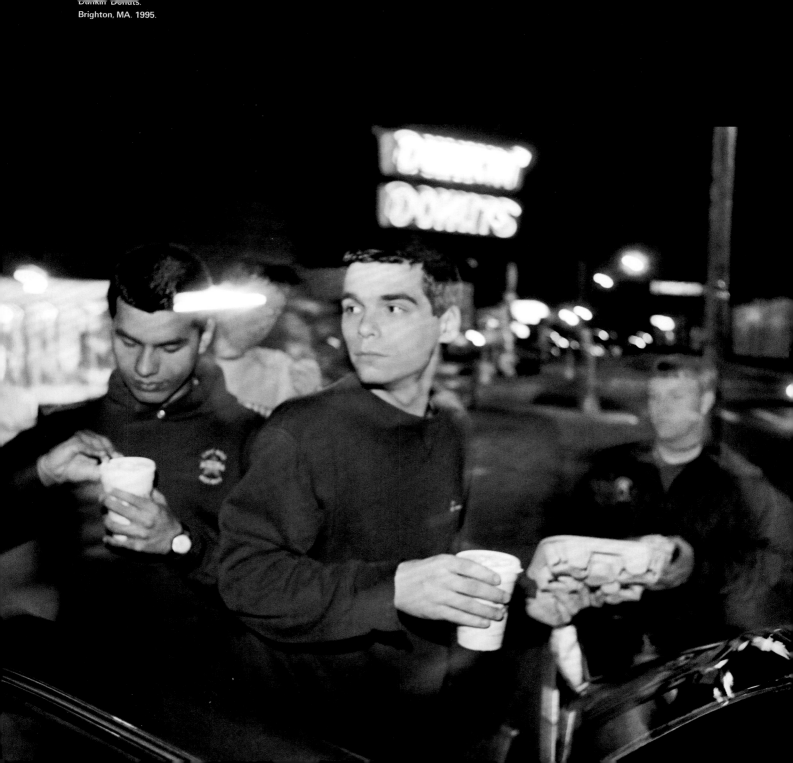

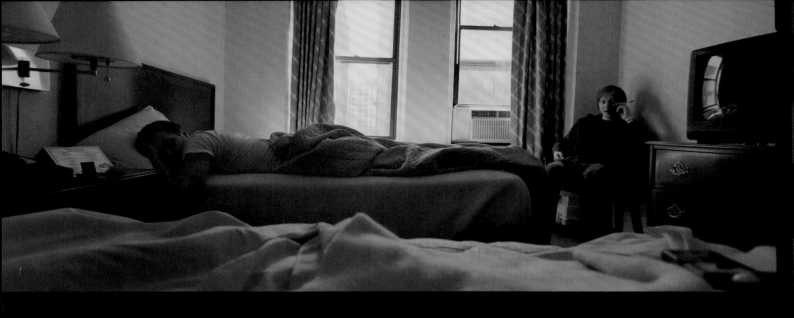

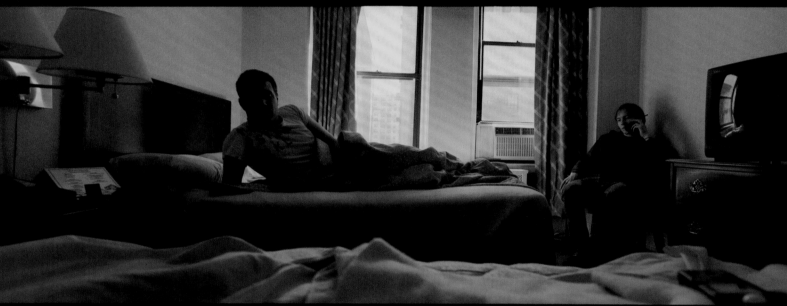

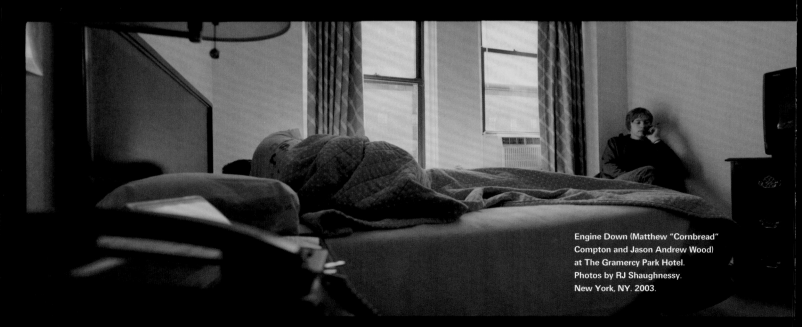

Engine Down (Matthew "Cornbread"
Compton and Jason Andrew Wood)
at The Gramercy Park Hotel.
Photos by RJ Shaughnessy.
New York, NY. 2003.

Everything & Everyone

WHERE DID YOU GET THOSE BEDROOM EYES?

TOP LEFT:
Gabe Saporta (Midtown) and
Benji Madden (Good Charlotte)
at Starbucks.
Photo by Michael Dubin.
New York, NY, 1999

TOP RIGHT:
Amy Fleisher Madden and Chris Carrabba
(Dashboard Confessional) at the merch table
at MACROCK. James Madison University.
Photo by Michael Dubin.
Harrisonburg, VA, 2001

BOTTOM LEFT:
Adam Lazarra (Taking Back
Sunday) backstage at Galaxy,
on tour with Rival Schools.
Photo by Michael Dubin.
St. Louis, MO, 2002

BOTTOM RIGHT:
Kevin Kusatsu and David
Soloway (Saves the Day).
Photo by Amy Fleisher Madden.
A hotel room somewhere
in America, 1999

TOP ROW LEFT:
Friends at The Format show
at Nita's Hideaway.
Photo by Stephen Chevalier.
Tempe, AZ. 2004.

TOP ROW RIGHT:
Pete Parada on the floor
of an airport.
Photo by Kevin Kusatsu.
Somewhere in the world. 2001.

MIDDLE ROW:
Claire and Jeremy Weiss
of Day19 at The Standard Hotel.
Photos by RJ Shaughnessy.
Los Angeles, CA. 2002.

BOTTOM ROW:
Travis Shettel (Piebald), Chris Conley (Saves the
Day), and Matt Galle at The House of Blues.
Photo by Day19.
Orlando, FL. 2002.

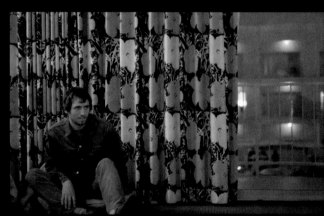
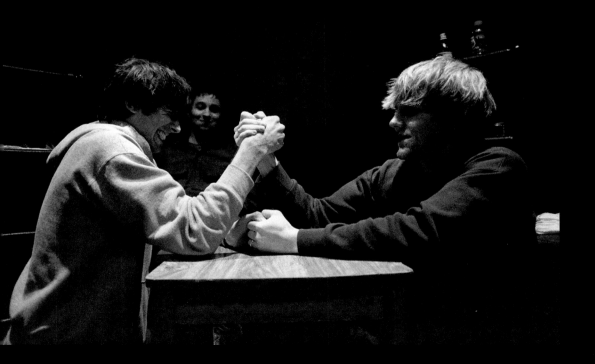

Photo by Maddy Traeger.
Somewhere in Florida. 1999.

Eben D'Amico (Saves the Day) being carried from the bus to the stage by two fans.

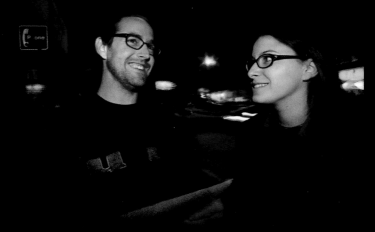

Isac Walter (a supreme archivist) and Amy Fleisher Madden outside of The El Rey.

Kevin Kusatsu at The House of Blues.

Josh Berwanger (The Anniversary) and Matt Skiba (Alkaline Trio) with Jimmy Perlman in the background.

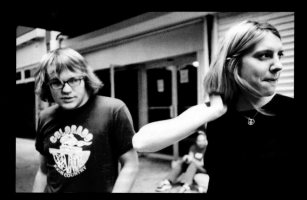

Rob Pope (The Get Up Kids) and Adrianne Verhoeven (The Anniversary) on the road.

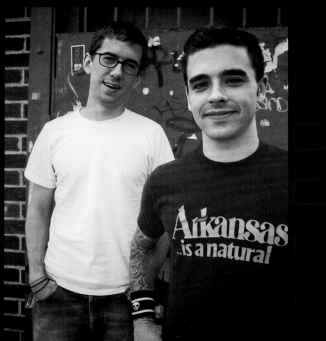

Photos by Kevin Kusatsu.
c. 2001.

Mike Poorman (Hot Rod Circuit) and Chris Carrabba (Dashboard Confessional).

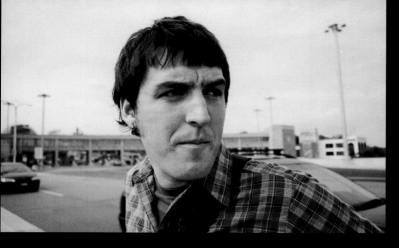

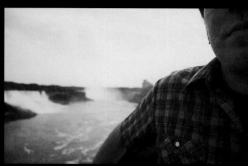

The many faces of Michael Dubin at Niagara Falls, NY.

By the time I moved back to New York after a three-year stint in Oakland in 2004, the gap between what we now call second and third wave emo had become *truly* pronounced. Texas Is the Reason—the band whose name will be seemingly affixed to mine forever—had only disbanded seven years earlier, but it was already clear that a curious mystique around who we were had developed in the interim. The reason for this is obvious now: Our entire two-and-a-half-year existence completely predated the social internet. Which is to say that if you wanted to be a Texas Is the Reason fan in 2004, your primary source of research wasn't going to be Google, YouTube, or Wikipedia. It was going to be the physical records we released, whatever blurry (and often black-and-white) band photos we used for album artwork or press, the few dozen interviews we did for out-of-print fanzines, or maybe, if you were lucky, a fuzzy VHS concert tape transferred to DVD. We had no choice but to be "enigmatic."

Of course, we, as humans, almost instinctively *hate* ambiguity. And our steadfast refusal to live with ambiguity, to truly accept it, more often than not compels us to fill in the blanks, to make up our own stories, to draw our own pictures. Some of these pictures may be "true enough." But many of the ideas we generate in the pursuit and creation of "knowing" often contain significant details that derive from the shared assumptions of a frequently centered majority. They reflect our stubborn insistence that the things we feel most connected with somehow *must* resemble a dominant, and therefore, familiar image.

So I bring up 2004 because of the time I met a younger Texas Is the Reason fan through some mutual friends during that cross-country move. And I bring up the "mystique around who we were" because that random introduction actually marked the first time I'd ever considered that younger fans

of the band during that time might have no idea what we looked like. And I mention "the shared assumptions of a frequently centered majority" because a few days after that meeting, I was directed to this younger fan's LiveJournal, where, after writing up an otherwise pleasant recap of our lunch, the young man concluded, apropos of literally nothing: "I never knew Norm wasn't Caucasian. It was kind of a shock."

"*Quick*—close your eyes and tell me about the first person you see when you imagine a 'punk.' Are they Black? Queer? Female? Gender-nonconforming?"

Before you judge, *quick*—close your eyes and tell me about the first person you see when you imagine a "punk." Are they Black? Queer? Female? Gender-nonconforming? Or are they white, male, and cisgender? Don't feel bad. We all know how this exercise typically ends.

Which is why I can truly say I was not at all mad when I read my new friend's LiveJournal entry. If anything, those two sentences, which had been composed with such matter-of-fact clarity, were something of an awakening to me. They showed me how seemingly innocuous (and yet ever-insidious) our assumptions of whiteness can be. Despite having played in hardcore bands for over ten years by that point, I was really only just beginning to wrestle with my life as a musician who is also a queer person of color, struggling to define myself outside of whiteness. And maybe for the first time, it occurred to me that in my misguided need to fulfill the more socially noble role of being "a musician who just happens to be gay and Latino"—as opposed to

being a proud gay and Latino musician—*I was actively playing a part in my own erasure*. Without knowing it, my new friend had simply highlighted a fact about the way in which unchecked assumptions often go on to become indelible parts of our cultural memory—and how that same cultural memory, once established, is then paradoxically deployed as "proof" for those earlier unchecked assumptions. How else could my brown skin be "a shock" to anyone if not for a completely whitewashed conception of what emo (or hardcore, for that matter) looks like? Knowing this has changed literally everything about the way I navigate my identity in the public sphere.

But that was then and this is now, right? Surely the modern power of Google has eased our ambiguity blues!

"And if you believe most of the documented histories that trace emo's origins back to 1985, when the punk scene in Washington, DC, declared a 'Revolution Summer,' then why don't we ever talk about Amy Pickering from Fire Party?"

I want to tell you that so much has changed, and if it weren't for a Buzzfeed headline from June of 2020—published a full sixteen years after that LiveJournal entry—maybe I could. Because when I read "Pete Wentz Is Trending on Twitter Because Many People Are Just Finding Out He's Biracial," my past suddenly became prologue.

It was kind of a shock.

Whatever rationale I used to dismiss the general lack of knowledge about Texas Is the Reason in 2004 simply did not apply to Fall Out Boy in 2020. By then, we had already lived with fifteen years of Pete Wentz's face being plastered all over print and digital media. His band had been packing arenas and stadiums all over the world. Their music videos were ever-reliable multimillion streamers for YouTube. In fact, Fall Out Boy's undying success is perhaps one of the reasons why a book like the one you are holding is able to exist. And yet our assumptions of whiteness are still so embedded in the cultural psyche that, when it came to Wentz's experience as a biracial man, we saw people *actually refusing to believe their own eyes and ears*. The idea of punk and emo as a white-dominant space had become so entrenched in our imaginations that a simple confirmation of one man's Blackness was enough to send Twitter into a frenzy.

I get it, Pete.

That's why, when I was asked to write something for this book, I knew almost right away that I would have to make a point about emo that most visual histories documenting this scene—and the wider punk and hardcore communities that came before it—have failed to properly capture from a collection of images alone. Because while a majority of the most popular and recognizable voices in emo and post-hardcore do in fact belong to straight, cisgender, white men, there is and always has been a plurality of invaluable contributions to this scene from women, BIPOC, and LGBTQ+ folks. And far too often, many of these sometimes groundbreaking pioneers have been unfairly sidelined, if not redacted from the historical record.

When it comes to emo's origin story, for example, there are valid questions we need to be asking. For one thing, could emo have even been called

into existence without the arrival of Zen Arcade by Hüsker Dü—the '80s melodic punk trio whose Bob Mould and Grant Hart are both queer men? And if you believe most of the documented histories that trace emo's origins back to 1985, when the punk scene in Washington, DC, declared a "Revolution Summer," then why don't we ever talk about Amy Pickering from Fire Party, the woman who literally coined that phrase and, by all accounts, worked tirelessly to galvanize that summer into being? Also, why do we seem to gloss over the fact that the entire first wave of emo that came forth from Revolution Summer was decidedly multiracial? Its extremely influential ranks included Fire Party's Nicky Thomas, Kenny Inouye from Marginal Man, Scream's Skeeter Thompson, and Shawn Brown of Dag Nasty (and later, Swiz), to name a few.

Of course, the work did not end there. Emo's second and third waves, which make up the substance of the book you are holding—and whose alumni include both Pete Wentz and myself—continued to give rise to an abundance of female, BIPOC, and LGBTQ+ talent. Queer and trans musicians like Jason Gnewikow of The Promise Ring, Kaia Fischer of Rainer Maria, Steve Pedulla of Thursday, Vanessa Downing of Junction and Samuel, Pete Moffett of Burning Airlines, and the late Sarah Kirsch of Fuel and Torches to Rome have all played significant roles in defining the genre. BIPOC artists—including the majority of At the Drive-In, Victor Villarreal from Cap'n Jazz, Teppei Teranishi of Thrice, Jeremy

Gomez of Mineral, The Van Pelt's Toko Yasuda, Coheed and Cambria's Claudio Sanchez, Taking Back Sunday's Eddie Reyes, and Longineu "LP" Parsons III from Yellowcard, among others—have all stitched a diverse range of experience into the fabric of what eventually became emo's break-through into the mainstream. And the singular contributions from so many women of these eras simply cannot be overlooked—including celebrated artists like Caithlin De Marrais from Rainer Maria, Kim Coletta from Jawbox, Elizabeth Elmore of Sarge, Jejune's Araby Harrison, Tracy Wilson of Dahlia Seed, Pohgoh's Susie Richardson, Hayley Williams of Paramore, The Anniversary's Adrianne Verhoeven, and Shift's Samantha Maloney (who actually went on to play drums for both Hole *and* Mötley Crüe). I am not even scratching the surface here.

No one book can do everything. But in using this space to share my story here—and in turn, telling *our* story to the best extent that my time and memory will allow—I hope not so much to "correct" the public record as I do to make sure that the existing record is more vivid, more rich, more complete, and ultimately, *more true*. Every time emo is reduced to the trope of "the sad white boy crying over a girl," countless scores of us are not only pushed to the margins, but quite literally pushed off the page. To write these words here and now is to make sure those assumptions no longer go unchecked. It is to say, *We are here. We have always been here. We will always be here.*

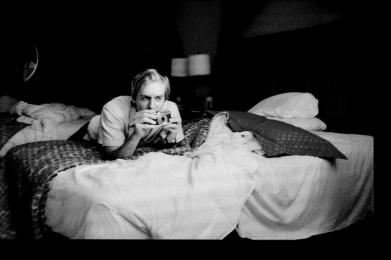

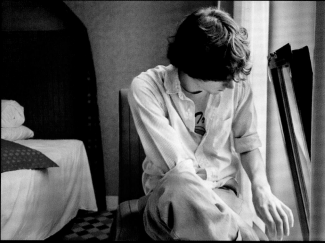

Andrew Paynter shooting
David Soloway (Saves the Day).
Photos by Kevin Kusatsu.
c. 2001.

Hot Rod Circuit and friend Scott
Nagelburg.
Photos by Amy Fleisher Madden.
Miami, FL, c. 2000

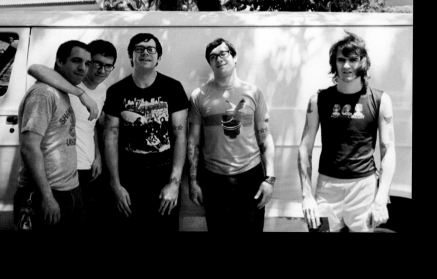

"These photos were taken in the driveway of my parents'
house. I remember Casey spent most of the morning
talking to my dad about jazz, and that night Jay and I
walked my dog around my childhood neighborhood
and talked about how we don't want to go home."

—Amy Fleisher Madden

ABOVE:
Texas Is the Reason
at Disneyland.
Photo by Steven Wade.
Anaheim, CA. 1995.

BELOW:
Chamberlain at CBGB.
Photo by Matthew Reece.
New York, NY. 1995.

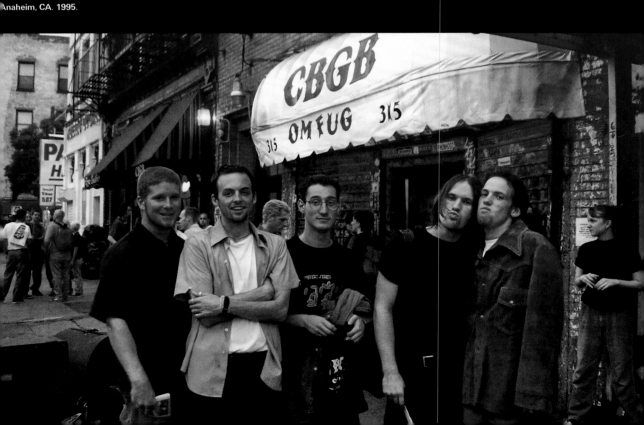

"This was one of the first tours I ever went on in 1998. It was with a band on my label called The Grey A.M., and we won tour bingo in every way. The van constantly broke down, we'd show up to shows that didn't exist, and right before the end of the tour, the singer quit the band. BINGO."

—Amy Fleisher Madden

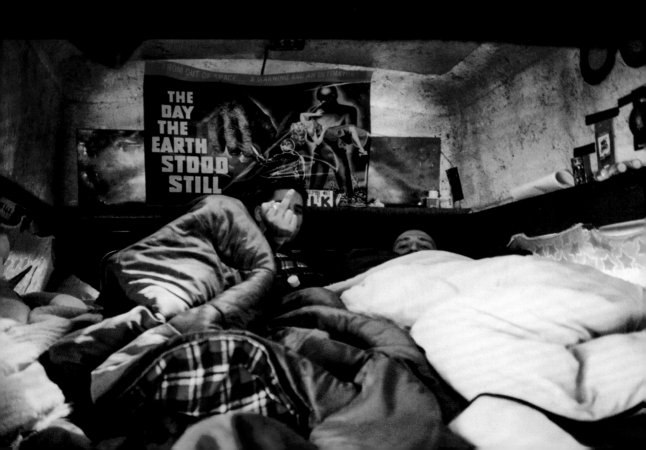

"I met this band through my friend
Justin Owen, and they were kind
enough to give me a ride to MACROCK
in 2001. The band's name escapes me,
but this might have been the first roll
of film that I shot 'on purpose,' and
although they're blurry, these are some
of my favorite images to this day."

—Amy Fleisher Madden

Gerard Way (My Chemical Romance) on a late-night grocery store bus run. Photo by Justin Borucki. Somewhere on the West Coast. 2004.

Andrew McMahon

Something Corporate / Jack's Mannequin / Andrew McMahon in the Wilderness

When I think back to the beginning of the ride, my life in music, the first thing I see is road cases piled high on a strip mall sidewalk. Future friends and label mates smoke cigarettes and pull at the waistbands of loose-fitting jeans. My skin smells of dried sweat, the aftermath of a hard-fought performance in a room with no ventilation. I scan faces in the parking lot melee, but I recognize very few. Every inch of this terrain is foreign to me, but I cannot shake the feeling I've come home.

It is a scene that will play out hundreds of times over the next few years, but that night was our initiation. My bandmates and I, pushing cases through a crowd of teenagers in the know. A secret society milling below the blue awning of a dive. There were years of songs and shows before that night, but all our hard work and luck had delivered us to that moment. We would follow that humble circus onto bigger stages in the coming years, but it would continue to look and feel very much like it did in that parking lot in the summer of 2001. I had assumed that the signing of my first record contract would feel more like a coronation than a tailgate party, but I'm glad now that it didn't.

Something Corporate was a garage band. Five high school friends who started out playing house parties and cafeteria lunch hours. By graduation, we were filling clubs in and around our hometown of Orange County, California, but most of our early success was forged despite the thriving local punk scene. It's not that we didn't relate to those bands— we just never imagined their fans would relate to us. But all that would change with the stroke of a pen. After years of hustling and rejection by the majors, we were offered a contract by a punk label and signed it despite our confusion. I was a West Coast transplant raised on Billy Joel who in the months prior had taken an ex to see New Found Glory and Face to Face. It was the first punk show I had been

to in years, and I left it certain of one thing: That audience would eat my band alive. For a time, this would prove true, but ultimately, what I came to understand is that a scene is malleable and what gets smuggled in at the fringes can shape its trajectory.

So we set sail from that first parking lot and never looked back. In our whirlwind first year, we traversed the country twice, recorded and released two records, and heard our music play on the radio stations we listened to as kids. I still marvel at the pace of our ascent, but we were not the exception to the rule. Countless acts we came to think of as friends were climbing charts and packing venues in what we now recall as a movement. There was no time to think of it that way back then. We were traveling so fast that all we could do was play, pack, and move on to the next town. We shared bills with punk and hardcore acts and watched audiences mosh to our downtempo love songs. None of it made sense to me at the time, but it didn't make it any less thrilling.

"We set sail from that first parking lot and never looked back."

I understand now why they called it a scene, but any desire to sand down its edges into something cohesive runs counter to the magic that made those days possible: a subculture of kids willing to embrace so many disparate styles at once. The ensuing collision of sound, fashion, and suburban angst made it possible for bands like mine to share stages with bands like Finch and New Found Glory without anyone thinking it was insane. When the dust eventually settled, that mighty crowd had conjured a generation of teen heroes who looked nothing like the ones I grew up with. Considering the media

landscape of the time, this was an accomplishment, to say the least.

When I think back on the legacy of Something Corporate, it's hard not to consider the strange and unintentional role we played in shaping the scene that adopted us. If anything, we were proof that a new generation of teenagers who identified as "punk rock" were, in fact, just kids looking for someplace to fit in. I could relate to that. Long before we arrived, punk as a genre had drifted from its roots, and we unwittingly ended up a part of that conversation. There was pushback from establishment bands and fans, and I honestly can't blame them, but Something Corporate and bands like ours were a trojan horse. Once delivered, we reflected a willingness of the Warped Tour culture to embrace a sound completely stripped of aggression. I always bristled when Something Corporate was referred to as a punk band. Not out of pretention but out of respect for what I knew of punk's origins. In the end though, how people saw us was out of our control. Whatever identity crises the genre was going through and whatever part we played in adding to the confusion, those crowds gave us their sweat and sometimes their blood, and my band and I gave ours in return.

What I took from those years I still hold close today. The ethos of van life and sleeping five to a hotel room. The post-show load outs and autograph signings that ended when the last fan went home. Memories of record release parties, gratitude for tour buses, and the sense of wonder I felt as I traveled the world for the very first time. Those days were a meritocracy of sorts. We were schooled by headliners and their road crews. Then we passed down what we had learned to the next band in line as we climbed the ladder rung by rung. We worked 365 days a year because we loved it and because we didn't know that there was any other way. That's how the scene operated. If you weren't touring, you were writing and making records. What else were you going to do? We never reached the mountaintop like so many of our peers, but it didn't really matter. The beauty of that time was that we were all rooting for each other. We watched our friends conquer *TRL* in an era of boy bands and Limp Bizkit, and in a way it felt like we were up there with them. The underdogs getting their due.

Reflecting on my bizarre career and the scene that launched it, I feel many things, but mostly I feel thankful. I've been an outsider my whole life, and even when I've found myself on the inside, I've failed to notice until it was too late. I can see now that I was a part of something. It's taken years to unravel it, but I understand why Something Corporate and so many of our friends found their way into the zeitgeist. We were kids with microphones, a carnival of traveling misfits, most of whom felt they never truly belonged. We saw each other, and those who listened to our songs saw something of themselves in us. Those days may not have delivered the next Radiohead to the masses, but for those of us who were there and those who chose to listen, it delivered something more profound: a sense of community. For many, it was the community they longed for their entire lives. In my case, it's one I didn't fully appreciate until the time had come and gone. I have been fortunate that many of the kids who waited in line to see Something Corporate all those years ago are still waiting in line at my shows today— many of them with kids of their own. They have seen me through my clumsy coming of age, cancer, and multiple name changes. And while so much is different now, one thing remains the same: We forged a bond in the sweat-drenched rooms of our youth.

"This image of PJ was taken on the day of the *Through Being Cool* photo shoot. Looking back on that day, we were all so young. I think the average age was around nineteen. None of us realized that this album was going to become legendary. It was just a group of friends (and friends of friends) coming together to make something fun. To be honest, I think it was the first time most of us had ever been a part of a photo shoot."

—Taryn Hickey

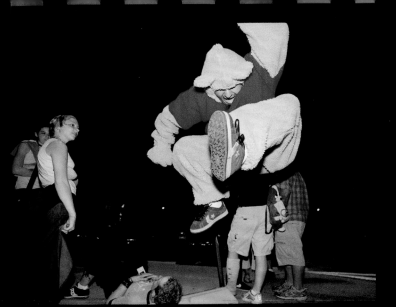

LEFT / ABOVE:
Ian Grushka (New Found Glory)
dressed as Pooh and Steven
Looker eating candy.
Photos by RJ Shaughnessy.
Somewhere in America. c. 1998.

BELOW:
Adam Lazzara (Taking Back
Sunday), Frank Iero, and Gerard
Way (My Chemical Romance).
Warped Tour.
Photo by Justin Borucki.
Sacramento, CA. 2004.

Anthony Green (Saosin).
Shaughnessy's bedroom.
Photo by RJ Shaughnessy.
Atwater Village, Los Angeles, CA.
2003.

"I brought Saosin over to RJ's house in
Atwater to take some photos. They
drove up from Newport, and I don't
even know if the band had a name yet
at this point."

—Amy Fleisher Madden

BELOW:
Justin Roelofs and Josh
Berwanger (The Anniversary)
in the van, on tour.
Photo by Kevin Kusatsu.
Somewhere in America. c. 2001.

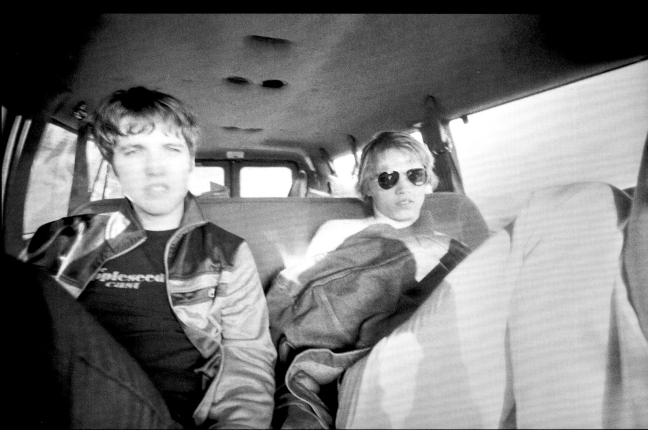

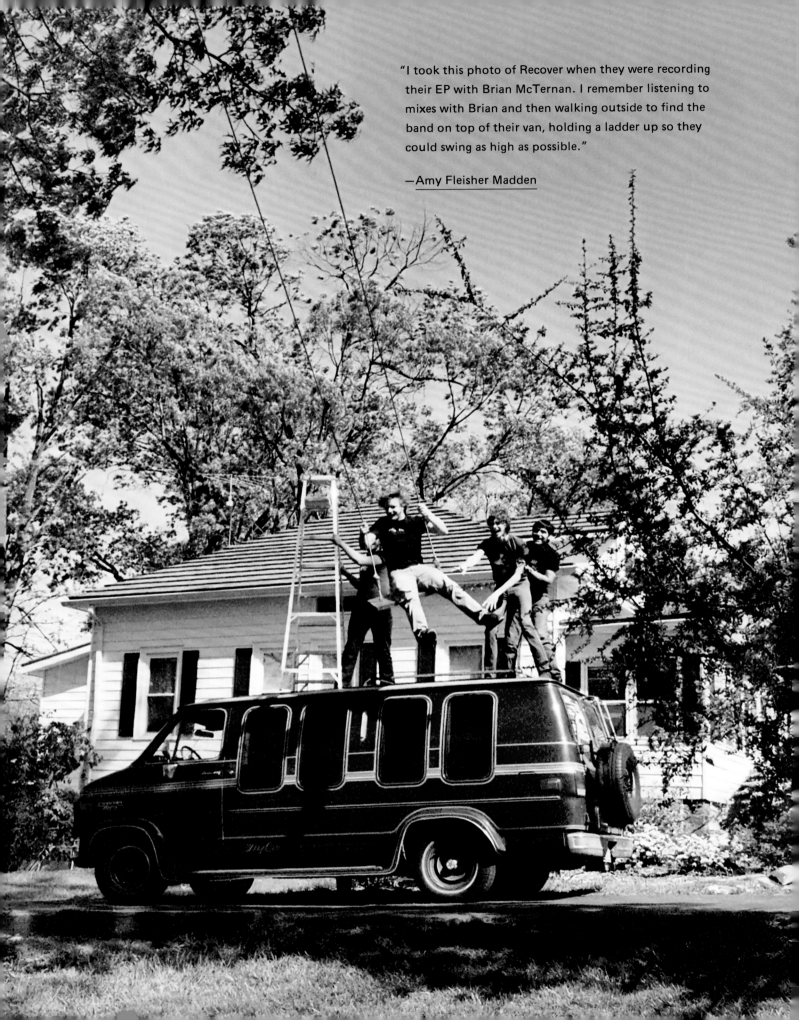

"I took this photo of Recover when they were recording their EP with Brian McTernan. I remember listening to mixes with Brian and then walking outside to find the band on top of their van, holding a ladder up so they could swing as high as possible."

—Amy Fleisher Madden

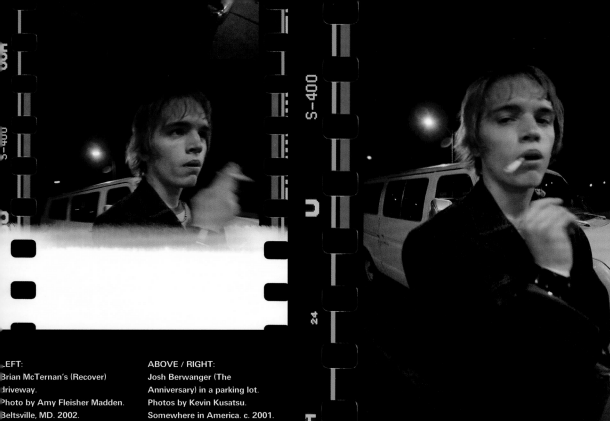

LEFT:
Brian McTernan's (Recover)
driveway.
Photo by Amy Fleisher Madden.
Beltsville, MD. 2002.

ABOVE / RIGHT:
Josh Berwanger (The
Anniversary) in a parking lot.
Photos by Kevin Kusatsu.
Somewhere in America. c. 2001.

BELOW:
Curtis Mead (Chamberlain) and
James Marinelli (Samuel).
Photo by Curtis Mead.
Somewhere in Vermont. c. 1996.

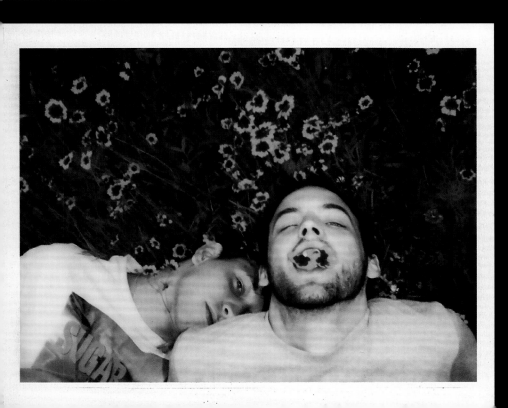

listen, I like to keep track of things. As a little kid, I'd line up and catalog my matchbox cars, then around five or six, I'd keep track of the Top 40 every week. Around eight or nine, I started making my own Top 40 and tracking that. Records, then cassettes, then CDs, then records again were all in meticulous order. So it's no surprise . . .

From 1996 to 2004, I kept track of everything. Every show I played, every movie I watched, every ticket stub, flyer, or set list I could save. I had a journal I wrote in every day. Eventually a blog where I counted down my favorite songs of all time. I took over six hundred Polaroids. I took photos of the crowd at every show in 1997 and on our first Europe tour with The Get Up Kids in 1998. It was like I knew something special was happening, and I didn't want to ever forget it. Come to think about it, *that* was probably the most "emo" aspect of that time. Not really the music or the lyrics, but literally everything else. The community, the photos, the stories, the collaboration—that whole time. In the liner notes of Braid's first record, we wrote, "We want to be on your comp." That's decidedly emo.

I mean, Hey Mercedes did a mix CD exchange before one of our tours where we each made a mix—if you sent us four copies of a mix that we could listen to on tour, we sent you our four individual mixes. There are songs I love to this day that distinctly came straight from those mixes. That's some good collaboration.

And it felt like we were part of a movement. One that was sometimes in danger of teetering on excessive. On those first Braid tours, we were giving ourselves five dollars each per diem. We slept on floors, in parks, in squats. Fast-forward to the Vagrant America Tour where you lined up every week at the our manager's bus and he gave you and all your friends 140 dollars. Every week! And for what?!

we already got food and drinks at every show. That a bunk. On a bus. With a little reading light. I never had to be shaken awake to drive. And all the while my rent at home was either zero or something manageable because I had roommates. It was ideal.

Hey Mercedes attempted to re-create that tour with a bus of our own, complete with an amazing illustration of a planet we named Planet Zebus. That tour was with Piebald and Koufax. You may have seen Joby Ford's luchador poster from that tour on *Friday Night Lights*. That poster and almost bowling a 300 in Boise are two of the things I remember most from that tour. It just wasn't the same. We lost a lot of money. Then we put out an ironically named record that might eventually get reissued if enough teeth can be extracted. And we went on oddball tours with oddball energy. Wheat, for example, was not interested in being shot at with bottle rockets the way Moneen was. Makes you look in the mirror and think, "Huh, maybe I'm a little old for that now."

Then in 2004, Braid did a reunion tour, and by the end of it, we were fighting again. I recall one particularly bad flare-up after a rough show in Oklahoma City. After that, we barely spoke to each other for six years. I got a job and started doing solo tours. And for a little while, I stopped keeping track of every little thing.

I mean, maybe one day I'll go through all the journals and photos, but I kind of don't have to. It's nice to know they are there if I really want to get into the dirty details, but I'd rather just remember it as the perfect time before everything got so complicated.

xxoo
Bob Nanna

Backstage at the Trocadero.
Photos by Taryn Hickey.
Philadelphia, PA. 2000.

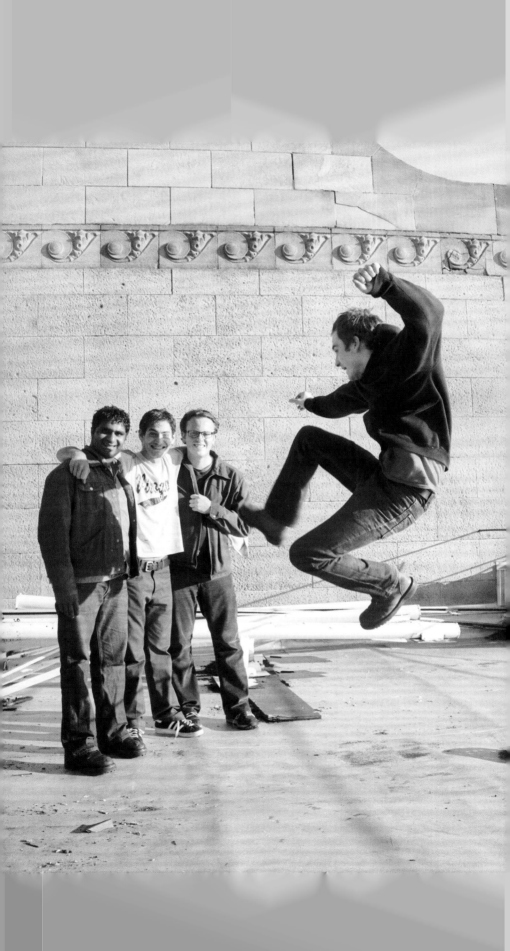

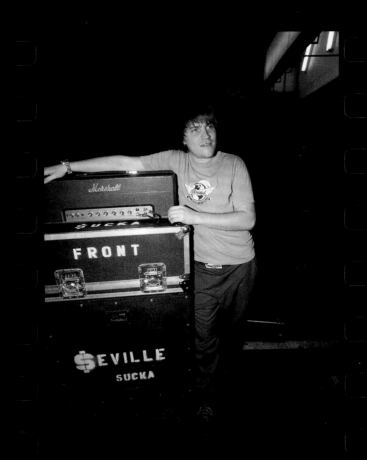

Chris Drueke (Seville).

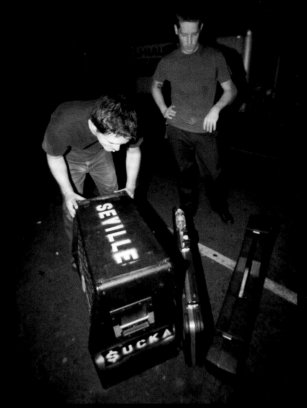

John Owens and Dan Bonebrake (Seville).

Heath Saraceno (Midtown) and Jessi Frick (Fiddler Records).

Seville show at Chain Reaction.
Photos by RJ Shaughnessy.
Anaheim, CA. 2001.

"When I die, if I'm lucky I'll get a carousel of images displayed in my mind before the lights fully go out. I know this will be one of those images. I took this photo of Bryan Newman [Saves the Day] in the Badlands. We stopped there on the way home from tour at the perfect moment when the sun was going down."

—Amy Fleisher Madden

Photo by Amy Fleisher Madden.
The Badlands National Park.
The Badlands, SD. 1999.

Let's all take a step back. How did we get here? Set your timer to an hour, and let the therapy begin.

For me it was moving. Constantly moving. Not even metaphorically . . . but literally. I come from a divorced family. Airplanes, car rides, different houses, different schools, getting kicked out of the house at a young age, having to find my way living on my own at seventeen, living in a car, living in a trailer park, living in an apartment while sharing a bedroom with another adult. Just keep moving, just keep moving, just keep moving . . . or else it will all stop. Many of my friends succumbed to that fate. When you stop, you don't exist. Again, this is not metaphorical. There's been a lot of sadness in my life. If you're reading this, there probably has been in your life too. Just keep moving.

I remember a time when I lived in Kingman, Arizona. Never heard of it? Yeah, most people haven't. This was during the glory days as a freshman in high school. Man, those were the best. Wait, no . . . they sucked. I can still remember the feeling of being breathless while getting punched in the gut by some asshole with perfect hair and feeling the padlock on the locker behind me bruise my spine. There's a silver lining to this story, though. This was when I found real friendship. There was a distinct separation at Kingman High. It was like a John Hughes movie. Literally. Jocks, hicks, preps, and punks. No shades in between. Just stark contrasts. I was punk, or so I thought. I couldn't catch a football, I didn't like country music, and I wasn't going to be caught dead in a button-up shirt. Speeding down the sidewalk on my skateboard, with the sides of my head shaved to look like Tony Hawk, I was mesmerized by the *click clack* of my wheels hovering over the cracks. This was my meditation . . . the metronome of my daily soundtrack. The slick, waxed curb behind Dairy Queen was where we kept court. There was

something special about having a home base where we felt comfortable, because we didn't feel comfortable in our actual homes. There were always friends there who had my back with no judgment. We learned from the older kids, and we sheltered the younger kids. This is what has truly been a staple in all the punk and emo scenes I've been involved with over the years. We take care of each other like the families we wished we had.

"This is what has truly been a staple in all the punk and emo scenes I've been involved with over the years. We take care of each other like the families we wished we had."

This was when I used music as medication. I would record the soundtracks to Powell-Peralta and H-Street skateboarding videos onto a cassette tape and learn about punk rock. The lyrics "I ain't no goddamn son of a bitch / You better think about it baby" would blare from my headphones, and I would surely be grounded by my stepfather if he heard that blasphemy. This was the beginning of everything. I was figuring it all out in a world I felt out of place in. Then I got kicked out of the house and found myself on a plane to Los Angeles to meet a father who had never actually been a father. Thrust into Lake Balboa. Little fish in a big pond.

The Cobalt Cafe was a sanctuary. It was a little coffeehouse in the Valley of Los Angeles that had a small stage for bands to play. My high school band, Plain, played there a bunch, and I felt like a real star. All twenty people who watched would agree . . . maybe.

This is the true beginning... band called Jimmy Eat World played this little-known coffeehouse, and it was the beginning of my emo journey. This was before their 1996 album *Static Prevails*. They honestly sounded like a NOFX cover band, but their first album with Wooden Blue Records was full of fast drums, palm-muted guitars, and angst. There was something different though. Something pure. I met the guys, and we traded demo tapes and probably pager numbers.

I started interning at Capitol Records that year. My memory is fuzzy, but let's say 1994 . . . the year I dropped out of high school. I found myself listening to demos of *Static Prevails* with Capitol A&R representatives Loren Israel and Craig Aaronson, followed by trips to Kinkos on Sunset to print out hundreds of covers for *Static Prevails* sampler cassettes that were stuffed into envelopes and mailed out all over the world.

Throughout this journey, I became friends with Jimmy Eat World. House parties in Arizona, recording studios in Los Angeles, and hours spent making flyers for shows. This coalesced into going out with them on their *Static Prevails* record release tour. Just four dudes and myself in a van. Lots of sleeping on people's floors and waking up sweaty at campgrounds on that tour. The glamour! To be honest, I'll cherish the memories and friendships I made for the rest of my life. Even if the Food Not Bombs houses were overrun with vermin so we slept with the sleeping bags zipped all the way over our heads. I didn't care—I was on top of the world, away from whatever conflicts I had left at home and surrounded by music every night. It was wonderful.

Somehow, though, this isn't my biggest memory of the emo scene. It was a catalyst though. There's a long-lost, ancient, forgotten gem from one of the early Jimmy Eat World shows, before *Static* was

board boxes were filled with 7" records of bands you had never heard of but were willing to spend two bucks to find out. Enter the ring, Cap'n Jazz.

I remember pulling the 7" out of the box. Hell, I can almost smell the dusty cloud that would emanate from those boxes. Cap'n Jazz . . . who the hell is this? Fast forward a few months later and I became infected with the out-of-tune instruments, the out-of-tune singing, and, for some reason, a French horn player who didn't know what a French horn was. I remember flying to St. Louis for the Fourth of July to visit my mom, and I somehow saw that Cap'n Jazz was playing a small venue called Bastille's. I probably saw a flyer pinned up at the local record store Vintage Vinyl, where I would search for more 7" records. I had to go. My mom dropped me off at the venue so early. Must have been noon, but I didn't care. I was going to sit on that sidewalk all day if it meant I got to see Cap'n Jazz. Then a van pulled up and a bunch of disheveled guys slowly emerged. Turned out Cap'n Jazz also got there early. We hung out for hours, talking about music and shooting fireworks off in the parking lot. For a kid who always felt out of place, I finally felt welcome here. That's the joy of music for me. When I can't express myself, I have someone more eloquent to do it for me. I just have to sing along.

I've heard some descriptions of Cap'n Jazz that compare their energy to Fugazi but with a fresh, boyish, and naive perspective. Their songs explore the sentimental energy of growing up and trying to find your place in the world, full of raw potential. This hits home for me, especially the naive and sentimental part. Growing up, I often felt so naive and emo music made me feel welcome, and for that, I will always feel sentimental for this genre.

Fast forward even further, and I somehow became all grown up, playing in a somewhat successful emo band called Motion City Soundtrack. I remember trudging through so much touring in 2002, as we were just starting to find our place in the world. Living in a van, sleeping on top of our equipment, and playing with so many great bands: Milemarker, Girls Against Boys, Fall Out Boy, The Starting Line, Desaparecidos, Rilo Kiley, Q and Not U, Rye Coalition, The All-American Rejects, and Fountains of Wayne. But there was one show I was looking forward to the most that year. We were opening for Jimmy Eat World in Michigan. My past and my present colliding at full volume. It was quite different than sitting in a van with Tom, Jim, Zach, and Rick. They rolled up in a tour bus. The good guys won. They made it. Now us guys in Motion City Soundtrack were the disheveled ones slowly emerging from our van, the way Cap'n Jazz had years before . . . naive and boyish.

I still feel naive and out of place, but now I get to express this from stage, grateful for every moment spent screaming my lungs out. I remember the same feeling when hearing Jim Adkins scream, "One, two, three, four!" every night when they played "Digits" live in 1996 before asking the crowd for a floor to sleep on and packing up the gear in the van, all sweaty, exhausted, and having the best time of our lives.

Ft. Lauderdale International Airport. 166
Photos by RJ Shaughnessy.
Ft. Lauderdale, FL. c. 1998.

THIS PAGE:
Jimmy Eat World in the woods.
Photos by RJ Shaughnessy.
San Diego, CA. c. 2003.

RIGHT:
Mike Poorman (Hot Rod Circuit)
giving us the finger.
Photo by Kevin Kusatsu.
Philadelphia, PA. c. 2001.

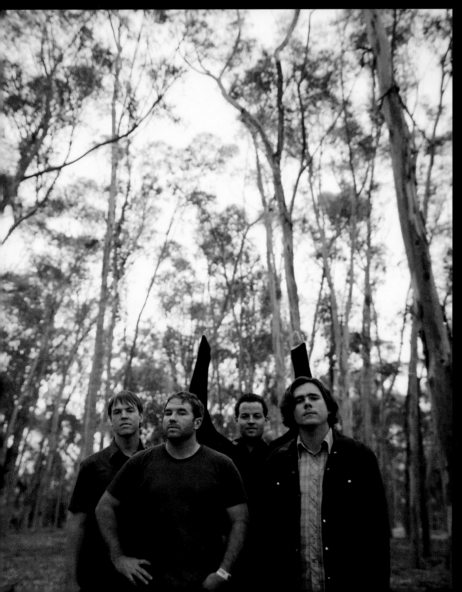

"This is one of those moments where I can remember the feelings, but not so much the facts about this shoot. I was running a magazine and I hired RJ to shoot Jimmy Eat World for the cover. We drove to San Diego to meet up with them on tour and convinced them to get in my car to go find someplace unexpected to shoot. RJ brought his Contax camera with him and let the band take pictures of each other while he shot them with a medium format Mamiya. So technically, the top two image photo credits are Jimmy Eat World."

—Amy Fleisher Madden

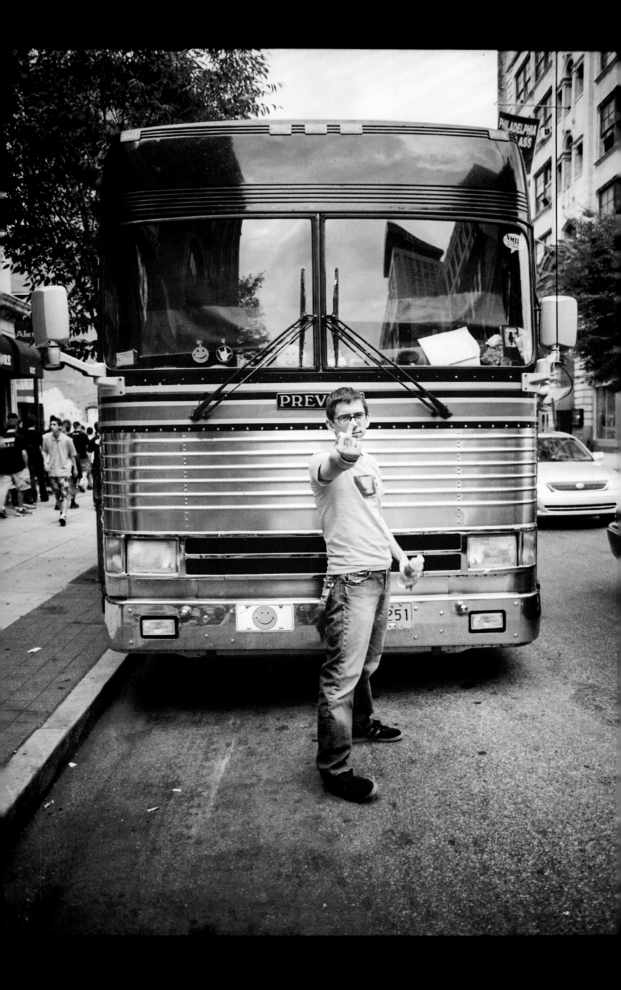

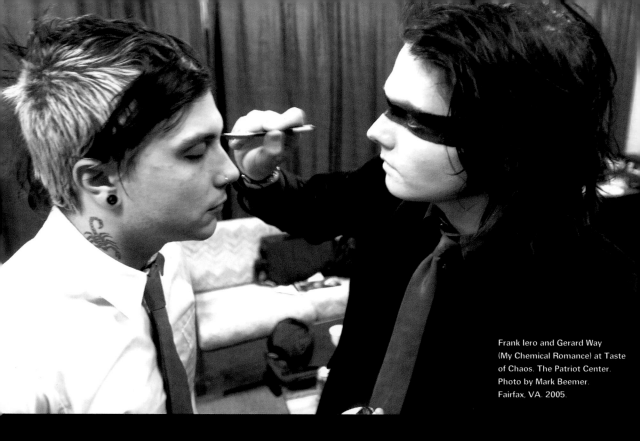

Frank Iero and Gerard Way
(My Chemical Romance) at Taste
of Chaos. The Patriot Center.
Photo by Mark Beemer.
Fairfax, VA. 2005.

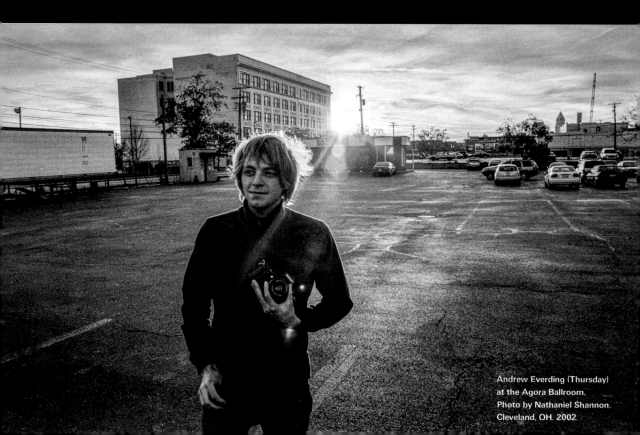

Andrew Everding (Thursday)
at the Agora Ballroom.
Photo by Nathaniel Shannon.
Cleveland, OH. 2002.

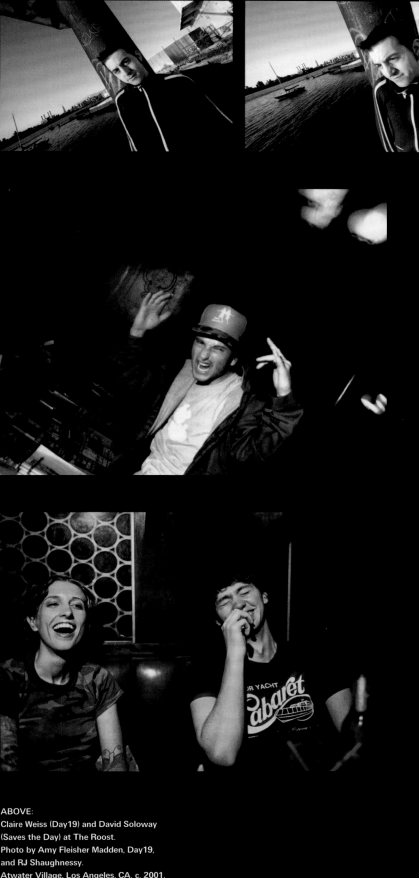

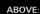

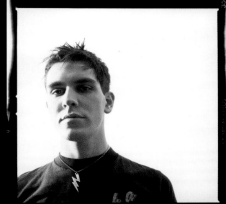

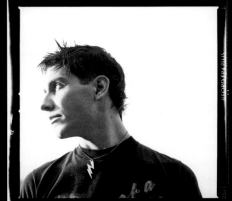

ABOVE:
Anthony Rayneri (Bayside).
The first Bayside photos. On the
border of Brooklyn and Queens.
Photos by Michael Dubin.
East Williamsburg, NY. 2000.

LEFT:
Sammy Siegler (Rival Schools)
at The Roxy.
Photo by Michael Dubin.
Los Angeles, CA. 2001.

BELOW:
Gabe Saporta (Midtown) on tour
with New Found Glory.
Photos by RJ Shaughnessy.
Somewhere in America. c. 2000.

ABOVE:
Claire Weiss (Day19) and David Soloway
(Saves the Day) at The Roost.
Photo by Amy Fleisher Madden, Day19,
and RJ Shaughnessy.
Atwater Village, Los Angeles, CA. c. 2001.

LEFT TOP:
Jordan Pundik (New Found
Glory) on a balcony.
Photos by RJ Shaughnessy.
Boston, MA. 1999.

LEFT BOTTOM:
On the way to MACROCK.
Photo by Amy Fleisher Madden.
Virginia. 2001.

BELOW:
Name Taken in front
of Shaughnessy's house.
Photo by RJ Shaughnessy.
Atwater Village, Los Angeles, CA.
2004.

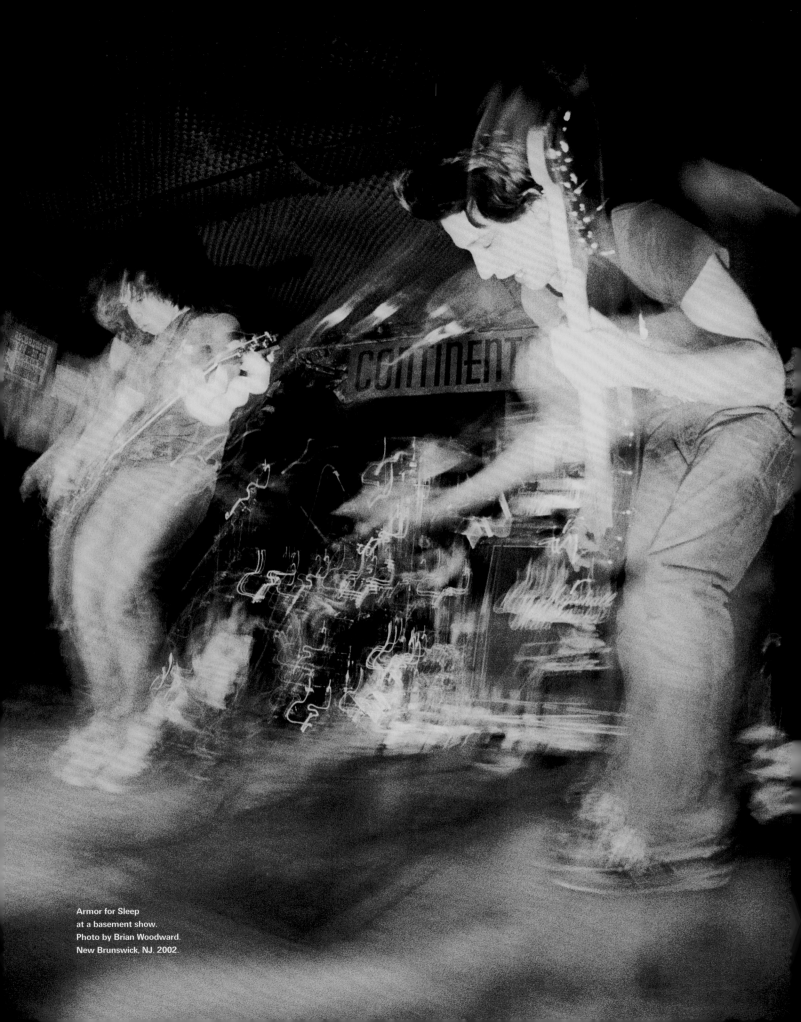

Armor for Sleep
at a basement show.
Photo by Brian Woodward.
New Brunswick, NJ. 2002.

Third Wave

An Introduction to the Third Wave

Geoff Rickly
Thursday / No Devotion /
United Nations

Everything is hardcore. Snapcase is hardcore. Obviously. Strife and Chain of Strength and Bad Brains are hardcore. Sick of It All is hardcore, and they're from New York, so they spell it NYHC. Shelter is hardcore and 108 is hardcore, and they're both Krishna, which means people call them Krishnacore. Earth Crisis and SSD are hardcore, but they don't do drugs; straight-edge hardcore. There are so many little signifiers in place to help people know what's up, but each one of these bands does actually have something in common: They are all hard as nails. They're hardcore.

It was the mid-'90s. I'd moved out of the dorms at Rutgers and into a house on Somerset Street with my old roommate, Clay, and my new housemate, Louis. We were a good twenty-minute walk from campus, but the house was weirdly small on the inside; it got bad light. But it had a big basement. Big enough to have shows in. Hardcore shows.

Luckily, by the mid-'90s, hardcore was everything, and everything was hardcore.

Converge was hardcore—full of guitars and drums that sounded like broken glass in a blender. But so was Rainer Maria, with twinkling clean guitars and dual vocals whispering and shouting in a joyous conversation. So were Ink & Dagger, in their corpse paint, smashing Aphex Twin electronics into Black Flag riffs. Fugazi was hardcore with a rhythm section that sounded like James Brown and a no-slam-dancing policy. Texas Is the Reason had twangy vocals and the most beautiful guitar parts that anyone had ever heard, and they were fucking hardcore—with the pedigree to prove it. They were one of the groups that inspired the latest wave of bands who were all playing shows in our basement, and in other basements like ours all over America: The Get Up Kids, The Promise Ring, Jimmy Eat World. They were all catchy and sweet, and full of youthful

innocence. And they were all hardcore, too. Everything was. The basement show was like an Olive Garden: If you were there, you were family—you were hardcore.

But holy shit, did we love to tease those bands— "You guys are so emotional, you're so fucking emo." Stick a tap in them and let the tears flow. That's all emo was to us: a taunt, a ribbing, a genre label that had never really stuck. I remember seeing Fugazi in the early '90s and someone yelled at Ian MacKaye, "You are so emo!" His reply was simple and seemed to shut down the label forever. He said, "Emo Philips?"—forcing the crowd to think of the awkward comedian, with his strange bob haircut.

"That's all emo was to us: a taunt, a ribbing, a genre label that had never really stuck."

So, years later, when we had a great young hardcore band from Princeton play in our basement, we shouted at them, "Oh my god, Saves the Day are so emo." Their singer, Chris, acknowledged it dryly: "Boo hoo." Or that time when At the Drive-In destroyed the Melody Bar in front of a crowd of five people. I told them, "That was so good, I could have cried . . . but I didn't want anyone to think I was emo."

We didn't know we were already part of it. A joke or not, we were already emo. When we started Thursday, we thought we were just another hardcore band in the wave of hardcore bands that we looked up to: Saetia, You and I, Usurp Synapse, Orchid, Reversal of Man, The Locust, Charles Bronson. Our friends. Our heroes. We were playing the same basements and VFW halls. We were buying the same vans and using the same dialers to get free calls on pay phones. We didn't know that, even as our own band took off, we were already emo, and we were about to be part of something new.

After *Full Collapse* came out on Victory Records—a very hardcore label—we spent a lot of time tracing the footsteps of all those who'd come before. We played to five or ten people a night, occasionally landing a festival where we'd do anything to get people to stick around. "Yeah, we have a three-way split with Joy Division and Swing Kids, but we're sold out of them right now . . . Still, we're playing after Dragbody if you've got the time to watch us."

Then Saves the Day offered us a spot opening for them on a national tour. Our friend Dan from the band Joshua explained to us that Saves the Day was the biggest band in hardcore. They'd hit the indie glass ceiling—they'd sold 100,000 records without being on a major label. We took the tour— first of four in front of 1,000 people every night— and something clicked. The very next tour we went out on, we were the headliner, and it was entirely sold out before we even left home. Something was happening. We broke through the 100,000 record glass ceiling, shooting to 400,000 records. All our friends were right behind us, in the next couple years, hitting a million records sold and more.

The press has always been a little tone deaf, and they'd already been using the term *emo* for years, so they tried to find something new and catchy for this rapidly developing phenomenon. They tried *screamo*, except not everyone was screaming—and the bands hated it. *Emocore*, except that term somehow sounded even wimpier than just emo—and the bands hated it. They even tried the term *xtremo*, and tried to line us up to play X Games–type events, with cans of Mountain Dew stacked on our amps, but the sponsors weren't sure about the crossover appeal—and the bands hated it.

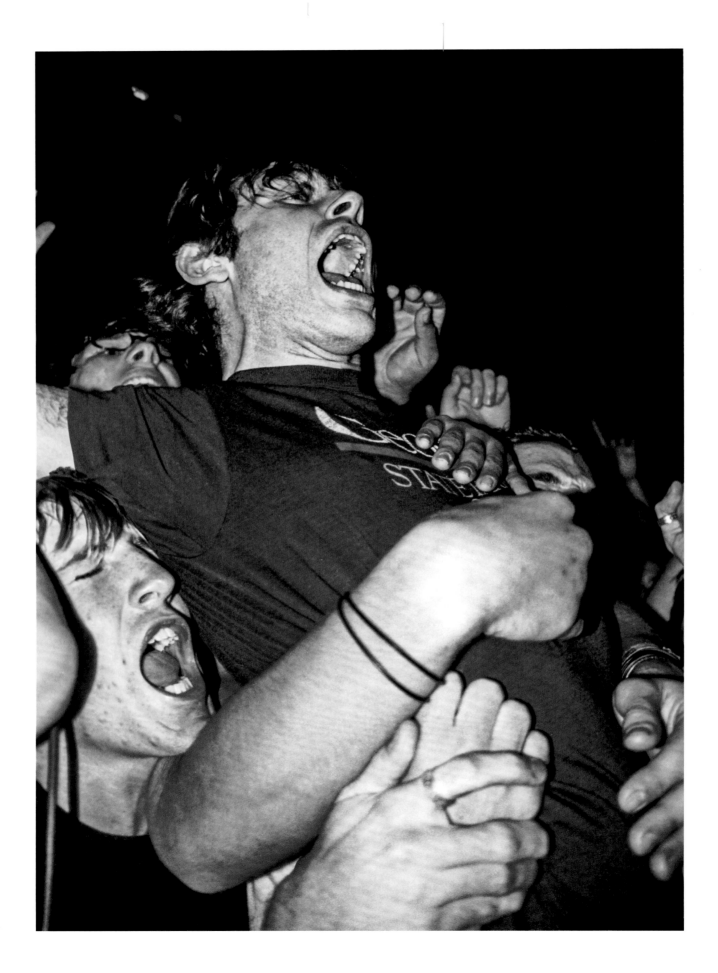

183

In the middle of all this, I had the chance to produce the first album from a scrappy bunch of hardcore kids who loved Placebo and Queen and comic books. They were called My Chemical Romance, and by their second record, they would solidify something that had been becoming apparent for the last couple of years: The 2000s were the decade of emo. It was everywhere. It was fashion and TV and billboards. It was celebrity. It was gossip.

"The press has always been a little tone deaf, and they'd already been using the term emo for years, so they tried to find something new and catchy for this rapidly developing phenomenon. They tried screamo, except not everyone was screaming— and the bands hated it."

And when money gets involved, things can quickly go to shit. Emo got increasingly commercial. It was codified. It was slick. It had songwriters and mega producers. It had A-listers directing music videos. The only thing it lacked was sincere emotion. The feeling was gone. A pretty tough break for a genre called emo.

By the 2010s, being emo was about the uncoolest thing in the world. The heavy hitters started breaking up. Not just the early torchbearers like us or our West Coast buds, Thrice, but the big guns, too. My Chemical Romance called it quits, and suddenly bands started dropping like flies. Pop singers dropped the emo haircuts. Things cooled off.

But then, half a decade later, something strange started to happen. The young kids began to go back to the roots of the genre, appreciating the earnest sincerity and adventurous musicality that made emo break out in the first place. The Hotelier, Teen Suicide, The World Is a Beautiful Place & I Am No Longer Afraid to Die, Joyce Manor, Hop Along— these bands brought emo out of the boardroom and back into the basement, bashing away at a glorious noise until the world started to notice. This "emo revival" was actually the birth of something new. It inspired Thursday to start playing again, and it inspired so many of our peers to do the same. We've gotten the opportunity to see this thing that we gave our hearts to through newer, purer eyes. Watching Pianos Become the Teeth and Title Fight and Touché Amoré burn with passionate intensity has reignited our fire. Seeing these photos, through Amy's eyes—seeing the vitality that has always been there—is much the same. It's changed everything, allowing us to restore a true relationship to our past work.

Recently, I had the opportunity to stand on stage with Thursday and watch a sea of kids scream along to these words from "War All The Time":

All those nights in the basement,
The kids are still screaming
On and on and on and on and . . .

And it was pretty hardcore—emotionally speaking.

Alkaline Trio

Est. 1996
Chicago, IL

—

Alkaline Trio, or "The Trio," is a gift from the darker side of emo. Rather than embracing the familiar vintage thrift store look, the band moved the needle toward gothic and horror punk—they were always in black, and named their albums grim things like *Good Mourning* and *From Here to Infirmary*. (And who could forget the resigned *Goddamnit?*) They were unafraid to showcase these dark vibes on their merch as well. I was stopped by an elderly woman in an airport once while wearing their old upside-down pentagram shirt. She told me that my shirt "evoked the spirit of the devil." My response was, "Oh god, I hope it works!"

If you're looking for the perfect third wave ballad, look no further than "Radio," which also happens to be my favorite tune from the band. The final track on 2000's *Maybe I'll Catch Fire* hits you so hard and so fast, that by the time the notey hook finishes and Matt Skiba brilliantly compares himself to a "dog shitting razorblades," you haven't had enough time to prepare for the emotional roller coaster you're about to embark on. It's the perfect single-sized serving of sadness, with its somber notes and simultaneously gritty and smooth-as-hell vocals. At the high point of the Vagrant Records era, Alkaline Trio's tour mates (Adrianne Verhoeven from The Anniversary, and Chad Gilbert and Jordan Pundik from New Found Glory to name a few) would come out on stage and belt the end of "Radio" in unison with Skiba. (Also, Hot Water Music did a split 7" with the band and covered the song.) Witnessing this moment live always supplied enough serotonin to keep me keeping on for the next good while.

RIGHT:
Photo by CJ Benninger.
The Fireside Bowl.
Chicago, IL. 2000.

OPPOSITE PAGE:
Photo by CJ Benninger.
Saint Andrew's Hall.
Detroit, MI. 2001.

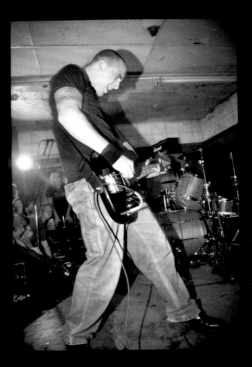

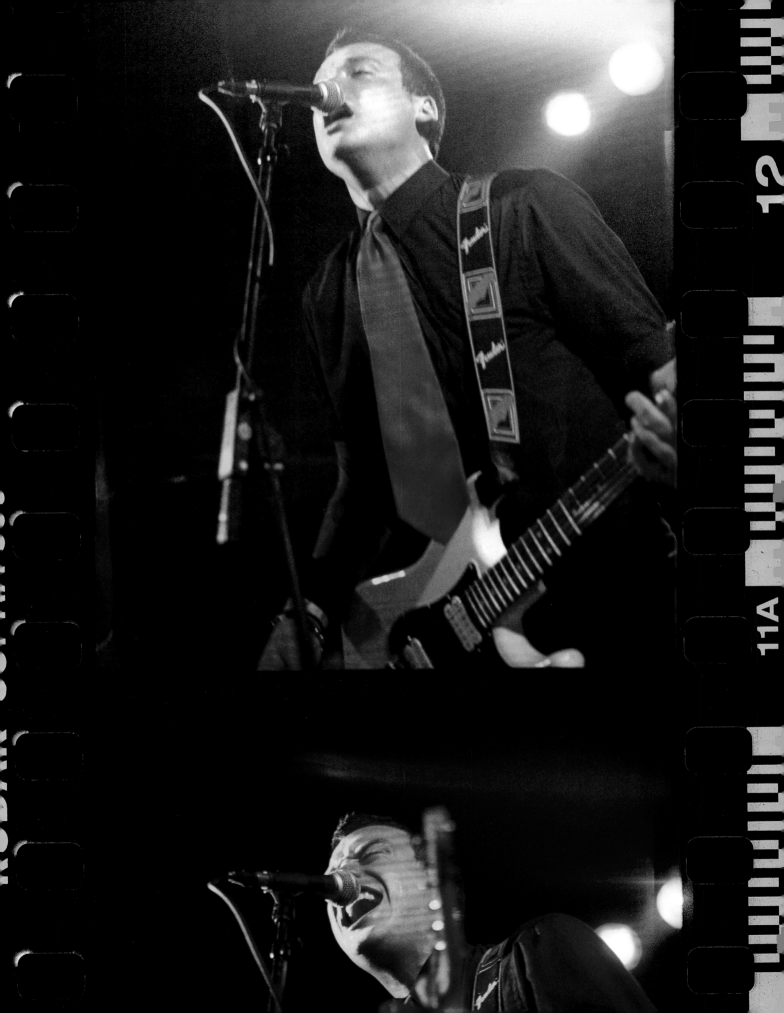

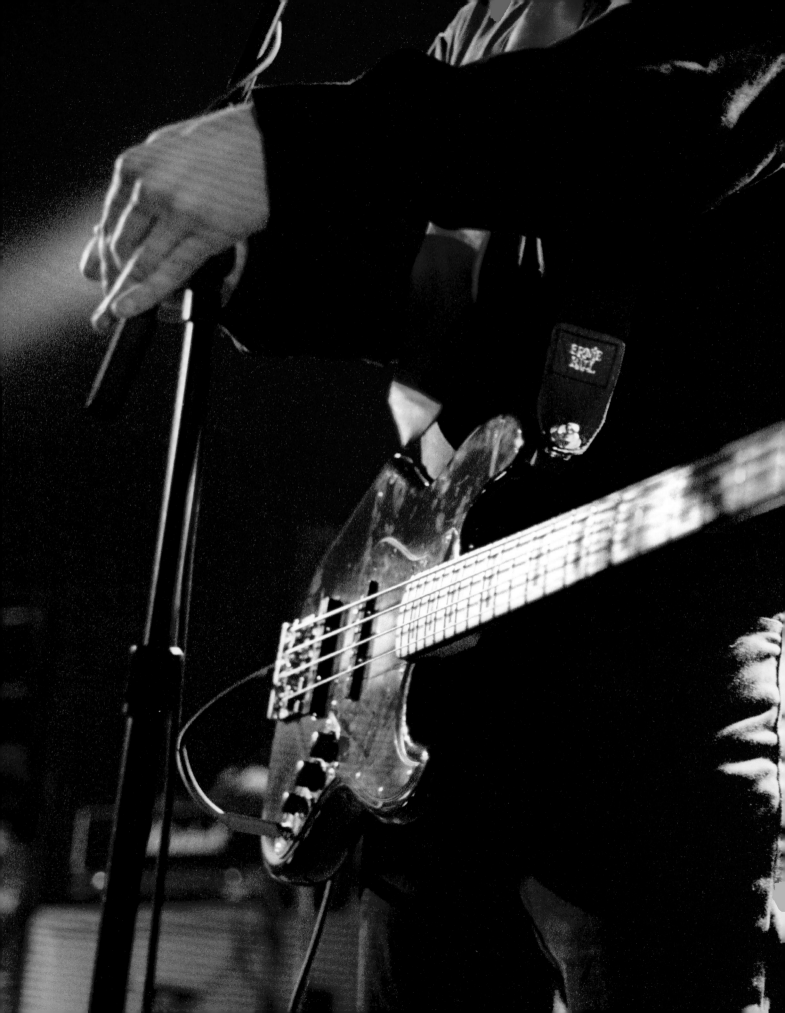

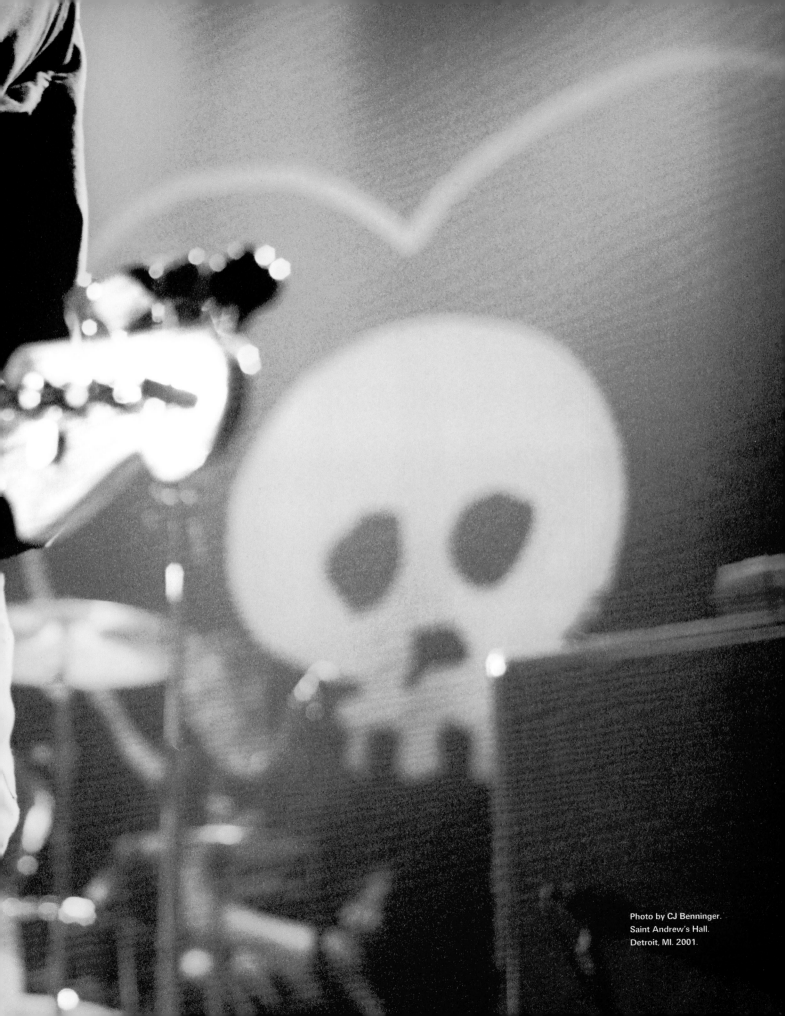

American Nightmare

Est. 1998
Boston, MA

—

Step into my time machine. The year is 2000. You're in Boston, Massachusetts, and it's *cold*—the kind of cold that no sort of streetwear can protect you from. Here, take my hat, and my gloves, and my scarf. We're going to go see a show. It's all local bands and no two sound alike. The venue is called The Middle East and it smells like falafel in here because we're above a Lebanese restaurant. Anyway, the bands we're going to see are Piebald, Cave In, and American Nightmare. At this point in time, these are Boston's biggest "local" bands, and while a show with this variety of sound and disregard for genre feels like no big deal right now, in a few short years, shows like this where the only prerequisite is heart and soul will go extinct. Right here, today, in the year 2000, there is still room for error. People and bands and venues and labels and everyone involved with keeping this massive hot-air balloon of a scene afloat can still take risks and can still, essentially, fuck up. We can all still take risks. We can book shows with a weird mathy emo band, an intensely heavy hardcore band, and a progressive metal band.* And it's because of this risk-taking—putting together such a diverse bill for this wild show that we're still at (I'm going to go get a water, be right back, I'll grab you one and some ear plugs)—that bands like American Nightmare are essential to understanding the fabric of emo that is woven so tightly.

Wes Eisold, vocalist, mastermind, and multihyphenate of American Nightmare (and Some Girls, XO Skeletons, and Cold Cave, to name a few others) was supposed to be in an emo band. He really was. But he discovered and fell in love with hardcore and decided to push his voice to the edge of collapse nightly instead. But listen: While Wes's voice does what it does, his lyrics are what they are, and what they are is emo as fuck and wildly influential. When American Nightmare's demo first started circulating among friends, it was really hard to ignore it. The cluster of songs was quick, deafening, and tight, juxtaposed with this wild yelling that was actually thought-provoking and tear-inducing poetry if you really listened. The world could tell a new voice in music had been born. Wes Eisold was our Salinger, maybe. No, maybe our Vonnegut. Yes, Vonnegut. The band's records were like books you just *had* to read.

If your ears and your heart can take a winding and rocket-fast trip down the tormented lover's lane, American Nightmare should be your band of choice. The words flow out of Wes, backed by what I can only call an assault rifle of a band—the *chugga-chuggas* are so epic, the drums so chest shaking, it's as if they're on a mission to destroy you.

*
That would be Cave In, whom I still consider emo, but I've lost that argument too many times to include them in this book. Shout out to *Creative Eclipses* and *Jupiter*.

Photos by Chrissie Good.
The Paradox.
Seattle, WA. 2001.

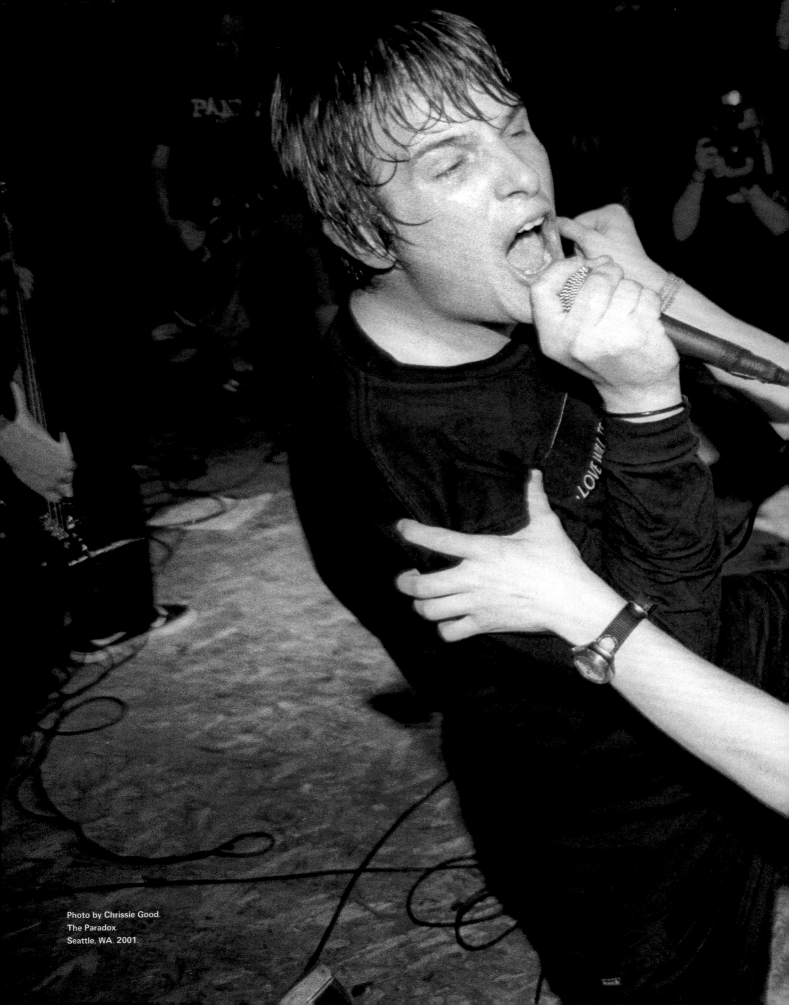

Photo by Chrissie Good.
The Paradox.
Seattle, WA. 2001.

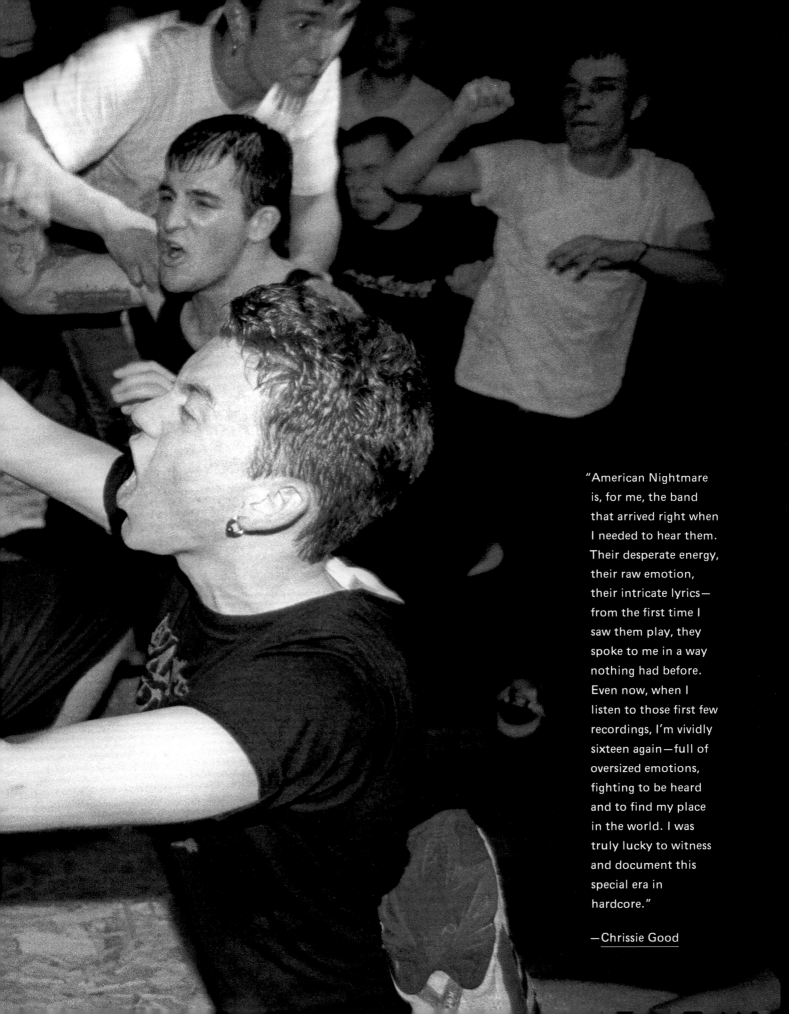

"American Nightmare is, for me, the band that arrived right when I needed to hear them. Their desperate energy, their raw emotion, their intricate lyrics—from the first time I saw them play, they spoke to me in a way nothing had before. Even now, when I listen to those first few recordings, I'm vividly sixteen again—full of oversized emotions, fighting to be heard and to find my place in the world. I was truly lucky to witness and document this special era in hardcore."

—Chrissie Good

The Anniversary

Est. 1997
Lawrence, KS

—

I cannot describe the copious amount of joy I felt the first time I heard The Anniversary. I had heard of the band from an old friend and Kansas local, Matt Rubin. He told me they were going to be "something"—and he was right.

When The Get Up Kids started their own imprint with Vagrant Records called Heroes and Villains (named so after what is arguably the best Beach Boys song), they helped release *Designing a Nervous Breakdown*. This release brought The Anniversary into the national spotlight—they were a long way from their familiar local Midwest shows. I remember getting an advance copy of the record while I was on tour with Saves the Day, and we listened to the album on repeat for hours during an overnight drive. There were very few albums from this era that we could play on loop for eight hours in a van full of exhausted, delirious, and unwashed people at the end of their collective rope, and *Designing a Nervous Breakdown* was one of them.* Josh Berwanger's punchy verses intertwine perfectly with Adrianne Verhoeven's melodies and it's vocal harmony bliss.

The Anniversary employed the same Moog-synth dance-pop sensibilities that The Get Up Kids had started leaning in to by their sophomore release (must be something in the water in Lawrence, Kansas). But The Anniversary did it differently than their friends. There was a classic rock, almost '70s feel to the band, and it sounded completely original. They were more like a jam band that woke up one day and just happened to stumble into the emo scene—and that was rad. They even dressed as such: Vocalists Adrianne Verhoeven and Josh Berwanger never skimped on theatrics, hats, or sunglasses. They were the pinnacle of style makers.

The breakdown at the end of "Perfectly" was something to behold live, and still 100 percent holds up blasting from speakers at full volume.

*

Clarity from Jimmy Eat World was another.

Photo by Kevin Kusatsu.
c. 1999.

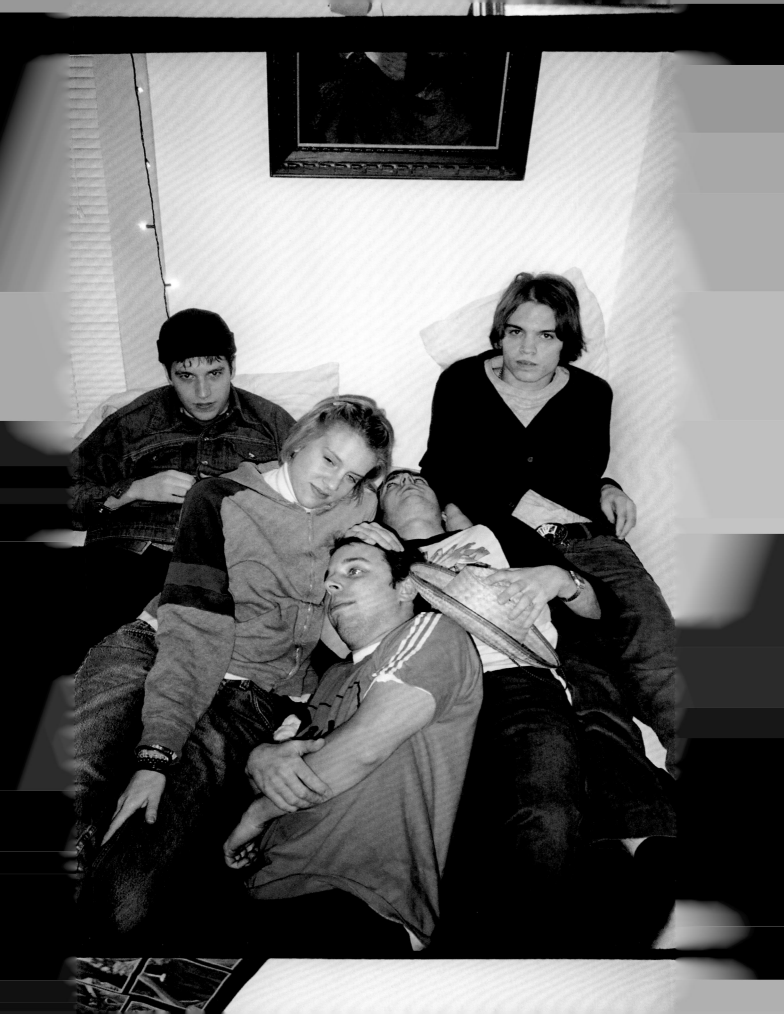

Armor for Sleep

Est. 2001
Teaneck, NJ

—

From the start, Armor for Sleep had a plan. They had a vision, and it was beautiful. When the band appeared seemingly out of nowhere with a handful of demos, they had a website—a proper website was a big deal during this era—and it was wonderfully designed at that. It was completely black, save for some delicate white snow falling and white feathered angel wings set dead center. Everyone noticed. Those of us in the industry *ran*, not walked, to get in touch with the band to inquire about signing them.

Armor for Sleep, led by Ben Jorgensen, flawlessly encapsulated the feeling of being young, lost in your own life, and torn apart by love in the American suburbs of 2001. If the perfect emo band had been created by some universal God, Ben Jorgensen would have been cast as himself. They had this undeniable mix of youth, shaggy windswept hair, vintage T-shirts, and boyish wonder that just made you want to hop on your ten-speed and ride around your neighborhood with Jorgensen and what felt like an updated cast from *The Goonies*.

Their debut album, *Dream to Make Believe*, was released in 2003 by Equal Vision. The title track still has the ability to move me to tears. Their sophomore release, *What To Do When You Are Dead*, is wholly enjoyable from start to finish, with "Car Underwater" and "The Truth About Heaven" being the most hauntingly beautiful and memorable.

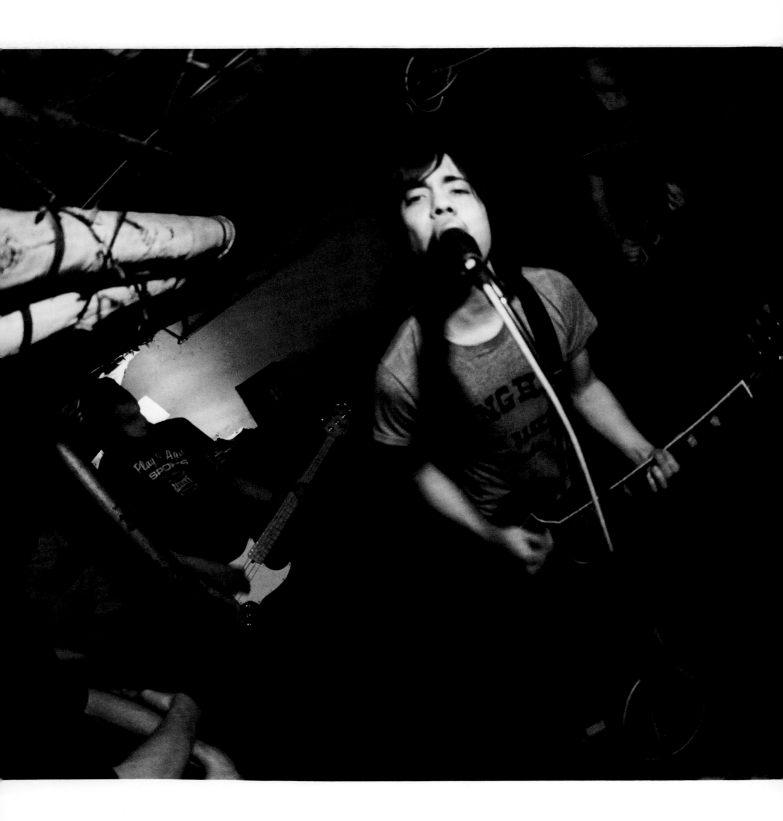

Bayside

Est. 2000
Queens, NY

—

There's something so familiar about Bayside the first time you hear them—it's like hanging out with a friend of a friend and suddenly realizing you've crossed paths before. This feeling is undoubtedly due to the tone and inflection of vocalist/guitarist Anthony Raneri—it feels like he's pulling from the depths of his soul to give you everything he's got. His voice is reminiscent of Greg Attonito from the legendary punk band The Bouncing Souls, which is never a bad thing in my book.

And while I wouldn't want the focus of this band's piece to be a tragedy, I'd be remiss not to mention that in 2005, while touring in support of their second album, their van hit a patch of black ice on an overnight drive and crashed. Bassist Nick Ghanbarian was seriously injured, and drummer John Holohan was killed.

To somehow find the strength to mourn and survive what they went through and the loss they suffered, and then to make the courageous decision to continue on as a band is a testament to their dedication and fortitude. No one would have blamed Bayside for never playing another show after that, but they somehow found a way to continue and have been releasing music and touring steadily since then. And I will be a fan forever because of that.

The song that initially caught my ear was "Devotion And Desire," and if I'm making a third wave playlist, you bet that track will be on there.

Photo by Billy Hamilton.
The Fireside Bowl.
Chicago, IL. 2003.

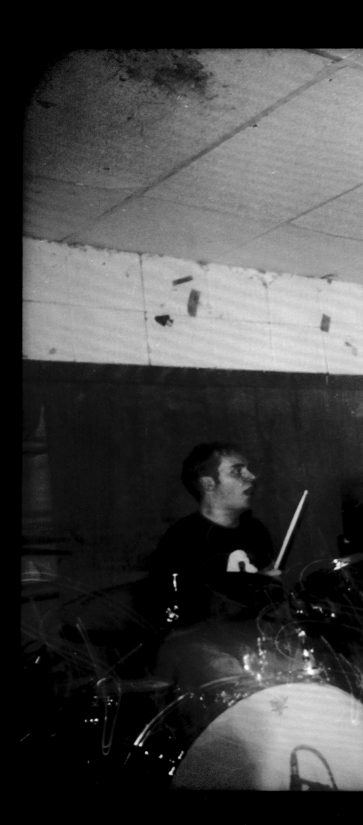

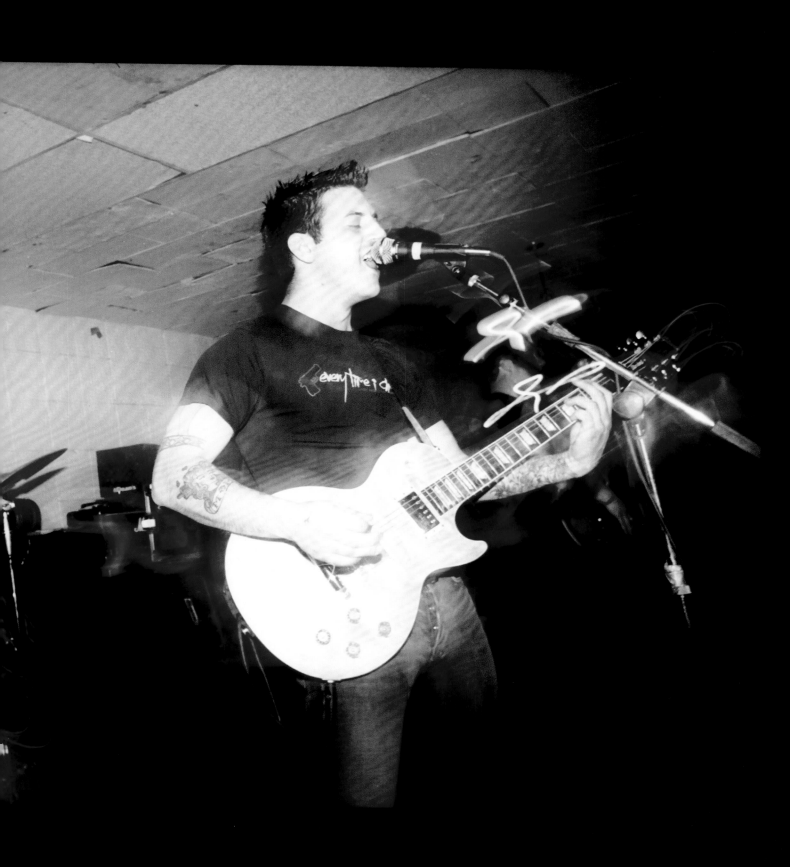

Circa Survive

Est. 2004
Philadelphia, PA

—

Before Circa Survive, vocalist Anthony Green was in Saosin. Wildly unhappy and missing home, he left the band to head back to the East Coast to take a breather, feeling creatively tattered and torn. It wasn't long until he formed yet another profound and influential musical group. Enter Circa Survive, assembled from members of several other local area bands. While Saosin seemed to tear at the very fibers of what you could (but should not) call "screamo," Circa Survive felt much more like a dark, ethereal, prog rock approach to emo. The constructivist guitar work felt less like "Let's melt your face off," and more like "These songs will fry your brain cells right out of your head and you'll come back wanting more."

Somehow, a burned copy of the band's demo (which is now known as *The Inuit Sessions*) ended up in my living room—I believe it had been left behind by a touring band that had crashed there for the night. In the middle of an embarrassingly infrequent cleaning spree, I put the CD-R into my CD player. By the time I heard the lyrics "Remember, remember!" I knew that lightning had struck again and Green had found himself yet another way to harness how it feels to be something on.

In 2005, when the band released their debut album, *Juturna*, they had a chance to show the world who they really were. Their original four-song demo was an adequate teaser, a nice handshake, but you didn't get the whole picture until the full album. There's a sarcastic, intellectual, irreverent nature to Circa Survive that sets them apart from their peers. Take "Meet Me in Montauk"—you can hear whistling, laughing, and someone throwing what sounds like loose change in chaotic dissonance, all intertwined with Brendan Ekstrom's and Colin Frangicetto's guitar lines.

With their intentional approach to songwriting, you can tell that the band knows when to throw everything at the canvas, as well as when to use delicate line work—this is the marker for expert level artistry. You can hear the myriad influences they adored, including heavy hitters like Bjork, Radiohead, and King Crimson; and they're never short on literary or film references that really underscore the mood.

Photo by Mark Beemer.
Otto Bar.
Baltimore, MD. 2005.

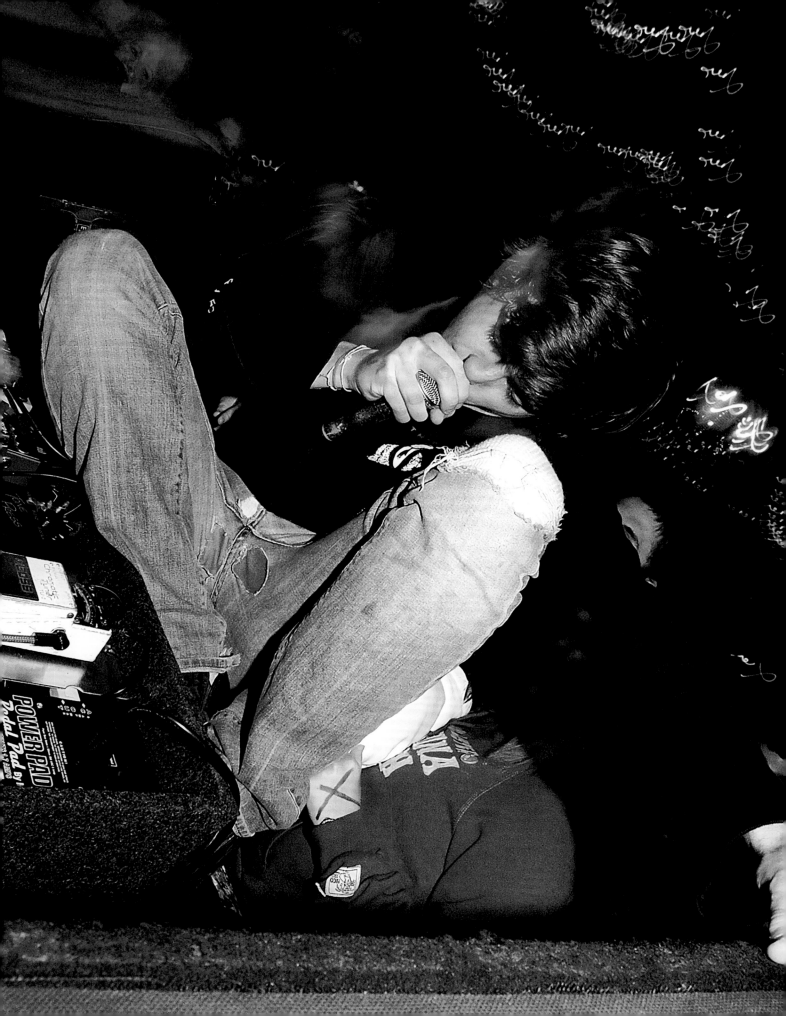

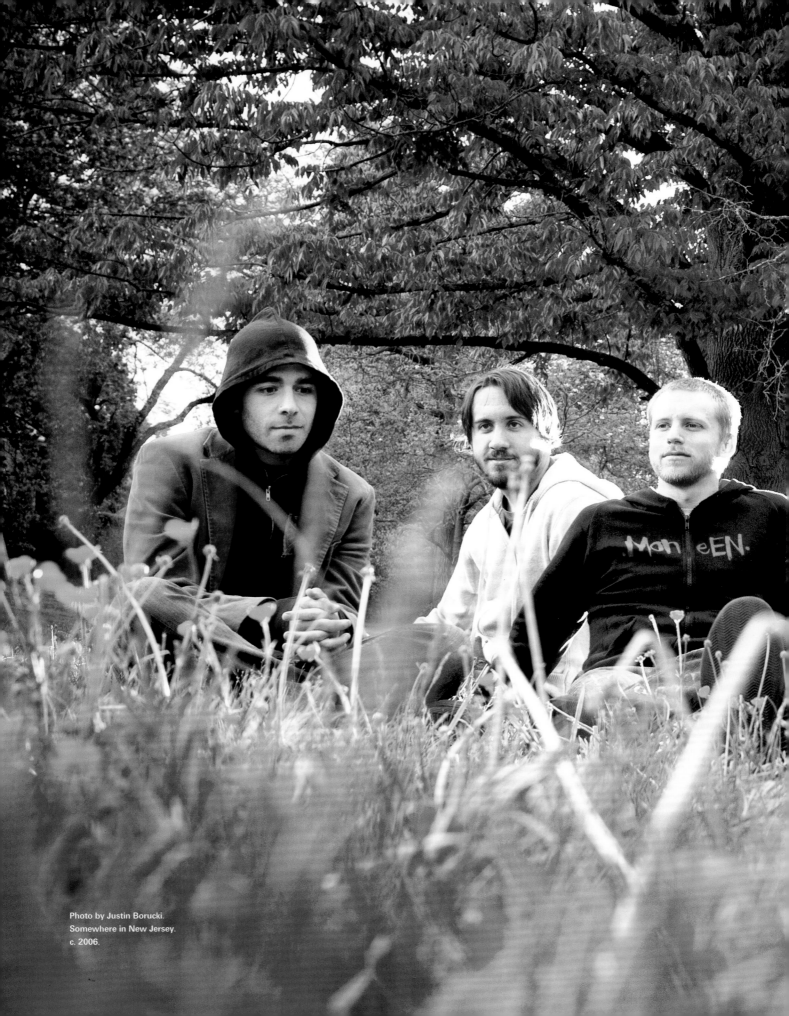

Photo by Justin Borucki.
Somewhere in New Jersey.
c. 2006.

Coheed and Cambria

Est. 1995
Nyack, NY

—

Every scene has those who live on the fringes, only to weave in and out, occasionally and unexpectedly dropping explosions of dazzling sonic mayhem. For the third wave, that was Coheed and Cambria. The fact that almost all the band's albums are concept records with their own companion comic book series lets you know that this band is cooking with gas and hell-bent on doing things differently.

While Circa Survive seems to have some prog rock influences, Coheed and Cambria is the most hair metal and prog rock band that I'll allow in this book because at the core, the members are emo kids. The DNA of their music and everything they've done is on Team Emo. If emo is allowed to have its version of Rush, with arpeggiating guitar solos and drum fills that would make Neil Peart's jaw drop, Coheed and Cambria is it. The band pays such close attention to every detail, visually and aurally. If you're in need of a serious breath of fresh air and creativity, start at the very beginning with *The Second Stage Turbine Blade.*

Photo by Nathaniel Shannon.
The State Theatre.
Detroit, MI. 2003.

202

"Coheed were always visually stimulating to photograph. Obviously there is the hair, but focusing on that is a cop-out. They were a prog rock band that had the energy of a punk band trying to play for beer money in a suburban basement. I could never wrap my head around some of those riffs and tempo changes. The YES of emo. I always strove to capture the complexity of their music with photographs I made of them, which . . . maybe I accomplished?"

—Nathaniel Shannon

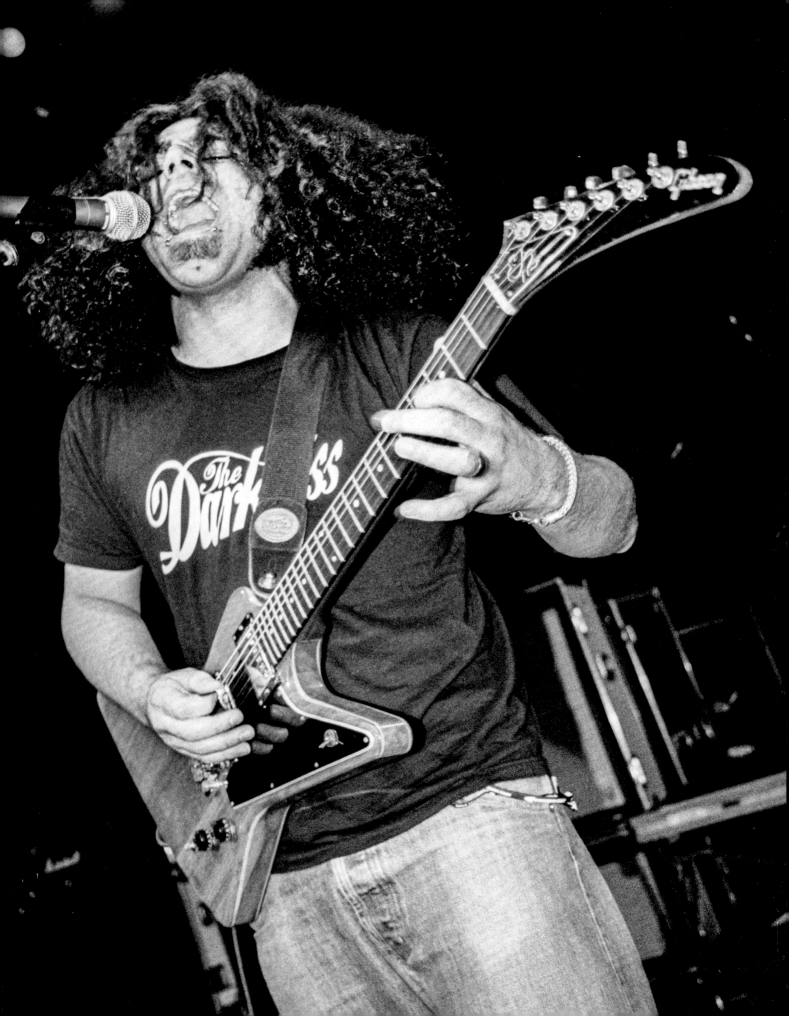

Dashboard Confessional

Est. 1999
Boca Raton, FL

—

Dashboard Confessional was an outlier in every sense of the word. The band started as just Chris Carrabba, alone, onstage with his guitar, playing and singing his actual heart out to the point of tears and/or blood every night.

And believe it or not, this raw performance style ruffled quite a few feathers along the way. In the early days, it was not unheard of for various projectiles to be hurled through the air with the singular mission of hitting Carrabba in the head. He took it all in stride, though, and used those feelings and the unwavering support of numerous hardcore and punk bands to fuel his ambition even further.

With the release of *The Swiss Army Romance*, Carrabba willed into existence ten songs that not only transformed his life but also transformed the entire trajectory of emo. Acoustic ballads were previously reserved for end-of-record or hidden tracks, but this record was sung along to at extremely high volumes in seemingly every car on its way to a show across America, and emo was forever changed. When I found myself with an A&R job at Vagrant Records, you can bet your shirts and gloves that Dashboard Confessional was the first band I brought to the higher-ups. Once they heard "Screaming Infidelities," it was a done deal.

Carrabba's status began to shift from cultlike deity to mainstream antihero with the song "Vindicated," which was recorded for the 2004 film *Spider-Man 2*. With this move, Carrabba solidified himself as the official harbinger of the third wave of emo. But no matter how big the crowds got, he remained the same down-to-earth guy with whom I used to drive around America in a busted old van—the same guy who would grab my hand so tightly before a show just to steady his nerves that it felt like my bones might break.

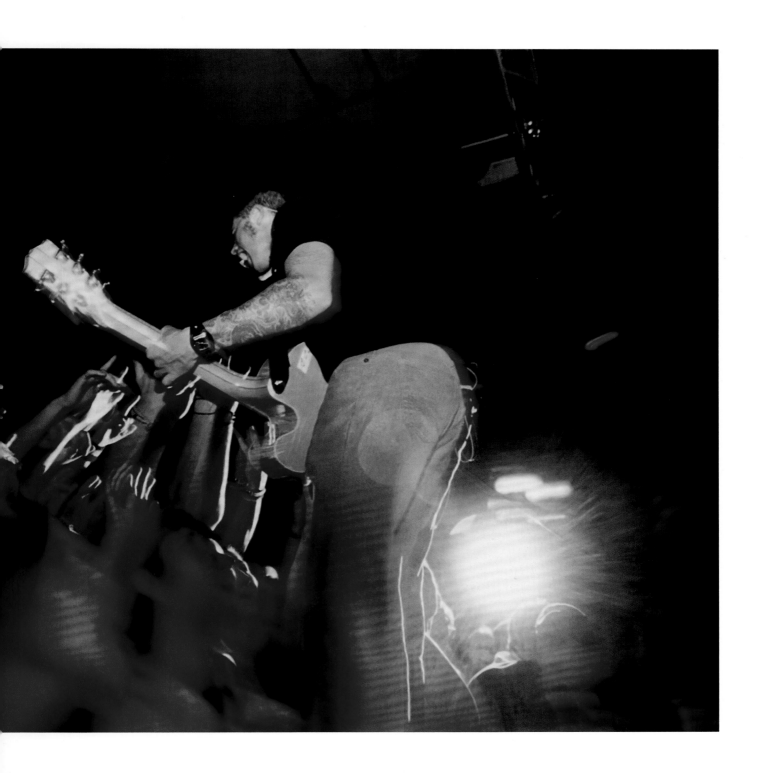

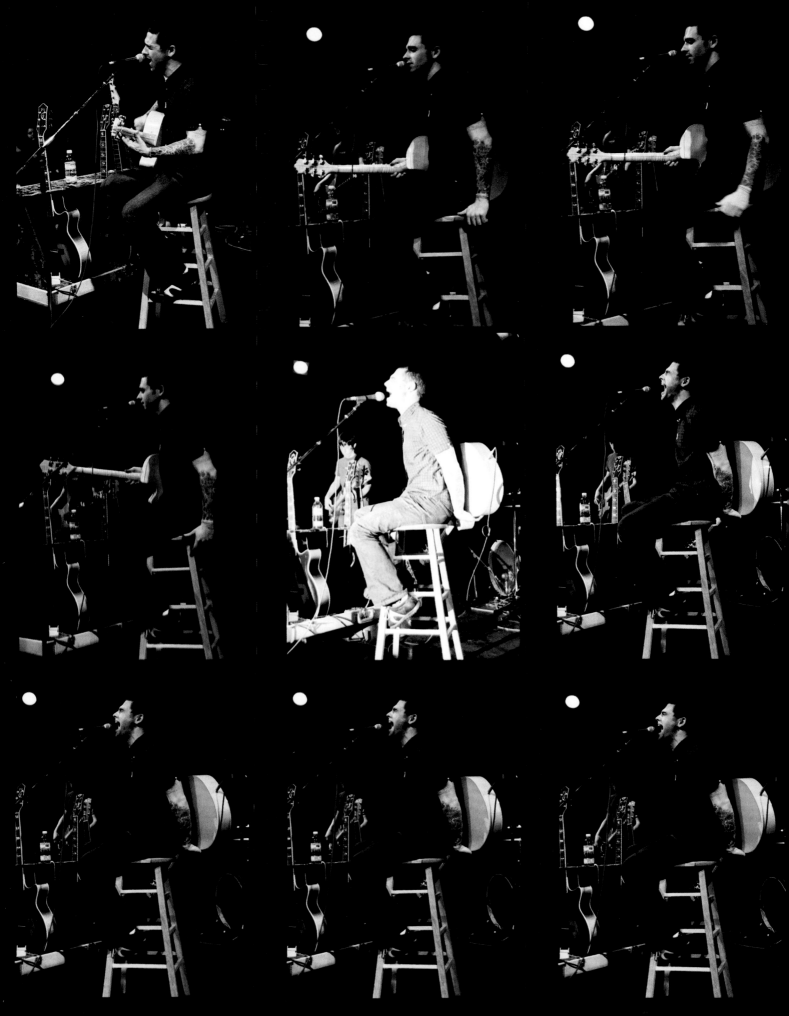

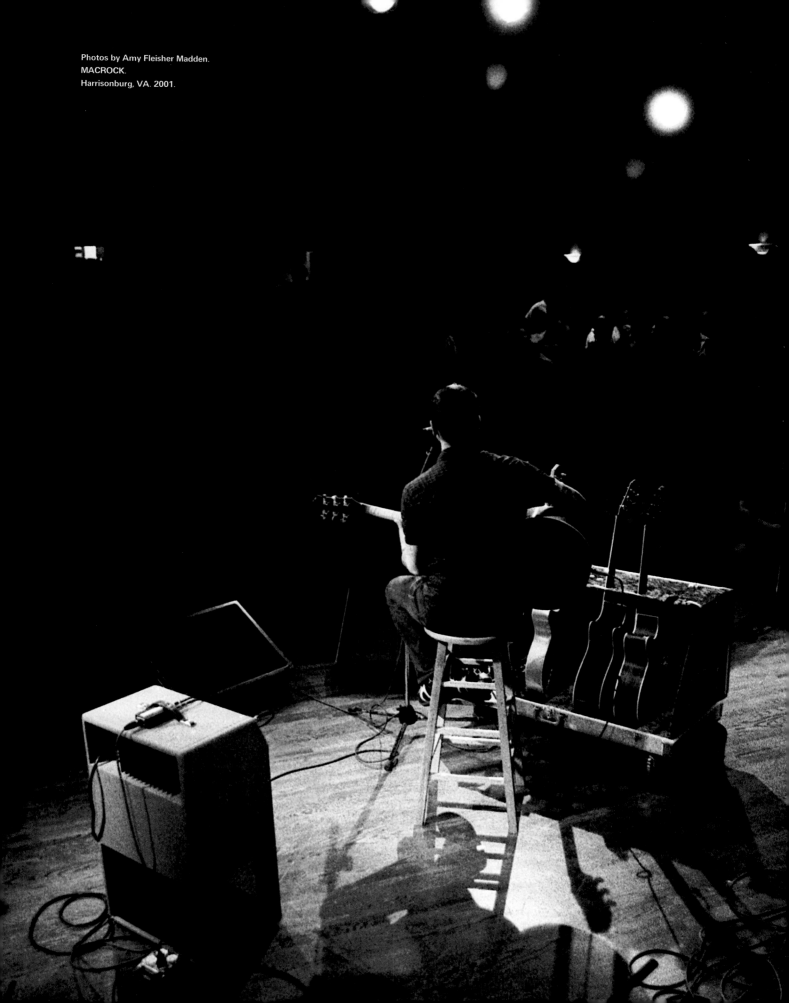

The Early November

Est. 2001
Hammonton, NJ

—

On the opening track of 2003's *The Room's Too Cold*, "Ever So Sweet," vocalist Ace Enders brings you into his world with a sweet, gentle introduction. You think you're in for a lullaby, but halfway through the song, Enders kicks it into overdrive with such masterful control, alternating between falsetto and borderline yelling. And hold on to your fucking hat, because by track two, "Something That Produces Results," you're thrown back out into the deep end of emotion, full of sonic earthquakes that will have you begging for more.

I was slow to come around on this band because of what we'll call "baseball." I am embarrassed to admit that I was involved in some drama back in the day—we were young, it happens—and there were a handful of bands that I refused to listen to because they were simply on *the other team*. As an older, grown-up human being, I stumbled upon The Early November's 2015 album *Imbue* and realized how great they were. Baseball is really fucking stupid. I missed out on a solid band because of it, and I am so glad I no longer care about "sports," because I can now enjoy and fully appreciate this band's entire catalog. This band is good. But you don't need me to tell you that. The Early November boasts solid and deliberate production nuances throughout their career-wide catalog—just listen to any of their albums (but definitely their sophomore release) and you'll pick up what I'm putting down.

Photo by Tom Cheney.
9:30 Club.
Washington, DC. 2005.

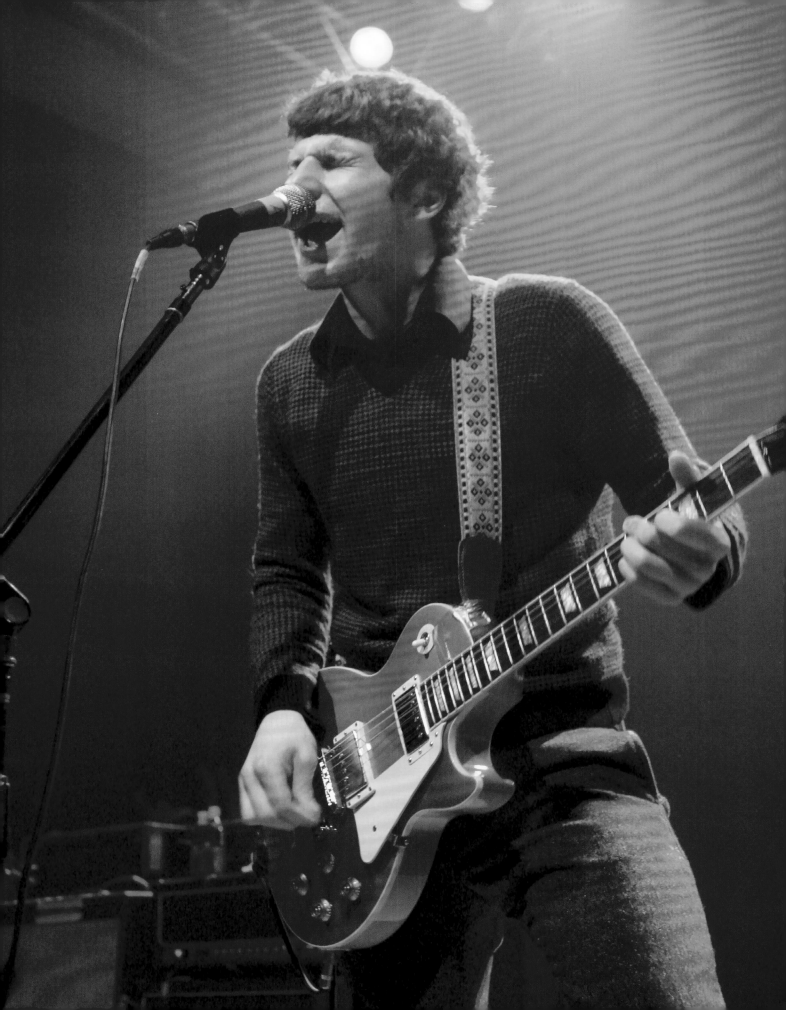

Fall Out Boy

Est. 2001
Wilmette, IL

—

There are a handful of emo origin stories that start with local scene members slogging it out (happily) in hardcore bands, singing youth-crew anthems until they start a band that sounds poppier. Fall Out Boy is one of those bands.

Pete Wentz was a mainstay in the Chicago hardcore scene, but when he recruited Patrick Stump as the vocalist for his next project, alongside Joe Trohman and Andy Hurley—lightning-in-a-bottle magic happened.

The DIY ethos that was instilled in Wentz from working with fellow indie bands for years became a guiding beacon for him. Actually following the scene's golden rules of working with your friends, caring about your friends, and looking out for others who want to follow in your wake—these were all facets of Fall Out Boy's career that made them essential to the scene. From the viewpoint of someone who started going to shows in the mid-'90s in VFW halls, it's just astonishing that they have become one of the biggest bands in the world.

Photo by Tom Cheney.
9:30 Club.
Washington, DC. 2005.

212

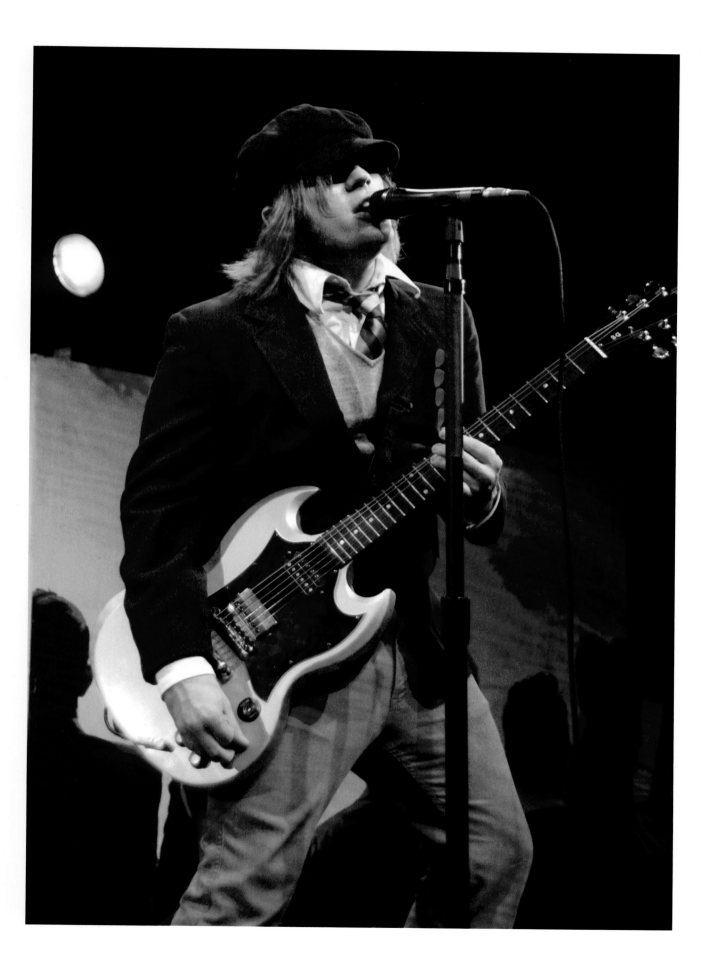

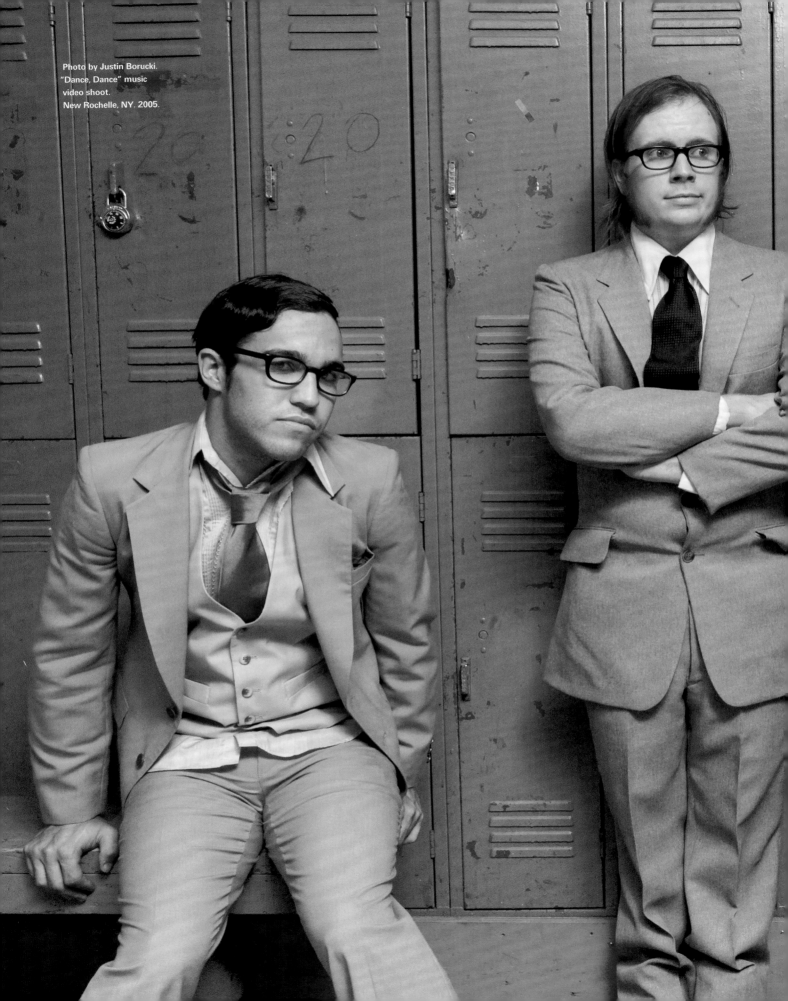

Photo by Justin Borucki.
"Dance, Dance" music
video shoot.
New Rochelle, NY. 2005.

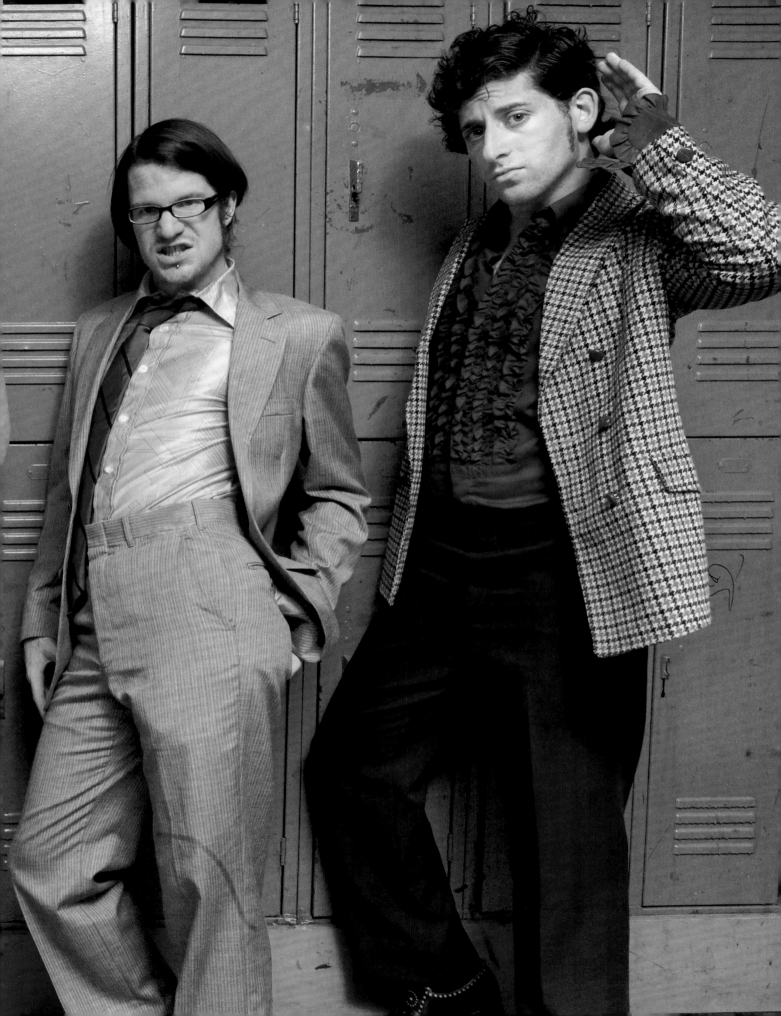

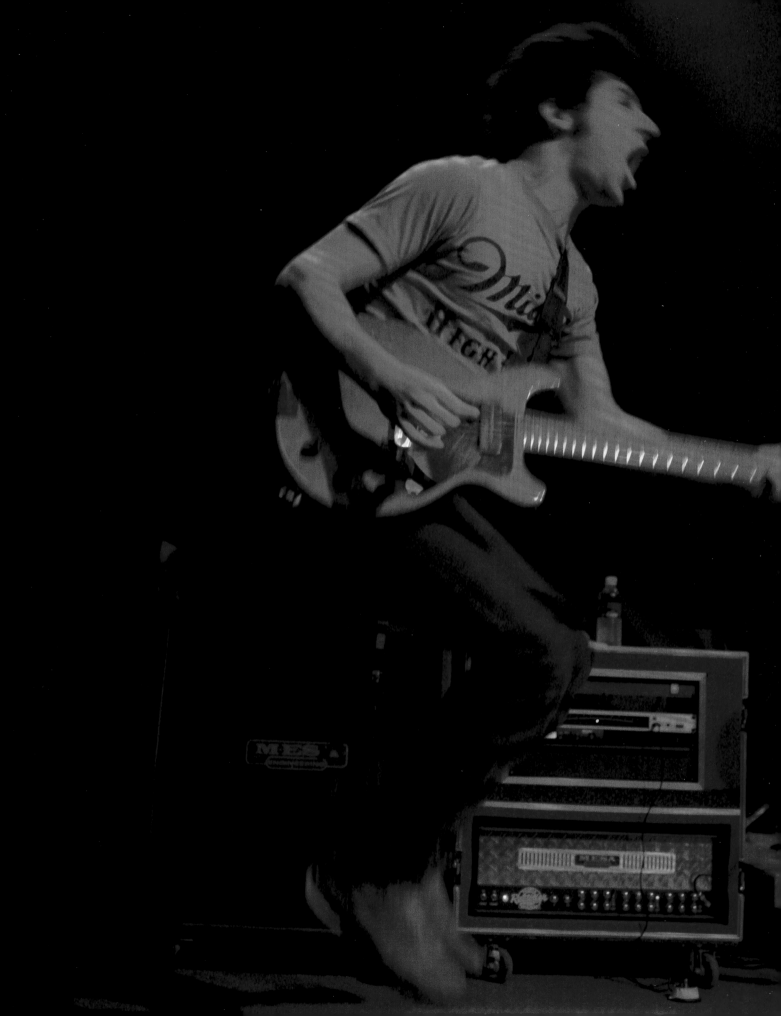

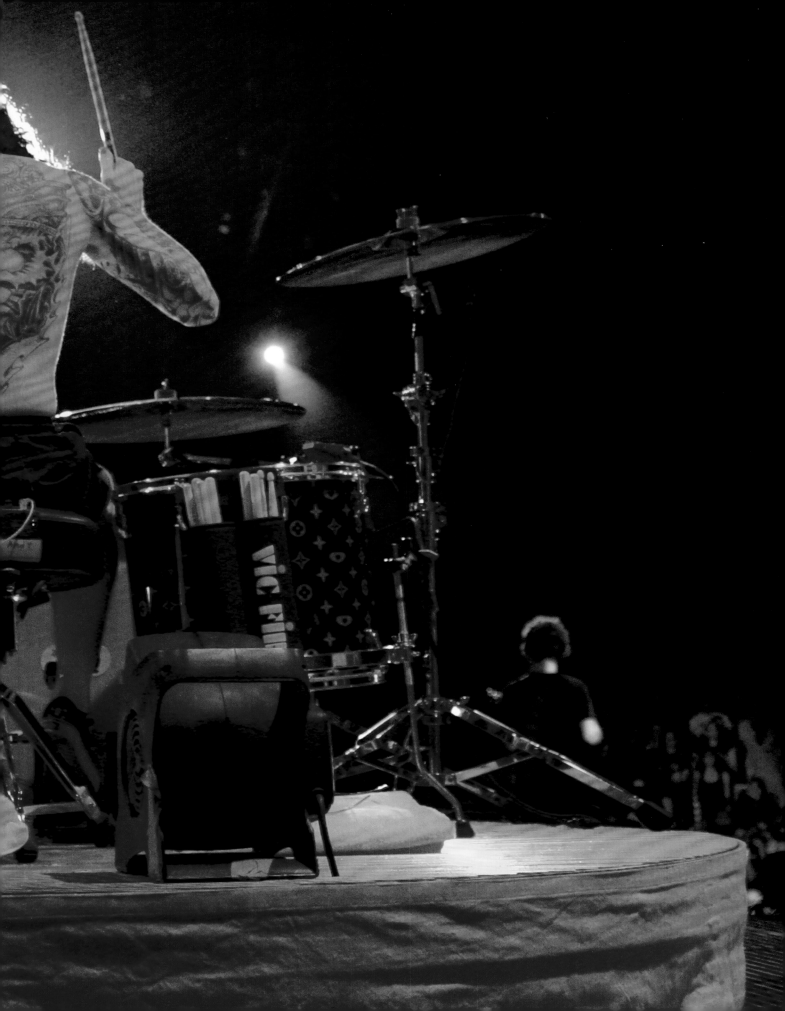

The Format

Est. 2002
Peoria, AZ

—

I've heard a lot of demos in my life. Sometimes when I hear one for the first time, it's the whole package that makes me fall in love, like Taking Back Sunday—each and every part of the band creates this magical, musical Voltron in my head and it all just clicks. However, The Format got me with just two things: a voice and a song. A voice to end all voices. A voice I was sure was going to cure cancer, end world hunger, save all the whales—even the dead ones. The voice: Nate Ruess. The song: "The First Single (You Know Me)."

I was sort of right. I was just a little early.

I drove out to see The Format play somewhere in Arizona. I thought the band was phenomenal, and I would have done anything to work with them. Unfortunately for me, I was not the only label there and I was not the only one who felt that way.

I missed out on The Format—I lost out to a major label. At the time, Nate expressed his thrill about there being major labels present, with my response being a more resigned, "Yeah, cool, cool . . ." We have since laughed about this meeting.

After The Format ran its course, Ruess went on to form a band called Fun. with the emo-adjacent Jack Antonoff (whose résumé at that point only included the band Steel Train and not Taylor Swift) and Andrew Dost (from the uber-indie band Anathallo). Most of the general public may be more familiar with the song "We Are Young" off Fun.'s second album *Some Nights*, and while I wish more people knew about The Format and "The First Single (You Know Me)," that Fun. song was the one that went on to be played at mega-sports stadiums and on mainstream radio stations around the world. I will go on record saying "We Are Young" is one of the greatest songs of all time. Please play it at my funeral.

Photo by Stephen Chevalier.
Modified Arts.
Phoenix, AZ. 2002.

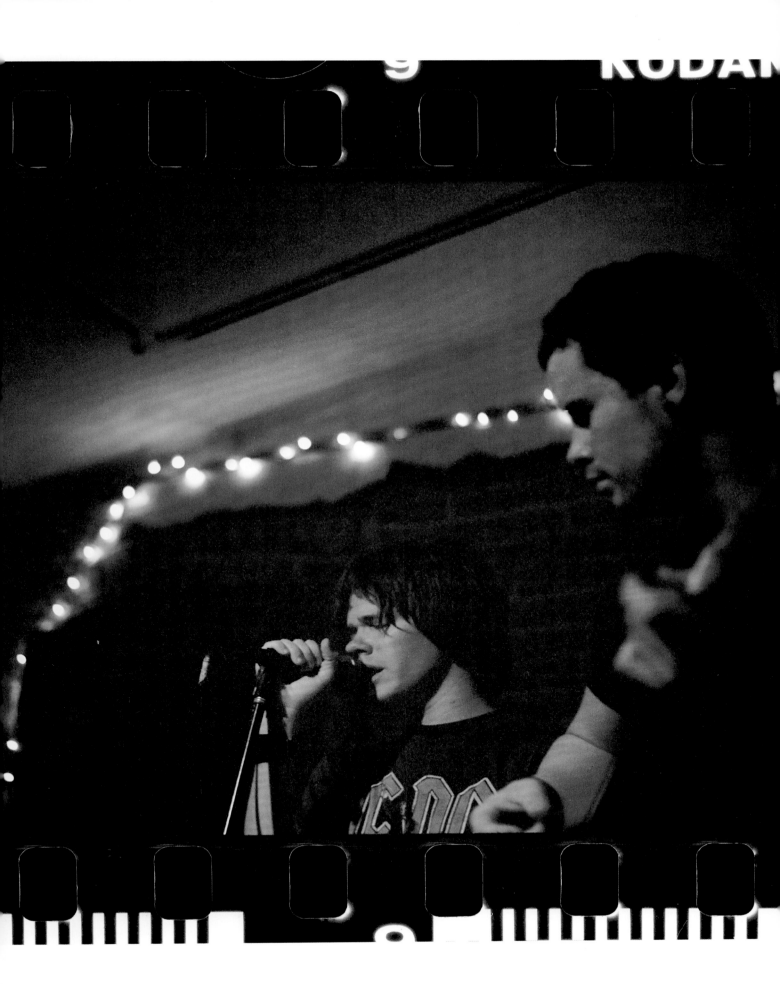

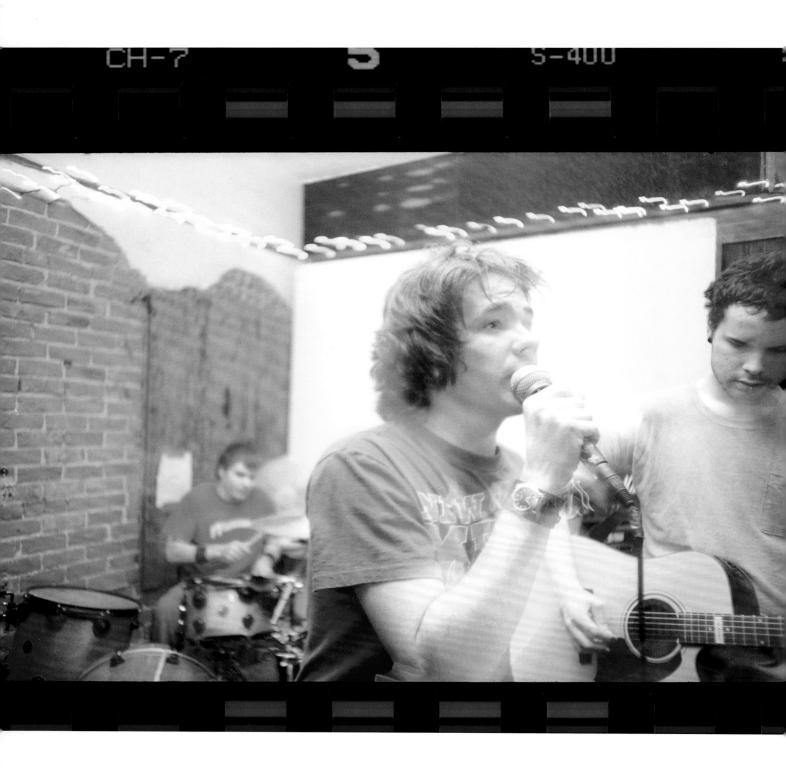

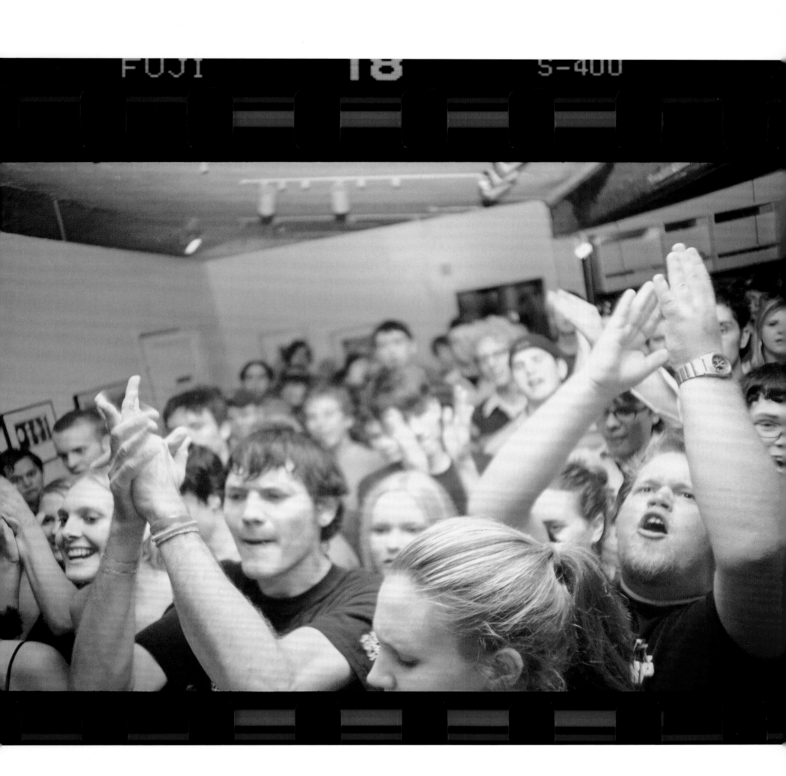

Further Seems Forever

Est. 1998
Pompano Beach, FL

—

I experienced some of the bands in this archive only as a fan, some as a business venture, some for love, and some for reasons I can't even remember. But with Further Seems Forever, I was in the room for a lot of it.

So, here's the story. Some folks in the band Strongarm were thinking of forming a new band. Strongarm were hometown heroes in South Florida for a few reasons, but mainly because they were a successful hardcore band who had signed with a real record label and gone on multiple tours. They had multi-color screen-printed shirts—they were fucking legit. The title track on *The Advent of a Miracle* will always be a favorite throwback of mine.

Anyway, this was around the same time Chris Carrabba was feeling disillusioned with his first band, Vacant Andys, which just so happened to be the first band I'd signed to my then fledgling label. One night, at a party at the "Vacant Andys House" in Pompano, Chris came over to me and said, "The Strongarm guys are here. They're starting a rock band, and they want me to be their singer." Chris was upset about the pending breakup of the Andys, and a few members of the band had already gone on to form a new band called Anchorman, so he was itching to find his next band as well.

He joined "the new Strongarm rock band," and the first two songs they recorded were phenomenal. However, the honeymoon period was brief—thankfully, it included the recording of a short-run split EP with Recess Theory, a track for *The Emo Diaries*, and the LP *The Moon Is Down*. With a good deal of arguments (some due to the fact that the band was contractually bound to Tooth & Nail Records), they realized they weren't going to make it as is.

Carrabba ended up departing from Further Seems Forever, playing his last show with them at Furnace Fest in 2001. Jason Gleason filled in live and eventually recorded with the band. However, that didn't work out either, and eventually the reputable Jon Bunch from Sense Field took his place. As the years went on, wounds were mended and healed—Carrabba returned in 2010, and they recorded another album. If you're looking for something special, the best album for me will always be *The Moon Is Down*, because with lyrics like, "Pasted wings and foil rings do not an angel make," you have my full attention!

"RJ and I wandered around downtown Fort Lauderdale with the band for the better part of a day, and we just happened upon a house that looked similar to the house from Minor Threat's *Salad Days* EP. So the guys just hopped up on the stoop and voila, this photo was born."

—Amy Fleisher Madden

Photo by RJ Shaughnessy.
A totally random person's
doorstep.
Ft. Lauderdale, FL. 1998.

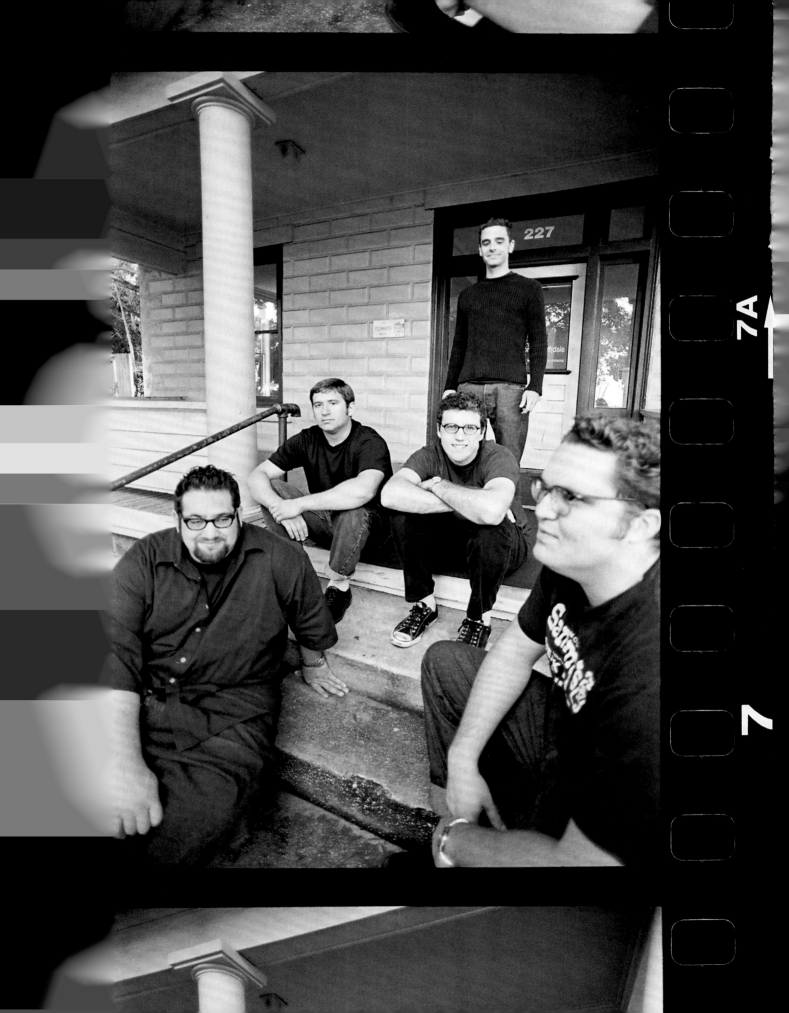

Hey Mercedes

Est. 1999
Chicago, IL / Milwaukee, WI

—

When a band called it quits, it was more than just an announcement. For many of us that needed this music more than we needed sunlight, it felt like the death of a friend. You would mourn the dearly departed band as if they were a corporeal entity. Maybe that's why so many of us wore black every day, regardless of the season or the occasion: We'd be ready for funerals, metaphorically speaking, whenever we happened to find ourselves needing to partake in one.

These bands had become more to us than just people. They were *proof*—proof that what we loved and were doing without any real support system could be accomplished. So, when bigger players from the era threw in the towel, you mourned that loss. A hairline fracture would appear, manifesting as self-doubt: If the varsity players couldn't make it work, then junior varsity didn't stand a chance. The loss of Braid was no exception. The band was such a one-of-a-kind creation that in sunk a creeping fear that nothing like it would ever come to fruition. And then, hark, from out of nowhere, a new band was formed.

Hey Mercedes featured three of the four members of Braid (subbing Chris Broach for Mark Dawursk initially, later replaced by Michael Shumaker), and all of us on the sidelines waited with bated breath to hear what new works of harmonious cacophony were in store. We yearned for that push and pull of beautiful dissonance we had fallen in love with in Braid. With a debut on Polyvinyl, all those fears were assuaged, and Bob Nanna's wonderfully unique voice and Damon Atkinson's explosive—though rhythmically perfect—drumming were once again united, and all of us who had been in mourning felt that, for the moment, everything was right with the world.

Hot Rod Circuit

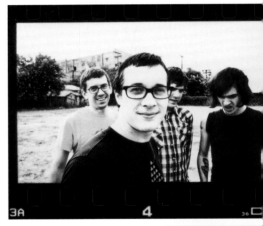

Est. **1997**
Auburn, AL / New Haven, CT

—

You'd have been hard-pressed to see a show in the contiguous United States in 1999 and 2000 without seeing Hot Rod Circuit billed as an opener. If you go by numbers and tour dates, they were the hardest-working band in show business back then, going straight after James Brown's heart. Hot Rod Circuit were the handpicked darlings of super-power booking agent Andrew Ellis and had an early strong vote of confidence from Fred Feldman at Triple Crown Records—an industry double whammy that landed them the opening slot for so many headlining tours of the era.

While the band recorded full-length albums with both Triple Crown and Vagrant Records, they never found their footing as headliners—but this by no means influenced their drive or live show energy, which featured Casey Prestwood's seriously impressive frenetic dance moves. To know Hot Rod Circuit was to love them, entirely, which explains why they were the favored opener—at the time, there really wasn't a more fun quartet to wander around America with.

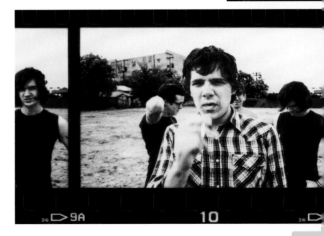

Photos by Kevin Kusatsu.
c. 2001.

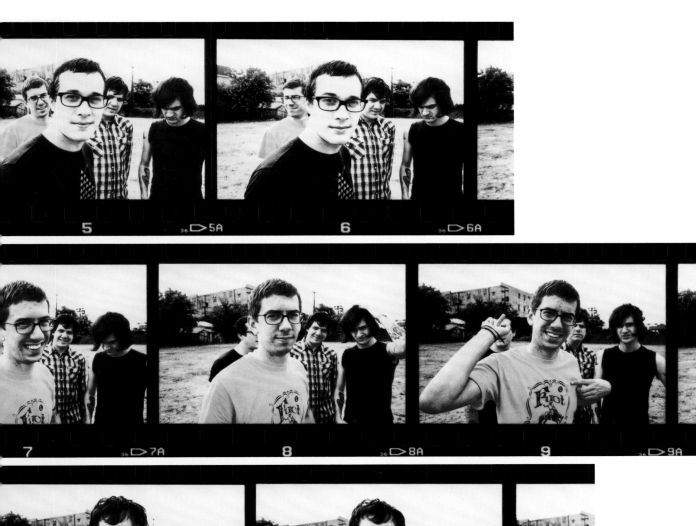

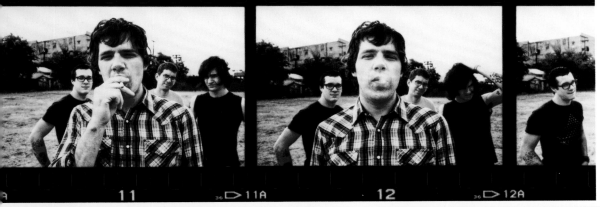

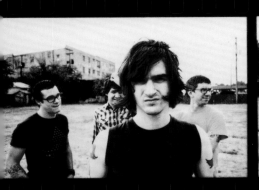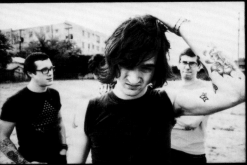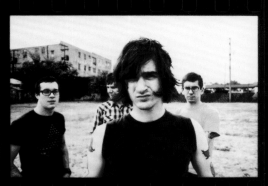

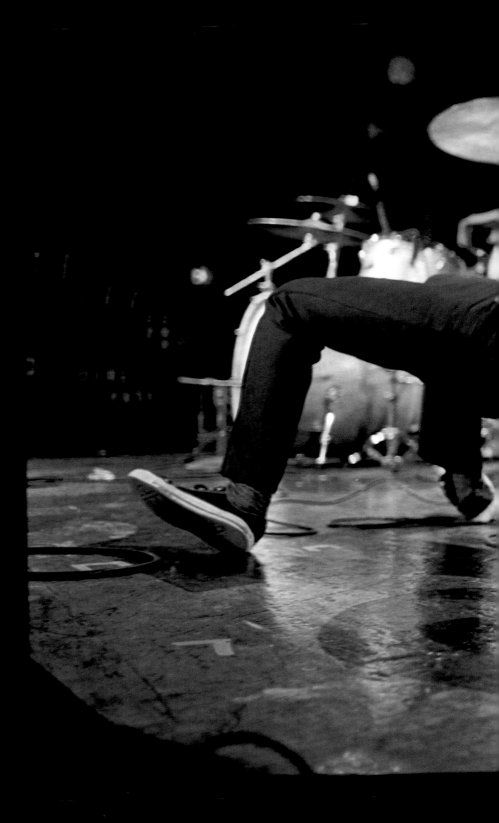

KODAK 5063 TX

Photo by Day19.
The Wiltern Theatre.
Los Angeles, CA. 2001.

28A

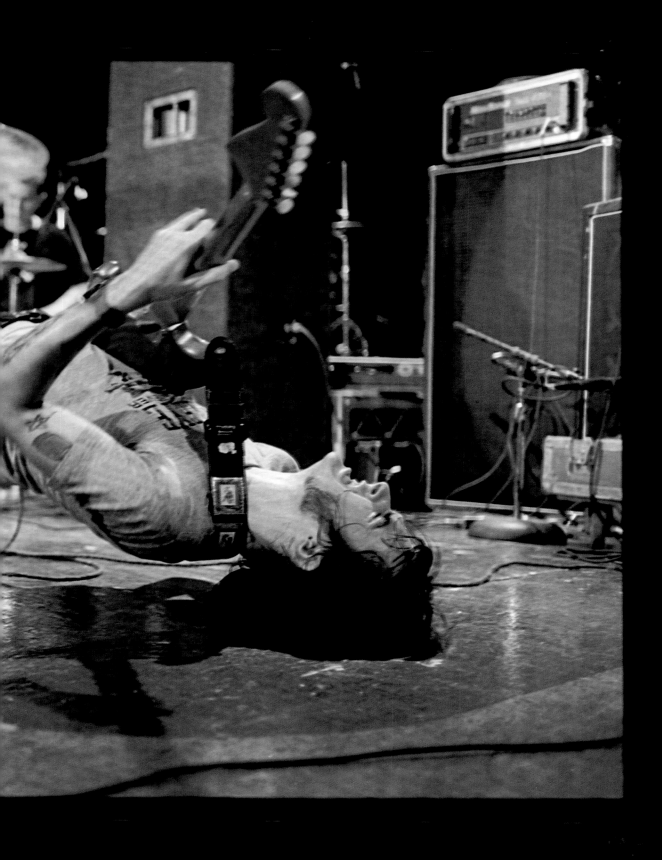

The Jealous Sound

Est. 2000
Los Angeles, CA

—

You either believe in the gospel that is Blair Shehan's vocals, or you simply haven't heard him sing yet. The Jealous Sound was a phoenix rising from the ashes of Knapsack, and for those of us who consumed music as often or more than food, this new band was absolutely necessary. Despite many lineup changes, The Jealous Sound's music never faltered— it always remained precious and intact. "Hope For Us" and "Anxious Arms" are pure gold, but all of their albums are worth spinning. The band served as a worthy flotation device for Shehan until he returned to Knapsack decades later.

Photo by Aaron Farley.
Rehearsal space.
Downtown Los Angeles, CA.

"I had never met any of the guys, so we had a quick hello in their practice space and then I photographed them on the couch. This was in the days of film, so I probably would have widened the lighting if I would've known my strobe was zoomed in, but I think this actually worked out better in the end, focusing intensely on Blair."

—Aaron Farley

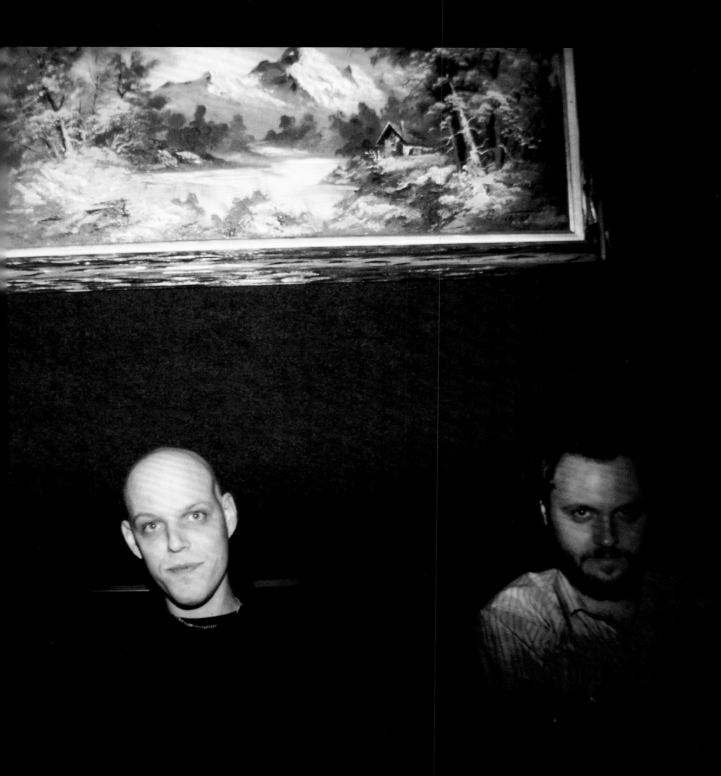

The Juliana Theory

Est. 1997
Greensburg, PA / Latrobe, PA
—

It's a very unsettling feeling when you're not sure if what you're experiencing is authentic, or even worse, possibly some sort of mockery of what you hold dear. At first, I wasn't sure if what The Juliana Theory was doing was serious or some great charade. I was on my guard—either the band was *really* good at committing to the bit or they had actually chosen a side. Was it one of those movies, where the hot guy pretends to like the nerdy girl with glasses and a ponytail, and by the end of the movie, he really does love her and it wasn't a charade? The answer is a resounding nope. What seemed a bit disingenuous at first turned out to be the real thing, and always had been.

The Juliana Theory was a mishmash of several local Pennsylvania bands, the most well known being Christian metalcore band Zao. Vocalist Brett Detar played guitar in Zao, and this band served as his musical jumping-off point. It feels like it took The Juliana Theory a moment on 1999's *Understand This Is a Dream* to get their footing, but they really found their groove with the release of 2000's *Emotion Is Dead*. The album leaned much more toward a high-end, "produced" alternative mainstream rock sound, instead of niche pop-emo, and with that change, they made it into the fan favorite category for so many eager ears.

Kevin Devine

Est. 2002
Brooklyn, NY
—

To the untrained eye (and ear) Kevin Devine may have seemed like the next iteration of acoustic guitar contemporaries—but he was not. Comparatively, he felt much more like he was from another era, following a mood and sound more akin to a young Paul Simon, which helped him hold his own when compared to the increasing amount of third wave "man with an acoustic guitar" types.

He is the heartfelt voice of city kids coming of age, and with songs like "Ballgame," you can feel him settling in as the writer who penned this generation's version of "The Only Living Boy In New York." He's the quiet, somber voice perfect for a lazy Sunday morning vinyl spin, or the soundtrack to a late-night walk through the Lower East Side to nowhere, just to get some air, or maybe a late-night coffee. Get your bearings within his deep body of work with *Circle Gets the Square* and *Make the Clocks Move*.

Photo by Justin Borucki.
Kevin's apartment, shooting
Circle Gets the Square artwork.
Bay Ridge, Brooklyn, NY. 2000.

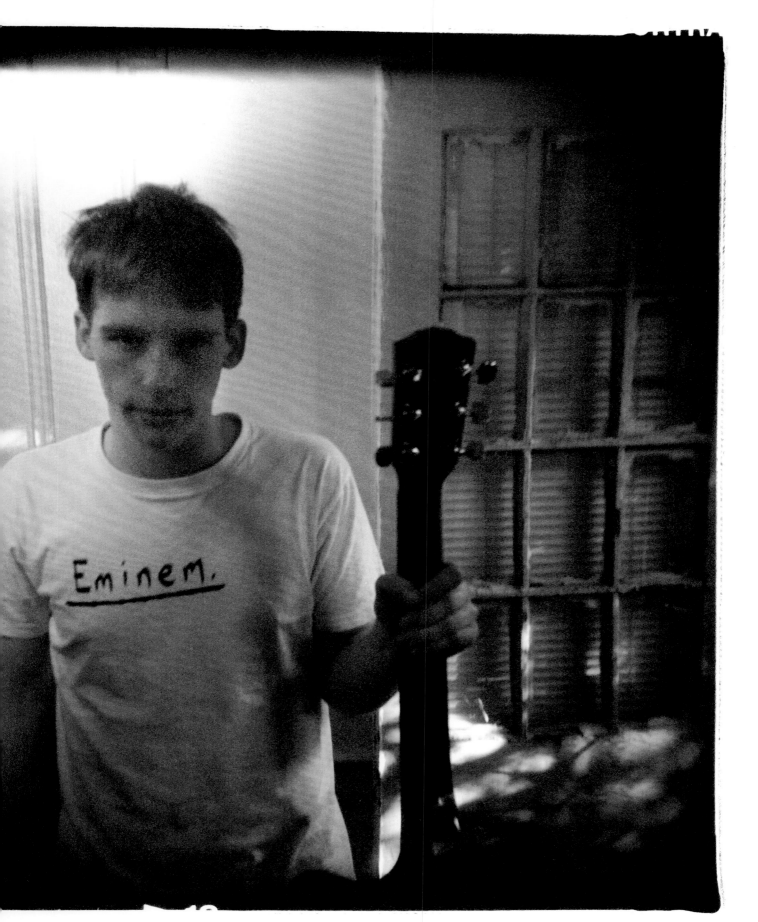

Midtown

Est. 1998
New Brunswick, NJ

—

I am not going to pretend I haven't heard some arguments over whether Midtown is an emo band or not. It doesn't really matter to me. They were 100 percent a part of the scene, and when putting this book together, no one single human being appeared in more photos than Midtown's own vocalist/bass player/man-about-town Gabe Saporta, and that's across *all* of the bands featured here.

In Heath Saraceno's and Tyler Rann's blazing guitar riffs, I actually hear and feel a much more metal-based genealogy, blended, of course, with their patented supercharged power-pop emo. And it's that special brand of New Jersey emo (see: Saves the Day, Senses Fail), with lyrics about a turbulent adolescence, which friends you can trust, and yearning for a long-lost love. Midtown serves us the Garden State special, and I can't get enough of it. Take exit 53 from I-80 and meet me at the Tick Tock Diner, and we can discuss it over some waffles and milkshakes at 2 a.m.

Photo by Kevin Kusatsu. c. 2000.

238

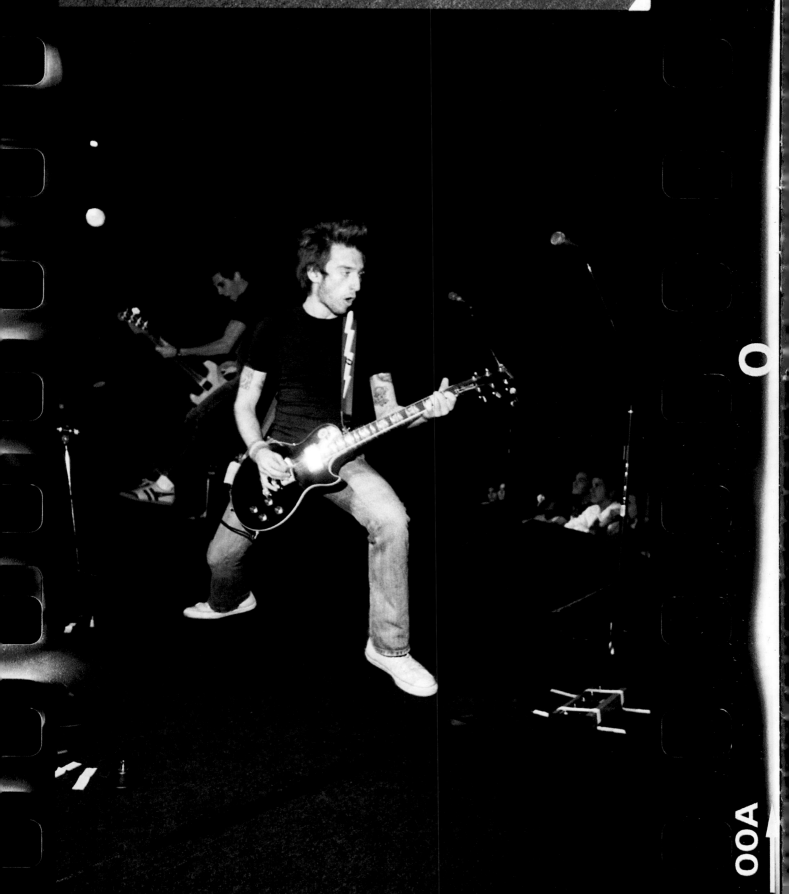

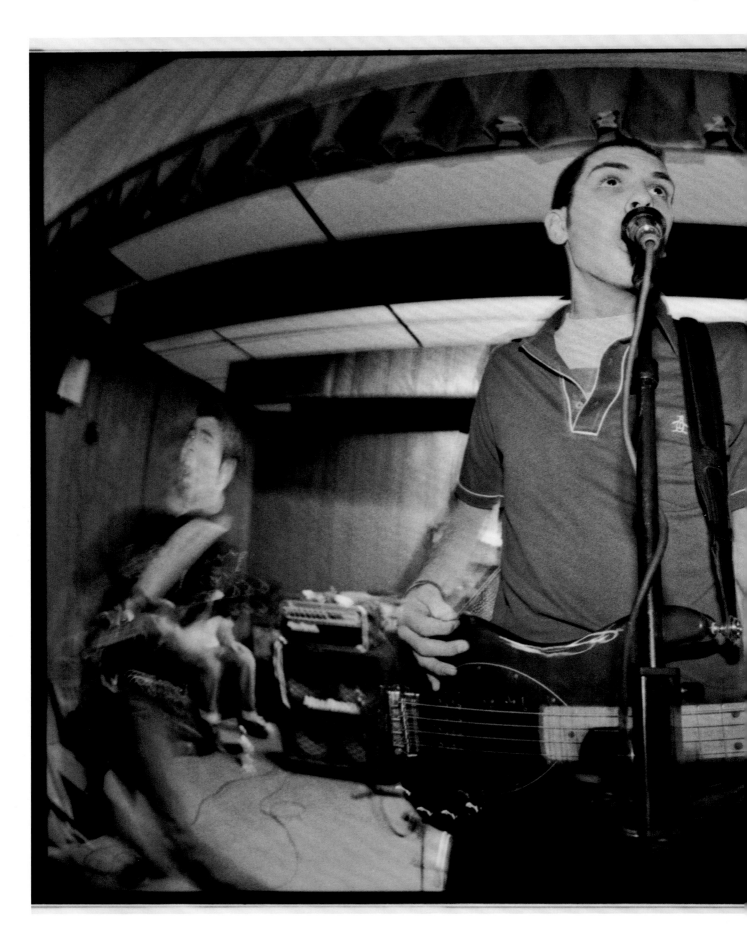

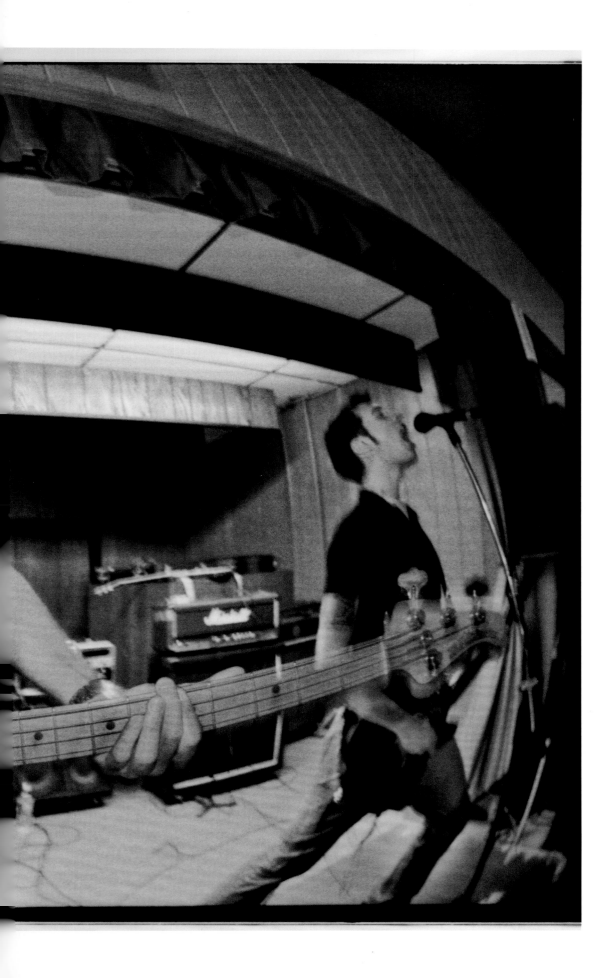

Photo by Paul D'Elia.
The Manville Elks Lodge.
Manville, NJ. c. 1999.

Motion City Soundtrack

Est. 1997
Minneapolis, MN

—

If you cracked open an album booklet and read the lyrics to pretty much any Motion City Soundtrack song, you would find the musings of a tragically self-aware, self-proclaimed anxious, neurotic, and psychosis-laden individual, a.k.a. vocalist Justin Pierre. I only feel comfortable shedding light on this because (a) these songs are out there for anyone and everyone to hear, and (b) I can relate, and maybe if more people came forward about feeling these feelings, then feeling them wouldn't seem so massive and isolating. Motion City Soundtrack's lyrics lay bare feelings and habits that illustrate what it is to be *human*, with acute insights of day-to-day life in all its wonderful and terrible splendor—that's hard to do. Listening to one of their albums can feel more like therapy, in a good, cathartic way.

When Pierre sings, "I'm sick of the things I do when I'm nervous like cleaning the oven or checking my tires, or counting the number of tiles in the ceiling," it feels as though he's trapped inside his head, engaging in a debilitating battle with his own neuroses, only allowed to let a little bit of his harsh reality out in song form. And thank all the holy things for whatever he's able to let out, because it makes for a one-of-a-kind listening experience. And it would be negligent not to note that their live show was its own one-of-a-kind experience, with Jesse Johnson ripping his infectious piano hooks while doing keyboard handstands. Whatever energy drink that man is having, I'll take two.

RIGHT: 242
Photo by Douglas Garfield.
Mississippi Nights.
St. Louis, MO. 2005.

BELOW:
Photo by Douglas Garfield.
Somewhere in North Carolina.
2005.

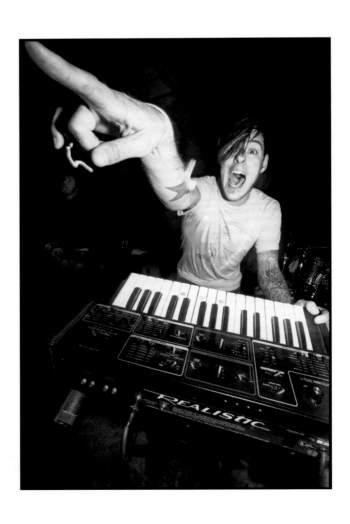

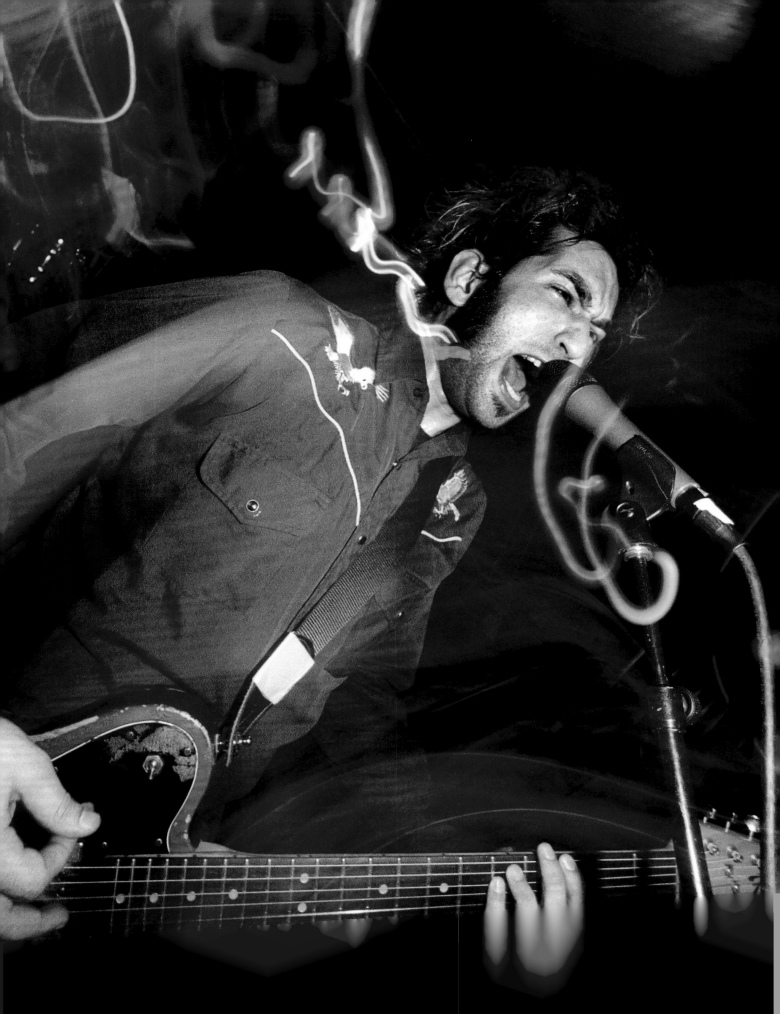

The Movielife

Est. 1997
Long Island, NY

—

The Movielife's early albums were deeply steeped in Lifetime-esque stylings and various youth-crew hardcore breakdowns evocative of punk/hardcore legends H2O. But somehow, when you put all of the band's elements together, you got emo.

I met the band early on when they were kind enough to invite me and a fellow touring band to stay with their families. I became fast friends with vocalist Vinnie Caruana, and one of my favorite tour memories is of staying up way too late watching movies with him. We watched *Sneakers* twice in a row for some strange reason, and the next morning his parents made us pancakes. It was the most wholesome and normal experience. Everyone always expects debauchery on tour—and sure, there was a good deal of that—but sometimes we were just regular people who wanted to do regular life things.

After a catastrophic van accident in 2001, the band recorded their heaviest hitter to date on *Forty Hour Train Back to Penn*. "Jamestown" with the chorus "Late night, snowfall, get us to the hospital," is about the accident they thankfully all survived. That album, produced by Brian McTernan, remains the band's most solid effort, with "Jamestown" arguably being the most epic anthem of their career.

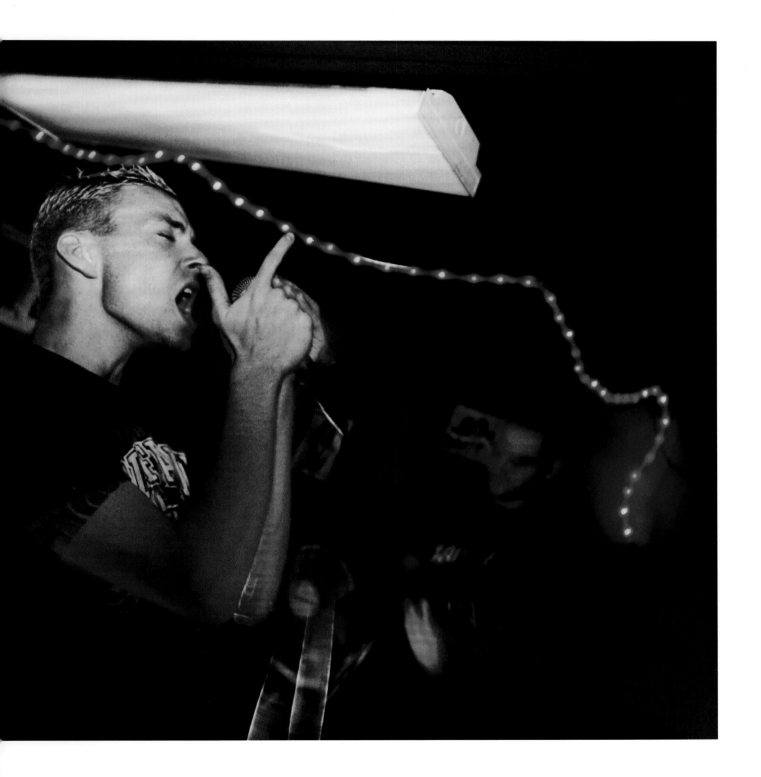

My Chemical Romance

Est. 2001
Belleville, NJ / Kearney, NJ

—

You can't discuss emo now without mentioning My Chemical Romance, but the early days of the band were fraught with unintentional mystery. There were rumors that it was a side project of the already established band Thursday, that they were vampires, that they were a death metal band. Only some of those rumors were true or . . . maybe partly true. What was definitely true, however, was that after releasing an ambitious first album that felt like an emotional hybrid of Ink & Dagger and the Murder City Devils, as well as signing to a major label, the band was on the tip of every scenester's tongue. At the time, it was noted that there was this palpable feeling that something big was going to happen. What no one knew was just *how* big, and that this band would break out globally and achieve rock star status around the world.

In 2004, when the video for "I'm Not Okay (I Promise)" was released, there were so many emotions and even more opinions. Some took the stance that this was emo exploitation; others celebrated that the music that had been bubbling up for years had finally broken into the mainstream. At first the band rejected the emo label, but after years of their fans waving the emo banner all over the place (and in their faces), they accepted it and gave into the title of reigning champs of third wave emo.

Regardless of which side you were on, My Chemical Romance's success was big. Big, like your parents who had never understood the kind of music you listened to (or why your hair or pants looked the way they did) could now see it front and center on the cover of *Rolling Stone*, kind of big. And to say that the band and their music changed the scene forever would be accurate. Some of the polarizing attributes of third wave emo that tend to agitate die-hard first and second wave fans were made abundantly popular by this band and their fans— and often the outright popularity of the band infuriated other emo fans who tend to gate-keep. You can't have it both ways, though. You can't only want certain friends within the scene to be successful, but be upset when others experience that success instead. That's a rough double standard and I can't get down with it.

My Chemical Romance risked everything to be successful and "make it"—and I fucking love and respect them for it. And listen, it is impossible for me to decide whether I love *Three Cheers for Sweet Revenge* or *The Black Parade* more, so please don't make me choose a favorite. Numerically speaking, My Chemical Romance is not the biggest emo band of all time. That honor is currently reserved for Fall Out Boy. But in my opinion, they are the most influential third wave emo band. It's no surprise to see Billie Eilish and her brother, Finneas, citing them as one of their greatest influences. No other band has had such an indelible impact on pop culture, the scene, and the future waves of emo.

Photo by Justin Borucki.
Skate and Surf Festival.
Asbury Park, NJ. 2003.

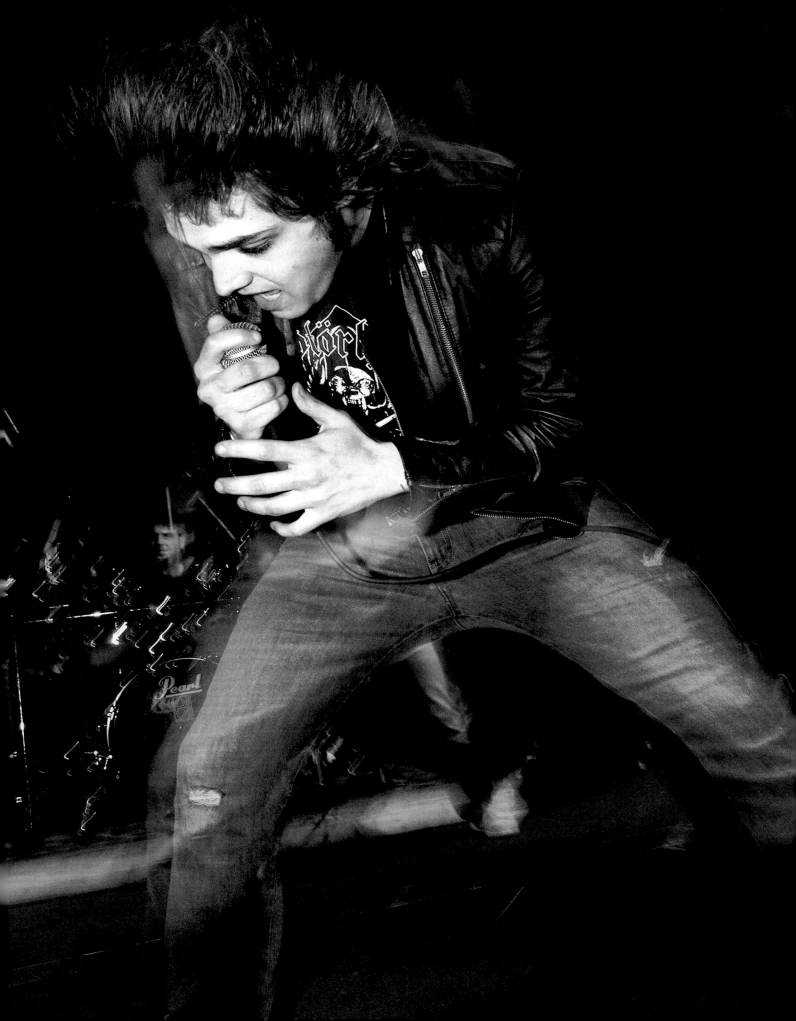

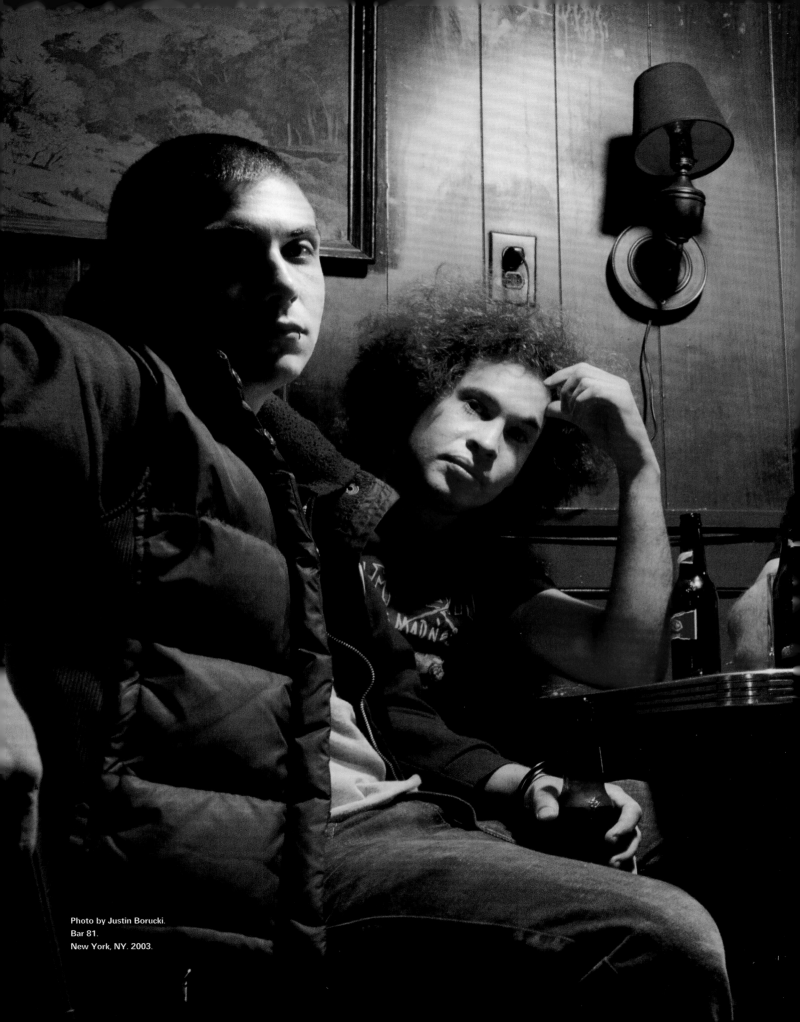

Photo by Justin Borucki.
Bar 81.
New York, NY. 2003.

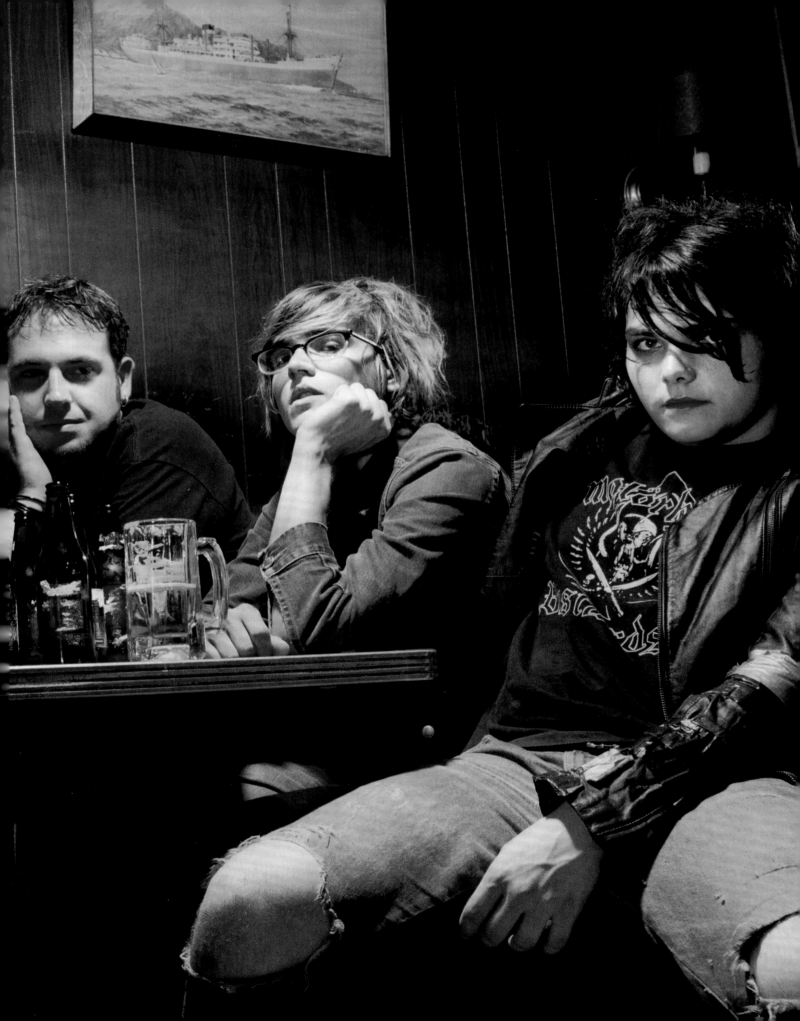

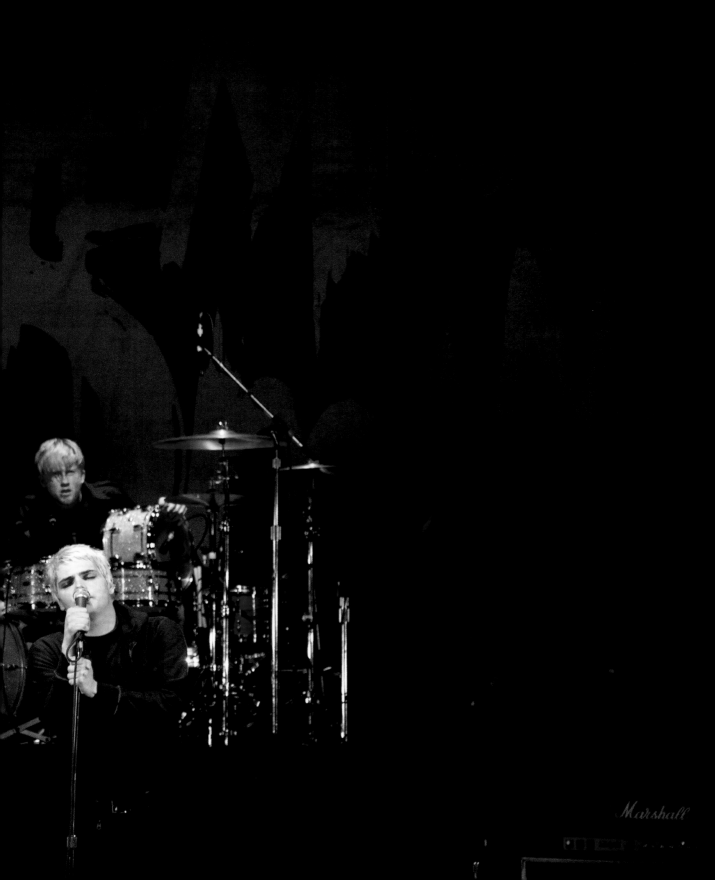

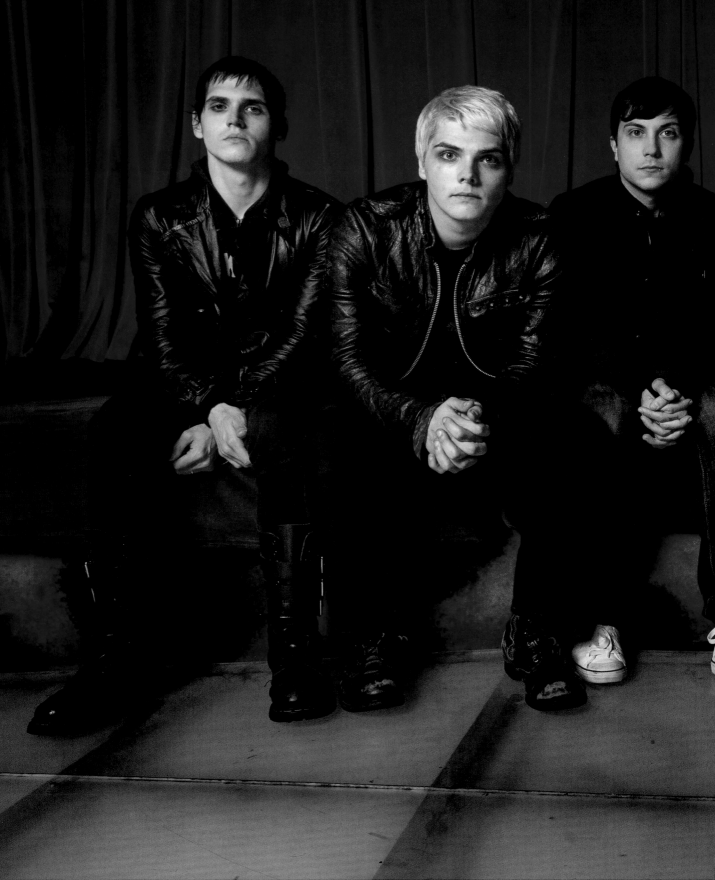

Name Taken

Est. **1999**
Orange, CA

—

Name Taken* was a solid quartet from Southern California that quickly rose to prominence after releasing a split EP with Bayside followed by a full-length album produced by Beau Burchell (of Saosin fame). The way Chad Atkinson sang, you swore he was part Muppet—he would open his mouth so wide, it looked like his head had been sliced in half like a honeydew melon for a breakfast buffet. This sort of passion and total disregard for bodily principles was mirrored by the band's fans. Name Taken's sold-out shows at Chain Reaction in Anaheim, California, early in their career epitomized the splendors of live music in its purest form. Guitars broke, people flung themselves onto the stage, and the humidity from the rabid crowd caused moisture to drip from merch-covered walls—it was wonderful, unadulterated madness. "Hold on for Your Dearest Life" is still one of my favorite songs of all time.

The website du jour of the era, AbsolutePunk.net, hailed Name Taken as the most promising band of the era, forecasting that they would change the landscape of music for all time. And in a wonderful homage to second wave giants, one year after that review, the band broke up.

Photo by RJ Shaughnessy.
In front of Shaughnessy's house.
Atwater Village, Los Angeles, CA.
2004.

254

*

There's so much irony in the fact that Panic! at the Disco, who at one point was one of the biggest bands in the world, took their name from a band called Name Taken. The phrase comes from the song "Panic," and apparently it was so perfect to a founding member that he decided to use it. You can't make this stuff up.

New Found Glory

Est. 1997
Coral Springs, FL

—

New Found Glory was the first band on my record label that broke nationally. They never even had a chance to be labeled hometown heroes because they embarked on a national tour six months after their first show. And it's wild to look back on it now. Their EP *It's All About the Girls* was in the works to be recorded and released before the band even played their first show—the buzz surrounding them just *being a band* was meteoric. The Miami–Ft. Lauderdale–West Palm Beach rumor mill loved that the band was "Chad from Shai Hulud's new band."* The EP sold out, and so did every reprint, and to be honest, their trajectory was faster than I could keep up with.

At the time, it was impossible to know the effect this band would have on this genre, as well as it's next-door neighbor, pop punk. Jordan Pundik stood front and center and sang his heart out with a voice that was a good deal higher than his peers. In the early days, this was something that was often commented on, some going so far as to imply that—oh, the *horror*—he sounded feminine. Globally, of course, this did not matter, and the not-so-smart anti-fans that used this as an out-clause for falling in love with this band fell by the wayside pretty quickly.

With their patented fast and upbeat style, New Found Glory sometimes seemed like Blink-182's more sensitive Floridian emo cousin and, when witnessed live, gave you this uncontrollable urge to run for the barricade so you could feel closer to whatever was happening onstage. The hooks, the youth-crew gang vocals, and Chad Gilbert's swirling guitar hooks became a thing of their own—the band could exist in a punk world or a pop world, and still be beloved by emo crowds en masse. The band even had merch declaring themselves "South Florida Easycore"—easycore being the obvious opposite of hardcore. (And let's thank goodness they didn't call themselves softcore, because that usually means a whole other thing entirely.)

*

Shai Hulud was a wildly technical metal/hardcore band that Chad Gilbert joined when he was only fourteen years old. The spectacle of "that kid on stage can scream like a grown two-hundred-pound man can" was a feat, sight, and sound to behold. If you need a pick-me-up of the blood-curdling kind, listen to "Solely Concentrating on the Negative Aspects of Life." This song still makes my heart stop a little, or like, a lot.

Photos by RJ Shaughnessy.
Somewhere in Florida. 1999.

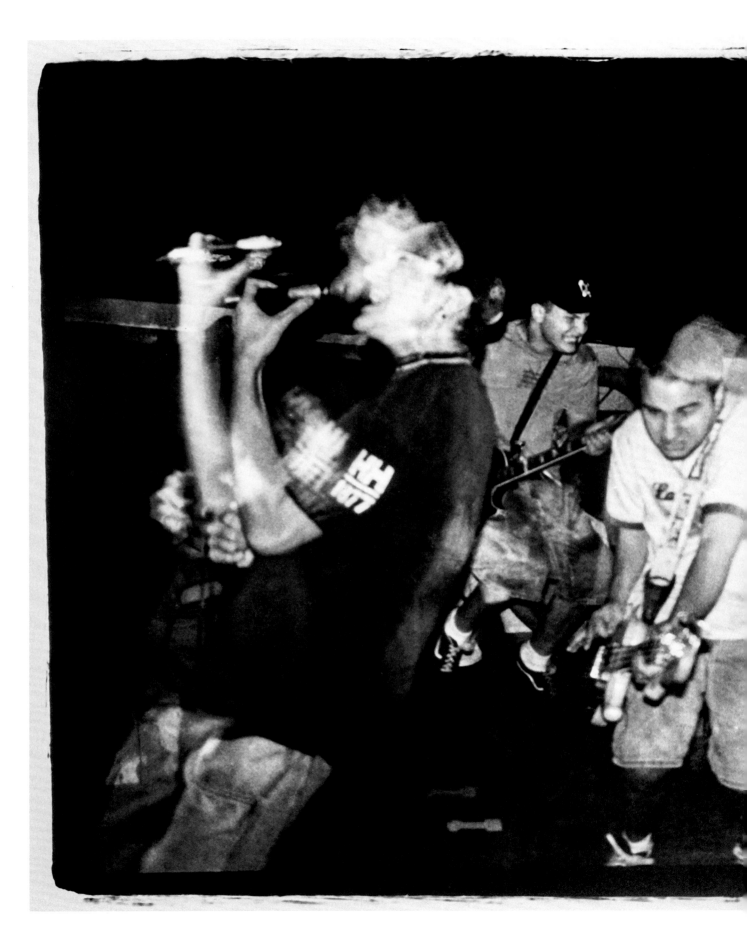

Photo by Lisa Schwalbe Boland.
Cheers.
Miami, FL. 1997.

"This is a photo of New
Found Glory's first show.
Lisa Schwalbe Boland shot
this and a few weeks later
was kind enough to give me
a print of it. I used this
photo on the back cover of
the band's debut EP, and
I've kept the original print
that Lisa gave me in an
envelope for over twenty
years—just keeping it safe
for a moment like this."

—Amy Fleisher Madden

Paramore

Est. 2004
Franklin, TN

—

Relatively speaking, I would consider Paramore the last third wave band to break into the mainstream. When I first came across the band, I had to just tune the world out for a moment and listen. It was emo—I was sure of it—but it was also really poppy. You could feel the nods to earlier third wave predecessors like Saves the Day, but it was also aggressive, with artifacts of hardcore and post-hardcore from bands like H20 peeking through. This wonderfully calculated hybrid dynamic was perfectly topped with female vocals and this band became an instant game changer.

The end of the third wave was a confusing time. There was a palpable feeling of change, and everything sounded newer. Songs were highly polished, recordings were almost always digital, and you could just feel a changing of the guard. Earlier third wave bands like Dashboard Confessional, and even second wave bands like The Get Up Kids that had stayed the course, began trying to plot their trajectory and find the sounds to fit, but younger fans seemed hungrier for the new bands, oftentimes ambivalent to the older ones. Peers like My Chemical Romance and Panic! At the Disco had predecessors who helped usher them through, one way or another—Thursday and Fall Out Boy, respectively—but Paramore had to blaze their own trail altogether. Not only that, but their salad days were filled with micro (as well as macro) aggressions from a predominantly male-leaning scene. It makes me feel all sorts of terrible that that's the world we came from, but all I can do now—and encourage you all to do, as well—is take the steps to make sure that's not the world we're heading toward.

Check out this prolific band's entire catalog, snout to tail—if you like a more upbeat sound, you won't be disappointed. Paramore has become one of the greatest pop acts of the era. (I may or may not be spinning their single, "This Is Why," right now.) And despite leaning toward pop, and despite reinventing themselves sonically and visually with each album, their early roots in emo can still be felt and heard breaking through in melodies or *chugga-chugga* breakdowns—or you know—seen with members of Paramore donning an At the Drive-In T-shirt.

Photo by Ilene Tatro.
The Rocket Summer, Nightmare of You, Brandtson, Paramore tour at SOMA.
San Diego, CA. 2006.

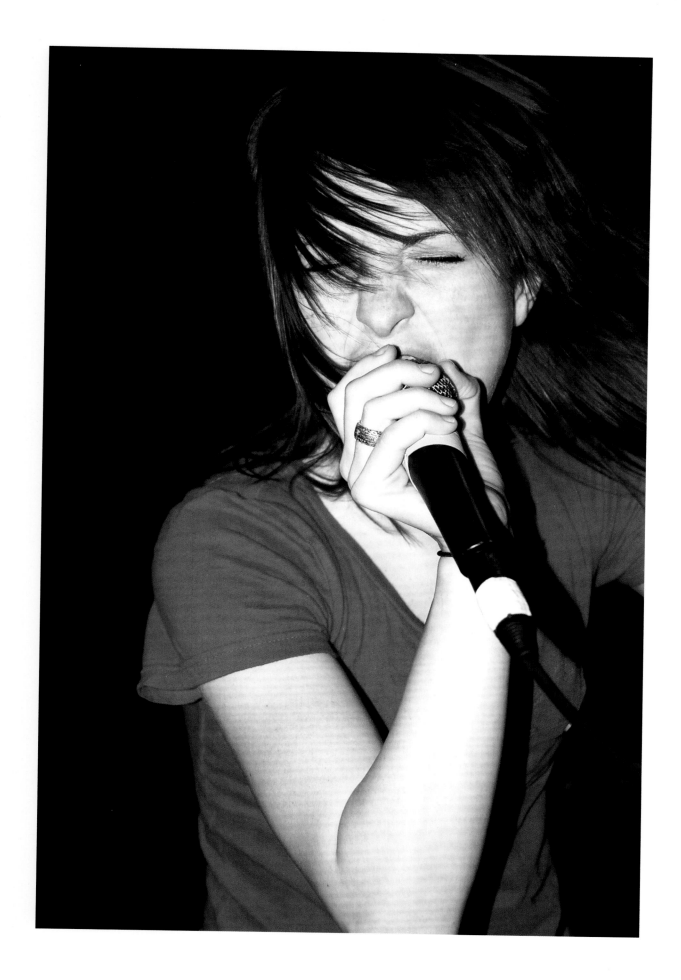

Photo by Ilene Tatro.
The Rocket Summer, Nightmare
of You, Brandtson, Paramore
tour at SOMA.
San Diego, CA. 2006.

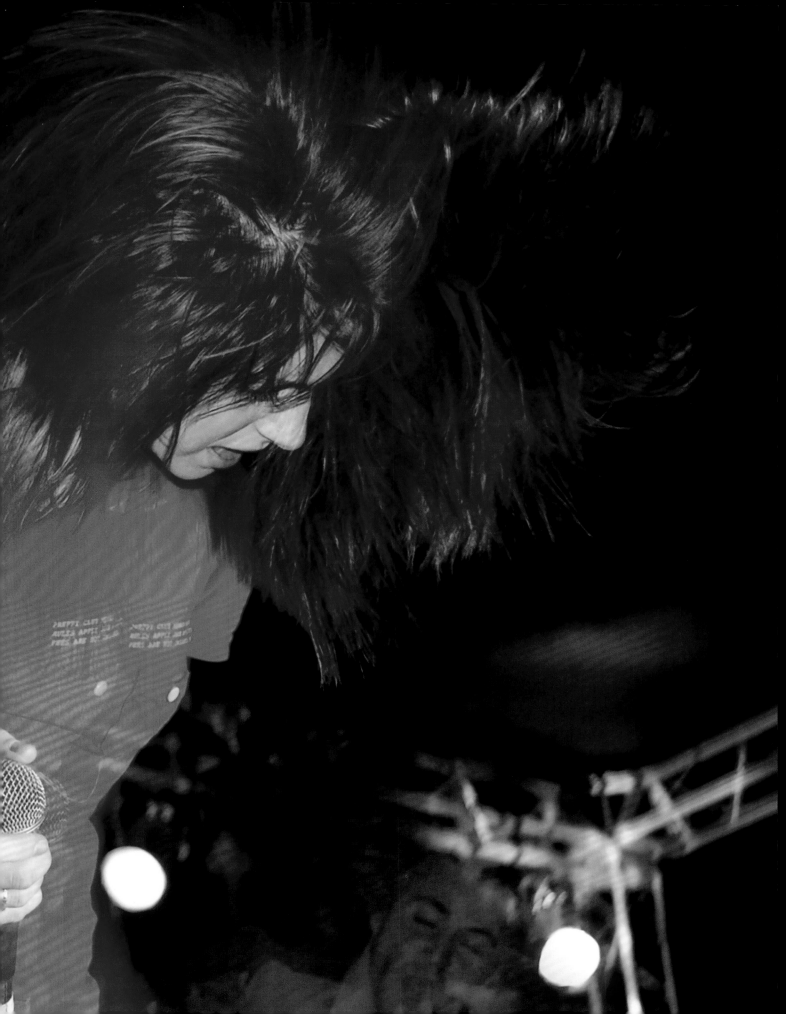

Recover

Est. 2000
Austin, TX
—

Recover is an anomaly. They were four neighborhood friends who met when they were six and survived adolescence and the horror that is high school together. They formed a band and made it, all without lineup changes, drama, or losing their cool.

To be around Recover in their prime was like stepping onto a speeding train and throwing all sense of normalcy and sobriety out the window. They had their own culture, their own style—at times, it felt like they spoke their own language. Everything had a nickname, a story, a reason to be the way it was.

The band released their first album, *Rodeo and Picasso*, on a budding label called Fueled by Ramen, and gained a following very quickly; but what solidified them as a household name was their sophomore release on Fiddler Records, an EP. These five songs, *Ceci N'est Pas Recover*, became an emo how-to guide that has often been mimicked but never recreated. A candid conversation with any other band of the era will reveal that this EP was the impetus for the stylistic change in emo during the early 2000s, where things took a heavier, more artful, and more dramatic turn.

Recover's repertoire serves as a treasure map for finding the way back to some of the most heavy-hitting songs written and recorded in this era.

Photos by RJ Shaughnessy. 264
Shaughnessy's bathroom.
Silverlake, Los Angeles, CA.
2002.

"RJ had a really strange bathroom that had an electric-light-bulb chandelier, and he always wanted to shoot a band in there just because it was so odd. Right after the Recover EP came out, we wanted to do a photo shoot with the band involving water, a nod to their song 'Inhale Water.' We ran with the opportunity."

—Amy Fleisher Madden

Photos by Vincent Perini.
Music Lab rehearsal space.
Austin, TX. 2001.

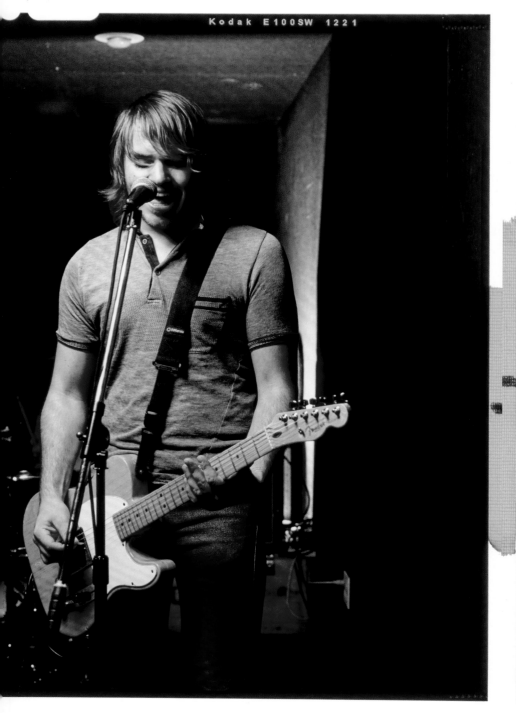

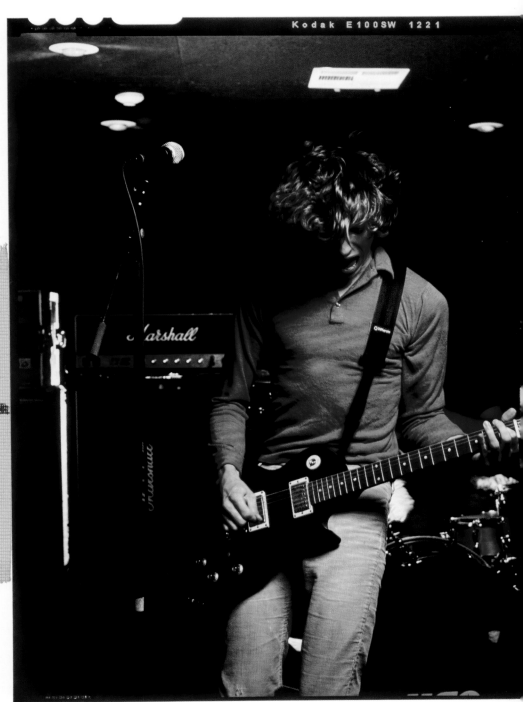

Rival Schools

Est. **1999**
New York, NY

—

Rival Schools was a Walter Schreifels–led band that came out of the dissolution of Quicksand, an essential first wave emo band.* Schreifels was a pillar of the late '80s and early '90s hardcore community, boasting membership to several foundational bands like Youth of Today and Gorilla Biscuits. (He's been in many others, but your homework starts with those two if you haven't yet heard them.) And then, after Quicksand disbanded in 1995, music from Schreifels was sorely lacking. It wasn't until 2001 that he officially resurfaced with Rival Schools, his most melodic and pop-leaning effort to date. This band was actualized with former bandmate Sammy Siegler from Youth of Today and the always crowd-pleasing punk/hardcore outfit CIV, Cache Tolman from the post-hardcore jazz-fusion wizards Iceburn, and Ian Love from Supertouch.

This was a big deal for us. Here is, of all things, my recollection of a conversation I had with Quicksand superfan Chris Carrabba late one night in whatever random parking lot we were sitting in:

CARRABBA: Walter Schreifels has a new band.
ME: The guy from Quicksand?
CARRABBA: And Youth of Today and Gorilla Biscuits . . .
ME: Right. But, that guy?
CARRABBA: Yeah, the band is called Rival Schools United by Fate.
ME: What kind of name is that?**
CARRABBA: A good one.
ME: Totally a good one.

Of course, once the band's debut album was released, we realized the band was just called Rival Schools and the album was called *United by Fate*. Anyway, they shredded, and it was a tall drink of water for those of us who had thirsted for the next Walter Schreifels project. If you need a place to start, jump in on "Used for Glue" and turn it up.

*

I have not spent much time speaking about the first wave of emo for many reasons—mainly that I wasn't old enough to really experience it. My impression of things is only valuable if it's real, and to front like I was there would be total bullshit. I can tell you that, when I was fourteen, I caught the tail end of Quicksand's set when they headlined the first ever Warped Tour in 1995, and that was really amazing to see. I was also really stoked to see half-pipes in a parking lot, because that's what Warped Tour used to be about.

**

The band's name was taken from a Japanese video game released by Capcom in 1997. Ka-pow.

Photos by Michael Dubin.
The Melody Bar.
New Brunswick, NJ. 1999.

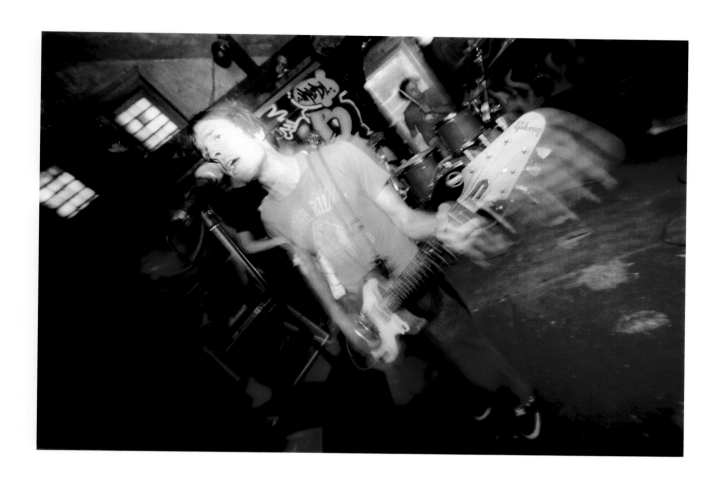

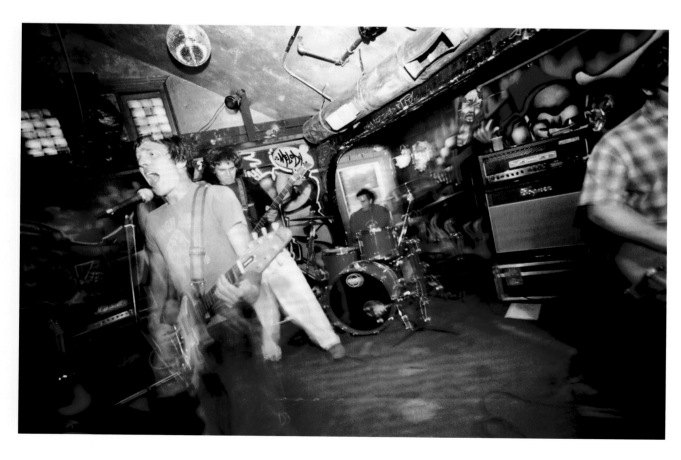

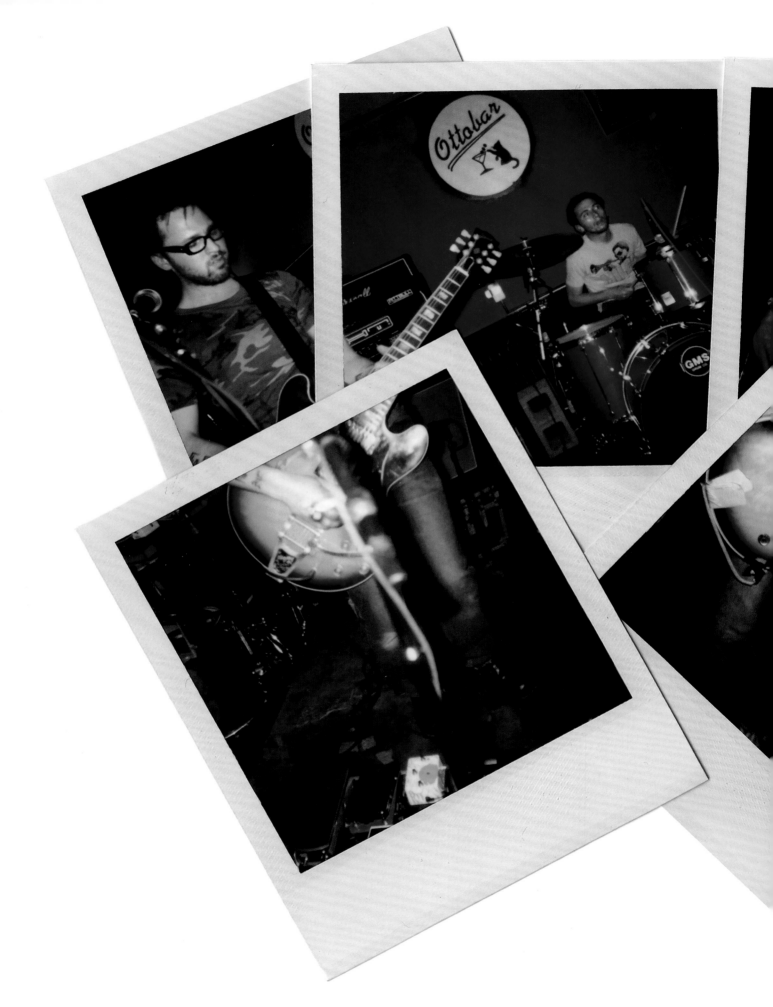

Photos by Michael Dubin.
The Otto Bar.
Baltimore, MD. 2001.

Saosin

Est. 2003
Costa Mesa, CA

—

Saosin seemed to have appeared out of nowhere. It's a phenomenon that happens when a band is able to fully utilize an online platform, or harness some sort of social media movement—we saw it back then and we still see it now.

Before the band even had a drummer, an eager fan posted two of their demos on AbsolutePunk.net, "Seven Years" and "Lost Symphonies." The rest is history. Sort of.

Beau Burchell and Zach Kennedy were in a brilliantly heavy post-hardcore band called Open Hand, but the band's helmsman, Justin Isham, wasn't really responding to Beau's songwriting efforts, so Burchell and Kennedy decided to jump ship. Once they fleshed out some material, the search for a singer was underway. Beau had his sights set on Keith Goodwin from the band Days Away, but in a strange twist of fate, Keith suggested his friend from Pennsylvania, Anthony Green, instead of taking the opportunity for himself. After some excited phone calls between Beau and Anthony, demos with vocal tracks appeared in the mail two weeks later.

Green wrote the rest of the lyrics for the remaining instrumental tracks that would come to be known as *Translating the Name* (or referred to in jest as "The White EP" after The Beatles' iconic album). He also gave the band their forever-debated name.* Once this EP was out, you couldn't look at an emo-related message board without seeing a post from a user asking, "Have you heard of Saosin?"

There were so many reasons Saosin was being talked about. There was something so special about those demos and that first EP. Bands killed themselves to sound anything remotely like Saosin, and most were unsuccessful. At the time, nobody in this scene sounded like Green. Nobody dared scream the way Green did—because they couldn't. And even if they could, it didn't sound as controlled or as melodic. There's something about his voice—ephemeral, angelic, sincere—that made Saosin different.

But the secret of Saosin was the constant push-pull between Green's vocals and the seamless sonic hurricane that was Burchell, bassist Chris Sorenson, and drummer Alex Rodriguez. And their early live shows were absolute mayhem—being anywhere near the band while they were performing was a downright frightening experience. Watching Green finding his way as a vocalist and front man felt like experiencing a demonic possession. And you were also a bit in danger of getting hit by a flying guitar.

Unfortunately, by 2006, Green had parted ways with the band and was replaced with Cove Reber for a while. But some years later, Reber departed, and Green reconciled with the band.

If you're new to this trailblazing outfit, start with *Translating the Name*. By the time you get to "3rd Measurement in C," you'll be hooked.

*

SAY-OCEAN or SAY-OH-SIN? PO-TAY-TO, PO-TAH-TOE.

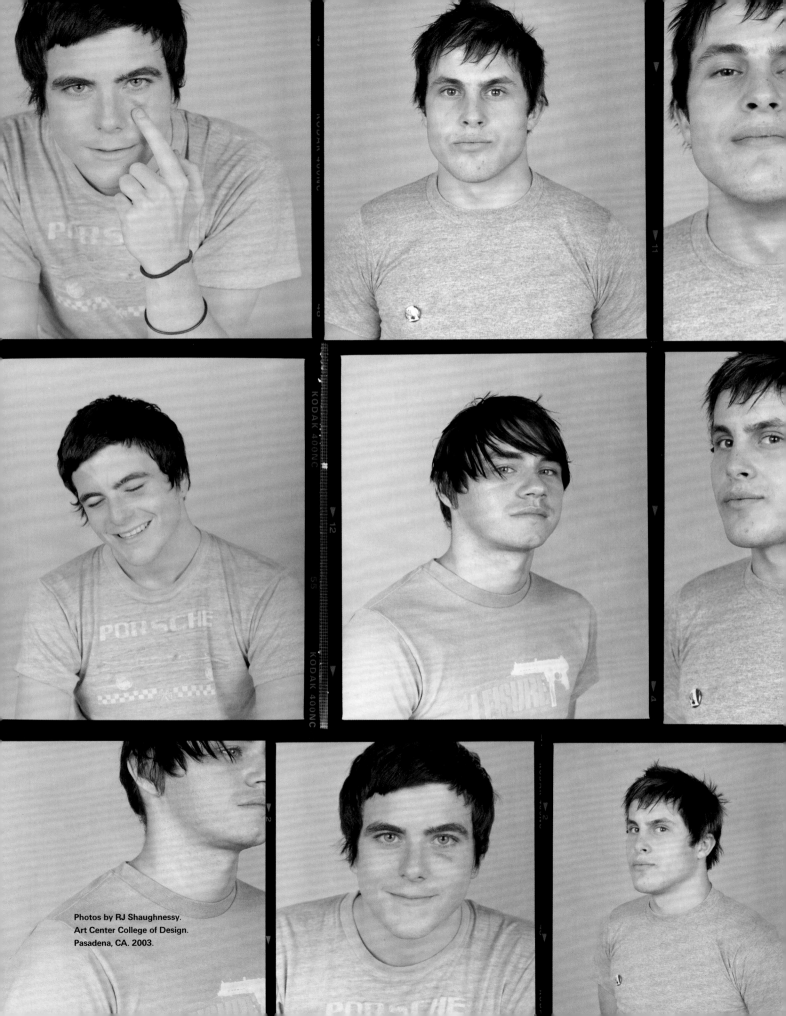

Photos by RJ Shaughnessy.
Art Center College of Design.
Pasadena, CA. 2003.

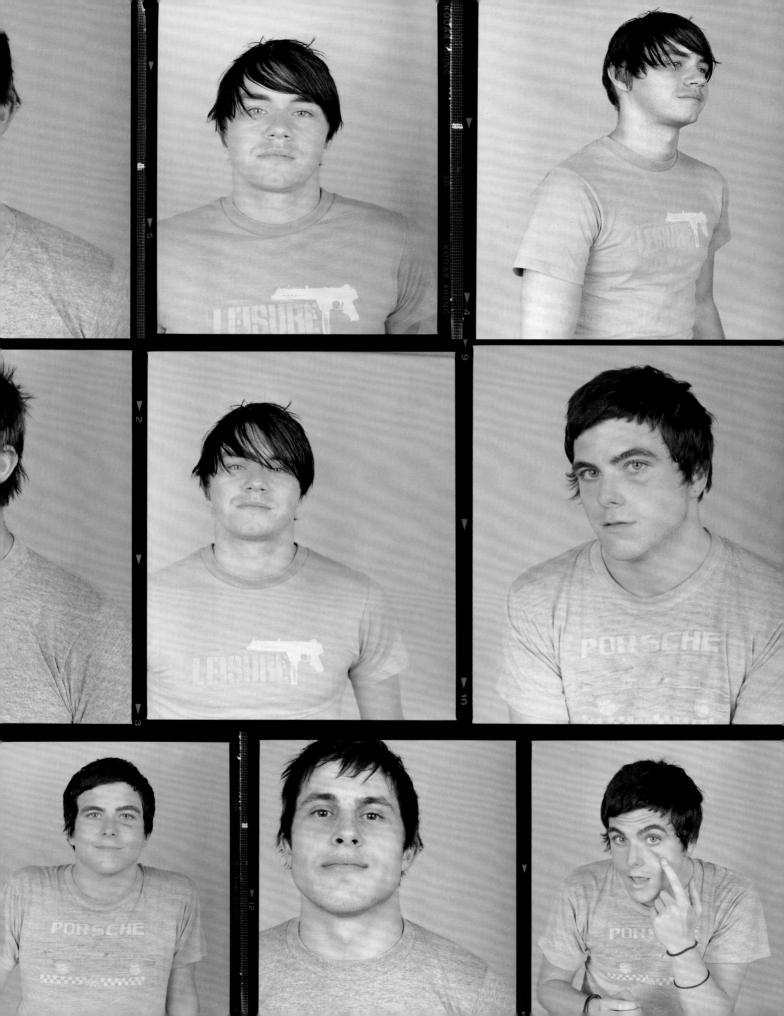

Saves the Day

Est. 1997
Princeton, NJ
—

I toured with Saves the Day during the *Through Being Cool* era, and did A&R at Vagrant Records through the recording and marketing of *Stay What You Are*. For some bands, once you see behind the curtain, the magic loses its wonder. This was the opposite. My proximity to the band only made me love them and their music more. My love for this band and what they mean to me is what fuels me to create things like what you're holding—because I know there are other people who feel the same way about so many other bands in this book.

Though Saves the Day started with a very Lifetime-influenced sound (listen to *Can't Slow Down*), they evolved quickly into one of the most original bands of the third wave. Vocalist Chris Conley's lyrics are introspective, often haunting, and always poetic. They are set to music that is emo and pop and rock, with all aspects blending harmoniously. Once *Stay What You Are* was released, a good handful of their peers tried to take their lyrics to that darker, more poetic place, attempting to create a similar soundscape universe. But honestly, no one else came close.

If you need a jumping off point, you can't go wrong with *Through Being Cool*, but my personal favorite is *Stay What You Are*.

Photo by Kevin Kusatsu.
Somewhere in America. c. 2001.

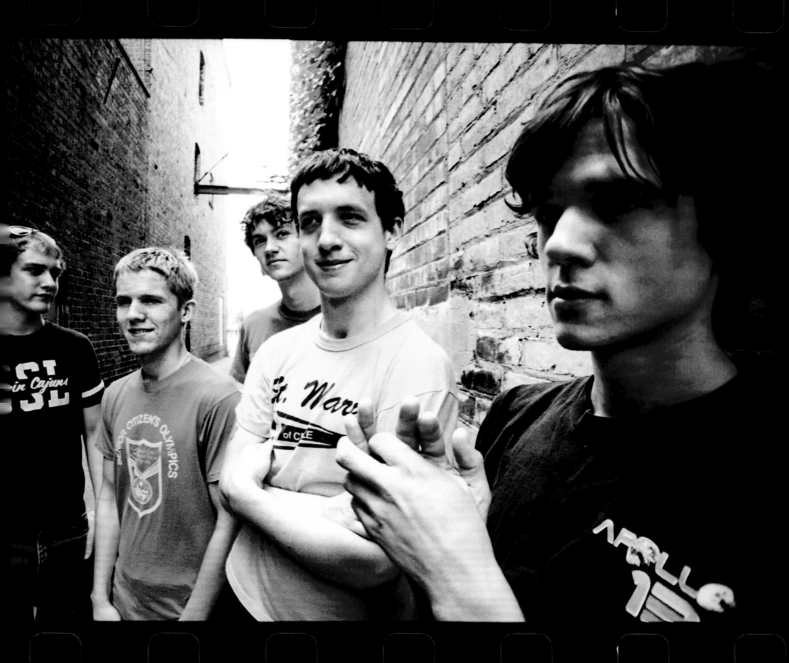

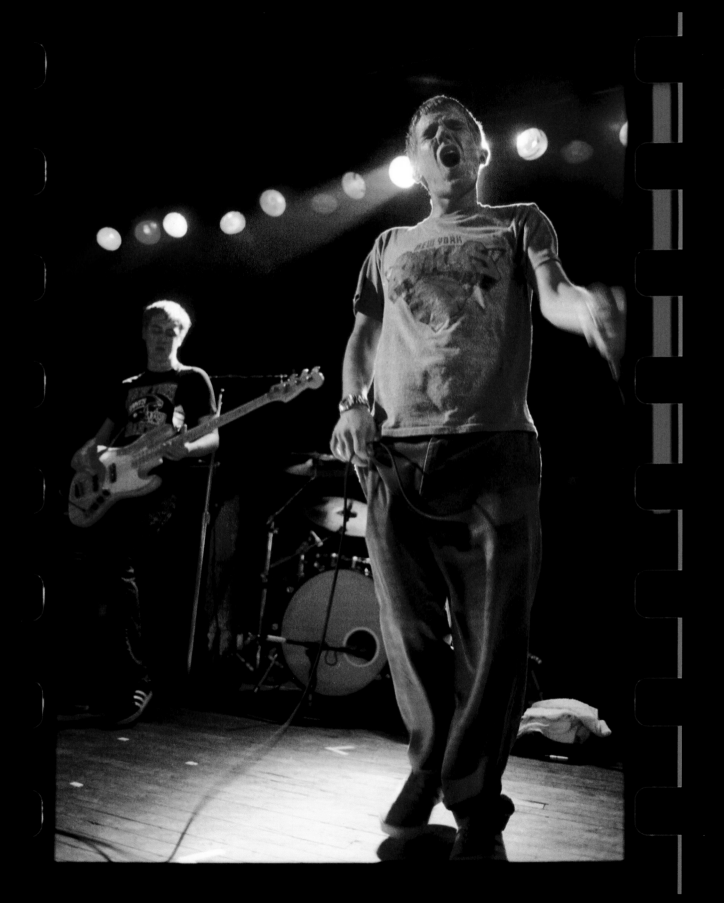

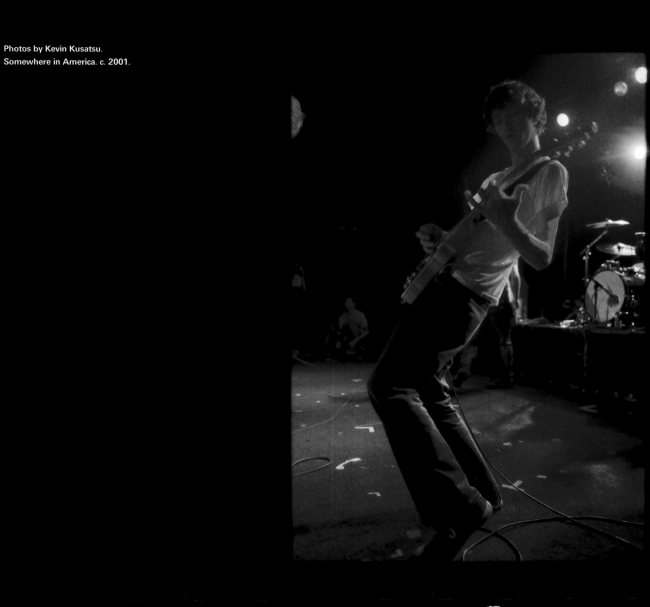

Photo by Justin Borucki.
Continental Airlines Arena
on tour with Weezer.
East Rutherford, NJ. 2003.

Say Anything

Est. 2000
Los Angeles, CA

—

You know that phrase, "Game recognize game?" For me, Say Anything is kind of like that. But our phrase would be "Fan recognize fan." Max Bemis, who for all intents and purposes *is* Say Anything, is and was a fan. The first time we spoke, at a show at the El Rey in Los Angeles, we bonded over our mutual love of all things emo. I felt like I had made a great new friend who loved this niche corner of the universe as much as I did.

Say Anything is the embodiment of all of Bemis's undeniable talent. He has the wild ability to jump from epic, self-aware ballads penned for a rock opera, to crushing pop hits, and on to what in less capable hands would be ill-conceived youth-crew/gang-vocals dance jams but through his lens are somehow beautiful and brilliant songs. This is no easy feat. Even harder is pulling it off live, which he has always done, backed by his rotating cast of band members, carefully selected for each album cycle.

Bemis is an incredibly offbeat genius, and songs like "Alive With the Glory of Love" are proof. The tune is an unexpected rock/emo/pop sing-along set in, of all places, a WWII concentration camp. It feels safe to say that's never been done before.

It's also worth noting that Bemis has this uncanny ability to tap into the zeitgeist and reference it conversationally, which is ridiculously hard to do without sounding pretentious. In "Woe," when he gave us the line, "I can't get laid in this town without these pointy fucking shoes," it was at a very particular moment during emo's adolescence when most of us had stopped wearing Chuck Taylors and sitting in parking lots, and started going out to bars at night, wearing heels and "grown-up" shoes.* We were finally of age and attempting to act like full-fledged adults and for him to be able to take a reality and a feeling and encapsulate it in song form in such a facetious, unexpected way is beyond rare. This song and every other one on the album speak to me, loud and clear . . . *Is a Real Boy* is a classic, and it still holds up perfectly over twenty years later.

*

I still don't wear "grown-up" shoes.

Photo by Emily Shur.
Amy Fleisher Madden's Lower East Side apartment shooting the cover of *Death + Taxes* magazine.
New York, NY. 2006.

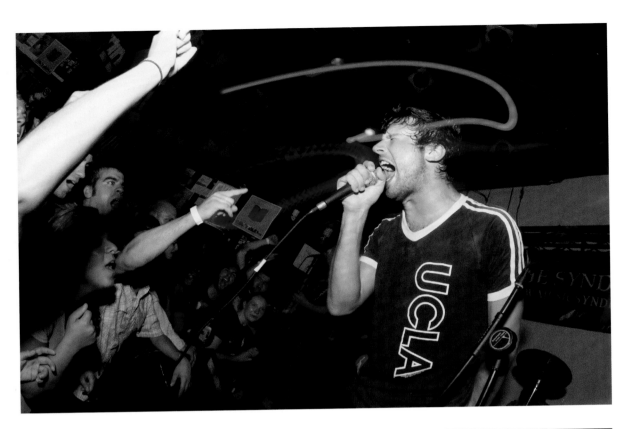

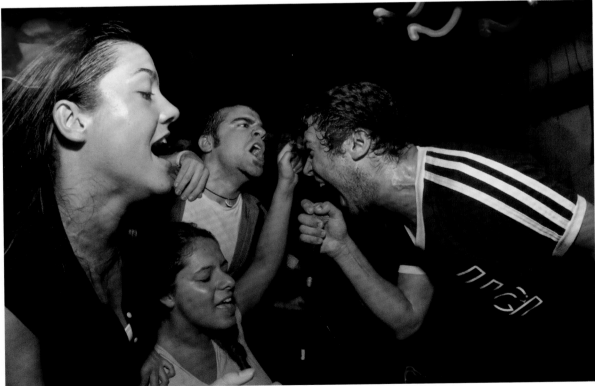

Photos by Brian Woodward.
CMJ Showcase at Downtime.
New York, NY. 2005.

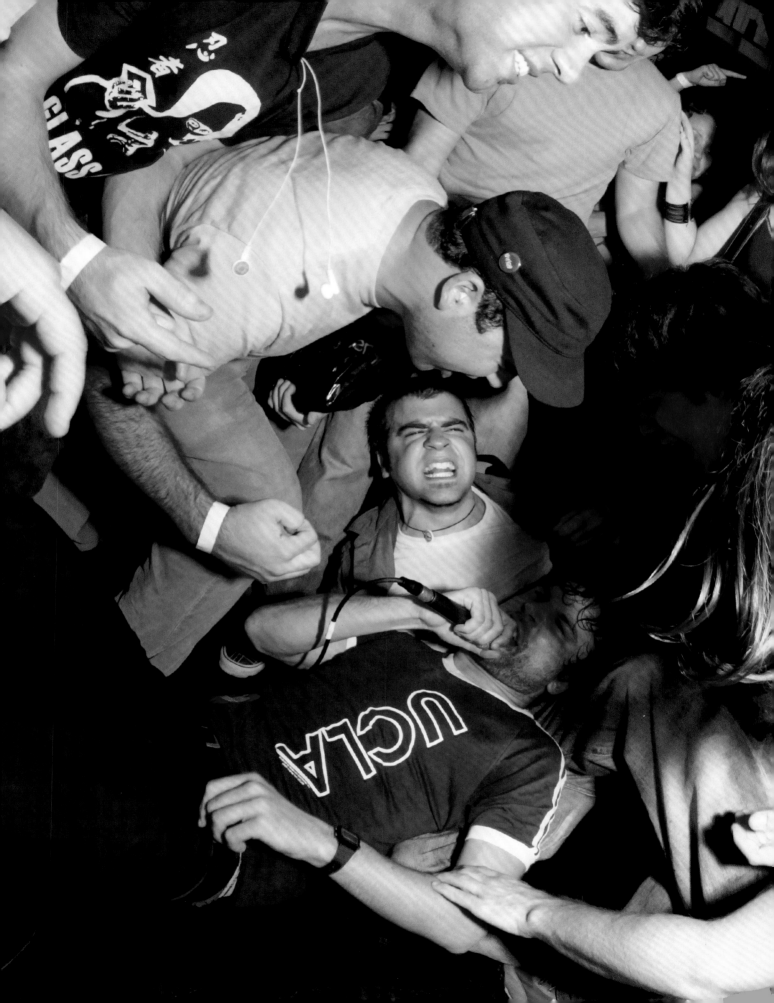

Senses Fail

Est. 2001
Ridgewood, NJ

—

Senses Fail lands on the heavier side of third wave emo bands, never in short supply of a guttural scream powerful enough to make you need to sit down and catch your breath. This band is proof that your fans can carry you through the darkest of times.

For a moment, it seemed that the only consistency for Senses Fail was inconsistency, as they switched labels and swapped band members numerous times. The mainstay of the band never faltered, and James "Buddy" Nielsen became the poster boy of his own movement, telling us all to just hold fast and keep going. With the support of thousands of fans backing him, he made it through to steady ground, and the band released several solid records. *Let It Enfold You* is a great jumping off point for submerging yourself in this band's world.

Photo by Justin Borucki.
New York, NY. 2003.

286

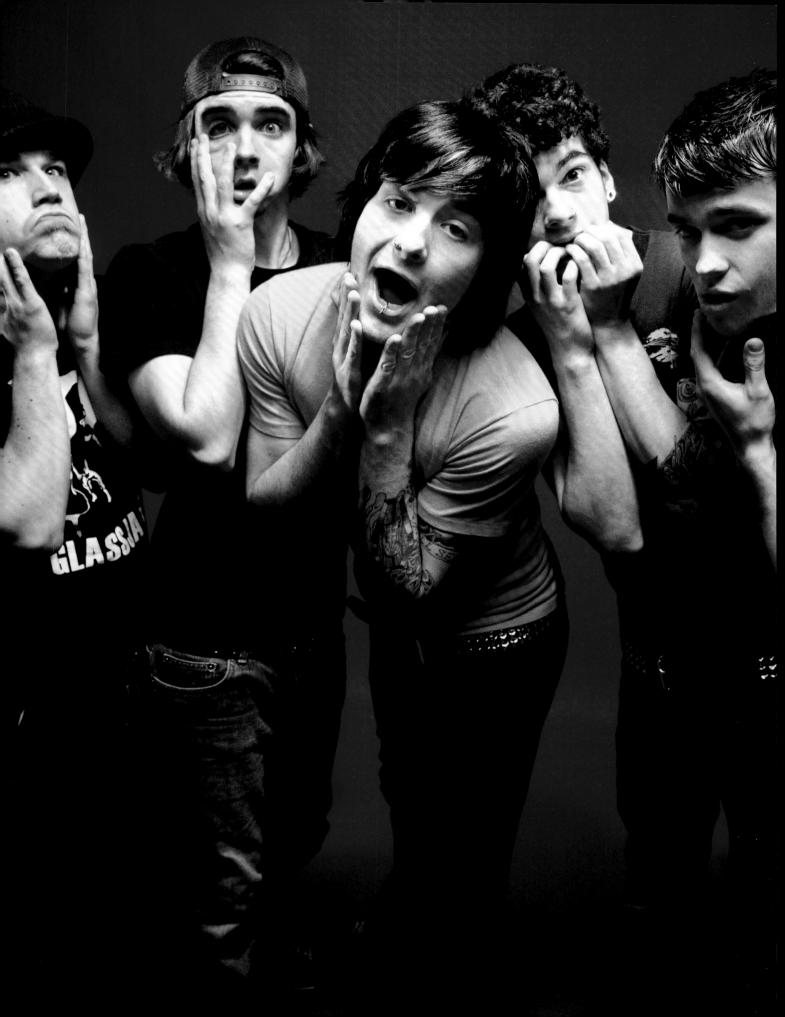

Silverstein

Est. 2000
Burlington, ON, Canada

—

When you name your band after one of my favorite children's authors and the artwork on your debut LP is a robot reminiscent of *The Iron Giant*, you have my attention. I wasn't the only person who noticed, though, and Silverstein took the scene by storm. Admittedly, I am out of my depth when it comes to the intricacies of Canadian emo culture,* but I can tell you that when Silverstein rolled into town in the United States, the crowds showed up in droves—and they still do.

The band appealed to the legion of fans into heavier-yet-melodic third wave emo and harnessed their thirst for more spine-shaking vocals and mosh pit–inducing breakdowns. Toward the end of the third wave, it was clear that there were two camps, and while some belonged in both, most tended to favor one over the other. The first camp was full of buoyant pop-punk sweethearts like Motion City Soundtrack and Something Corporate, while the second contained the heavier, more turbulent metal/post-hardcore sound heard with Saosin, Senses Fail, and, of course, Silverstein.

Regardless of whichever camp you reside in, both are incredible in their own ways, and there's something here for everybody.

*

I've never been to a show in Canada. Someone please invite me—and can I sleep on your floor?

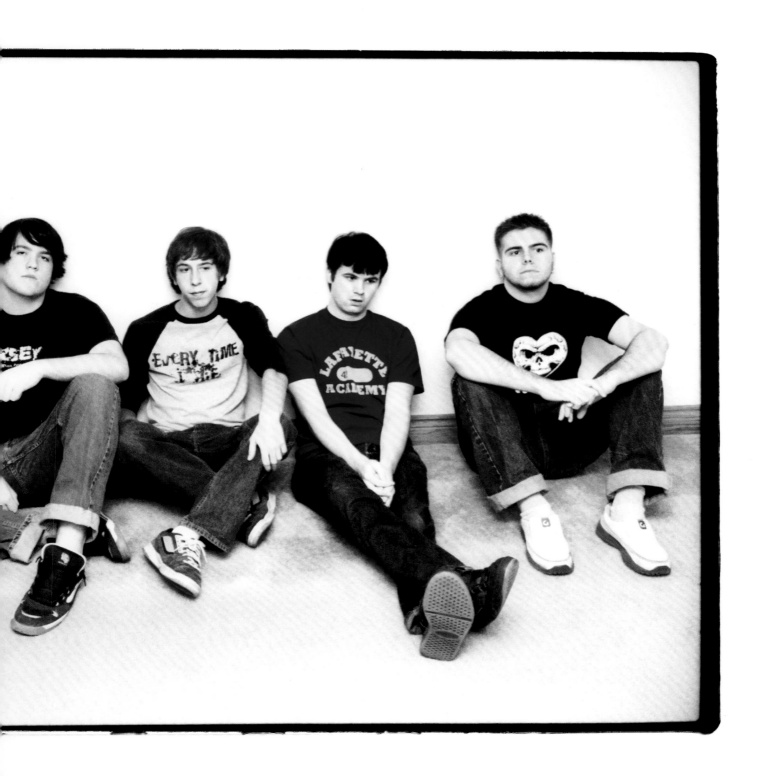

Photo by Gordon Douglas Ball.
At the Boy's Night Out house.
Burlington, VT. 2002.

Something Corporate

Est. 1998
Dana Point, CA

—

Sometimes, when you see a person play or hear them sing, you just know there's no other life for them. There's no college backup, there's no office job that will cut it, there's nothing else for them — they *have* to create art or they will *lose their minds*. Andrew McMahon is one of those people. The man was destined to be in a band on stage, always, and Something Corporate was the first jump for him.

For some people, Something Corporate — or SoCo, as the kids called them — was the end all be all of third wave emo, which makes sense, because when you add up the albums sold and shows played by this band, you can't deny their résumé. I swear I couldn't walk through a mall in 2002 without hearing "I Woke Up In a Car" or "If You C Jordan."

McMahon has carried on with other projects (Jack's Mannequin and Andrew McMahon in the Wilderness), and now twenty years into his career, it's just really amazing to see how far he continues to go.

Photo by Tom Cheney.
Nation.
Washington, DC. 2004.

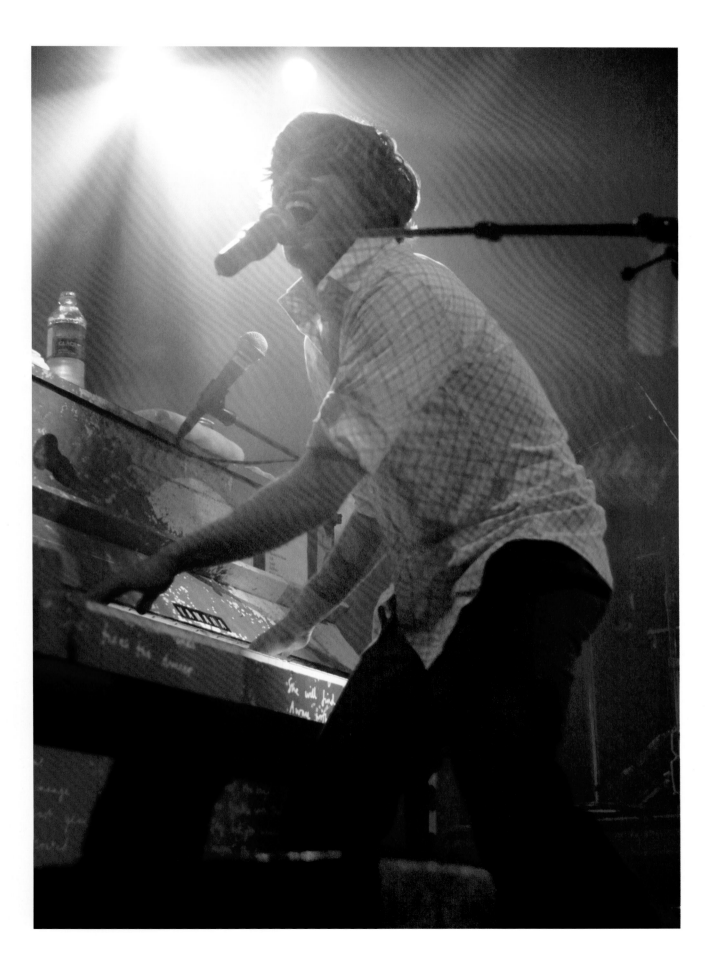

The Starting Line

Est. 1999
Churchville, PA

—

If we were playing Pictionary and I picked *The Starting Line* out of the bowl, I would draw a zip-up track jacket. The band took the classic Adidas fit, but slapped its own logo on it in glorious hurried silkscreen ink, and just like that, the merch game changed. The Starting Line was a gentler, heart-on-my-sleeve band. They were more focused on hooks and melodies than pushing the envelope—like, why reinvent the track jacket when it's totally fine as is? While they sound like someone put New Found Glory, Midtown, and Saves the Day into a blender, somehow they don't sound derivative. They have their own thing, and it's fun, and it works. Check out "The Best Of Me"; it's not to be missed.

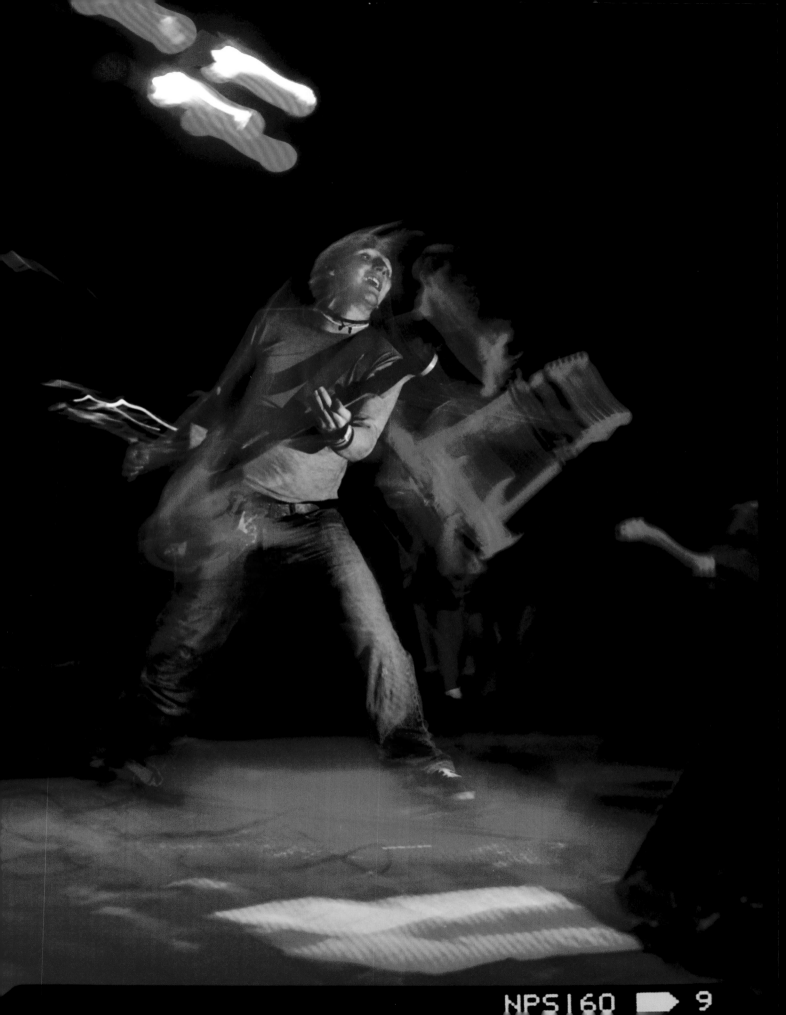

Straylight Run

Est. 2003
Long Island, NY

—

"Still I'm convinced wondering 'what if' is the worst thing there is."

I want to tell you this lyric is about John Nolan wondering if he should leave Taking Back Sunday. I want to tell you that this lyric is about a massive feud between Taking Back Sunday and another Long Island band. However, I can't tell you either of these things because I am not John Nolan and I am not a mind reader. What I can tell you is that if I had to make a Rob Gordon top five list of my favorite songs of the era, I would tear my brain apart having to choose between "Mistakes We Knew We Were Making" and "Existentialism On Prom Night"— because if I'm only given five, two of the spots can't be occupied by the same band. I simply can't choose between them, though; they're both a masterclass in all things emo.

Anyway, it's impossible to talk about Straylight Run without first mentioning Taking Back Sunday. After their first album, founding members John Nolan and Shaun Cooper departed from the band. Nolan was sitting on a handful of songs that he felt weren't quite right for TBS, so this was his opportunity to do something with them. Nolan and Cooper borrowed Mark O'Connell from TBS before enlisting Breaking Pangaea's drummer, Will Noon, and Nolan's sister, Michelle DaRosa. What resulted were a handful of demos that took the scene by such surprise, I don't think some of us ever fully recovered.

On those demos, you can feel and hear Nolan's newfound creative freedom. You can feel him deciding to make a change, you can hear the desperation in his voice that he needed to be heard, and you can fully appreciate what it is to have Nolan in the driver's seat alone for the first time.

Nolan and Cooper have since returned to Taking Back Sunday, but Straylight Run was a good answer to a difficult question. Surely there comes a time in most bands' careers when an unhappy member wonders, "Is the grass going to be greener on the other side?" The toughest choice can pay off. Take a look at Chris Carrabba and Anthony Green. For Nolan and Cooper, even if it was briefly, they successfully said yes.

If you can find the original demos (ya'll heard of Napster?), do yourself a favor and listen to "Mistakes We Knew We Were Making" as loud as you can. When John Nolan yells, "You can't go home again," try not to get chills. I dare you.

Photo by Justin Borucki.
SIR Studios.
New York, NY. 2003.

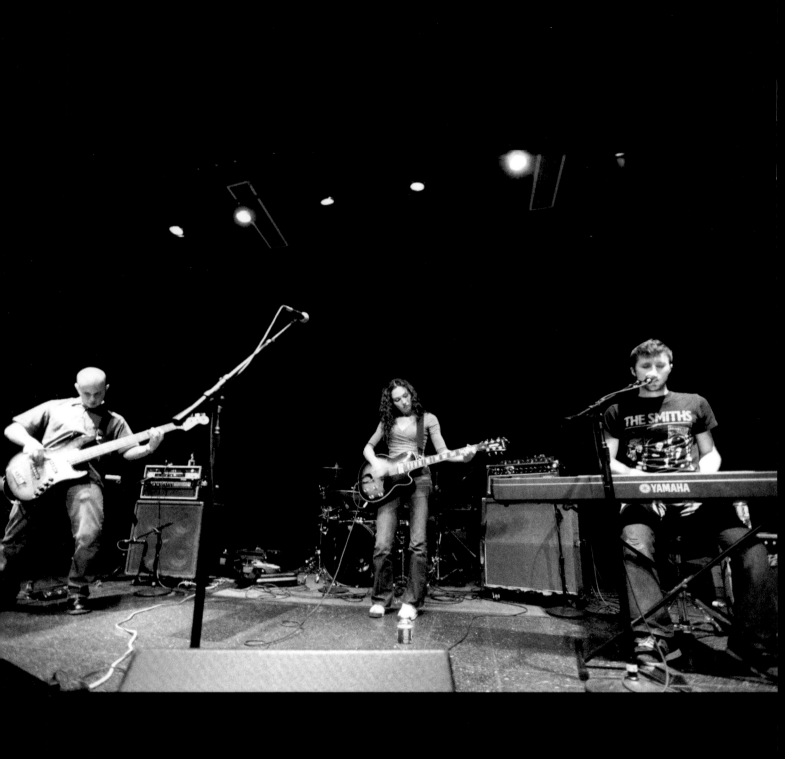

Taking Back Sunday

Est. **1999**
Long Island, NY

—

"Sign my band, or I'll kill you."

There are so many notes from my past that I wish I had saved, and this handwritten note attached to the Taking Back Sunday demo I received in the mail in late 1999 is one of them.

By that time, I was receiving about one hundred demos a week, so the one that threatened murder stuck out just a little bit.* I promptly put the CD-R into my car's stereo and listened to it on my way home from the post office. I still remember how taken I was by these two distinct yet entangled voices as I drove down Beverly Drive (shout out, Death Cab). The vocals had a call-and-response cadence, which I know had been attempted before, but I hadn't heard it done this well. It was sort of like the first time I had expensive sushi and was like, "Oh, fuck, *this* is what tuna tastes like?" I was hearing the new gold standard of emo vocals and knew Taking Back Sunday was about to set the bar so high.**

Taking Back Sunday brought the energy, brought the intensity, and sometimes, they brought the drama. There were several internal and external fissures throughout the years, but thankfully, all past and present band members have hashed things out without bloodshed. Taking Back Sunday's artistry and panache is 100 percent unmatched. If Kevin Devine is the Paul Simon of emo, vocalist Adam Lazzara is the scene's Elvis. The hips, the moves, the mic swings—I will forever be all shook up.

TBS writes hard-hitting, life-mirroring songs that you can't help but sing along to. Whether you even know the hook or not—their music just hits you with the need to catch the melody. And while they've continued to reject the emo label, the emo label forever accepts them, and you know what they say: If it walks like a duck, and swings a mic like a duck . . .

*

Tip: If you're in a band and you're sending out demos, while this did catch my eye,
I generally don't recommend this approach.

**

By the time I responded to their death threat, they had already signed with someone else.
I blame the speed of the postal service for this egregious error in A&R timing.

Photo by Justin Hollar.
New York, NY. 2006.

Photos by RJ Shaughnessy.
Art Center College of Design.
Pasadena, CA. 2003.

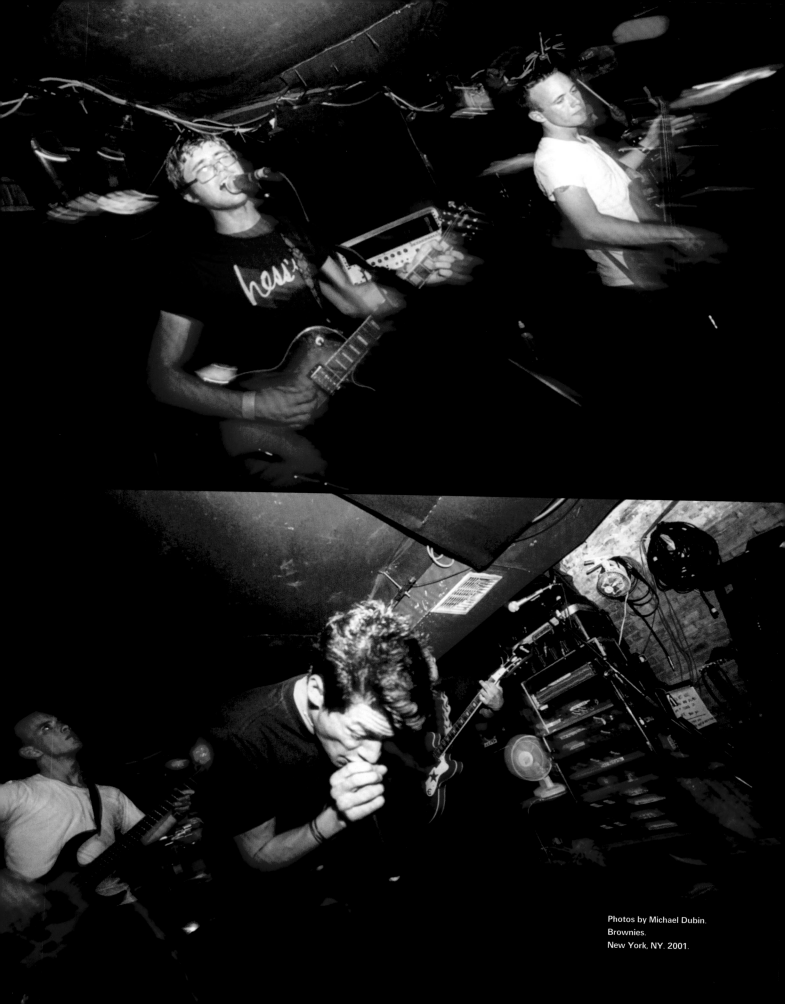

Photos by Michael Dubin.
Brownies.
New York, NY. 2001.

Thrice

Est. 1998
Irvine, CA

—

Thrice harnessed the fog of teenage angst and rebellion surging through the veins of every Orange County kid in the early aughts and turned it into something positive. Sometimes hardcore was just too hardcore, and metal too metal—enter Thrice, a perfect blend of hardcore, metal, rock, and raw emotion. It's impossible to listen to "Kill Me Quickly," the first track on *The Illusion of Safety*, without feeling something and knowing that you're not the only one feeling it. Dustin Kensrue's vocals evoke such a feeling of brotherhood, you can almost feel sweaty friends bumping into you and yelling alongside you while you listen.

Every album they've released has its own distinct style and sound and deserves to be played loudly, preferably while driving fast and screaming along at the top of your lungs. While most bands I've written about in this archive have early albums that are closest to my heart, my love for Thrice only grows as their career continues. If it's possible, I love all their albums completely, as soon as they're released. To me, the secret sauce is that these four guys, two of them being actual brothers, are wholeheartedly friends—and when they collaborate, whether in the studio or live, it legitimately feels like four souls have intertwined.

Thrice was swept up in the signing frenzy of the early 2000s and maneuvered their ascension to major label status and back down to indie territory like champions. Some bands did not get off so easily. There was a moment when everyone on the sidelines watching the millions getting pumped into hometown-hero bands gambled on whether Thrice or Thursday would make it "to the top" first. Joke's on them: There is no top. This game is a never-ending marathon not a sprint, and I'm happy to see Thrice still running laps just because they fucking love running.

RIGHT:
Photo by Kevin Kusatsu.
c. 1999.

OPPOSITE PAGE:
Photo by Nathaniel Shannon.
The State Theatre.
Detroit, MI. 2003.

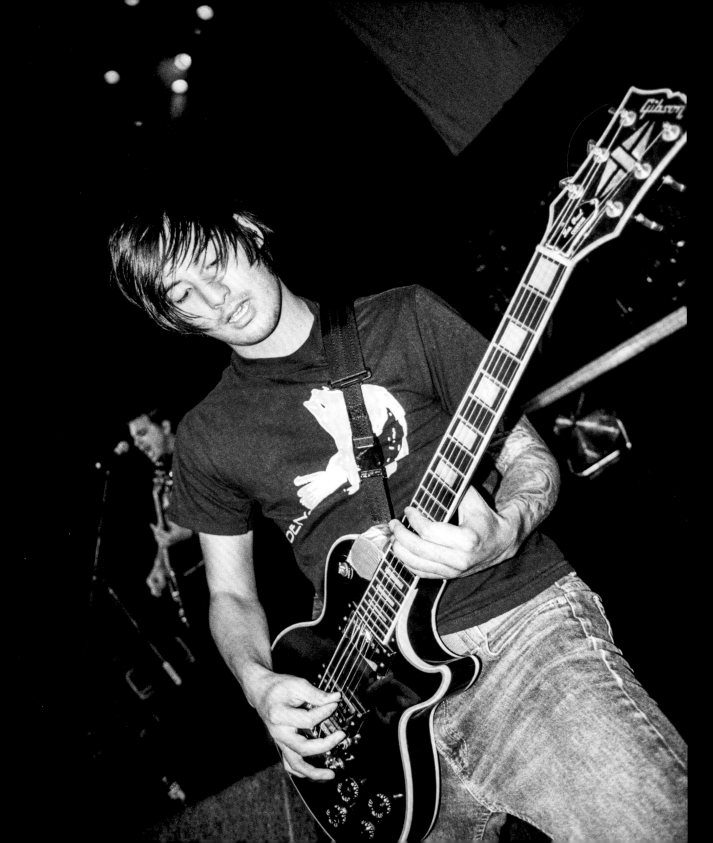

at Brian McTernan's studio in Beltsville, Maryland, while I was working intensely on my cancer charity. We hung a lot during those recording sessions. We ate endless meals together, we watched CNN as the US invaded Iraq, we discussed the use of jazz on the Playboy Channel—we became quick friends. And the friendships I made in this time period will live with me forever."

—Mark Beemer

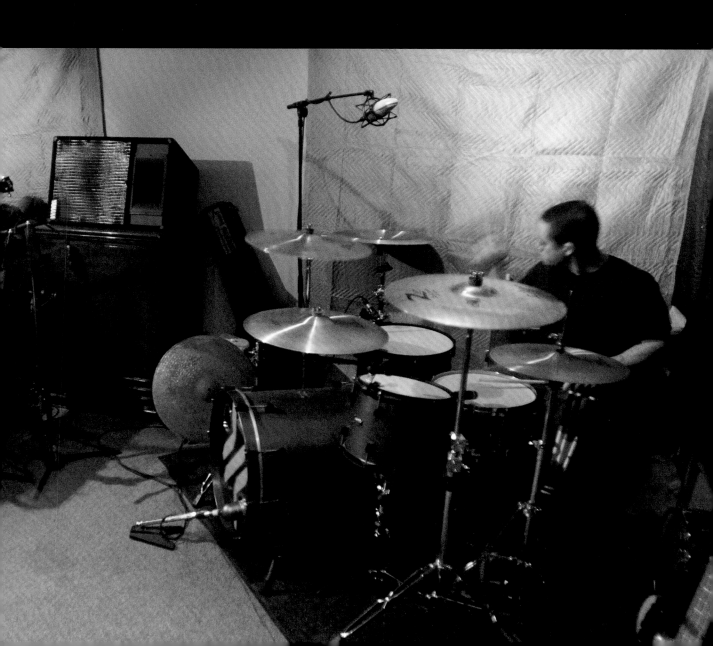

hursday

t. 1997
w Brunswick, NJ

fore Thursday, no one from this world had ever
tten a music video into heavy rotation—no one.
ere was a glimpse when At the Drive-In had a
oment with "One Armed Scissor" but the spins
re light and even more sporadic. Every band
shed that they could turn on the TV and see
emselves rocking out, but it seemed as impossi-
e as turning lead into gold. You have to remem-
r, this was long before smart phones and social
edia, so for someone to actually *see* your video,
had to be on MTV or Fuse. Premiering videos on
ur website wasn't quite as exciting, and those
ndom late-night single showings that warranted
ge parties with too much alcohol were fun but
ver achieved constant airplay.

en suddenly one day, Thursday's video for
nderstanding In a Car Crash" was on MTV2 seem-
gly on the hour, every hour, or more, and it felt
e the small, tight-knit emo scene had been struck
lightning overnight. Not only was Thursday the

first band to get this type of exposure; they were
the first band to make it to the airwaves by straight-up
screaming. There was always a better shot for bands
with pop and acoustic tendencies, like Dashboard
Confessional. Even Saves the Day had some hope.
But for a band with blatant, artful screams—screams
that were not backed by a serious amount of major
label dollars—this was a first.

And the universal sentiment was, "It couldn't have
happened to a nicer bunch of dudes," because it
was true. The humble and the authentic ones never
make it to the top—but Thursday did. They made
it all the way to the top, and they brought every-
body they could along with them. Their post-MTV
shows were massive, and their opening acts were
always friends from the early days. They were ready
to share the spotlight with everyone they'd met
along the way, and aside from their brilliantly crafted
and heartfelt songs, that's why their legacy has
endured.

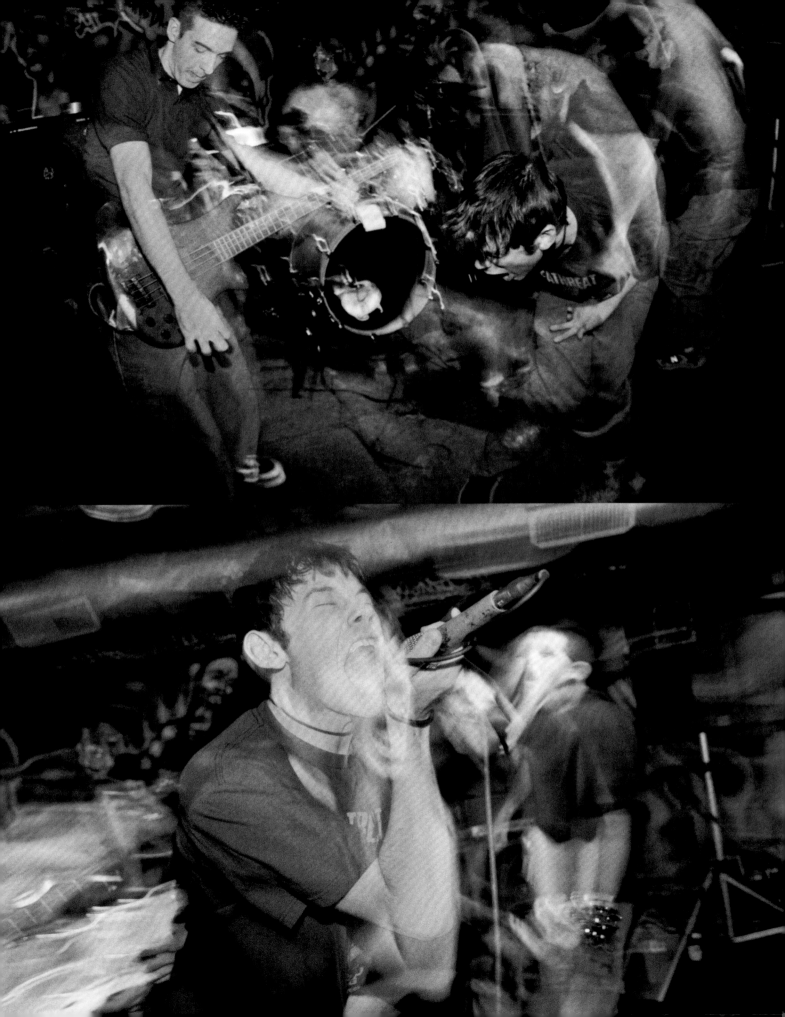

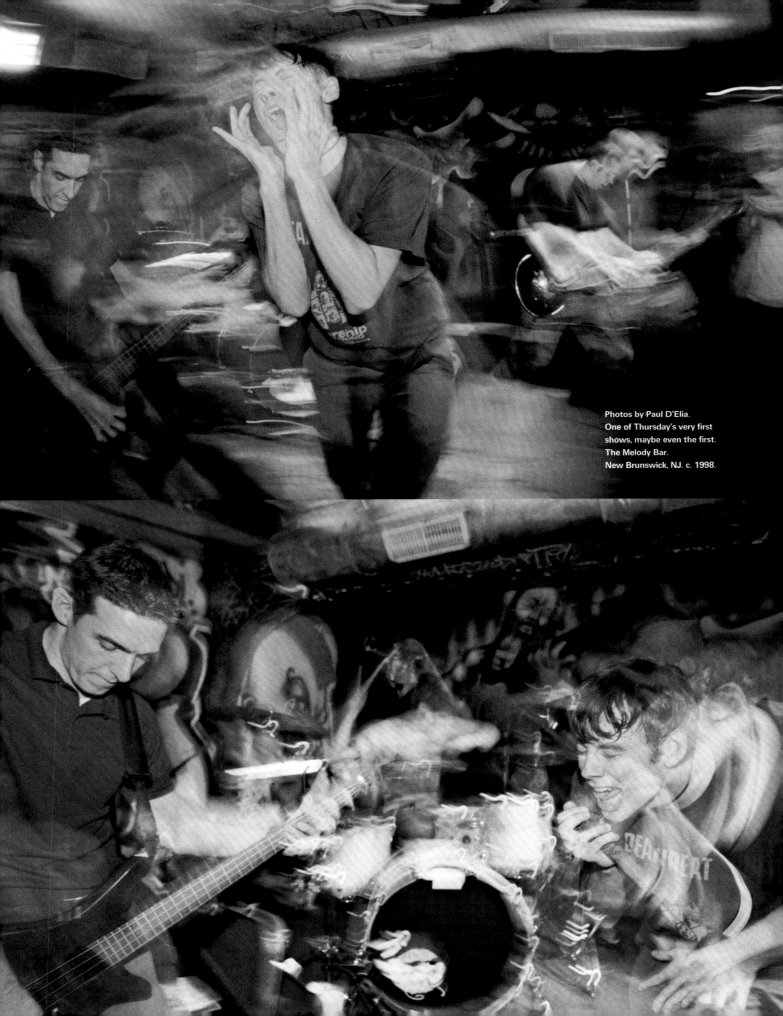

Photos by Paul D'Elia.
One of Thursday's very first
shows, maybe even the first.
The Melody Bar.
New Brunswick, NJ. c. 1998.

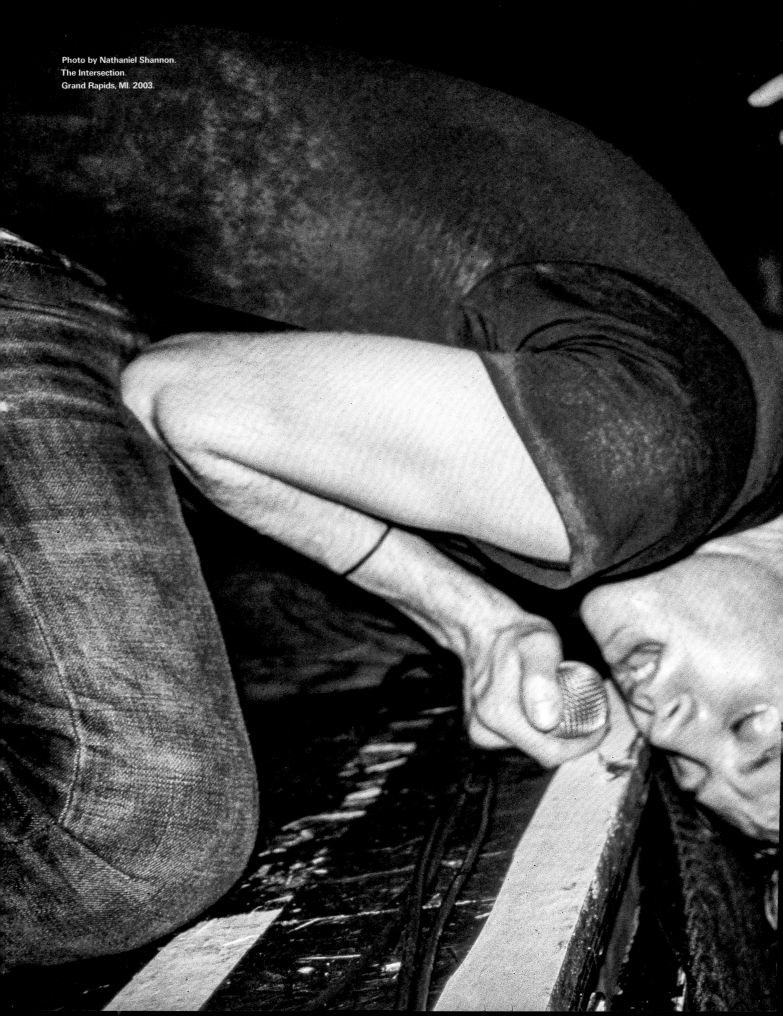

Photo by Nathaniel Shannon.
The Intersection.
Grand Rapids, MI. 2003.

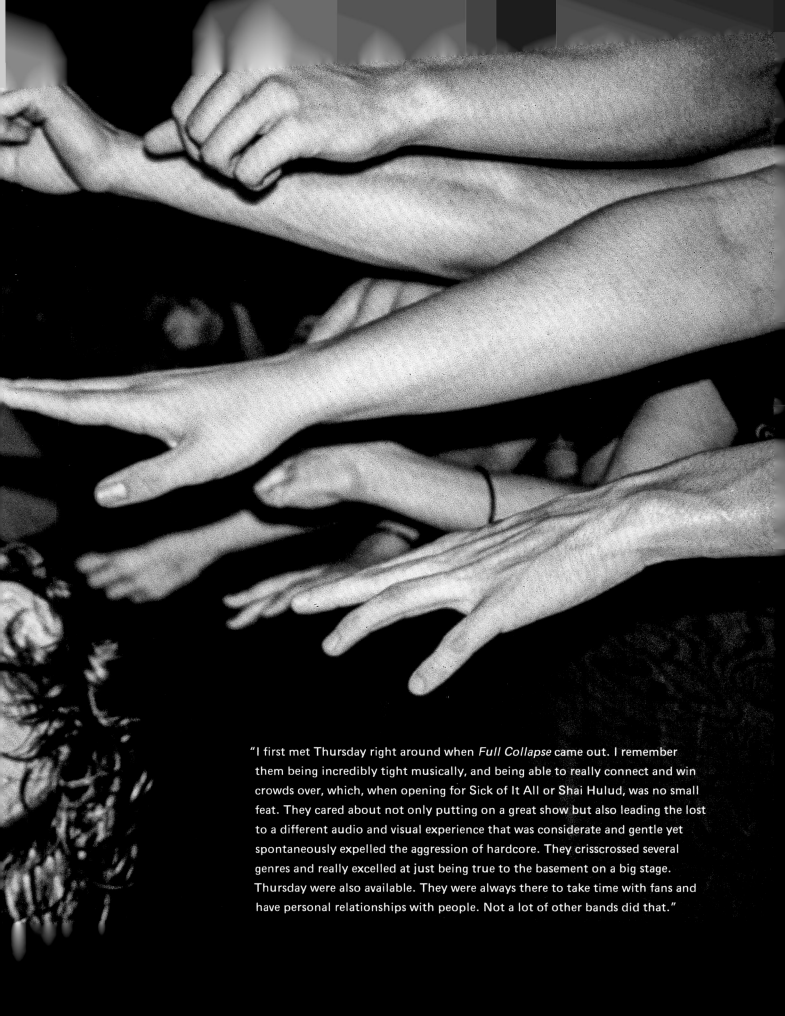

"I first met Thursday right around when *Full Collapse* came out. I remember them being incredibly tight musically, and being able to really connect and win crowds over, which, when opening for Sick of It All or Shai Hulud, was no small feat. They cared about not only putting on a great show but also leading the lost to a different audio and visual experience that was considerate and gentle yet spontaneously expelled the aggression of hardcore. They crisscrossed several genres and really excelled at just being true to the basement on a big stage. Thursday were also available. They were always there to take time with fans and have personal relationships with people. Not a lot of other bands did that."

The Used

Est. 2001
Orem, UT

—

Once the undeniable growth and dominance of emo became omnipresent, it didn't take long for major record labels to take notice of every indie label's front-running stars, and start picking up the emo demos that had undoubtedly been flooding their mail rooms since the '90s. While My Chemical Romance, Say Anything, Motion City Soundtrack, and so many others were transitioning from indies to majors, from out of nowhere—a.k.a. Orem, Utah—appeared The Used. The band came out swinging with a highly polished album on Reprise Records (owned and operated by Warner Music), produced by former ska band front man John Feldmann. They're one of the few bands in this book that had a major label release their first record.

Because of this, many, including myself, were wary of this band that had just *appeared*—but once we heard the record, we got it. Their self-titled album, released in 2002, was a near-perfect record, and I listened to it over and over until it actually disintegrated. Once they broke, they broke big, and there wasn't a band around who would say no to touring, collaborating, or hanging with The Used. In 2005, The Used and My Chemical Romance released a joint cover of "Under Pressure," and it was clear the third wave had found their Freddie Mercury and David Bowie, respectively. It was a perfect punctuation mark with which to close out the era.

Photo by Justin Borucki.
The bar next to Irving Plaza.
New York, NY. 2003.

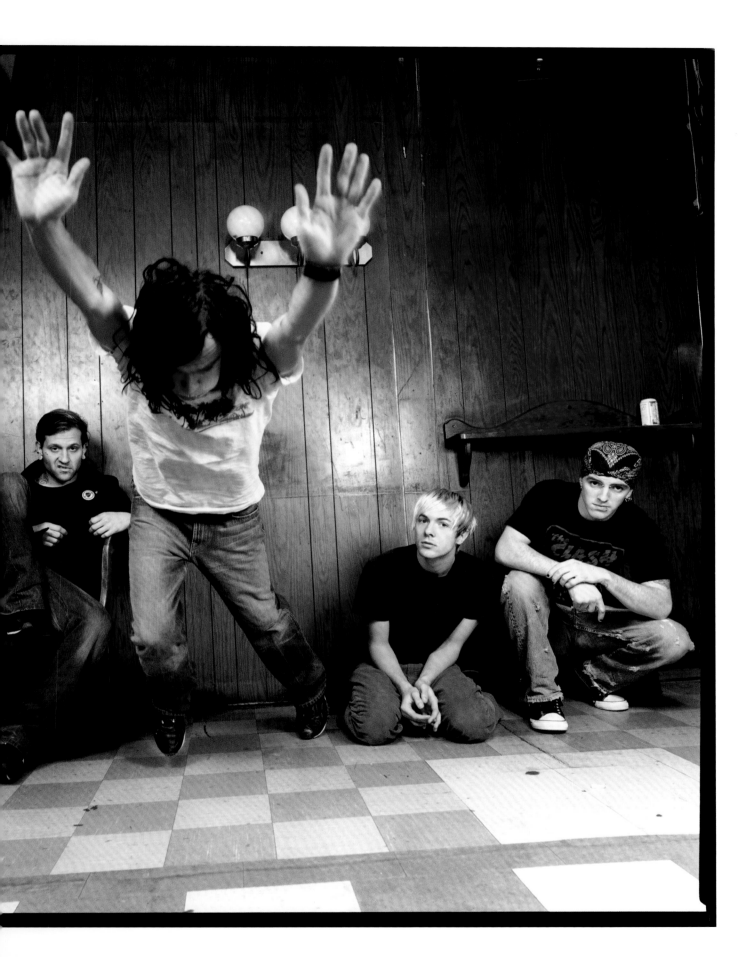

Afterword

Frank Iero
My Chemical Romance /
L.S. Dunes

2006?

There's not a ton of things I remember about 2006 firsthand. Most of my memories are like those of your childhood: bulked up by photos you've seen or anecdotes other people have told you about your life. I actually tried to google "2006 my chemical romance" in order to prepare myself to write about some of the things that happened around that time. My browser autofilled the search bar to "2006 my chemical romance calendar," and I thought to myself, "Oh, that's actually super helpful, that way I can see where I was that year," and I electronically ran with it. The results that popped up were just hundreds of scans of a high gloss calendar the band sold as a merch item back then. And it strangely felt kinda fitting.

In 2006, I definitely remember thinking I was crazy at one point, and I went to see a doctor who in turn overmedicated me to the point where I lost days and weeks at a time to the ether. Antidepressants and anti-anxiety meds, bars and blackouts. I remember feeling like we worked for a big corporation, and I don't recall if I ever met the boss. If Wikipedia is correct, it tells me My Chem released our documentary/live album, *Life on the Murder Scene*, in March and then our third record, *The Black Parade*, in October of that same year. Damn. There's a pretty striking disparity between those two releases . . . Hell, there's a pretty big difference between those two bands. Quite the learning curve. I don't know if I did as much growing up in those six to seven months as I should or could have, maybe not as much as everyone else did, and definitely not as much as I needed to in order to deal with what was about to come. I felt sad a lot of the time, and awkward, and desperately out of place. We didn't see our friends as much, we didn't see many

Photo by Justin Borucki.
Warped Tour, Randall's Island.
New York, NY. 2005.

317

people other than the crowd really . . . and no one was seen outside of the gray concrete walls of an arena underground parking structure. We were all fast approaching that time in your life where older loved ones started passing away, and the people you left back home a few years ago were growing tired of your absence and assumed you deserved to be brought down a notch whenever necessary. Maybe it's a natural reaction or a defense mechanism, but these types of occurrences will make you retreat even more, and it becomes increasingly difficult when you don't know where you belong, if anywhere. So you put your head down, pop a pill, and play a show.

I get anxiety when people ask about the time frame surrounding *The Black Parade*. I don't know if my reality was like everyone else's. A lot of the time I felt like I was standing in the center of a tornado . . . not spinning myself really, but a bewildering force immediately surrounding me was changing the topography of the world in a very visceral and violent way and I had no way of controlling it. I didn't feel a part of anything other than the parade, and even then I was probably more apart than a part. Maybe we all were. Now, financially and from an outside career perspective type situation, things were booming! So you'll find that no one wants to hear about anything else, and no one wants to say they're unhappy when it seems like so much is going right for them. But times were different then, and they were changing faster than they ever had before.

When it comes down to it, I wouldn't change anything if I had a magic wand, as everything that happened got me to where I am today. And for the first time in my life, I think I can say I'm happy and actually mean it.

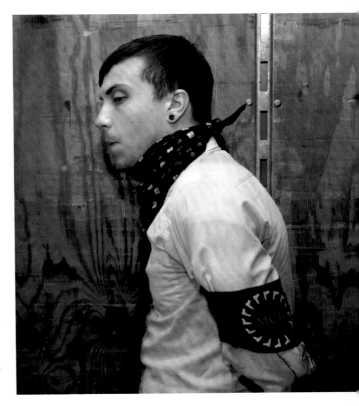

I love the things my friends and I accomplished together, all of them . . . even if I can't really remember being there. One day, maybe I'll sit down with someone who can dig out the things I have misplaced or buried in my subconscious and I'll tell you about them, but today is not that day.

Part of me thinks that type of thing is best left when the job is done . . . and I'm currently writing this in my Notes app on airplane mode flying to the next gig. Keep the faith.

—xofrnk, 2023 in a plane over an ocean

Acknowledgments

I think it's safe to say that after all this, I am a very sentimental person. Sentiment is a core principle of emo, so at least that tracks. There is a long list of people who have helped with the creation of this book, and I want to take the time to thank every single one of them.

When I look back, it's so wild to me to realize that the core group of friends I made from booking shows, touring, and literally by accident the first week I moved to Los Angeles in 1999 are the people who really helped me pull this whole thing together. RJ Shaughnessy, Michael Dubin, Kevin Kusatsu, Claire and Jeremy Weiss, Isac Walter: You all have been unbelievably helpful—both back then, and now. Thank you all so much for the endless support, energy, and help.

Thank you to all the photographers. If you are reading this, the full list is to your right >>>

These people are the real superstars of this book, and without their contributions this book would have only been about twenty pages and not so beautiful. Thank you for entrusting me with your art.

To all the writers . . . Chris, Norman, Matt, Geoff, Andrew, Jesse, Bob, and Frank—thank you for digging deep down and unearthing your thoughts, feelings, and memories to help paint this picture with me. Your insights are so valuable, and I can't thank you enough for sharing everything you could manage to share.

To my core Chronicle team . . . Olivia Roberts, my editor, you saw this project, and I didn't know you yet, but I could hear you screaming from 385 miles away. This book would not exist without you. My design powerhouses, Neil Egan and Wynne Au-Yeung, thank you for burning the midnight oil on this one and discussing *every. single. photo.* with me.

To my agents, starting with Brad Petrigala, who I met while touring with New Found Glory: I arrived at your Ohio doorstep frozen to death with no winter clothes—you helped me then, and you helped me now by bringing Clare Mao and Leah Petrakis into the fold. The three of you saw a very excited person with a pile of five thousand images and believed I could turn that pile into a book. I cannot thank the three of you enough.

My photo editor, Chris Kopinto, you are hands-down the best friend that I have ever made on the internet. Thank you for resuscitating these images and breathing new life into them. Your dedication to this project knows no bounds, and I'm eternally grateful.

To William Johnston, for always being my sounding board and extra set of eyes, thank you.

To my actual and adopted family at MDDN, thank you for letting me move in and take over entire rooms whenever necessary. Your support never went unnoticed.

Jessica Maria Johnson, it's safe to say I don't ever want to work on a book without you in my corner. You are a one-in-a-million friend, and I will never forget it.

To my husband, Josh, you are my partner in everything and I love you. Thank you for running the show and doing the dance at the end of the day when my eyes could no longer focus.

And lastly, thank you to all the bands in this book. Your art has shaped my life and the lives of millions of other people. Hold your head high. We were here and what we did mattered.

Contributing Writers: Norman Brannon
Chris Carrabba
Frank Iero
Jesse Johnson
Andrew McMahon
Bob Nanna
Matt Pryor
Geoff Rickly

Photographers: Gordon Douglas Ball
Roman Barrett
Mark Beemer
CJ Benninger
Lisa Schwalbe Boland
Andrew Bonner
Justin Borucki
Tom Cheney
Stephen Chevalier
Day19 (Jeremy and Claire Weiss)
Paul D'Elia
Paul Drake
Michael Dubin
Peter Ellenby
Aaron Farley
Douglas Garfield
Chrissie Good
Billy Hamilton
Taryn Hickey
Justin Hollar
Chris Kopinto

Kevin Kusatsu
Amy Fleisher Madden
Brian Maryansky
Curtis Mead
David Moore
Andy Mueller
Vincent Perini
Matthew Reece
Samiam
Aaron Schultz
Nathaniel Shannon
RJ Shaughnessy
Emily Shur
David Sine
Chad Stroup
Ilene Tatro
Maddy Traeger
Steven Wade
Isac Walter
Carrie Whitney
Brian Woodward

Library of Congress Cataloging-in-Publication Data

Names: Madden, Amy Fleisher, author.
Title: Negatives : a photographic archive of emo (1996-2006) / Amy Fleisher Madden.
Description: San Francisco : Chronicle Books, 2023.
Identifiers: LCCN 2023007060 I ISBN 9781797220994 (hardcover)
Subjects: LCSH: Emo (Music)–Pictorial works. I Rock musicians–1991–2000–Portraits. I Rock musicians–2001–2010–Portraits. I Emo (Music)–History and criticism.
Classification: LCC ML3534 .M308 2023 I DDC 782.42166092/2–dc23/eng/20230221
LC record available at https://lccn.loc.gov/2023007060

Manufactured in China.

Cover design by Jesse Reed, Order.
Interior design concept by Jesse Reed, Order.
Additional design by Neil Egan, Wynne Au-Yeung, and Amy Fleisher Madden.
Photo editing by Chris Kopinto.
Front cover photo and photos on pages 2 and 3 by Day19.
Back cover photo by Amy Fleisher Madden.

10 9 8 7 6 5 4 3 2 1

Chronicle Books LLC
680 Second Street
San Francisco, CA 94107
www.chroniclebooks.com